Taking Fame to Market

On the Pre-History and Post-History of Hollywood Stardom

Barry King
Auckland University of Technology, New Zealand

First published 2014 by
PALGRAVE MACMILLAN

Palgrave Macmillan in the UK is an imprint of Macmillan Publishers Limited, registered in England, company number 785998, of Houndmills, Basingstoke, Hampshire RG21 6XS.

Palgrave Macmillan in the US is a division of St Martin's Press LLC, 175 Fifth Avenue, New York, NY 10010.

Palgrave Macmillan is the global academic imprint of the above companies and has companies and representatives throughout the world.

Palgrave® and Macmillan® are registered trademarks in the United States, the United Kingdom, Europe and other countries

ISBN: 978–1–137–34427–4

This book is printed on paper suitable for recycling and made from fully managed and sustained forest sources. Logging, pulping and manufacturing processes are expected to conform to the environmental regulations of the country of origin.

A catalogue record for this book is available from the British Library.

Library of Congress Cataloging-in-Publication Data

King, Barry, 1944–
 Taking fame to market : on the pre-history and post-history of Hollywood stardom / Barry King, Auckland University of Technology, New Zealand.
 pages cm
 ISBN 978–1–137–34427–4 (hardback)
 1. Motion picture industry—United States. 2. Motion picture actors and actresses—United States. 3. Fame—Social aspects—United States. 4. Fame—Economic aspects—United States. 5. Branding (Marketing)—United States. I. Title.
 PN1993.5.U6K56 2015
 384'.80973—dc23 2014028968

Contents

List of Tables

Tables

Acknowledgements

This book is the outcome of a prolonged course of research and study in a variety of locations and institutions of higher education. It would be too cumbersome to name everyone – the living and the dead – who has provided ideas and inspiration. I can only hope that my glosses on these influences have not strayed too far from their originators' spirit and intention.

Some immediate debts need to be recorded. First and foremost, I need to thank my wife, Andrea Sisk King, for her work on editing the original manuscript and her on-going support throughout the process. I also wish to recognize the immense help provided by the Interloans Team at Auckland University of Technology who are true conquerors of the tyranny of distance

Special thanks, both personal and professional, go to Sean Redmond, Leslie Sklair, James Bennett, Su Holmes, John Benson, Andrew Hemingway and to Larry Gross of the Annenberg School for Communications, University of Southern California, who provided me with the opportunity to teach and research on Celebrity Culture in Hollywood today. Sharon Carnicke, John Thornton Caudwell and David Craig were also instrumental in providing me with information and access to their networks while I was there. At AUT I have benefitted from the support of colleagues, Frances Nelson, Rosser Johnson, Olaf Deigel and David Robie.

Lastly on a personal note, this book is dedicated to Bill and Phyllis Sisk, brothers-in-law Jon and Mark Sisk, to my children, Toby, Helen, Sally and grandchildren, Joe, Thomas, Emily and Alex.

William Hazlitt, writing on Edmund Kean, once wrote: 'Our highest conception of an actor is, that he shall assume the character once and for all, and be it throughout, and trust to this conscious sympathy for the effect produced.' Change the word actor to author and I can only hope for the same.

Introduction

In this book I analyse stardom and celebrity, in its Western manifestations, as expressions of the anthropology of capitalism. By this latter term I mean more than the economic aspects of stardom as a system of inequality, but a cultural institution or form of life that justifies high reward. As Marx famously observed, a commodity appears as a natural thing to those living within a capitalist culture. But upon examination it abounds with 'metaphysical subtleties and theological niceties', promoting the perception, exemplified by the money form, that commodities are intrinsically valuable rather than valuable because they are the products of collective labour (Marx, 1867/1976: 163ff). What stardom and celebrity share is the perception that fame is a result of individual 'natural' qualities that come from outside the collective labour of media production. The different ways in which stardom and celebrity promote this perception is also part of the matter to be analysed.

To begin to make these points I will consider the case of David Garrick, the actor-manager of the Theatre Royal Drury Lane, whose name is linked in the OED to the first recorded use of the word 'star' in 1779 – coincidently the year of his death. I will also make a comparison between Garrick and Edmund Kean, a star of the next generation, and make further observations on the status of female stars as contemporaries or near contemporaries. All these actors are denominated as stars but I will argue that they represent polar reference points in the cultural meaning of stardom and its semantic shadow, celebrity.[1]

The first point to note, which is perhaps obvious, is that to speak of Garrick as a star is to ignore the metaphorical roughness of the term as first recognized by the OED. Dictionary benchmarking clearly lags behind practice.[2] Within the theatre it had long been recognized that some actors, sometimes called capital actors,[3] were especially talented

1

and skilled. Indeed, it is quite possible to imagine a system in which character actors are the chief means by which the theatre satisfies the demands of the market – for example, the widespread fame of Richard Tarleton (Halasz, 1995). But as I will elaborate further, these popular players are strictly speaking only the harbingers of stardom, sharing some of its attributes, but without the fullness of realization found with Garrick and then those who succeeded him. Another way to express this is to say that the formation of stardom has an intimate and organic connection with the merchant form of capitalism.

This much said, I acknowledge that calling Garrick a star as is understood today – as a performer who has property rights invested in a persona – is somewhat anachronistic. It might be better to refer to him as a proto-star that reveals the preconditions for the development of stardom.

But not to run ahead of my analysis, I shall now make certain distinctions that are necessary to show that the accomplishments of Garrick as a performer and as a public figure set the terms in which stardom proper is formed and then extends out from the English theatre. Moreover, the term proper should be taken in a moral sense in contrast to improper. Succeeding stars were not 'proper' in the way Garrick's circumstances permitted him to remain through his long career. The latent 'immorality' of stardom, particularly imagined as a quality of female stars, is perceived as more shocking and dangerous if appended to male stars as the example of Kean demonstrates. The patriarchal keying of stardom is part of the reluctance to recognize female stars, some of whom were Garrick's contemporaries. But it is also a general feature of acting that it produces 'sexual suspects' (Straub, 1991). The passionate behaviour of Kean, on and off-stage, is shocking and exciting in part because it sexualizes male identity. But there is also a class dimension that determines who can be explicitly sexualised as a male which feeds into the 'erotic' mix. As shall be shown subsequently, the tension between the kind of stardom that Garrick and Kean exemplify structures the cultural field of commercial theatre and thus demarcates the institutional parameters of stardom (Bourdieu, 1983). These different articulations of acting and fame have had an impact on the development of stardom in American cinema.

Of course, the notion that film stardom and capitalism are intimately related is not a new insight. Thus two leading commentators observe:

> The star is a specific product of capitalist civilization: at the same time she satisfies profound anthropological needs which are expressed at the level of myth and religion. The admirable coincidence of myth

and capital, of goddess and merchandise, is neither fortuitous nor contradictory. Star-goddess and star-merchandise are two faces of the same reality: the needs of man at the stage of twentieth-century capitalist civilization.

(Morin, 1960: 141)

Or:

We're fascinated by stars because they enact ways of making sense of the experience of being a person in a particular kind of social production (capitalism) with its particular organization of life into public and private spheres. We love them because they represent how we think that experience is or how it would be lovely to think it is.

(Dyer, 1987: 17)

Another hint of a connection between stardom and capitalism in the Anglophone world can be found in etymology. The term star as defined in the OED – as a person of brilliant reputation or talents and an actor, singer, etc. of exceptional celebrity, or one whose name is prominently advertised as a special attraction to the public – did not become common currency until the first decades of the nineteenth century. At that time, it was applied to leading theatrical players such as Rachel Felix and Francois-Joseph Talma in France or Kean and Mrs Nisbet in Britain.[4] The lexical consolidation of the term is, in itself, an index of a historic shift in the public standing of the actor, from rogue and vagabond to a respected professional (Bradbrook,1962). The professional reputation of acting is a fragile and hard-won accomplishment, in part because specialized training is not a necessary condition of entry. Generally, the standing of the actor rests on public approval and by extension, since the actor is required to be a source of excitement, on an appropriate degree of licence in relation to an established image and what the interested public are prepared to tolerate. Another reason, mentioned below, is that actors are moral agents.

What I offer is, I believe, a good way to think about stardom and celebrity; a means to bring some measure of coherence to what remains dispersed and underdeveloped. For example, Morin's formulation, cited above, is potentially if not actually circular as many such observations are.

So for me, the connection between stardom and capitalism is a guiding assumption in need of further exploration. To start this, in the first chapter I will explore the relationship between stardom and an urban market for theatrical entertainment in England as a precursor

to the development of the Hollywood star system. It is in eighteenth-century London that the formation of the actor as a commodity first appears and this formation sets the terms of a commercial vocabulary of fame, which still exercises our imagination. As Marx also remarked, the anatomy of man is the key to the anatomy of the ape; a backward glance from the present can uncover features that seemed 'natural' in the past. The first step in the analysis is to focus on the non-theatrical concept of a person, in its private and collective manifestation, as the ground through which performance-specific notions of character and persona are informed and reconstructed. To trace this particular grammar of selfhood and identity involves constructing a 'deep' historical evolution or genealogy. The entry into this history depends on showing how changes in the prevailing precapitalist conception of a person come to represent the existential glue of a capitalist society based on commodity exchange. I contend that the development of stardom in the theatre not only draws on this broad transformation, but augments and codifies it. The development of the star system exercises a cognitive power that exemplifies (multiplies and intensifies) the perceptions on which it drew. What was the role of theatre in the promulgation of the new competitive version of the self that sought to gain advantage over others through impression management, rather than to affirm its place (and therefore prescribed entitlements) within a shared collective order?

My aim, then, is not to characterize the impact of commodity relationships on culture in general – though this is clearly a literature on which I shall draw – but their impact upon the culture and social organization of acting. I must stress that what follows is a grammar of personhood in acting; I do not essay a close analysis of performances, as there are already plenty of these. Rather, I seek to delineate the strategies of performance that permit acting to refer to the extra-theatrical world through the optic of the market. To show this I will track how the conception of the star that originates in the theatre is translated through a complex process into Hollywood stardom and finally, into media or mediated celebrity. Specifically, I focus on theatre in eighteenth-century London because it is there, historically, that the primordial connections between personality and the market were forged. It is through this primary forging, translated to early American theatre and thence to Hollywood, that the star as a luminous individual, distinguished from the collective activity of film-making, becomes the fulcrum through which the effects of commodification in performance work are concretized, given bodily form and ultimately global effectiveness.

Accordingly, the ultimate aim of this book is to contribute to a political economy of stardom and celebrity as a form of fame, a form that, in order to build mass demand for products and services, reaches intensively into the personality of the performer rather than extensively into the collective crafts of production and performance. Although painters, writers and musicians develop personalities, strictly personae, that affect the reception of their work, the actor as a feigner of appearances, using his or her body as an instrument, is most directly engaged in the exploitation (by the self or by others) of person-based resources of meaning. Broadly, I contend that it is how the cultural meaning of acting is inflected and articulated through the social relationships of commodity production that create stardom and impart a distinctively capitalist form to acting as work. This formative influence impacts and transforms notions of craft distinction, reward and recognition. Moreover it is the further incursion of commodity relationships that has led to the development of celebrity as we know it – as absolute fame, as fame without an intrinsic or specifiable connection to a recognized or agreed set of skills or even talent. This intensifying incursion has created collateral developments in other fields of performance – music, sport, literature and politics – where absolute fame takes the form of a heightened emphasis on presentation over representation that is predominant today (Marshall, 2010).

Coming to terms

In celebrity journalism terms such as fame, celebrity, stardom, reputation and renown are often used interchangeably. Such terms are undeniably fuzzy and interdependent but they are not mere synonyms. To treat them as such permits a certain facile writing which popular celebrity journalism demonstrates, which in turn creates confusion and alarm about the pervasiveness of celebrity. Therefore in what follows, I propose to restrict the term stardom to refer to renown, a condition of fame that rests on excellence in a particular field of human endeavour and the term celebrity to mean being widely known, without any necessary or demonstrable link to specific achievements. Stardom and celebrity can go hand in hand, but they need not – an individual can have celebrity without achieving the highest levels of craft accomplishment or without possessing exceptional talent (Currid-Halket, 2010). Admittedly, the relationship between stardom and celebrity is more complex than this elementary disjunction suggests. There is, for example, a temporal dimension to the nature of fame so that even if stardom and celebrity coincide in the present they may diverge significantly in the future.

The professional accomplishments behind a reputation may be surpassed by other contenders, be diminished by changes in fashion and taste or be depleted by the ageing of the self. In this circumstance, a name functions as a memorial to a previously possessed standard of excellence (Lang and Lang, 1988).

The advent of the mass media, starting with the press, has obviously complicated the relationship between stardom and celebrity by extending the chance for the simple survival of a name to have longevity beyond accomplishments. As Boorstin observed, it is largely with the emergence of the media, that is, the Graphic Revolution, that fame can become a tautology – of being known for being well known, rather than for achievement (Boorstin, 1963). This tautology is what underlies contemporary concerns about celebrity as unwarranted fame. Although Boorstin's distinction between genuine fame and pseudo-fame or celebrity is arguably overly moralistic, it is equally wrong to conclude that celebrity is an unproblematic term denoting a person who is much written and talked about regardless of his achievements in a particular sphere of activity. Rather, it would be better to say that celebrity is that condition of fame where it is not possible to finally determine whether talent or publicity accounts for fame. Much ink and footage is expended on exploring this very question. So Boorstin was right to claim that the development of the mass media – the mass circulation press and cinema, radio and television – created a disjuncture between fame for accomplishment and fame for a media presence and profile. This can be taken further to suggest that only with the invention of moving image production technologies – cinema, television and lately, computer generated imagery – that permit the creation of 'doubles' has the distinction at the heart of stardom and celebrity become a culturally significant fact (Castles, 2008). But it is not a matter of technological development alone, since we are not talking about the media, however conceptualized, but a capitalist media.

Generally speaking, a film star is a species of the genus actor that is epitomized in the popular imagination by Hollywood. It can be suggested – exploiting an ambiguity in the word species – that the Hollywood star is a kind of spectre that haunts the way excellence in acting and other spheres of performance is judged and rewarded worldwide. Thus stars of Indian cinema, as the name Bollywood suggests, are routinely compared to Hollywood stars (Nayar, 2009). So although my focus is finally on Hollywood stardom, what I propose is an exploration through one critical case of the processes by which the actor becomes a symbol for ideas about the nature of fame. This, it needs to be said, is not a new concern (Braudy, 1986). But my aim is to bring greater precision to the mechanisms

that underpin the formation of the endless circulation of fame between stardom and celebrity.

At a more abstract level, my analysis presents an archaeology of stardom, the examination of the emergence of the conditions and forms of a discourse (Foucault, 2002). This discourse, and even more so that of celebrity which flows from its development, far from contributing to the de-centring of 'Man' that Foucault located in the eighteenth century, leads in the opposite direction to an absolute centralization of the individual.[5] Such process of centralization also has, to use Foucault again, a genealogical aspect since it is also about power relationships that sustain a particular discursive practice. But there is a clear historical dimension which I connect to the impact of the market and the commodification of performance. As long as the practices of acting remain governed by rhetoric one could speak of a discourse of acting; the impact of the market is to turn the practice of acting into the production of ideolects. It is my contention that stardom and celebrity are ideological mechanisms that represent and then present this transition, through the process of relinquishing a formal code of performance to the contingencies of embodiment.[6] The other theoretical tributary that I draw upon is a production of culture perspective. Such a perspective offers a composite analysis of the impact of the various features that create a field of cultural production (Bourdieu, 1983). As its leading exponents have defined it:

> The production of culture perspective focuses on the ways in which the content of symbolic elements of culture are shaped by the systems within which they are created, distributed, evaluated, taught, and preserved.
>
> (Peterson and Anand, 2004)[7]

The nature of the economic, class-based relationships that exist between artists and performers and their audiences has a fateful impact on the manner in which a particular art form can develop, on what is practically and aesthetically possible. Although the areas of consumption – where cultural products are evaluated, taught and preserved – provide powerful feedback effects, it is the area of creation and distribution that has analytic, and empirical, priority if we are to comprehend the movement of an ongoing field of activity. We cannot talk meaningfully about the undeniable impact of fan cultures on stardom and celebrity, for example, until we analyse why and how these discursive variants have been framed within the realm of production as a hoped-for passepartout to market success.

Acting and the semiotics of visibility

When terms like stardom, celebrity, icon, idol and so on are deployed as synonyms, certain facets of the process of signification are suppressed. This suppression creates a glittering uniform condition. But this suppression, convenient for celebrity journalism, creates a quandary: the terms used seem equally relevant and therefore equally meaningless. But fuzziness is serviceable too since it represents stars and celebrities, even more so, as forces of nature, prominent precisely because they are beings mysterious and difficult to define. It is no small advantage that ambiguity is fertile for the production of more 'buzz' and chatter.

As Goffman (1990) observed, all forms of social interaction involve self-presentation. But to act or even to perform as one's self is a second-order form of self-presentation, under the 'mask' of pretending, and oriented to create a representation.[8] The actor's performance may occur before a directly present audience. This audience has the potential to disrupt the process of feigning, forcing the actor to slip out of character and momentarily enter the condition of mere or abject personhood as the example of Kean or Sarah Siddons suggests.[9] Yet in the context of mass mediation, the significant audience is not just the one present, or even a concrete audience segment watching remotely, but the market as a smoothing machine – capitalism's significant Other and the primary mode of recognizing the will of the collective. In this process the fame of the actor or performer is posited as an abstraction from the multitude of small acts of exchange that comprise the market. For although by direct or indirect observation, viewers or professional critics may question whether a star or celebrity deserves his/her fame and fortune, it is the box office that remains the final arbiter of value, a capricious and unpredictable god of fame. So the value of the star does not depend on his or her usefulness as a public symbol or a professional role model, but how his or her personal qualities function as exchange values. The dynamics of this process will be explored further but the general point is that being a star or celebrity is to find one's career less determined by the opinion of one's peers or contemporaries than by the law of large numbers, by the box office as a machine for smoothing the multitude of individual choices (acts of exchange) into a mass choice. So it can happen that individual consumers find their own choice confronted, affirmed or perplexed by the weight of the choice of an anonymous alien mass.[10] Through the history of Hollywood and the mass media, the fact of audience alienation through quantification has been humanized by the figure of the star as a kind of social type (Klapp, 1962). But as we shall see it is this equation – never stable or problem free – that is breaking down.

As I have already indicated, a fundamental set of distinctions underlies the functioning of the actor as a public figure. Such distinctions constitute distinct routes to reference and thus are contrasting articulations of meaning (Goodman, 1981). In considering stardom, the foci of meaning are personage, person, character and persona. How these foci or modes are combined form a figure – a being that represents some higher or supervening reality held to inhabit the material presence of the actor. His or her standing as a social body rather than a physical body.[11] Person, personage, persona and character are differently scaled articulations of figure. A performer may be famous – cut a figure – for the role s/he holds in a particular social setting exclusive or antecedent to any role. This is most clearly observed in the British case of a theatrical knighthood where, for example, Sir Kenneth Branagh means the actor has become an institutional symbol rather than just a star – a precedent established by Sir Henry Irving, the first actor to be knighted. An actor or performer may be renowned for his or her performance of a single character or a type of character, effectively playing cameos or avatars of the same character through out his or her professional life. He or she may construct a professional identity – a persona – a durable image that draws upon the selection of personal qualities that exemplifies a type. He or she may work to submerge the self in a string of unrelated characters, refusing a facile equation between a character type and his or her private person. Or s/he may only be a person, as in the case of reality television and talk shows, presenting a likeable image of him/herself which answers to the fact of being on show but is not adjusted to the demands of fitting the self to a fictional character. As I use it here, character is a threshold term between fiction and actuality that implies some moral evaluation. A fictional, theatrical character has moral quality just as an individual has in everyday life.[12] Personality as I use it is not a figure, but a quality of a figure. On the one hand, it means a being that has the quality of selfhood, as opposed to thinghood. On the other hand, it is necessary to distinguish this usage, which in effect equates personality with a self, from a more situational definition of personality as an impression of a self formed in a particular context. So in show business, the noun 'personality' refers to a special performer whose fame rests on being him/herself rather than seeming to be someone else. Yet personality can also refer to an impression of a person projected by a fictional character and/or the impression of a person created in social interaction. Though the ambiguities in the term cannot be entirely avoided, I will use personality to refer to the manifestation of a self or identity that is situational rather than categorical. The quality

of humanness is assumed; my focus is on how it is manifested. In the realm I analyse – between the theatrical and everyday social interaction, between the public and the private – personality can be a quality of the person, personage, persona and character as states of being, and indeed much of the fascination with celebrity and stardom rests on their enigmatic interdependency as a source of ontic bemusement. Overall, I assume that selfhood and identity are synonyms, which refer to a hypostatic condition of being, an entity that presents versions of the self (personalities) depending on the internal or external circumstances. In this sense, a concrete individual has a number of personalities (or what in sociology would be termed social roles) which, in the optimal case, are held together by an awareness of the self or identity based on memory and a bodily continuity (Neisser, 1988).[13] Viewed statically, rather than as performance processes, these identity options can be mapped.

Such options are by no means as exclusive as Table 0.1 would suggest, and the star or celebrity may 'dine out long and well' on their confusion. As aspects of the actor's self, they may have a different salience across a career. Evidently, the notion of choice, itself connected to the belief in the actor's creativity, is limited by material factors such as typecasting, the competition of others within a particular type, luck, changes in fashion, beauty standards and the like.

The fundamental axis of variation in these states of public identity depends on their relationship to the theatrical concept of character. As observed, as a general rather than specialized theatrical term, character refers to the moral qualities expected of the individual on the basis of his or her role, a standard that may be revised but not abandoned on the basis of observed behaviour. If character is taken in this sense, then public interest in stars and celebrities is always, whether it is realized or not, a moral judgement of worth, of the quality of being deserving of fame. It might seem that the fact that an actor feigns, playing a character as a fictional or quasi-fictional being, carries less of a moral charge. Yet the long history of resentment of theatre and of actors suggests this not the case; indeed, since acting is represented as an exercise of creative freedom,

Table 0.1 Modes of the self

Modes of identity	Actual	Fictional or virtual
Singular	Person	Persona
General	Personage	Character

the moral judgement may be more severe. An actor delivering a glamorous portrayal of a killer can be held to weaken the moral condemnation of such behaviour, just as a portrayal of a paedophile priest may damage the character of the priesthood as profession. Whether or not such conjectures are valid, they indicate that playing fictional characters is implicated in the assignment of moral values in the broader sense of the term (MacIntyre, 2007). The two senses of character are therefore interwoven and their conjunction forms a figure around a particular star or celebrity as an expression of moral agency, but it is the positioning of the variants of identity – as person, character, personage and persona – that concretizes the moral value of the star or celebrity as some kind of sign.[14]

It is a commonplace that casting as a process tends to determine the fit between the physical attributes of the actor or performer and prevailing conceptions of type (Turow, 1978). Or, more exactly, it is only after the fact of casting that the material qualities of the actor begin to be considered in terms of his or her potential to be a figure. From the perspective of the audience, this consideration is time sensitive. In a debut role, all the general public is likely to know about the person of the actor will be framed in terms of the qualities of a particular character. If the actor's performance proves popular, then that character will become the professional recess for a public self, developed by typecasting as the spine of a career. When this happens, and to the extent that it happens, there eventuates an amalgam of the dramatic and the extra-dramatic (or extra-cinematic) contexts, which is the persona. The persona, as a durable image manifested repeatedly in the media, seems to be the property of the actor's person outside of character; whereas it is actually an adjustment of the self to the contingencies of media exposure.

In a successful career, the persona becomes a self-sufficient public image and, in line with commercial opportunities, character roles are selected to confirm that the actor is plausibly identified with his or her persona, minor departures from type being carefully framed as 'creative holidays' from the main line of business. In this way, the development of a persona opens up the possibility of a public self that, thanks to the operation of the media, can rest on a stock of publicity generated not only through acting, but in other fields of performance. Once having arrived at the threshold of persona, there remains the ever-present possibility that the interest in the actor will 'descend' below the frame of representation and fix upon the publicly revealed qualities of his or her person, however burnished for media appearances. In recent times, this descent has become more concrete, which is to say more abstract. This abstraction is accomplished by the exposure aspects of the actor's

private self that do not conform to his or her persona and the faith that the general public and fans have invested in it. Of especial interest is gossip that shows the person of the performer to be a source of discrepant behaviour, which questions his or her fame as deserved. In recent times, the separation of public and private life which has traditionally protected the integrity of the actor's persona has been breached, not just by paparazzi, but in some cases by the actor or performer himself/herself. As a result, a hybrid has emerged – the public private self. When this happens the attenuation of a connection with specific characters or the realm of the dramatic arts can approach the status of an activity-free, pure expression of the self which is a prominent contemporary meaning of celebrity. One interpretation of this development is to see it as an effort, driven by commercial motives, to steal the figure of the actor from the realm of public representation.

The possibility of this latter development rests on a feature of the semiotics of performance. Behind any performance of an identity are certain elements of the actor's actual presence that must be kept from attaining the status of manifested meaning. The stuff of the actor as a material being is meaningful in its own right just as the stuff of a piece of jewellery (plastic, wood or gold) conveys a meaning and has a value – but such latencies are not all pertinent to a particular performance. The general name for them is figurae, elements of meaning that within a given sign vehicle are treated as having no meaning (Eco, 1979). This does not mean that they are meaningless but rather that figurae have to be managed to ensure that they do not distract or destroy the desired overall impression of a self. So just as performances on screen or stage are supported by the use of make-up and lighting, and in cinema and television by flattering camera angles, framing and focus, so appearances in person are manipulated to produce what is judged to be the best effect. For although it is tempting to think of the person as outside the realm of performance, as, for example, a site of authenticity, it, too, is a performance involving the suppression of figurae. In this sense, person, personage, persona and character are selections of qualities occurring in and obedient to different formats of visibility – in our time, the on-screen or on-stage performance, the celebrity chat show, public appearances and random on-street encounters – and in different combinations of channels, such as the visual, auditory, tactile and olfactory with only the gustatory remaining, presumably, purely private.[15] So it is not the reality of the actor, his or her true or authentic self, but his or her being as a creature of signification – especially in the pragmatic context of fashioning a commodity self – that is at the heart of my analysis.

1
Unsettling Identities: From Custom to Price

The concept of the self as a kind of performance, managing the relationship between being and seeming, had emerged in courtly circles during the Italian Renaissance. The literature of that time such as Baldasar Castiglione's *The Courtier* (1528) and Giovanni Della Casa's *Galateo* (1558) was widely read and imitated in England – the first targeted at a courtly readership and the second, a guide for general social decorum.[1] The popularity of such guides is evidence of a widespread anxiety over self-transparency, particularly intense in authority contexts where the failure to present an agreeable exterior could jeopardize one's well-being.

In England, from the latter part of the sixteenth century onwards, a new perspective on identity gained ascendancy. This viewed physical appearance, including dress, demeanour and gesture, as instruments to be controlled in the projection of the person as a respectable being, compliant with one's ascribed position. Implicit in this view was the conception that the 'natural' self was a source of discrepancies that, if not appropriately controlled, could expose the individual's true condition and intentions. Depending on the circumstances, the failure to control such signs, or more exactly signals, rendered the individual so transparent that s/he might be a ready gull for others or, worse still, would prove incapable of carrying forward his/her own schemes for control and influence.

At first, this heightened awareness of the need to fashion the self – more positively construed as a show of refinement – was largely and pragmatically confined to the milieu of the Court and aristocratic society, where advancement was dependent on Royal favour (Elias, 1978: 56). As Stephen Greenblatt has demonstrated, the notion of self-fashioning – the studied adoption of an efficacious appearance and demeanour – enjoyed wide currency in Renaissance courts, especially

amongst men and women who, because of their origins or religious convictions, were marginal to the Elizabethan Court and the Church of England (Greenblatt, 1980: 2, 7–8, 162).

In English Court circles, Queen Elizabeth I was a powerful proponent of the importance of appearance and personal display in the maintenance of majesty.[2] Self-fashioning was not, as we might think following Goffman, a democratic form of jockeying for position in which anyone might connive to avoid embarrassment and garner respect (Schudson, 1984). Far from being a process through which formal equals might calibrate their relative advantage, Elizabethan self-fashioning operated within a strictly prescribed social hierarchy in which appearance was circumscribed by rank, with clothes and other items of adornment, positioning the individual in relations of deference.

Whatever individuals thought in private, the public theatre of Court required outward conformity and a prescribed decorum, if preferment was to be gained or the wrath of the Monarch avoided.[3] Metaphysically, disrespect for vestimentary codes translated as disrespect for the 'Great Chain of Being' – the hierarchical order ordained by God in which all persons were allotted their place at birth and expected to abide by it without complaint or a show of hubris. To infringe the prescribed boundaries of attire for one's rank was not merely vanity or misrepresentation of one's due, in the manner of a con artist, but a flouting of God's larger plan for humanity. Particularly to be feared was a weakening of the sanctifying glue of deference – given by the aristocracy to the Crown, by commoners to the nobility, by women to men and children to their parents.

In such a customary culture, unlike today, where fashion (of appearance and manner) signals the unique choice of an individual, authenticity was seen as inhering in obedience to one's station (Gregerson, 1990: 1). The legitimate purpose of clothing was to express the man, as God had prescribed, not to make the man. Sumptuary laws codified this intent, drawing upon passages from the Bible to prescribe the relationship between patterns of consumption and social rank. From the time of Henry VIII, the key focus of such laws had been on controlling the consumption of foodstuffs and other luxury items. Successive sumptuary acts in 1363, 1463 and 1483 were justified as curbs against vanity and excess amongst the lower orders, but the real target of such legislation was the middling stratum that harboured aspirations to the rank of gentleman. Indeed, it was those who already had gentleman rank and above who were most vociferous in petitioning the Crown for an increasingly draconian implementation of sumptuary legislation. On her accession to the throne in 1559, Elizabeth I issued a series

of proclamations requiring a more rigorous enforcement of sumptuary statutes. These proclamations were specifically aimed at the regulation of apparel, introducing tighter controls over the style and materials that persons of a specific rank might wear. These controls had the narrow aim of preventing impersonation of court and civic officials by confidence tricksters (Hurl-Eamon, 2005). But they were also intended to re-enforce the customary order. In wearing the livery or the dress codes prescribed for his/her station, the individual demonstrated allegiance to the institution, the Crown, which 'dignified and protected their person'. Dress conformity was the visible marker of a 'loyal' subject (Stallybrass, 1996).

It seems likely that Elizabeth's enthusiasm for sumptuary control had a gender dimension. As Kantorowicz (1997) has shown, medieval thought was concerned with maintaining a distinction between the corporate symbolism of Kingship and the infirmities of the physical body of the King. Elizabeth's gender was additional 'infirmity' that served to compound the problem of incarnating in a frail human body the institution of Monarchy. Her obsession with vestimentary correctness seems to have surpassed vanity. Making extravagant display her prerogative has been read as a conscious strategy to reconcile the 'male' attributes of leadership and power with their lodgement in a frail female body (Sponsler, 1992: 266, 281; Montrose, 1991: 1–41, especially 27–28).

At the same time there was also a political dimension to her actions. An increasingly powerful class of merchant capitalists, ironically the source of financial resources for the sumptuary expenditures of the aristocracy and gentry, was in the ascendancy.[4] As an emergent social category not readily mapped onto the geography of deference, merchants were also responsible for feeding the appetites of even more nebulous and socially undefined groups; urban youth, especially male apprentices, and assorted upstarts whose extravagance of dress and behaviour seemed to mark them as a new and threatening kind of social being (Corfield, 1991). In a manner reminiscent of modern anxieties about youth subcultures, the behaviour of this 'sort' was a lightning rod for respectable fears (Bailey, 1998). But the economic power of merchants meant that sumptuary statutes were largely unenforceable. They were repealed in England in 1604, much earlier than on the Continent or in Scotland – even though the underlying concern for a proper deferential equation between social seeming and social being persisted, with bills introduced into Parliament without success until as late as 1640. Notwithstanding the ineffectiveness of sumptuary legislation, a reverse-utopian longing for visible distinctions in ranks and honours remained a persistent theme in political and social life. Thus Blackstone's *Commentaries on the*

Laws of England in 1765–1769 asserted the prescription of appearance as a constitutional necessity (Hooper, 1915: 499).

For some, the waning of sumptuary regulation was an opportunity for self-enhancement in two respects. First, it sustained the narrow pursuit of interactive advantage or the con (Goffman, 1990). Second, it provided a means of demonstrating social superiority – as witnessed by the fad for masques – where the aristocracy, having the wealth for conspicuous consumption and the licence provided by a gentle birth to 'play' at identity, had the upper hand (Castle, 1986). In reality the sumptuary status struggle was centred less on the issue of the lower sort dressing above their station – poverty and the effects of hard labour would prevent that – than of ensuring that aristocratic society, the 'better sort', was able to exclude parvenus and maintain its leadership. But with the waning of sumptuary laws, the control of appearance became a 'war for social position' between an emerging upper middle class and the aristocracy, in which extravagant forms of dress such as big wigs were the weapons of choice.[5] These manoeuvres, linked to the development or persistence of social types such as the fop and the macaroni or 'gay' peacock, on stage and in print, still postulated an equation between the inner being and appearance – by those bent on deception and passing as much as those seeking acceptance, if not admiration, from their peers (Festa, 2005). So, despite the alarm felt by conservatives at breaches of a sumptuary order's ideals, those who felt undervalued (and therefore challenged), as well as those who affirmed such an order, believed that appearance should reliably communicate a person's social standing.

As the first features of a consumer society gained ground in England, a reverse-utopian longing for a sumptuary order in which all knew (and looked) of their place remained a persistent theme in conservative thought. Needless to add, those who succeeded in advancing their prestige through the game of masks and manners took their turn asserting that the sumptuary order was a sound indicator of human quality. Nonetheless, by the mid-eighteenth century – the era of Garrick – England as observed by foreign visitors was a realm in which an uncontrollable thirst for novelty, fashion and the shuttlecock of fads held sway (Freudenberger, 1963: 4).

The new order of the market as a risk society

In a risk society, the consequences of individual or collective action are no longer nourished by an overall sense of societal and cosmic order. For the individual – now experienced as a mere entity, abstracted from the

imaginative coherence of the social order – ontological insecurity is as pervasive as the drive to resolve it.

The concept of a risk society was developed to explain certain features of late modernity (Beck, 1992). But if a risk society is, amongst other things, a society in which social relationships are no longer clearly discernible – and consequently, no longer nourish a sense of place or the certitudes of being – then it is useful to see life in eighteenth-century urban England as a situation of risk. An important question then turns on what crucial social developments disturbed the expectation that personhood was achieved by submission to a sovereign power, heavenly or secular, permitting the worrying perception that the self as presented was merely a tendentious mask.[6]

So if concepts of self-fashioning remained embroiled in an idea of selfhood as prescribed by – or at least answering to – social status, this connection was increasingly confronted by a different concept of the self that was responsive to the contingencies of commodity exchange. Although, as Harold Perkin (1969) put it, this emergence was bewildering to contemporaries in the eighteenth century, it was a matter not only of perception but of substantial rifts in the social fabric of the city, which emerged as a site of insecurities and risks to life and limb. London had undergone an unprecedented expansion in population; from 1650 to 1801, the population grew from around 350,000, with an approximate increase by 200,000 every 50 years, to nearly a million.[7] The sheer accumulation of people created a perplexity that exceeded the imaginative economy of the Great Chain of Being, its predictable and reassuring relationships between moral worth, appearance and motivation seemingly breaking down.[8] A new fluidity of personal identity called for a new cartography, new maps and new guidelines for navigating encounters with strangers who did not sit comfortably within traditional types.

> The expansion of bourgeois mercantile and commercial classes in the 18th Century capital was accompanied by both the appearance of many unclassifiable people, materially alike but not cognizant of their similarities, and the loosening of traditional social rankings. Absent was a new language for 'us' and 'them', insider and outsider, 'above' and 'below' on the social ladder.
>
> (Sennett, 1978: 49)

On a material level, the increasing sense of social opacity, of disorder and disintegration, stemmed from changes in the social relations of production. In the former, now-declining agrarian order, relations of production were directly embedded in the social units of the manor, estate

and village. There a paternalistic regime operated in which the better sort might scrutinize the doings of their socially defined inferiors. But by the eighteenth century, the 'spontaneous' policing of the 'meaner sort' was weakened with the onset of a national market driven and sustained by cash-centred transactions. Even where petty manufactories remained local, their owners and workers gained a measure of autonomy through their engagement with distant (urban or even foreign) markets and by receiving earnings in cash rather than as payments in kind. In time, such petty mode establishments were replaced by manufactories located in urban centres whose productive relationships were shorn of paternalistic norms of reciprocity by the cash nexus.

From the perspective of an agrarian ruling class, the concentration of formally 'free' labour in cities created a breeding ground for a placeless and potentially ungovernable mob, a perception compounded by high levels of geographical mobility in and out of urban centres (Stone, 1966: 31). Moreover, if the popular culture of the countryside was brutal, its manifestations in an urban setting were perceived as aggravating its ferocity, especially given the absence of the moderating influence exerted by the aristocracy and gentry.[9] Social observers were aware that a prosperous urban trade was creating a 'middling sort' that by religious conviction and its own desire for respectability entertained a parallel disdain for the urban poor, but this phenomenon was too new to be reassuring. In itself this proto-bourgeoisie 'buffer' was unnervingly amoebic:

> artisans, shopkeepers and small merchants; surveyors, attorneys, tutors, stewards, eminent clergymen, substantial merchants, rich factors and barristers as well as the inferior clergy, . . . tenant farmers and even Grub street writers, doctors, surgeons, and apothecaries, military and naval professions, the London monied interest, people who worked but ideally did not get their hands dirty with that employment of a servant was one of the basic criteria of something approaching middle-class status.
>
> (French, 2000: 281)

Such a sprawling description was, in part, an attempt to capture embryonic class relationships within a failing lexicon of customary relationships; what had once seemed natural now seemed forced. Hitherto tacit social understandings governing the relationship between the ranks were now perceived as requiring explicit efforts at re-enforcement, a reaffirmation of the letter of the law over the declining comforts of habit. The perceived negative consequences of a growing national market economy

were re-enforced in turn by anxieties over political threats from abroad, such as Jacobite conspiracies to restore the Stuarts and, as the century wore on, by egalitarian doctrines that were seen to culminate in the French Revolution.

In response, the ruling elite looked to the State and especially the Law to maintain order (Mingay, 1963).[10] Through a flood of amendments to the criminal code, enlarging the number of offences covered by capital statutes, the High Court and the locally assembled Courts of Assize laid down increasingly severe sentences and, when the full letter of the law was applied, the visibility of punishment. State occasions became martial spectacles, and parades demonstrated to enemies at home and abroad the resolution of the State to quell opposition and dissent. Emphasizing the determination of the better sort to celebrate their vision of patriotism and fealty, the calendar of traditional folk festivals was replaced by an official calendar of national events. At the local level – of the manor and the estate – the aristocracy and gentry had long been accustomed to staging periodic displays of the capacity for benevolence and punishment, the latter run through the presence of bailiffs, flunkeys and assorted intermediaries.

> We have here a studied and elaborate hegemonic style, a theatrical role in which the great were schooled in infancy and which they maintained until death. And if we speak of it as theater, it is not to diminish its importance. A great part of politics and law is always theater; once a social system has become "set," it does not need to be endorsed daily by exhibitions of power (although occasional punctuations of force will be made to define the limits of the system's tolerance); what matters more is a continuing theatrical style. What one remarks of the eighteenth century is elaboration of this style and the self-consciousness with which it was deployed.
>
> (Thompson, 1974: 389)

The significant development is that the local theatre of stick and carrot, of punishment and charity, required the national theatre of greatness to underwrite what was once perceived as the natural order of things. The 'theatre' of greatness in its national and local staging did not go unchallenged from below – by workers, the poor and elements of the middling sort – when it abridged ancient rights such as a 'fair' price for bread or involved withholding goods from the market (forestalling). This quotidian theatre of the street demonstration was replicated in the theatre proper through the conduct of audiences towards the actors on stage,

who were deemed to be public servants, and between different class factions in the audience. This micro-politics often led to actual riots and must be seen as focused manifestation of the larger political struggles covered by Thompson (Baer, 1992).

From one aspect, the show of increasing force and exemplary punishment for minor offences – notably those against private property – fractured what it sought to preserve: the image of a smooth, legible, inclusive social order regulated by patronage and deference. This paradox was implicitly recognized in the development of coping mechanisms that could act as a triage for the old dispensation. Thus a sharp increase in capital offences and sentences was not matched by an increase in the actual number of executions. Pardons and commutation of sentences served to underscore the importance of mercy as an ideological tool to sharpen adherence to the norms of deference (Hay et al., 1975: 51ff). The increasing severity of the law, if moderated in its application, was politically significant because it conjured up an image of society that was increasingly bent on exclusion, imagining a 'sort' of people who were undeserving of sympathy, an outcast group beyond the pale of civilization.[11] There was an underlying reality that supported this imaginary, albeit not the automatic moral judgments drawn from it.

For most of the eighteenth century, the greater part of the population, especially in London, lived in a precarious state brought about by pronounced inequalities in income and wealth. It has been estimated that during Garrick's day, up to 90% of the English population earned less than 50 pounds per annum, the bare minimum on which to support a family, with a 'middling' family earning 200 pounds and a small number of temporal Lords earning 6000-plus. With regard to wealth, it has been estimated that 5% of the population owned 85% of the wealth, the majority of which was derived from landed property (Mingay, 1963). A consequence of this 'flat' income and wealth distribution was that the great mass of the population struggled to stay above the poverty line. Particularly for urban dwellers in centres such as London, lacking the resources to live off the land, the resort to crime was a predictable reaction to need.[12] Some of the newly identified capital offences, such as stealing bread, fell under this heading.

Even amongst the more comfortable 'middling sort', the threat (or at least the fear) of a descent into poverty was ever-present.[13] For skilled tradesmen and small businessmen, work could be irregular and for the many individuals below this standing, even more so. The shadow of the debtors' prison and the threat of descent into bankruptcy (especially given no limit on personal liability) was a prospect that might engulf

families both high and low, but especially by the ranks of law-abiding families just above the poverty line (Langford, 2002; George, 1964). Nor did increasingly punitive law-making alone create a climate of terror. In urban centres such as London, apprehension and informing became a free-enterprise activity. A swarm of predators – civic officials such as trading magistrates, bailiffs and catchpoles – made a living out of debt collection and the 'sale' of indulgences for those they helped commit to debtors' prison. Freelance debt collectors and informers without office, confidence tricksters and loan sharks preyed on the reckless or unwary, profiting from their downfall (George, 1964; Hay and Rogers, 1997). Nor were these activities solely reliant on personal initiative. The Society for the Reform of Manners deployed its own 'regulators' to make citizen's arrests of individuals for breaching existing ordinances and statutes concerning blasphemy, drunkenness, lewd and disorderly behaviour, Sabbath-breaking and so on. The Society was responsible for over 100,000 charges brought against individuals between 1694 and 1738, the young being particularly targeted (Hunt, 1999: 36–7). In the midst of this social policing and surveillance, it was not just those on the edge of poverty but also the middling sort that had before them a constant reminder of the instability of life and the ever-present possibility of a fall from grace into the abyss of poverty.

Another potent ideological effect of the new draconian code was to project the effects of mass poverty into the interior of the person, as a lack of moral integrity or character. This view was in some ways the validating correlate of the view, congenial to the aristocracy, that their wealth was an outcome of superior personal qualities, which could be claimed, despite the troublesome odd rake and rogue, on the basis of noble lineage.[14] The concentration of immense wealth in the hands of a small number of individuals and their families only furthered the perception that inequalities arose less from social position than from individual qualities (Bergel, 1962: 5–7). But this perception also opened the door, however reluctantly, to the dilution of aristocratic collectivism by individualism.

With the growth of urban markets – pre-eminently London – it became necessary to concede that individuals in commerce and trade might attain a certain virtuous distinction. Property ownership, especially in land, was seen as a prophylactic against immorality and radicalism. By acquiring land, individuals were imbued with desirable personal qualities such as stability, patriotism and dependability, which those without property constitutionally lacked. The gulf between the virtuous noble or gentleman and the common sort was most emphatically marked by the

stigma attached to manual labour, but the sullying of the person also applied to those whose fortunes rested on trade and finance alone (Klein, 1996: 222–223). Perceived as parvenus, merchants, bankers, lawyers, independent tradesmen and the like might escape the taint of manual labour, but not of money as a transient, unstable and protean shape-shifter that stood for commercial advantage rather than national interest.

So for the nascent commercial elite, the possession of great wealth could not bestow on the self the assurance of quality guaranteed by bloodlines and the descent of landed property. For this social group, whether in the molecular theatre of mercantile dealings or in the great theatre of power, there was pressure to engage in Goffmanian demonstrations of taste and refinement. This partook of two dimensions. Internal to the group, there was a need to distinguish oneself from peers and rivals. Externally, there was a need to ameliorate aristocratic disdain from above and the resentment of the 'lower' sort from below (Langford, 2002). In this manner, the commercial elite (sometimes, ironically, the provider of loans for the aristocrats who disdained them) operated as an indeterminate buffer zone, 'a middling sort' tied by a line of 'magnetic' dependence to the patronage of a landed ruling class, yet prepared on occasion to tactically align itself to popular protest.

Finding its existence structured by forces outside of its control and lacking a political means of advancing its interests, the forerunner of the nineteenth-century middle class had to navigate a terrain fissured by identity struggles over the importance of local versus national culture, ruralism versus urbanism, business interests versus citizenship and the rights of men and women (see, for example Gunn, 2005; Wahrman, 2004). These contradictions fuelled a proto-class struggle carried on in terms imposed by the frameworks and understandings of a waning customary culture. In the longer term, the 'middling sort' (anachronistically, the middle class) was to forge its own standards of refinement and distinction that aped, even as it transformed, aristocratic notions of a worthy life, persisting in the hope that the stigma of commerce or a prehistory of manual labour would be erased after three generations of professional life and, above all, a 'noble' marriage and the acquisition of a landed estate (Corfield, 1991; Cannon, 1984).[15]

Merchant psychology

At base, the new equivocation of identity expressed an ontological shift in the metabolism of exchange, as behavioural norms attuned to payments in cash displaced older rituals of payments in kind. Historically,

the exchange of goods and services had been regulated by norms of reciprocity found in familial and community relationships. The spatial location of markets at the margin of social life expressed the importance of a boundary between the logic of the gift and the logic of exchange, governed by an impersonal standard of value expressed through some variant of the money form (Agnew, 1986). Market transactions in a customary economy were strongly framed and regulated by rituals that defined what was appropriate and fair and what expectations the partners to the exchange might have of one another (Mauss, 1973). The market was a sequestered place on the margins of everyday life where goods might be alienated, passing from the seller to a buyer without, as was the case in a gift economy, the former retaining any residual rights of possession (Weiner, 1992). With the development of a cash-based economy, complete alienation through exchange became the norm. Customary rules and practices were set in abeyance or became, to an extent, optional or dependent on the goodwill or honour of the participants. Such a setting-aside was accomplished by the displacement of value as an expression of social relationships into the intrinsic value (according to some measure of universal equivalence, that is, money) of the things themselves. Through the medium of the money form, a strict calculus of economic advantage is vested with the power to override the claims of sociality. In this development, monetary exchange has the potential to free the individual from the constraints of reciprocity and from the confinements of his/her ascribed social type. But such freedom comes at the cost of isolation and alienation from collective processes (Simmel, 2011).

It is now in the micro-texture of exchange that the remnants of collective identity must be affirmed or, in other words, consciously performed. In the old 'trust' economy, individuals striking a bargain had still to attend to perceptions of fairness operating in the community and governed by ancient rights (Thompson, 1971). Despite differences in social standing, a broad equality could be evoked within the interior of the act of exchange in which the buyer and the seller were deemed to be men of honour accepting a common obligation. The power differences between participants might affect the punctuality of the settlement – as in the aristocratic distinction between debts of honour among peers, which must be paid immediately, and legally enforceable debts to tradesmen that might be slowly discharged without dishonour – but this did not affect the notion of a just price. For merchant capitalism, by contrast the notion of a just price is replaced by the notion of nice bargain (Thomas, 2009: 152). The enhanced theatricality of merchant

life stemmed from the relational gap between the buyer and the seller imposed by the logics of a cash-based economy wherein price became a contingent value no longer fixed by custom. Compared to customary forms of exchange, which bound participants into a social relationship of trust, the simple form of commodity exchange had an asocial potential. It required no more than a zero degree of association, in which individuals had only to consider a narrow self-interest. For the merchant or seller, the overarching goal was to buy cheap and sell dear in order to profit on cash advanced. The profits were then used to buy (or produce) further commodities for sale and so on, theoretically, ad infinitum. For the buyer, possessing cash or token equivalents, the purpose of the transaction was to obtain use-values for consumption and to do so at the cheapest possible price. On the one side, a continuous relationship with buying and selling, and investing mediated through the process of exchange, the persona of the merchant; on the other side, a discontinuous, anonymous act of purchase by the consumer as a transient, fractal instance of aggregate demand (Marx, 1991: 254, 744–745, 1003).

The transition from a gift to a cash economy is a recursive dialectical process. Even in developed capitalist formations where the money form functions as a universal equivalent, there remain areas that operate outside of the cash economy. An important feature of the transition under consideration, the operation of a cash economy was dependent upon the imaginative resources of a customary society, not merely because this was the established model of social order, but for concrete reasons related to the 'immaturity' of the media of exchange. From the late sixteenth century onwards, the extensive shortage of coinage of sufficient quality (as gold or silver) or of small enough denomination to encompass routine purchases meant that commodity transactions were elongated serial processes in which cash payment could be extensively deferred. If legal contracts and other instruments of credit (such as promissory notes, bills of exchange and tokens) proliferated with growing personal indebtedness, their effectiveness for the most part relied on a shared sense of obligation to sustain the serial passage to a cash settlement. Not until developments in the later part of the eighteenth century, such as the large joint stock company and, following the Restrictions Bill of 1797, the increasing use of paper currency, did a concept of abstract or impersonal credit adjacent to and essentially divorced from communal entanglements emerge (Muldrew, 1998).

It was through this complex development that notions of the moral content or character of the person became infused with the responsibility of ensuring economic or monetary values. For given the discontinuities

in the process of exchange, the parties to it perforce became the guarantors of value, like so many surrogates for money. This is most apparent if one considers the conflict between hegemonic aristocratic ideals, which devalued a too-exact attention to financial settlements and preferred rent to commercial profit, tradition to innovation and, in terms of personal worth, gentility to entrepreneurial skills (Taylor GV, 1967: 482). The tendency towards the financialization of the person, closely aligned to the psychic mechanisms of commodity fetishism, was particularly associated with London, as the centre of luxury production and consumption (Brewer, 1997). But another basic feature of merchant capitalism, which the 'inefficiencies' of the money form did little to moderate, was the tendency to shrink the scope of relationship between the buyer and seller to the act of exchange itself, with an attendant depletion of reciprocity.

Theatre and the market

The first examples of a commercial theatre organized for market exchange developed in the subsequently named Age of Shakespeare. Before then, theatrical events had occurred in two formats. Players were employed in permanent private theatres with the patronage of the guild, the church or the aristocratic household. In such settings, the actor's status was as a protected servant or factotum of the relevant master, undertaking a range of duties, some of which were theatrical and ceremonial, some purely domestic in nature. In contrast to comparatively stable employ-ment as a factotum, the majority of actors – though the prevalent term was *player* – owing to their casual status led a precarious, strolling life, ever at hazard of prosecution by provincial authorities as vagabonds or purveyors of lewd entertainments. The irregular and meagre earnings made by strolling players made their activities closer to begging than gainful industry. This marginal status – dissociated from a particular estate or village – seemed to local authorities to indicate a potential for disorder. Players were seen as 'masterless' men and women of ill repute and in all probability harboured some individuals who were little more than vagrants (Hill, 1984: 48–50). If employment in the noble house-hold offered economic security, it also meant subjecting oneself to the tastes and ideological preferences of the patron.[16]

The aesthetic flowering of English theatre in the Age of Shakespeare was closely connected to the development of permanent 'public' the-atres, as the Elizabethans termed them, housing licensed companies per-forming for the general public for an admission price. The development

of public theatre took two forms. On the one side, an exclusive variant of Court banqueting halls, more expensively priced or managed through subscription, which catered to a socially mixed 'quality' audience of aristocrats and merchants. On the other side, amphitheatres accommodating larger and more socially heterogeneous audiences and offering an alternating diet of drama, tragedies and comedies, and traditional 'brutal' entertainments. Edward Alleyne, a leading player and his father-in-law, Philip Henslowe, were joint owners of The Rose and Fortune theatre and Masters of the Office of The Queen's Games of Bulls and Bears. Entrepreneurial spirits, they bolstered their revenue streams by alternating bear- and bull-baiting with theatrical performances and, as lucrative sidelines, ran alehouses and brothels (Gurr, 1980: 12–18,123–31 and 142–6).

The association with 'low trades' and a strong tradition of anti-theatricalism meant that many of the most popular public theatres had to be located outside the jurisdiction of civic authorities, the Lord Mayor and the city Alderman. In this manner, Southwark on the South Bank of the Thames, conveniently connected to the City proper by London Bridge, developed into a thriving theatre district.

Despite (or perhaps because of) the odium attached to play-going by the respectable, especially Puritan, City fathers and the threat of prosecution it encouraged, public theatres were immensely popular. From 1565 to 1642, when all public theatres were closed by Parliament for a period of 18 years, London had 12 amphitheatres, 9 playhouses and 6 inns where plays were regularly performed.[17] It has been estimated that there were at least 50 million separate visits to London theatres in this period. The percentage of London's population attending theatre in Shakespeare's day was 13% compared to 1.7% in Garrick's, though shifts in population size and what is encompassed by the term 'theatre' may make the disparity appear more striking than it actually was. Even so, the Elizabethan and early Jacobean stage has a creditable claim to be a theatre with a mass audience (Agnew, 1986: 247).

Without denying the close association of playhouses with 'low' or illicit activities, for those with a conservative or religious mind-set, public drama per se, irrespective of its content – in any case closely censored – posed an intrinsic threat to the orderly and ordering assumptions of customary society. Acting companies of necessity, despite the lowly birth or a compromised social standing of some of their members, had to play all ranks, thereby throwing into view questions of an appropriate relationship between social rank and appearance. Dependent upon the nature of the plot, actors in a particular

play might portray their betters in a less than favourable light. Indeed, according to the laws of Shakespeare's day just portraying a King as an ordinary mortal could be regarded as treasonable, let alone performing with the intent to lampoon, satirize or engage in social criticism.

One did not have to share the Protestant dislike of pretence as an insult to God's ordering of appearance to recognize that because of its potential to hold up the various estates and conditions of persons to open scrutiny, theatre as a medium was intrinsically suspect. The new public theatres, within broad limits, admitted anyone who could afford a ticket. So there was always the possibility that reflections on matters unsuited to the station of plebeian theatre-goers might cause discontent or diminish respect. A society shown is a society treated as known. So *how* it was shown and *to whom* it was shown were perennial concerns. Unless carefully overseen or, ideally, restricted to an audience of the better sort, public theatres were seen as a potential, if not actual, threat to social and political order. Hence within the jurisdiction of the City Fathers, plays were subject to a tight regime of scrutiny and, generally, to prior censorship by an officer of the Royal household, the Master of the Revels.

For my purposes, two aspects of the foregoing developments need to be emphasized. First, the broad outlines of theatre regulation – the Office of the Master of the Revels, aristocratic protection and patronage and so forth – were established in the Elizabethan period, and in Garrick's day remained essentially in place. Second, the development of public theatres effected a significant shift in the economic standing of actors. With the advent of permanent companies, some actors at least became permanent employees offering drama as a commodity to fee-paying customers. As shown by the example of Shakespeare, in the new context successful playwrights and leading actors could become partners, with a share of the profits, in a company protected under a Royal Charter. Such a company would employ their services and those of freelance actors and, though not actually in direct association with traditional guild organizations, run a system of apprenticeships. With development, leading actors and sometimes playwrights became investors and managers, employing personnel, owning theatrical premises, wardrobes and stock, and acting as go-betweens with the licensing authorities and the public. In short, they became merchants of dramatic experience, introducing proto-capitalist relations into what had been a collective enterprise that had flexible roles and an absence of hierarchy.

An important aspect of the development of commercial theatres is their impact on dramatic form. The extensive literature on this topic is not, however, my concern here. Rather, I want to focus on the commercial

theatre as a place (alongside the press) where a new geometry of class relationships could be concretized and dramatized (Agnew, 1986: 111). This dramatization had a metonymic and metaphoric dimension. Metonymically, the new commercial theatres were merchants of entertainment and to that extent part of the general development of merchant capitalism itself (Bruster, 1992). Much like merchants in general, the owners of commercial theatres – whether in dealing with customers and civic authorities or securing loans for investment or debt financing – relied on projecting an image of trustworthiness. The importance of such an image to trade was underscored by the publication, in the period from 1560 to 1630, of more than one hundred items – reference books, economic treatises, bookkeeping and training manuals –that advised merchants on how to create and sustain a 'trustworthy' persona. Seeking to mask the disjuncture between the motive to accumulate and the suspicions of the customer, the merchant's persona needed to be seen as real rather than pretence, if it were to secure the confidence of others (Sullivan, 2002: 43, 140). In this way, practical advice on sound business methods, such as double-entry bookkeeping, was integrated into a performance of identity that was para-theatrical. A commercial theatre extended an already established practice of self-fashioning into the realm of drama through the convention of stardom as a guarantee of the quality of performance. For what were actor-managers but merchants of drama?

In sum, in its general outlines, the transition to a cash economy attained its perceptible form as a direct social relationship in the Hanoverian city. As the latter became a cultural magnet for the aristocracy and gentry, who regularly spent a 'season' in town, a largely country-based ruling class came into direct contact with an anonymous mass of labourers – tradespeople and their families – who provided the labour power for goods and services. In the city, within the recursive molecular experience of exchange, identity became a matter for validation even as the development of a consumer market permitted greater opportunities for individual expression. Increasing geographical and social mobility compounded status uncertainty, with judgements of social quality becoming harder to apply. In sociological terms, the antecedent and then surrounding ecology in which the progenitors of stardom emerged was one of status ambiguity, in which the various dimensions of social existence – an individual's trade, family background, religious beliefs and so on – did not smoothly cohere.[18] An intense scrutiny of the individual becomes the city's order of the day because the surface of demeanour and attire takes on the characteristics of performance to be evaluated for its credibility.

In order to understand Garrick's stardom and the style of performance it encouraged, it is necessary to consider the prevalent conception of the self in this early mercantile phase of English capitalist development. The self was a dispersed passionate entity that expressed its refinement and civilization through its obedience to an externally ascribed *type* of person. Such a type, even as it constrained how the self might be publicly presented, afforded an efficacious image or protocol of a person – what might in contemporary sociological parlance be termed a role. Contrary to contemporary ideas about performance being a mask that depletes the authenticity of an inner self, the self only became real at the moment of its engagement with a social type (Trilling, 1972).

Such a commitment to being – whose truth status needed to be ascertained – was not, therefore, an expression of the truth or authenticity of an inner self. Such a depth-surface model of identity only became a norm for 'people' reading in the nineteenth century as romanticism counterposed the integrity of individual experience to society (Brown, 1987; Wharman, 2004). Rather, it was an attestation of allegiance to being a kind of person. The quandaries of identity, which theatre would exploit for dramatic tension, did not draw on an operating expectation that the outer shell of the person ought to be authentic or faithful to an essential core self.

So as the onset of the urban market significantly complicated the reliance that could be put on appearances, fashion – its pre-eminent expression – was not judged to be inadequate as self-expression, but in terms of entitlement: what rights and respect an individual might rightly claim. In this manner, a measure of prescription could be a precondition for personal freedom (Wharman, 2004: 207, 275–76).

From politeness to etiquette

The steady permeation of merchant capitalist relationships, dragging in their train new identities and concepts of value, posed problems of visualizing social order. In the city, especially, a new social imaginary – a means of furnishing new scripts of sociability and feeling through images and words – became a practical ingredient for the conduct of everyday life (Taylor 2002: 106). In such an imaginary reposed the hope that the established relationships of the ancien régime might be refurbished so as to accommodate new kinds of economic forces and subjects. The problem of imaginative integration was evidenced above all by London, but a stream of uncertainties was fed back into the established relationships of rural life. Such an imaginary could not be a

direct expression of a class-based ideology for a number of reasons. First, its social driver – the new rank of moneyed interests not based on landed property – did not acquire economic and political leverage until later in the next century when, with the development of a working class as its objective correlate, it developed its own class-based vision of collective order (Wharman, 2004; Thompson, 1978). Second, social formations in the ascendancy project their sectional interests as the universal interests of humankind, such claims for inclusiveness tending to be retrenched upon the consolidation of class power (Marx, 1970). Third, following from the preceding, the development of the first consumer society, if ushering in dispositions, motives and forms of association that were capitalistic, was not perceived as a class struggle but as a contrast between different worldviews, although they were latently the expression of contrasting relationships of production and ownership. As the political commentary of the time envisioned it, the fundamental opposition was perceived in terms of morality, rather than political economy, between the ethical and moral dispositions sustained by landed property and commercial or moneyed interests (Pocock, 1985). The aristocracy and landed gentry were entitled to govern because their ownership of landed property bestowed civic virtue. The country estate was imagined as the 'Eden' of loyalty and patriotism, a material investment in the nation, before the 'Fall' of commerce. In contrast, 'mobile' forms of property such as cash and goods were wanting in virtue. They were seen as being in thrall to private interests, subject to the vagaries of paper currency, investments and markets. Since moneyed interests depended on the pursuit of profits, they would be unlikely to – and, some feared, essentially never would – respect national loyalties and values proven by tradition (Gordon, 1964). The merchant and the speculator in pursuit of profits would deal with anyone and not, according to prevailing concepts of quality, *someone*. So as individual aristocrats were drawn, in the season, to the attractions of city life and the opportunities offered by investment, the general customary equation between ownership of land and superior rank was threatened. Adding a further complication to the mix, neither the aristocracy nor an emergent haute-bourgeoisie was exclusively associated with one form of wealth – many merchants acquired country estates, and many aristocrats and gentry engaged in investment and speculation (Plumb, 1950; 14–15).

Such developments were facilitated by historical factors. The long-term decline of the influence of the Court and the Church, as patrons and effective arbiters in matters of taste and manners, created a space in which the liberal subject required by capitalism assumed the tasks

of self-regulation. In the city, commercial entertainments were seen as intensifying the alienation of individuals from traditional ideas of a life well lived – in the confines of the country estate, or within the community of the church through practices of ascetic piety. Moreover, indulgence in urban 'pleasures' by those prepared to enjoy them contained its own dangers. The pursuit of pleasures by louche and libertine persons of quality meant mixing with social inferiors and the demi-monde in spaces less (or not at all) regulated by decorum. These opportunity spaces were potentially unsafe. The thrills of the urban street could not be dissociated from its attendant threat, real or imagined, of contact with beggars, pickpockets and thieves and sexual predators (Warner et al., 2000). Even for those not inclined to prowl the fleshpots and stews, the enjoyment of the 'pleasures of the imagination' required entry into public spaces – the theatre, the art gallery and the pleasure garden – that might contain their own dangers. Worse still, reading about such matters unobserved in the privacy of the parlour – the 'natural' domain of women – might, if lacking the steadying presence of others, sap one's moral fibre. In particular, the key protagonists of public life – educated and polished men – stood in risk of a horrid range of corruptions: effeminacy; a softening through luxury; loss of self-control through overindulgence of the passions and, worst of all, seduction by the perversions of French fashion (Brewer, 1997: 81–83).

All these elements, real or imagined, called for an imaginary synthesis that would preserve aristocracy leadership over social totality and yet have the capacity to afford aspirant groups, such as prosperous merchants and professionals, a partial entrée into positions of influence, power and prestige.[19] At the same time as recomposing the ranks of the elite, the proposed synthesis would work to sustain respect for the present order among the majority of individuals of lower standing. What was in hand was a project of social recalibration rather than the strict reformation sought by religious groups. It was assumed that all ranks, from the humble tradesman through to the affluent merchant, were infused with a spirit of emulation – if not outright envy – of the wealthy[20] (Wharman, 2004). In this configuration, the poor and those without property – the precursors of the proletariat – were simply dark matter, an abject negativity outside of the bonds of civilized life, to be contained by force and repression. Many contemporaries agreed with Henry Fielding that growth of crime was a product of the envy presented by the onset of styles of conspicuous consumption (Fielding, 1751).

It is useful to distinguish two broad interventions that shaped and promoted a culture of politeness (Langford, 2002; Copley, 1995). The first,

associated with the writings of Shaftesbury, Hutcheson, Hume and Burke, argued in reaction to Hobbes that human beings possessed an innate moral sense, which, as Locke had argued, when shaped by a gentlemanly education, would form the basis of a virtuous society. Politeness, as a code for producing a civilized habitus, would work to ameliorate the breaches occasioned by new kinds of wealth and economic interests that flowed from mercantile capitalism. As a way of life, politeness drew its most abstract formulation from the revival of the Renaissance ideals of civic humanism. Such ideals were sociologically inflected. Full participation in the civic life of society depended on the ownership of property – the pre-eminent form of property reflecting the dominant relations of production and ownership in a particular society (Pocock, 1985). Only a landed aristocrat or gentleman possessed, compared to the lower sort, the stability of commitment and independence of mind that would allow personal interests to be set aside in the national interest. Yet the possession of landed property alone did not create a superior human being; rather, it was a particular style of living, a particular habitus and taste.

A key exponent of the importance of 'taste' was the Third Earl of Shaftesbury, Anthony Ashley Cooper. Although an author, Shaftesbury did not publish his work in his lifetime, seeing it as essentially private, written for his own amusement and for circulation amongst an intimate circle of his friends and peers (Cowan, 2004). The policy of private publication was an expression of Shaftesbury's view of the nature of society. So if arguing that aesthetic appreciation was based on a universal capacity for disinterested contemplation, he nonetheless accepted that only his own class might aspire to it. For him, the 'natural' social setting for the development of taste was not the marketplace of ideas, a place of corruption in his view, but the coterie or private club, where the noble and the genteel could engage in a civilized polite discourse and playful raillery. Thus the moral sense or capacity he identified as the basis of good taste could only find its true embodiment in the micro-sphere of courtly sociability. The tension between humanist universalism and the social restriction of the requisite sensibility was only paradoxical if one did not share Shaftesbury's class consciousness (Chaves, 2008; Agnew, 1986). The old aristocratic value of otium, the leisure in which to study and acquire polish, announced itself in the aesthetic robes of taste. All humans had a moral sense, but not all had the capacity to awaken it (Rind, 2002).

Concerned like many of his contemporaries with the impact of fashion and the fad for polite sociability on social distinction, Shaftesbury distinguished between the genuine politeness fostered by the aristocratic circle and the superficialities of deportment or 'theatrical politeness'

found in the public spaces of urban culture. For Shaftesbury, ensconced inside his country estate, the urban pleasures of the imagination held little attraction and he professed to care nothing for fame, castigating authors who sought it (Klein, 1984–1985; Gurstein, 2000: 203–221).

The second intervention, especially associated with the periodical *The Spectator*, sought to popularize Shaftesbury's aesthetic rendering of taste with the reform of popular taste. If the notion of refinement could be propagated amongst the 'conversible sort' (the proto-middle class) it would ameliorate social conflicts and the corruption of virtue. The cultivation of the Fine Arts would reinvigorate the fundamental tenet of aristocracy – rule by the best people – reforming the libertine habits of the aristocracy and creating an order of emulation for the middling sort whose terminus ad quo was participation in a new republic of taste (Barrell, 1986).

The Spectator (1711–1712 and 1714), edited – despite featuring letters ostensibly from readers – and mostly written by Joseph Addison and Sir Richard Steele was the best-selling and probably the most profitable periodical of its day. Circulating in the numerous London coffee houses, tearooms and parlours, it had multiple readers for every copy sold. The focus of the periodical – moderated by 'Mr Spectator', Addison and Steele's composite avatar – was on the correct comportment of the self in public life, at the theatre, concerts, in the coffee house, shopping, or even in the solitary pleasures of the closet. Essays suggested what the standards of public behaviour should be in order to maintain civilized social relationships. The correct forms of sociability should be valued for their own sake, not for commercial or social advantage; the higher principles of taste should be exercised or, if beyond the capacity of the ordinary reader, respected. Counting aristocrats and commoners amongst its readership, *The Spectator* attempted to mediate between the landed and moneyed interests, including in The Spectator Club (an imaginary stock company of types) Sir Roger de Coverley, an ancient but graceful aristocrat, and Sir Andrew Freeport, a gentlemanly merchant trader. Besides The Spectator Club, the journal featured readers' letters commenting on aspects of the urban scene and its follies, charms and passions. To what extent these letters were genuine as opposed to written by Addison or Steele is uncertain. But even if they were, the general style of free indirect reporting meant that the ostensive views of readers were all filtered through the sensibility of Mr Spectator. Although claiming to tutor elite and commoners in matters of taste, *The Spectator* reserved its sharpest satire and mockery for the bad taste of the middling sort. In other words, its project was the reform of manners from an aristocratic perspective (Eagleton, 1984: 10).[21]

In their essays, Addison and Steele advanced the Whig position that in furtherance of the national interest, trade should be free. As Addison claimed, the conflict between landed and moneyed interests was merely specious, since commerce would spontaneously promote harmonious relationships as a form of diplomacy consistent with the leadership of an enlightened aristocracy.[22] This dual blending of a *doux commerce* view with deference accorded with the editors' own social position. They were aspirants to and recipients of aristocratic patronage and commercial publishers exploiting an emerging consumer market. By commenting on the everyday behaviour of urbanites, they aimed to evoke an imaginary republic of refined persons, combining – with due recognition of their relative prestige – the aristocrat, gentleman and affluent commoner (Knight, 1993: 164). The ethics that derived from civic humanism were affordably vague, since they needed to address a disparate range of 'free' individuals: those who needed to be polished and civilized, those who needed to be situated in ideas of national culture, those who needed to temper the pursuit of economic self-interest and those who needed to be trained in the spirit of democracy (Miller, 1993).

If Addison could declare that 'the wise, the good, or the great man, very often lie hid and concealed in a plebeian, which a proper education might have disinterred and have brought to light' (*Spectator*, 215), neither he nor Steele argued for a more equitable distribution of income and wealth and the wherewithal to acquire it (Bloom and Bloom, 1971). Addison explicitly links the distinction between a polite and vulgar imagination with the financial ability to withdraw from the common traffic of the world and not follow the ungracious shuttlecock of gossip and fashion (Axelsson, 2009). Addison's and Steele's use of pseudonyms – conjointly as Mr Spectator and, for Steele, singly as Isaac Bickerstaff, the fictitious editor of *Tatler* – could be rationalized as devices to preserve their anonymity as observers. But it also protected their personal reputations from the taint of association with the common sort (Furtwangler, 1977).

Described in the first issue of *The Spectator*, the persona of Mr Spectator – Addison and Steele's composite avatar in print – is depicted as a gentlemanly outsider. As the owner of an ancient, if modest, country estate, the fulcrum of universal moral vision and economic independence, Mr Spectator could observe, with calm and objectivity, the follies of the fashionable world. To many of his contemporaries and the rising generation, such as James Boswell, Addison was a cultural hero, a model of literary achievement and a nationally recognized legislator in matters of taste and refinement; the success of *The Spectator* therefore testified to the aspirations, if not the actual behaviour, of the more

affluent sections of the middling sort, or at least those who aspired to be such (Klein, 1996).

As is well known, Habermas (1989) credited *The Spectator* (and its predecessor *Tatler*) with being the prototype of a bourgeois public sphere, a realm of public discussion and debate governed by rational rules of debate and removal of limits on what might be spoken about and who might speak. Later scholarship has tended to qualify Habermas' depiction of *The Spectator* as progressive, finding the culture of the coffee house less a space of free and equitable discourse than he imagined (Barrell, 1986; Cowan, 2004). Again, the claimed freedoms of the public sphere – however compromised in fact – were only proper to men. Mr. Spectator reserved the full brunt of his moral didacticism for women. As shoppers and consumers – and worse still as politically awakened beings – women were chided for abandoning their true place in the domestic sphere and the virtuous pursuits of their sex: beauty, sociability, charm and the nurturance of men and their families (Barker-Benfield, 1992: 306–309).

The way this was achieved owed more to a process of detached observation than a public engagement in dialogue. The reader, if accepting Mr. Spectator as a model, would engage with a threatening social world from a secure space outside of it – the domestic interior or the country home. Or if out in public affect the omniscient detachment of a god laughing at human folly. Rather than an ethics of conversation, *The Spectator* advocated an ethics of visibility in which the body is conceptualized as an object to be surveyed and evaluated, the object or the subject of the gaze (Pollock, 2007).[23]

It is not difficult to discern in the figure of Mr. Spectator an anticipation of panopticism, as subsequently proposed by Jeremy Bentham. Mr. Spectator implied that his readers, like Bentham's characterization of the situation of the prisoner in his model penitentiary, should consider themselves under constant surveillance by an inscrutable and hidden observer, necessitating the external show of docility (Foucault, 1979).[24] Clearly not possessing the power of direct observation imagined by Bentham, *The Spectator*, with a nearly daily cycle of publication (Sundays excepted), sought to inculcate in the unpolished and unlettered what might be termed a sociable soul: an internalized regulator that could compensate for the loss of the priest's and squire's oversight that was the disciplinary glue of country life. It taught the lowly how to be visible and, implying skills could be learnt, how to be a superior overseer of others' performances. The direct coercion of the supervisor's eye, proposed 100 years later, found its literary anticipation in ridicule, the threat

of public exposure, the embarrassment of being out of touch, unfashionable, ungainly and unattractive (Gordon, S.P., 1995: 3–23). *The Spectator* anticipates the form, but not the scientifically legitimated rationale, of governmentality.[25]

In current times, Abercrombie and Longhurst (1998) have identified narcissism as the conception of the self, whether in public and private, as before an audience. *The Spectator*, in a less-saturated media environment and within the constraints of print, worked to inculcate a similar discipline of self-monitoring, an experience which, as the name Mr Spectator suggests, was inherently theatrical and dependent on the exercise of sight, rather than an engagement through conversation and dialogue (Kinsley, 1967).

> Ultimately, the Spectator's image of an ideal society depends on a doubling of inward meanings with inward response: the ideal community is based on a symmetry of feeling between the actor and the observer, where the observer's willingness to penetrate to the meaning of a gesture raises in him the same feeling.
>
> (Ketcham, 1985: 151)[26]

In this manner, the figure of Mr Spectator comes to embody a new variant of the traditional *theatrum mundi* metaphor. Life may be likened to a stage not from a position of external contemplation, but from the interaction of players and audiences in the construction of common bonds of sympathy (Marshall, 1986). It was through the performance of a polite self that the strangeness of others might be ameliorated and the republic of taste affirmed.

The performative sensibility evoked by Mr Spectator became a common theme, however differently explored, in the development of the novel from the mid-century. The concept of character steadily acquires particularity, ceasing to be governed by physiognomic codes or notions of human nature, but rather by the capacity to respond, for better or worse, to the demands and contingencies of social and commercial exchange (Lynch, 1998: 128). This capacity often emerges as a kind of theft or giving up on speech in which the body, especially the 'massively sensitized' female body, resonates with the chords of its emotions much like an actor focused on projecting his/her feelings to a gathered audience (Mullan, 1988: 61).

Considering the spread of politeness and sensibility – the form and its supposed substance – across the arts suggests a deeper structural process which relates to a persistent or immanent structural lacuna imposed by capitalist commodity exchange. In such a market people might well

be formally defined as possessive individuals, expected to behave (and perhaps believing they were) as the free and sole proprietors of their (his more likely than hers) talents and abilities and the products acquired by their labour (Macpherson, 2010).[27] But much like the merchant pursuing trade, the worth of individual 'possessions' depended on the recognition by others as having a tradable value: as an object of interest (commercial, social or erotic) sought by others. In other words, individualism in practice was propositional, and became possessive only after the completion of a transaction, on the conjoining of an offer to treat and be treated as a value – after which it lapsed into a propositional state awaiting a new circuit of exchange. This recursive experience naturalized uncertainty and cast the self in the role of an actor or performer before an audience.[28]

Until later in the century, the operating assumption of polite society was that sincerity was accepted as a norm, inviting censure in its demonstrated absence. But there was a deeper assumption underlying this claim: that a polite exterior was a reliable, though not infallible, sign of inner virtue. If the other could be trusted to have some level of attachment to the appearance of honesty, one might maintain one's own position in a polite and mutually pleasing or affirming interchange. The posthumous publication of *Lord Chesterfield's Letters to His Son*, in 1774, tested this equation by showing that disinterestedness was at base a cynical performance. Yet the odium of hypocrisy attaching to Chesterfield did not diminish the immense popularity of the letters, which went through many reprints (Carter, 2002). By the start of the nineteenth century, the old courtly arts of a polite facade became the regulating principle of public life and adherence to a formal code of manners – or, as Chesterfield termed it, an etiquette – became the trademark of compliance (Arditi, 1998). For apart from the logical weakness of politeness, there was a latent and developing sociological weakness. The idea of a shared moral sense threatened to dissolve the superior claims of a solidifying of bourgeois culture, with its logic of classes as tribal or racial categories, distinguished by antagonistic manners and appetites (Chevalier, 1973; Balibar and Wallerstein, 1991, 204–215).

In sum, the culture of politeness was inherently theatrical both in the theatre of life and in the life of drama, because it is in the moment of interaction, of performing before and with others, that the sociable, polite self is formed and revealed. It was through rhetoric and stagecraft, in particular, that a direct, rather than reported, collective modelling of the relation between sensibility and the passions occurred. The

performer, especially the actor, could claim to be the paradigm case for the demonstration and exemplification of politeness and do so before a socially mixed and often unruly audience in need of edification (Goring, 2005). Such was the strategy of Garrick.

To be is a matter of taste

The first manifestation of stardom within theatre took place in a macro-context where the concept of the person – a natural resource set, however refined and extended by training, brought to the portrayal of character by the actor – was rendered imaginatively problematic. Social identity began to assume a performative quality since individuals now had a choice to appear as better than their social origins, as required by current circumstances and their underlying intentions. In some cases – such as impersonating a court or public official – pretending to be what one was not for purposes of fraud was a felony, and under the 'bloody code' became a capital offence. But, for the most part, it was a game of social influence. Identity claims to be a person of some consequence had a freer range before the advent of photography. The efforts of Garrick (and others) to promulgate personal images might be considered an effort to close the gap between looks and social standing, if not solely an attempt to imitate aristocratic fashion. But for most individuals, outside of one's circle of immediate acquaintance, the integrity of the person rested on general external markers – bearing, clothing and speech – that might easily be imitated. In the interaction of strangers, the photographic age's finalizing visual image of identity – the face – was a mere ingredient, less probative than larger accoutrements and verbal accomplishments (Hurl-Eamon, 2005). It was in this larger context that an actor might provide an exemplar of how to present the self as a model of achieved cultural refinement. Such an image would be particularly attractive to those whose birth offered no automatic validation of quality. But this was no mere exercise in impression management for momentary advantage. If there was a fortune to be made in catering to the market for entertain-ment, there was a chance for an individual actor to gain honours and prestige that playing had not hitherto provided. Garrick was not just a professional who might earn a living from exploring audience con-cerns about identity; he was in actuality a member of the 'middling sort' with similar social aspirations. It was in this context of a struggle over social betterment and prestige, hedged by pervasive social and personal insecurities and draconian penalties, that the star system in the English theatre emerged.

2
The Formation of Stardom

The first chapter outlined the general social and cultural conditions within which a commercial theatre emerged, particularly as they provided a context for the formation of stardom. The purpose of this chapter is to give more precision to this development at the level of the labour process of acting. My basic argument is that stardom depends on an intimate and organic connection with the merchant form of capitalism.

Garrick's path to stardom

In this section I will argue that Garrick's stardom arose from the fact that he could operate as an impresario or merchant of drama rather than as a wage labourer, a condition that many of his contemporaries, even if well paid, did not escape.[1] I will elaborate on this distinction subsequently. For now I want to focus on the broad parameters of the commercial theatre's development in London as encountered by Garrick in 1741.

The first general condition is that the theatrical context in which Garrick operated was marked by an intensified process of market capture brought about by the Licensing Act of 1737. This Act intensified the cultural monopoly of the two London-based patent theatres, Drury Lane and Covent Garden, over the presentation of drama, removing the licensing protection from other non-patent theatres in London and in the provinces. Outside of the patent theatres, performing drama became a precarious activity dependent on the goodwill of local magistrates not to prosecute players.

The power of the Master of the Revels, as an officer of the Lord Chamberlain, to preview and license plays for performance had been a

feature of government regulation from the time of Elizabeth I. The decision of these officers of the Court was final and required no justification. The granting or withholding of a licence was crucial if players were to be protected from being arrested as rogues and vagabonds. The first decades of the eighteenth century had seen a rapid growth in non-patent theatres that presented a commercial challenge to the two patent theatres. This growth also posed a challenge to the regulatory structure. Non-patent theatres, though lacking the right to present plays and opera, were less constrained in their operation than the patent theatres. The latter, receiving no subsidy from the Court and dependent on profits, were held to a higher standard because the Royal imprimatur held them to be custodians of national standards of taste, despite the appeal of sensationalism to large sections of the audience.[2]

The privilege of owning or leasing a patent carried with it an obligation to submit new plays for approval by the Office of the Lord Chamberlain. Compliance with prior censorship conferred immunity from prosecution – for example, by civic authorities – and added a badge of respectability to players in an otherwise disreputable business, pointing the way to the notion of a profession. Leading actresses, in particular, by association with Drury Lane and Convent Garden gained a rough equality with men and were able to set a respectable distance from the demi-monde and prostitutes who were part of the theatrical environment (Richards, 1993).

The 1737 Act marked a more draconian return to the dual-market structure set up by Charles II when the Restoration of monarchy ended the 18-year ban imposed by the Commonwealth on public performances. In 1660, Charles granted an exclusive patent to perform 'serious' drama to Davenant and Killigrew, leaving non-patent theatres free (pending delegated Royal approval) to present light entertainment such as musical interludes and pantomime. The implied tolerance for the non-patented theatres was probably not dissociated from licence fees' contribution to the Royal purse – given Charles' revenue problems – and the theatre in particular provided opportunities for sexual adventures, which Charles himself was not slow to exploit. But it also expressed a patrician tolerance for 'low' or plebeian entertainments. Moreover, the practice of commerce, much disparaged by the aristocracy, had carried the connotation of sexual venality from Elizabethan times (Bruster, 1992). Restoration drama took full advantage of the terms of ambiguity to disseminate an aristocratic critique on the foibles of merchants as cuckolds and wittols and, reputedly, their less than faithful wives (Dawson, 2005). But such a dramatic universe merely

added to the association of the theatre with sexual licence and exciting tales of impropriety. Beyond the specifics of content, magistrates and city aldermen saw the rapid growth of theatres as undermining discipline in the workplace, promoting absenteeism and old habits of 'St. Monday'. The old Puritan polemic against theatre per se, found for example, in Stephen Gosson's *Schoole of Abuse* (1579), had found a new life amongst the respectable middle class, who were concerned that theatres in the wrong hands were promoting sexual immorality and disease – not that the legitimate theatres were entirely innocent of this charge (Crean, 1938). In this sense, the 1737 Act was not just a reaction to jurisdictional inefficiencies, but to the patrician liberality of past practices.

At the same time, the 1737 Act was driven by immediate political motives. The very popularity of the non-patent theatres, particularly in London, seemed to mark a crisis of authority and, with their sometimes rowdy and assertive audiences, a threat to order. Their ability to thrive seemed to publicize the impotence of the Lord Chamberlain's Office to maintain standards and ensure deference. They were adept at circumventing existing legislation by offering dramatic pieces sandwiched between the ostensive main attractions of comic opera, musical intermezzi (burlettas) and pantomime. Economically, their growth was threatening the position of the patent theatres, which, given their Royal patronage, were charged with promoting the legitimate standards of a national theatre.

At the more immediate level of politics, Whig government leader Robert Walpole had endured numerous affronts through the contemptuous satire of dramatists. For example, John Gay's *The Beggar's Opera*, a particular irritant for Walpole, was first performed at a non-patent theatre, Lincoln's Inn Fields, having been rejected by Colley Cibber, the manager of Drury Lane. Prior to the 1737 Act, outright suppression, as opposed to the post-performance imposition of fines and other penalties, was hard to achieve, and often non-theatrical legislation related to treason or criminality was evoked. For example, Gay's *Polly* (1729) was suppressed by the threat of capital punishment under the Black Acts for showing a blackface on stage. Walpole, personally offended by the political content of some new plays, was convinced that non-patent theatres were forcing houses of radicalism. He was determined to shut down all London theatres, save the two protected by Royal Patent. It was Henry Fielding's works, especially *Pasquin, The National Register* and supposedly *The Golden Rump*, that provided the impetus for a crackdown. It is doubtful that *The Golden Rump* was actually written by Fielding and

it was never performed in the theatre. Ironically, its only performance was a reading before parliament by Robert Walpole as evidence of the urgency for a new bill (Wright, 1964). Henry Brooke's *Gustavus Vasa* (1739) was the first play to be banned from performance by the Lord Chamberlain under the new provisions of the Act.

Garrick's debut performance as Richard III, 'by a gentleman never seen before on the stage', was at an unlicensed venue, Goodman Fields, in October 1741. As the story goes, the brilliance of Garrick's performance and its contrast to the static rhetorical style then in force – as typified by one of the leading players of the day, James Quin – was perceived as the acme of realism; a coup de theatre that announced a new era. But Garrick's performance was not, as was perceived, wholly original. Another renowned actor of the day, Charles Macklin, 20 years Garrick's senior, had been developing a style of performance that introduced everyday speech rhythms and behaviours into the existing conventions of performance derived from classical rhetoric. But Garrick added a new vitality and force to these developments, marked by the mobility of his features and the subtlety of his movements and gestures (Angus, 1939). Nor was he entirely new to the stage, having already performed for a summer season at Ipswich. The claim of being new to the stage was a well-established convention designed to protect the performer in the case of failure and, perhaps worse, the taint of a 'low trade' (Nichol, 1980).

Word of the power of Garrick's performance spread from an initially small audience that included many of his friends and associates, and 'people of quality' flocked to Goodman Fields to see him perform, depleting patent theatre audiences. Recognizing his power at the box office, Charles Fleetwood secured a contract with Garrick for three special, highly paid performances at Drury Lane and in concert with John Rich, the patentee of Covent Garden, evoked the 1737 Act to drive Goodman Fields out of business. Garrick's drawing power continued to grow, and Fleetwood offered him a contract for the 1742–1743 season at 500 pounds per annum plus benefits.

> In his first season at Drury Lane (his second as a professional actor) Garrick was making some 50% more than the company's long time stars, and more than double what the next rank of principals was earning. He got this salary because his effect on the box office made him worth it, however reluctant Fleetwood was to pay it.
>
> (Milhous and Hume, 1988).

Before taking up his Drury Lane engagement, Garrick was hired by Thomas Sheridan for the summer season at the Theatre Royal, Smock Lane, Dublin. His debut there, acting with his lover of the time, Peg Woffington, replicated his London success, inciting 'Garrick fever'. On 23 August 1743 he returned to London, in the company of another leading player, Susannah Cibber, with whom he shared the lead at Drury Lane for the 1743–1744 and 1744–1745 seasons (Stone and Kahrl, 1979). His engagement by Drury Lane was marked by conflict and, perhaps as a result, absences through illness. Fleetwood's profligate lifestyle, gambling and drinking, had depleted his annuity of 5000 pounds and he was living off the profits of Drury Lane. By the end of the 1742–1743 season the two leading players at Drury Lane, Garrick and Macklin, were each owed substantial arrears – in Garrick's case, of more than 600 pounds. Fleetwood temporized when asked for settlement, as he did with monies owed to lesser actors and employees. Garrick and Macklin finally refused to perform until they received the monies owed them. Teetering on the edge of bankruptcy but emboldened by the 1737 Licensing Act, Fleetwood entered into a secret cartel agreement with John Rich, the patentee of Covent Garden, to ban competitive bidding in an effort to lower acting salaries (McIntyre, 1999; Klepac,1998). When this agreement became known, Garrick and Macklin, together with other leading players at Drury Lane, entered into a signed agreement to withdraw their services, committing to the formation of a new company to be located at the Haymarket. In order to ensure solidarity, Macklin added a clause through which the signatories bound themselves not to accept individual offers from Drury Lane or Covent Garden to quit the strike. Fleetwood in the meantime had put together a 'scratch' company on lowered rates for the upcoming season and was preparing to dilute legitimate drama with crowd pleasing attractions such as rope dancers, acrobats and monstrosities (Knight J., 1894/1969).

The new company, if it was to be protected from vagrancy laws and legally entitled to compete with the patentees, required the approval of the Lord Chamberlain, Lord Grafton. The involvement of Garrick, the most popular actor of the day with many aristocratic admirers, was thought likely to ensure a positive outcome notwithstanding the more restrictive climate created by the Act. Receiving the petition, Grafton refused to grant a licence or a patent. Upon hearing what Garrick and others were earning, Grafton felt their complaints lacked merit and hardly needed redress when soldiers (such as his son) were paid less to risk death for their country. This decision left the petitioners locked out with little recourse than seeking work abroad – notably in Dublin – or an

accommodation with Fleetwood. In a complicated sequence of events, Garrick, begged by others not to abandon them for Ireland, began negotiations with Fleetwood. His drawing power was such that despite their recent conflict he was offered a salary of between 600 and 700 pounds to return to Drury Lane. Mindful of the impact of his decision on the other signatories, he made it a condition of his return that the others be reinstated. Fleetwood agreed but with one exception. He refused to reinstate Macklin – despite Garrick's offer to play for 100 guineas less if Macklin was permitted to return.[3] Macklin, for his part, refused offers of help from Garrick, accusing him of reneging on their agreement. This 'betrayal' irrevocably soured the relationship between them despite the fact that Macklin, the older player, had been a personal friend and influenced the development of Garrick's realistic style of performance. On the first night of Garrick's return to the Drury Lane Stage following the strike, December 1743, a pro-Macklin mob stopped the performance. A few days later a countermove by pro-Garrick supporters drove the Macklin faction from the pit and permitted the performance to go ahead (McIntyre, 1999). The depth of rancour between the two leading male players of the day was a hot topic in the press and pamphlets, which gave exceptional coverage to celebrity gossip, of the love life and rivalries between socially prominent figures such as aristocrats and leading players and theatrical personalities. Allegations of Garrick's betrayal of Macklin continued to be debated in print for nearly two years following (Klepac, 1998).

For the 1745–1746 season, possibly to escape further controversy, Garrick returned to Dublin and comanaged as well as performed at Smock Lane with continuing success. Quin, for example, was obliged to leave Dublin because the available acting days for the upcoming season had all been reserved for Garrick (Davis, 2000). Prior to Garrick's departure for Dublin, Fleetwood's mismanagement of his finances had brought him to the verge of bankruptcy and he sold the remaining term of the Drury Lane patent (three to four years) to the investment bankers, Richard Green and Morton Amber, for a lump sum of 3200 pounds and an annuity of 600 pounds. Green and Morton engaged James Lacy to manage the theatre and Lacy invited Garrick, as the leading player of the day, to become a partner. Garrick on this occasion declined Lacy's offer (much to the latter's displeasure) because he felt the Stuart rebellion had created an insecure environment for investment in the theatre.

On his return to London for the 1746–1747 season, Garrick signed for a short engagement with John Rich at Covent Garden. Green and Amber encountering financial difficulties of their own sold their patent

to James Lacy who once again offered Garrick the chance to become a partner in Drury Lane. Raising the asking price of 8000 pounds, Garrick became the actor-manager at Drury Lane. While not the first – his predecessor was Colley Cibber – he brought a level of charisma and innovation to the role that had hitherto been lacking. Upon his retirement in 1776 he sold his stake to Richard Sheridan for 35,000 pounds or 6,571,764 at current prices.

Garrick's progress: from wage labourer to impresario

Having tracked Garrick's induction into the social organization of the theatre in his day, and having explored what this trajectory means for the manner in which he sold his services or acting labour power.[4] From Elizabethan times, theatre had operated through some variant of the petty mode, dating from the establishment of permanent playhouses (Ingram, 1992). There were variants of this mode, depending on how the collaborative labour process was organized, who had authority and how its participants were rewarded. In general terms, the petty mode is associated with agricultural and artisanal forms of production in which the means of production are owned by the direct producers and output is oriented towards a socially diverse and geographically dispersed mass of consumers (Hechter and Brustein, 1980).[5] The key implication I want to draw is what these developments tell us about Garrick's changing status in the political economy of the Georgian theatre. To better comprehend this, it is necessary to identify the variations in the petty mode of theatre.

The creation in 1660 of the Patent Theatres – Theatre Royal Drury Lane and Covent Garden – followed the Elizabethan precedent, but with an increasing concentration in the ownership and capitalization structure. In the case of the most important theatre, Drury Lane, the capital for building was raised by a private subscription issue of shares – always 36 in number. The building was then leased to a company of actors who paid rent for each acting night, with the subscribers receiving an income in proportion to their investment. The investor structure had three elements: the owners of the patent or Lord Chamberlain's licence; the building shareholders, who owned the ground lease from the Dukes of Bedford; and successive groups of actors, who rented the theatre and shared what profits remained after payment to the subscribers and performance expenses. The tendency to separate owners from direct producers, evident in this structure, became more pronounced as the number of building shareholders

who were also actors declined and the shareholders in turn became *rentiers* only (Sheppard, 1970). Garrick's second offer from Lacy to become a part owner of the Drury Lane patent might be seen as moderating this trend.[6] But this is less clear if contrasted with pre-existing forms of petty production.

In Shakespeare's time, the commercial theatre had typically been composed of a standing company of players, licensed to perform, organized as a partnership with leading players (or sharers) purchasing a share in the theatre as a fixed capital asset together with variable capital assets such as costumes, sets, stage properties and plays. The sharers were permanent members of the company, receiving an income, net expenses, from the receipts. They determined which plays were performed and who played which parts, and commissioned new plays from writers. Performers themselves, the sharers also employed other actors as hired men on a temporary basis for a wage and selected apprentices who were unwaged but received bed and board (Stern, 2000).

This 'sharer' system can be contrasted to an earlier collaborative mode of production – the commonwealth. This was a company of players in which all the performers shared the receipts equally, or, at least, according to some collectively agreed scheme of fairness – what in contemporary terms would be called a cooperative. In Garrick's time, notwithstanding the impact of the 1737 Act, the tradition of the commonwealth persisted in the provinces, just as it had under more jeopardized circumstances during the closure of the theatres under the Commonwealth from 1642 to 1660.[7] Garrick's earlier failed attempt, in concert with other leading players, to set up a company at the Little Theatre in the Haymarket, had evoked the idea of a commonwealth, as evidenced by the solidarity clause introduced by Macklin.[8] For my purposes, the most salient feature of the petty mode is the position of the direct producers as the owners or non-owners of the means of production:

> The private property of the labourer in his means of production is the foundation of petty industry, whether agricultural, manufacturing, or both; petty industry, again, is an essential condition for the development of social production and of the free individuality of the labourer himself.
>
> (Marx, 1990: 927)

The commercial theatre, as typified by Drury Lane, signals a first step towards the subsumption of the petty mode to more developed capitalist forms of control, marginalizing the role of the direct producers in favour

of stars, or at least individual leading players. But at the same time, the subsumption of the actor to direct capitalist control can never be a complete process because of specific features of acting as an embodied process. For the actor, and mutatis mutandis other performers, owner-ship of the means of production has a dual character. All actors, whether as leading players or supernumeraries, own the direct instruments of production – vocal, physical and psychological capacities as limited by their genetic endowments or 'talents' as developed by training and the experience of performing. But not all actors own the extra-personal instruments of production – the physical space of performance and the various instruments and materials, including plays, required in order to perform before a paying audience.[9] The different relationships of ownership to the means of theatrical production – the commonwealth, the sharer system and the patent-based commercial system – are varia-tions in the petty mode that accord greater or lesser degrees of owner-ship in the means of production to the direct producers. So within the collectivist forms of the petty theatrical mode – the sharer system and the commonwealth – some actors were wage labourers or hired men.

It is in this topography of ownership – the locus, if not the direct control of the means of production – that we need to locate Garrick if we are to understand the nature of his form of stardom. At the start of his career, prior to his acquisition of a part share in the licence of Drury Lane, Garrick was basically a wage labourer dependent on being hired – although his pre-eminence after his debut would incline us to see him, to use a contem-porary phrase, as an independent contractor or a hired hand with exclu-sive conditions of service. He belonged to that minority of actors who were able to derive *economic rent* as fee for his personal services, which was a function of the strength of the theatre-going public's interest in his performance compared to their level of interest in other performers. His claim to possess a unique set of innate personal qualities, however burnished through experience and application, was ratified by the sale of seats (and, for that matter, the social capital value of providing free seats to friends and influencers). Without a singular and strong public response, his talents would remain unrecognized (Milhous and Hume, 1988).

From the perspective of employers and stakeholders – a perspective that Garrick assumed towards himself when he became a manager – his stardom was demonstrated through his durable ability to minimize the moral hazard to investments in the relevant theatrical enterprise (MacMillan, 1948). In terms of his debut, his performance manifests itself as a shock – an exogenous event that is not predictable in terms of current internal arrangements and practices. Such a shock is directly

perceived as the expression of a singular talent. As the oft-quoted remark of his contemporary James Quin put it: 'If he is right then the rest of us are wrong.'[10] The notion of talent as an exogenous factor, as something that an individual brings as a natural quality to his performance, is an ideological sine qua non of stardom. This does not mean that the individual has no talent, but rather that the talents possessed are not necessarily lacking in other actors.[11] Garrick's preferment did not therefore change the general conditions of actors as workers for hire, though in fairness his charitable acts, such as setting up a charity for distressed actors, contributed to this process.

When Garrick acquired an ownership stake in Drury Lane, profiting from the business and having direct responsibility for managing the company of actors and productions, his commercial status changed. He became an entrepreneur or merchant functioning within the petty mode. In his role of manager, he negotiated the terms for the sale of the labour power of other actors, playwrights and assorted functionaries. In addition, he was also the direct producer of some of the goods and services that were sold, receiving annual incomes for acting as well as managing Drury Lane.

The social positioning implied by his change in economic status was decisive. First, he no longer operated in a simple exchange relationship selling his skills and talents. Rather, he proceeded as a cultural intermediary, managing the relationship between sellers and buyers. In short, he was a merchant of dramatic experiences. Viewed abstractly, the role of the merchant is to procure goods from the seller(s) and then sell them to buyers at profit – buying cheap and selling dear. In this process the goods in question are temporarily sequestered from the realm of commodity exchange. In the case of theatrical performances (or for that matter, films, concerts, dance and the like), sequestration is driven in part by practical matters.

Like his predecessor, Colley Cibber, Garrick had a lifelong 'love of a lord' and certainly owed some of his professional success to his early entrée into aristocratic circles through his marriage to Eva Marie Veigel, a protégée of the Countess of Burlington (Stone and Kahrl, 1979: 258–259). But if he was undeniably hungry for status and vain, Garrick's aspirations were not a mere personal idiosyncrasy. His role as a holder of a Royal patent included showing deference to the Establishment, or at least, a tactically important section of it, as well as currying favour with aristocratic patrons and Court-appointed censors. In addition, a specific historical feature of the actor's inflection of the relationship between his person and character must be factored into the account. It is not

merely the physical and behavioural features of the actor that have to be managed (inflected or deflected) in performance but the low, even disreputable, social standing of the actor as a social type which, moreover, had acquired a level of visibility hitherto reserved only for the great and powerful. Nor is it a matter of a dubious upstart vying for national attention, but the means whereby this attention is achieved and sustained: through meeting the conflicting demands of a market that is socially promiscuous, open to anyone who can pay. Even worse, any actor might undertake to please spectators by making a spectacle of him/herself in character – a spectacle driven as much by the desire of upstaging other actors as by titillating spectators. On one account, there is evidence of 'over-expressive' performances, constructing through exaggerated and ambiguous words and acts a protective shield that removes the actor's private identity from becoming the object of a prurient or overly detailed scrutiny (Fawcett, 2011).[12]

Cibber, Garrick's predecessor, had presented himself as a professional mutation of the aristocratic body. Just like a real Prince, Cibber as a Prince of Theatre publicly incarnated the representation of the body politic of English society – meaning by the term the society of the great and good (Glover, 2002: 531). Garrick, with greater talent (and less sycophancy), connected his own prominence with promoting acting as a profession and a liberal art through a sustained courtship of the aristocracy. As with Cibber and many of Garrick's fellow actors, the elevation of *playing* to *acting* shared in the general social project of the emergent middle class to construct a shadow nobility based on the exercise of craft or professional skills, which rested on claims to the possession of refined tastes and sensibility.

Before a play can be presented to the theatre-going public, it must be written, cast and rehearsed. Such efforts are always marked by some claim to cultural significance – a new play, a revival, a new cast and so on – that assures the audience of the qualities to be obtained from paid attendance, assures in other words the use-value of the event. In tangible goods trade, such a withdrawal from the market, its duration and purpose, may reflect purely monetary calculations such as the impact of a glut on price but even here it may have a ritual significance. In this latter circumstance, the merchant serving as a go-between, or a commercial psycho-pomp, weighs up and differentially assigns an exchange or use-value to goods and services. Goods and services identified as use-values are typically withdrawn from the exchange process as inalienable signifiers of prestige or ritual objects (Middleton, 2003). In Garrick's case, the search for marketable plays and performances

was constrained by Drury Lane's status as a Theatre Royal. As a manager with responsibility for setting the national standard for legitimate drama, he was required to pay attention to matters of cultural quality that went beyond what was dictated by the market – assuming of course that this was clear. This is a process that requires careful gatekeeping, especially since the play-going public is composed of different taste cultures and social ranks. Alongside his responsibilities as an actor, Garrick performed a public role of custodian and emblem of respectable culture, a requirement he was happy to assume for its implied status of an arbiter of taste, especially in an era when actors were still regarded as servants at the whim of audiences – whether plebeian, aristocratic or royal.[13] Garrick's solution was to infiltrate Drury Lane's repertoire with plays that emphasized spectacle and staging, in an effort to draw on the demonstrated popularity of 'low' forms such as pantomime, but do so in the framework of 'legitimate' drama. His rewriting of Shakespeare's plays providing happy endings for tragedies such as Lear, adding prologues and epilogues and spectacular masques, is evidence of this strategy – which, as demonstrated by the examples of Colley Cibber and Nahum Tate, was not unique. What *is* unique about Garrick is the degree of self-promotion that accompanied these efforts. Stardom at the time of Garrick was an embryonic version of what it would become. Moreover, opportunities for self-promotion were limited before the development of motion-based (audiovisual) transcription technologies and, in our time, the Internet. Nonetheless, Garrick managed to obtain a national level of exposure through his careful management of existing media such as print and graphics, portraiture, engravings, statues and miniatures (MacPherson, 2010).

Although Garrick's image cannot be distributed 'live' and his live performances are confined to London (despite early career forays to Dublin and later to France), these are imbued with national significance and prestige by being situated in the capital and the foremost theatrical market. In particular, it is the social standing – itself enhanced by publicity – that has the greatest power. As an exemplary member of the emergent middle class and an example of upward mobility (from the position of vintner's apprentice), Garrick is not just a symbol of the emergent middle class, but a personal index of its national significance and its aspirations for upward social mobility. As a person, he secured a social entrée into aristocratic society through his marriage, and was to enjoy the company of the high-born and lordly for his entire career. But his project also reached higher grounds as he devoted his talent and powers to the consecration of Shakespeare as the national poet.[14]

His staging of the Shakespeare Jubilee in 1769 was one of the most concrete manifestations of his ambition to be regarded not merely as the foremost Shakespearean actor of his day, but the reincarnation of the Bard (Dobson, 1992). This aesthetic strategy is of a piece with Garrick's own social ambitions to become the first aristocrat of talent rather than birth [15] – an aspiration that followed the precedent set by the desire of the merchant princes, who headed urban society, to acquire country estates (Plumb, 1950: 14). Garrick founded his estate at Hampton with its very own Temple to Shakespeare, a development that was very much to the distaste of his nearby neighbour, Horace Walpole (McIntyre, 1999). In this manner, Garrick's personal social aspirations to be seen as a person of taste and sensibility connected to Protestant nationalism via the consecration of Shakespeare as a national poet (Dobson, 1992: 179). So emerged the tradition, carried down through present times by succeeding generations of British actors, of creating a triangle of cultural value linking conceptions of great acting, Shakespeare and middle-class virtue. In other words, the apotheosis of Garrick defined acting as a profession (Dobson, 1992: 179). Garrick's symbolic strategy was to represent himself as a person of quality, who possessed, if none of the aristocratic credentials of a noble birth, a certain sensibility and refinement that betokened a 'natural' nobility. He aspired, in short, to be a gentleman. In this effort, his stardom was based on a claim to be a personage. But before placing personage in the space of stardom, we need to look more closely on what this meant for his approach to performance.

The space of stardom

As Bourdieu (1983) shows, the field of cultural production operates in a relationship of homology with the economic field. More precisely, the struggle between various agents, particularly informed by the interests of those with the greatest economic, social and cultural power, frames the process of homology construction. Homologies are not simply semantic or cultural representations that are also constructions of value; a functional object may be endowed with an enhanced exchange value as a collector's item, such as beer bottle caps. The structure of a specific cultural field rests on the balance that emerges between different kinds of artistic practice and creative traditions. These traditions, each with their own temporalities and potential mismatches between consecrated aesthetic values and the economic means of livelihood, operate in a state of negotiation, if not outright contestation. The specific social and

historical context, especially the nature of the balance between social groups and classes, limits the value assigned to particular forms of cultural expression. In a capitalist social formation, the primary driver of homology formation is found in an ongoing process of symbolic struggle. Conceived in the broadest terms, this struggle inscribes the relationship between aesthetic values tied to the world views of social classes and the impact of market systems tied to particular forms of patronage and support (Bourdieu, 1983).

In the case of Garrick and his contemporaries, the economic and the cultural fields of theatre are disorganized – not strongly institutionally or formally demarcated as separate spheres. This is because the market for theatre – the urban public – is itself consumed with an interest in defining the nature of social relationships and identity and driven by conflicting notions of what is and is not desirable. The theatre as a site of social ritual has a pivotal role in rehearsing the positive and negative features of an emergent capitalist social formation. Nor is this rehearsal simply a matter of taste and decorum – though it may appear as such. Pressing in on the field of a theatrical practice is a 'proto-class' struggle in which the stakes turn on fundamental issues of life and death, authority and the untrammelled pursuit of individual wealth and prestige. There is no question that Garrick, appointed to be a steward of a national theatre, was committed to supporting the status quo, of finding his place on the basis of merit and refinement within a natural aristocracy of talent that supplemented rather than challenged aristocracy by birth.

In this context, it was Garrick's task to function as an agent of articulation. But a significant aspect of his management was to ensure financial stability, which cannot be dissociated from his cultural role in managing an environment which was pervaded by anomie – the sense that prevailing norms and values offer few, if any, reliable guidelines to conduct.

In one aspect, Garrick's management of Drury Lane was a collective project. Through his efforts Garrick elevated the standing of acting to an occupation with a plausible claim to be a profession, rather than a déclassé means of support for vagrants and social outcasts. But it was also an expression of self-advancement, which Garrick could effectively pursue because he was protected by his monopoly position as patent holder. Any other actor's employment position is otherwise systematically precarious because the sale of actors' labour power takes the form of a tournament between individual actors and by extension between the theatres, both licensed and unlicensed, in which the actors compete for audience approval. In essence, a tournament is a machine for finalizing the pre-eminence of individuals through competition (Rosenbaum,

1979). Garrick could afford to withdraw from direct competition or, at least, take supporting roles without loss of income or prestige (though there is anecdotal evidence to suggest that he was vigilant in ensuring his light was not dimmed by rival talents). Undeniably, Garrick was propelled to his position of eminence by his talents, innate and acquired, as recognized by contemporaries; but post hoc, they no longer exclusively determine his pre-eminence. Adjacent to questions of talent, his position and authority as a manager depended on pleasing the theatregoing public, and although he occasionally failed to do this, most notably in the case of the Chinese Festival (1755), when he misjudged the strength of the public mood of anti-French sentiment, this was an exception (McIntyre, 1999: 241–242).

The tactics of identity

During his 29-year tenure at Drury Lane, Garrick carried multiple responsibilities as manager, actor, author and private person (Murphy, 1969: 154–155; see also Holland, 1996). In terms of the schema developed in Chapter 1, these identities can be related to the scheme of actor identities – person, personage, character and persona. Because Garrick was operating within a legal context of extensive if not complete market capture, he was able to fuse the private and public aspects of his life into a personal project. In these circumstances the possibilities for self-promotion, latent in the work of the actor, can be rendered as variable dimensions that face only a limited challenge from other actors (for example, Spranger Barry). In the social context of the transition from a customary to a market-driven culture, Garrick's dispositions at a bodily and social level – what Bourdieu (1983) denotes by the term *habitus* – are articulated around the notions of respectability and taste that can be mobilized for personal advantage as well as a supra-individual consecration of acting as a profession. So it is not that Garrick appears as a person in one context, a character in another and a persona in yet another, but rather that he exercises these options tactically in public life as part of a strategy of becoming a personage (Woods, 1984: 107–118).

To appreciate the force of this essentially extra-theatrical aim, it is necessary to consider the grammar of Garrick's performance as it relates to the formation of his stardom – its ontological grounding in performance. By the term *grammar* I refer to the selection of images and sounds in order to perform meaningful representations of human beings – through the categories of personage, person, persona and character (Kress and Van Leeuwen, 2006: 1). In focusing on an essentially text-based process I do

not intend to diminish the importance of the extra-textual resources that Garrick drew upon to develop his professional identity – his economic power as a manager of Drury Lane was considerable – nor are his zealous efforts at publicity and self-promotion to be discounted. Such resources created a sequestered space in which Garrick could develop his craft, a space that many of his peers lacked. Obviously, our understanding of Garrick's authority as a star – one might say his personal rather than institutional charisma – would benefit by an audiovisual record of his performances (Rogers, 1984). Needless to say, there is no such thing.[16] We do know that his contemporaries credited him as the leading actor of his day and eyewitnesses praised his realism – insofar as this was understood in the mid-eighteenth century. So the only resort to be had relates to the manner in which Garrick theorized an effective performance. The resources for this, too, are scant: a brief essay on acting and some letters.[17] But they indicate the development of his own distinctive visual idiolect as a means of performance. Against the established tradition, derived from rhetoric, which prioritized declamation and the static, epitomizing pose, Garrick placed an increased emphasis on the body as an instrument for visualizing affective states through gestures, facial expressions, posture and movement. So compared to a statuesque Sarah Siddons, Garrick was (George III observed) something of a 'fidget' (Siddons, 1942). His parlour piece of placing his head inside a miniature theatrical frame, as observed by Denis Diderot, was a virtuoso demonstration of his ability to rapidly shift from one emotional expression to another with remarkable conviction.

Such a concerted visual display seems to have anticipated the cinematic close-up, but in Garrick's day there were more pressing needs to own one's likeness as a live performance. First, the emphasis on the performer's body underscored the discrete contribution of the actor more than a focus on the dramatic text, which was also the province of the playwright or the orator; second, Garrick's voice was not his strong suit. Accordingly, he developed an acting style that was pantomimic, with an intense mobility of face and body, rather than declamatory (Wood, 2001). Again, in his preparation for a role he drew on the precedent set by his former teacher, Macklin: direct observation of everyday behaviour. Essaying Lear? Observe the behaviour of an old man driven insane by grief. This approach to character development through borrowing from life is today somewhat of a cliché, associated with the term 'acting from the outside in'. But at a time when actors were enjoined to study classical sculpture and paintings in order to create effective performances, it was a novelty on par with the 'discovery' that ordinary people might be the subjects of painting.

There was also a demotic element to Garrick's style that responded to the necessity to entertain a culturally and socially diverse audience. He moved fluidly between Tragedy and Comedy – between high- and low-cultural genres – evoking for some the risk of debasing the former while pursuing the latter. Joshua Reynolds' theatrical portrait, *Garrick between Tragedy and Comedy,* captures his versatility as a dilemma. A caricature of the portrait engraved by Matthew Darly emphasized a more pressing dilemma between dramatic integrity and commercially efficacious spectacle – 'Behold the muses Roscius sue in vain/Taylors and Carpenters usurp their reign.'

These changes in acting style and other forms of representation of character were an aspect of deeper changes in the metaphysics of human nature associated with (as an expression and codification) changes in the traditional world view of customary societies. Prior to Garrick's day, the prevalent conception of personality was as a natural outcome of physiological processes caused by the action of bodily fluids or humours. Humoralism, dating from the time of Hippocrates (460–377 BC), and given its most systematic and influential treatment by the Roman physician Galen of Pergamum (AD 130–200), postulated that the temperament and health of an individual depended on the balance between the four vital fluids – black and yellow bile, blood and phlegm. As a nosology, the chief limitation of humoralism was that it described illness through symptoms rather than through the systematic analysis of specific causes; in this sense it was fundamentally a psychosomatic theory masquerading as a theory of disease. Despite this limitation, or perhaps because of it, humoralism informed not just medical practice, providing a rationale for bloodletting and purgation, but also literature, philosophy and the popular imagination, of which Richard Burton's *The Anatomy of Melancholy* was a best-selling example (Stelmak and Stalikas, 1991; Davison, 2006: 4). Again, since the action of the humours defined the personalities of individuals and predetermined them to have specific temperaments – the choleric, sanguine, melancholic and phlegmatic – humoralism reproduced judgements of good and bad human nature, thereby ratifying social inequalities.[18]

As a theory of identity, humoralism supported the notion that the features were a direct revelation, a temperamental reflex, of inner feelings informed by the action of natural forces. As such it shared a common assumption with the practical 'art' of reading character from facial features. Traceable back to Aristotle, and enjoying a revival in the late sixteenth and early seventeenth century with the publication of such works as Giambattista Della Porta' *De humana physiognomia* (1586),

the ancient art of reading faces was converted in the eighteenth century into a 'positive' science – physiognomy. The leading exponent of physiognomy and its revivalist popularizer was the Swiss pastor Johann Kaspar Lavater.[19]

Lavater saw the architecture of facial expression as part of God's design that humans should reveal their true feelings to one another. He aimed to popularize physiognomy as a science for increasing understanding in a puzzling world, a world that the market relationships of emergent capitalism had rendered opaque and susceptible to deceit:

> In an age of artifice and pretension, Lavater believed in physiognomy as a science that would help people know truth and love one another.
> (Stemmler, 1993: 153)[20]

Physiognomy valued the static 'digitized' image of the face as the locus of objectivity and the source of revelation. The 'analogic' mobility of the features was identified as pathognomy – a source of error which arose from the tendency of humans to manipulate their features in order to deceive. Such a deception frustrated God's desire for moral transparency and truth. Nor was it a small matter that the tendency to deceive challenged the authority of 'physiognomical' analysis. Implicitly, in response to the uncertainties of social identity created by urbanism and the rise of the market, Lavater's system became increasingly fixed on what could not be manipulated, the fixed and durable features of the head – such as the shape and slope of the head, front and back, the ears, nose and chin – eventuating in the nineteenth-century fad of phrenology (Ewen and Ewen, 2006; Porter, 1986).

Although Lavater's emphasis on biometrics, however primitive, smacked of a turn to empiricism, it was, like humoralism, inherently categorical and deterministic – ugly people had ugly souls and beautiful people, beautiful souls. Like humoralism, physiognomy entertained a concept of character as a fixed quality. Such explanations of character, notwithstanding their persistence in popular perception, had been losing ground in learned circles from the middle of the seventeenth century. This was largely because of the impact of Locke's notion of identity as a product of self-interpretation and, in a parallel development, the rise of mechanism in Science, led most forcefully by Isaac Newton. Descartes' *The Soul and Its Passions* (1649) was particularly influential in promoting a more nuanced and voluntaristic account of the relationship between inner feelings and their outward physical manifestation. Rather than cataloguing character types with fixed temperaments, Descartes places

states of emotional arousal (or passions) at the centre of his analysis of mental life (Bos, 1998: 40–41). Schematically, different emotional states were conceptualized as the result of different 'hydraulic' pressures on the soul, located in the pineal gland, by the flux of the inner spirits. Further, bodily spirits (or as we would say, emotional states) that arose as reflex responses to external stimuli – fear at the sight of a ferocious animal, for example – were distinguished from responses to inner stimuli that arose from the constructive (constitutive) powers of the mind or soul. In contrast to reflexes, he termed such responses, the *passions*, which – arising from the promptings of the imagination – were susceptible (and morally should be) to conscious control (Bos, 1998). It was a short step, already foreshadowed by the humoral catalogue of noble and base types, to conclude that not everyone would be equally susceptible to the influence of the passions. Some individuals – men rather than women, adults rather than children – possessed the will power to control their reactions more effectively than others. So the humoral fixity of character was replaced by a more fluid conception of identity, which came close to the concept of personality – a set of dispositions that could be successfully or unsuccessfully controlled. Another practical consequence, given this more contingent view of the passions as dependent on the action of mind, was that the capacity to control the feelings might be taught. Physiology, so to speak, could be harnessed by psychology.

For those engaged in the Arts – painting, writing, acting and oratory – physiognomy, however interpreted, had great practical significance. Despite the nuances of interpretation, all authorities agreed that the passions exhibited themselves in regular significations. Where they differed of, course, was in the level of determinism between the inner state and its outer manifestations (Roach, 1985: 31). Regardless of their metaphysical significance, these manifestations, if carefully documented, might provide a set of templates through which characters (as performed, described or depicted) could be developed for the purposes of communication.[21] One very influential guide, influenced by Descartes, was developed from a lecture given by Charles Le Brun, the Rector of the French Academy, in 1668. His *Conférence sur l'expression générale et particulière* had become a standard training manual for painters, writers, actors and orators (Cottegnies, 2002). In England, Le Brun's source book of facial expressions influenced the work of such leading painters of the day as Joshua Reynolds and Hogarth, who were all closely associated with Garrick. New theories of the nature of beauty, as advanced by Hutcheson, Hogarth and Shaftesbury, began to apply geometric concepts to the understanding of the nature of beauty, promoting a Platonic equation

between physical beauty and moral goodness. These developments in aesthetic theory in turn provided a fertile ground for the reception of Lavater's system (Bos, 1998; Shortland 1985).

English actors, from the time of Betterton, had been taught to study classical paintings and sculpture as a guide to their performances. In relation to available technology, use of the portrait or engraved figure in manuals, both scientific and popular, served to propound a fixed correlation between the appearance, especially the countenance, and moral character. By consulting such manuals, writers, painters and performers, as well as curious lay people, might discern the moral qualities of the persons depicted or encountered. Such guides appealed to ordinary people anxious to improve their performance in the social game of influence and self-presentation, but it was the actor by profession who was expected to demonstrate expertise in such matters.

For actors, there was a strong practical appeal in Descartes' evocation of the soul as the ghost in the machine. His mind–body dualism seemed to resonate with an ever-present reality of the experience of playing. For what was the actor, in feigning the outer signs of inner feeling, but a ghost inside the machine of character? One of the effects of Cartesian dualism was to provide an intellectual rationale to an ancient theory (still powerful today) that a more complete evocation of the passions rested on the imaginative powers of the individual, or, in eighteenth-century parlance, on his/her sensibility. A good actor, well trained in the arts of playing, could connect with spectators through the provision of a more intense rendition of the requirement that lay people should manipulate their demeanour in everyday life – a need most strongly felt in an urban environment. Moreover, imitative practices might have perceptible limitations in the hands of amateurs, limitations that the actor, as a matter of profession, was required to strive to overcome in circumstances where pretence was understood to be occurring. The problem of credibility in the theatre had hitherto relied on the development of stereotypical patterns of behaviour or character templates, for which physiognomy had provided visual exemplars. However, in a context of the changes in everyday life where the predictable formulas of dress, appearance and speech no longer guaranteed identity, theatrical conventions began to lose their credibility. Accordingly, the performance of the external signs of a passion might fall short of convincing an audience of its credibility.

But there was a more systematic problem. Cartesianism, as, for example, popularized in acting by John Hill, had begun to encourage the idea of psychological complexity and depth – with consciousness or the

preferred term 'sensibility' emerging as a crucial source of variation and potential richness in portrayal. But this did not mean that the notion of the static pose was abandoned – after all even in the established formal style, different actors could achieve different effects – but rather that the performance of character would begin to focus on the nuances of external detail. But the issue was: how far should an actor depart from reliance on static poses to communicate emotional states, especially since these were generally understood by audiences and provided ready keys to character and, importantly, keys to the actor's perceived personality. The classical heritage that underlay a rhetorical style of acting provided no guide since it advocated that passion was automatically conveyed by the measured gesture and pose.[22] The developing practice of eighteenth-century acting sought to synthesize the performance of the passions as discrete mental states with the transitions from one 'passionate' state to another required by dramatic action.

So if acting practice embraced physiognomy in the casting system, as a pragmatic move to align acting with the companion and more legitimate arts of sculpture and painting, this did not dispense with the actor's agency. Even in the case where the build and appearance of the actor was roughly consonant with a given character, s/he would be required to emphasize or de-emphasize aspects of his/her actual temperament, or even current emotional state, to fit with dramatic developments as they unfolded. Further, physiognomy was based on first impressions, whereas the actor's work consisted in sustaining expressions over time and in concert with others.[23] As John Hill observed, the actor must not merely have the power to project feeling but the ability to quit one feeling for another, often in rapid succession (quoted in Taylor G, 1972: 68). On this account, the actor could be seen as the living epitome of Descartes's *Ghost in the Machine*.[24] Aaron Hill's *The Prompter* embraced and popularized Cartesianism, arguing that the actor should imagine the relevant passion when (or even in place of) practising in front of the mirror or studying paintings. This act of the will would directly cause the muscles and the nerves to bear the imprint of the thought within (Roach, 1985: 80–82; Hill and Popple, 1966 (1734–1736)).

Garrick, influenced by the acting of Macklin, appreciated these developments, and in effect became a living demonstration of them throughout his career.

> 'It would seem that Garrick looked first for the passion, and only then considered a method of expression suitable to the character and to the genre of the play (Taylor, 1972: 61).[25]'

And another authority observes:

'His fame as an actor rested on bravura demonstrations of the management of transitions between passions, each one realised in its manifestation as an 'epitome' of the character's inner state. His practice, albeit exceptionally skilled, also reflected the orientation of 18th century acting that utilised bits of stage business to build climaxes or 'points' that punctuated and froze the flow of dramatic action – demonstrating the actor's skill and offering the audience models of how to express feelings.

(Downer, 1943)

The representational grammar of acting

The Cartesian split between the mind and the body had created an expressive space between the static and the mobile methods of character depiction. This space was also a space in which to seek distinction. There was a career to be carved out from intensifying the plastic aspects of performance, of infilling portrayal with a manifestation of a new kind of discrimination – based not on the fixity of types but on the subtleties of interpretation and a show of taste or sensibility. A number of actors and writers besides Garrick had advocated a new 'natural' style of performance to set against the 'old' rhetorical acting, typified by James Quin. The theory of sensibility, of which more will be said below, provided a bridge between Garrick's style and his desire for social eminence – a desire shared by many, including other actors.

The space of personality that surrounds acting in Garrick's day mirrors the larger environmental framing of character psychology as codified by physiognomy and the tradition of character writing as established by Theophrastus (Boyer, 1706). Each actor enters this space in order to construct his/her character in contrast to other actors in their characters. Although acting is intrinsically a collaborative process, actors in Garrick's day were imbued with an ethos of practical solipsism, which evoked in the context of the stage an analogue of participants in the process of commodity exchange (Sohn-Rethel, 1978). Actors received only their own parts and learnt them in isolation, with neither sight of the play as a whole nor full cast rehearsals; when not speaking or behaving on stage they tended to drop out of character, though Garrick eventually required his actors to stay in character. Rehearsals of the whole cast were not the norm and even with Garrick, who was more meticulous than his contemporaries, rehearsing was mostly limited to leading

or capital players as private events between Garrick as manager and the player.[26] This pattern of a self-contained performance was also emphasized on stage. Garrick, as a leading exponent of bits of business or by-play, tended to add idiosyncratic nuances to the existing dictionary of types – for example, Abel Drugger's reaction to a broken commode and Hamlet's start at seeing the Ghost. Such nuances were designed to stamp a proprietary brand on parts which a leading player owned for the duration of his/her career. Garrick's introduction of stage lighting, inspired by Philip James De Loutherberg and his policy of clearing the stage, anticipating the development of the fourth wall, tended to increase the cynosure of the leading player – especially during moments of self-expression, or 'points' – freezing the action for a moment of player appreciation or 'clap trap'. Garrick was particularly adept at points and his performances were identified with distinct idiomatic inflexions rather than through a complete re-visioning of prevailing conventions (Downer, 1943; Freeman, 2002). So his style of acting, which Quin saw as a complete revolution, was actually a modification of preceding best practice. In this tack he was not different from his peers, save for the plasticity of facial expression and gesture which he brought to by-play. In effect, he positioned the static emblems of physiognomy within a stream of pathognomic data that was based on his personal idiolect of looks, movements and gestures.[27] He also furnished the stage with real objects that were involved in minute and detailed by-play, thereby creating in the on-stage performance a closer resemblance to the mundane experiences of spectators (Wood, 2001: 71). These innovations helped to increase the spectators' engagement with on-stage action and, given the virtuosity of his performance, triumphantly proved his personal efficacy as a source of theatrical exchange value (Angus, 1938: 36). But what did this particularizing movement mean for the logic of identity, the grounding of its representation, as played out between Garrick and his audience?

3
Garrick as a Personage

That a prominent actor in a social order that judged individual worth on the basis of noble or ignoble birth should construct himself as a personage of national importance is hardly surprising, nor unusual as an aspiration. It should also be recalled that eighteenth-century Britain was in many senses a 'servile' society – with significant numbers finding employment as servants, especially in London (Sherman, 1995; Hecht, 1956). Garrick as an actor, rather than as 'Shakespeare's Priest' and landed gentleman, was also a servant of the public, in a compound sense: as patentee meeting the expectations of Royal and noble court patronage, and as a performer at the service of the market and the conflicting expectations of a socially mixed audience. For my account, the distinctive questions arise less from his social climbing and the social manoeuvres he undertook to be accepted in polite society than from what these meant in terms of the grammar of identity defining his stardom.

Stepping back from the level of social context and biography, I want to approach the semiotics of performance and question the kind of identity space implied by Garrick's practices as a star – which during his time was perceived not just as a version of stardom but, arguably, *the* version. Other leading actors, his contemporaries and successors, find their own pursuit of stardom structured as more or less successful reiterations of, or at least constrained departures from, the standard he set. Therefore this chapter will look more closely at the semiotic space materialized through his approach to performance as setting the fundamental parameters of stardom and celebrity. There is another reason for this emphasis that relates to Garrick's reputation as a leading actor. If his standing as a theatre manager was certainly a necessary condition for his stardom, it was not a sufficient condition. Sufficiency depended, rather,

on his demonstrated capabilities as a performer, which in turn implied a specific relationship to the labour process of performance.

Generally speaking, his approach to character playing, common to actors of his day, was indicative or statuesque rather than existentially saturated. For example, the few observations he made on his approach to character portrayal emphasize the necessity for a firm control over the countenance, the posture, the spatial disposition of the arms and legs and vocal intonation (Forbes, 1984). Such control is necessary in order to signal to spectators the relevant 'passionate' state of the character, which they might reconstruct in themselves as a realization of a shared and decorous sensibility. This objective is apparent in Garrick's definition of acting:

> Acting is an entertainment of the stage which by calling on the aid and assistance of articulation, corporeal motions and ocular expression imitates, assumes or puts on the various mental and bodily emotions arising from the various humours, virtues and vices incident to human nature.
>
> (Cole and Chinoy, 1970: 4)

This evocation, this 'putting on' is not about the actor's exposure of his/her inner feeling, but, rather, the production through the command of physiognomic semaphore – working at both the macro-level of the body and the micro-level of the face – of an epiphany of the universal grammar of the passions. Such a grammar, concerning the control of the kinetics of performance (gestures, looks, posture, tone and variation of voice), certainly predated Garrick. So, for example, Betterton observes:

> The Stage ought to be the Seat of Passion in its various Kinds, and therefore the Actors ought to be thoroughly acquainted with the whole Nature of the Affections, and Habits of the Mind, or else they will never be able to express them justly in their Looks and Gestures, as well as in the Tone of their Voice, and Manner of Utterance.
>
> (Gildon, 1710: 40)

Commenting on the 'just delineation of the passions', John Wilkes cautioned:

> It is certain . . . that every passion and sentiment has a proper air and appearance, stamped upon it by Nature, whereby it is easily known and distinguished. . . . This every Actor ought to be strictly acquainted

with, else he may affix the most unnatural grimace and gesture to the most striking passages, and yet call it natural and just acting.

(Wilkes, 1759: 109)

The pursuit of the 'just delineation' as a moral as well as mimetic value was seen as Garrick's specialism:

The passions, and all their operations, were his constant study; their turns, and counter-turns, their flux and reflux, and all their various conflicts, were perfectly known to him; he marked the celerity with which they rise and shift; how they often blend, unite, and raise one mixed emotion, till all within is in a state of insurrection. . . . Many of his great parts in tragedy were so many lectures on the subject.

(Murphy, 1969; Rogerson, 1953: 80–81)

Preparing for a part, Garrick decided what governing passion motivated a specific character, then proceeded to manipulate kinetic cues (gestures, postures, movements, facial expressions, vocal dynamics) to create the external signs of inner passion as 'natural' symptoms of humankind. The theatregoing audience, familiar with the coding of gestures in the theatre and subsidiary texts such as paintings, sculpture and engravings as well as written accounts, would construct a matching inner response, always according to their level of refinement.

In this way, the apparent contradiction between Garrick's acclaim for being a natural performer and yet a studied and fastidious manipulator of behaviour (as identified by Diderot's paradox) was brought into a felicitous and 'refining' relationship that seemed to be based on universal values (Taylor, 1972: 52). His acting was not naturalistic, in a much later sense of being coded to everyday behaviour, but a representation of a polished or polite human nature – the decorous revelation of the better parts of being human, advocated alike by Shaftesbury, Mr. Spectator and Adam Smith (Roach, 1985; Valihora, 2001). In this conception the actor became a tutor and demonstrator of feeling, a practical moral philosopher giving visible and audible form to universal human values at the point of utterance (Goring, 2005; Wasserman, 1945).

The spatialization of identity in acting

Anyone appearing on stage (or on camera) – unless unaware of being watched – adjusts his/her behaviour according to that fact. So strictly speaking, there is no zero degree of performance.[1] There is, however,

a distinction to be made between merely responding to being on stage and responding on stage to the demands of character playing.[2] So it is meaningful to distinguish between a minimal and a maximal degree of performance within a theatrical (or cinematic) frame. Between these limits there are gradations of performance, which prompt speculation about the 'actorliness' of a particular player. Who plays him- or herself, who can be said to be a great actor, who is 'natural' or contrived, and so forth? Obviously, no actor can entirely suppress personal qualities in character portrayal and, indeed, the whole economy of casting testifies to their influence. But there is a choice to emphasize or de-emphasize such qualities. Evidently, the degree of emphasis or de-emphasis in a performance will depend on the actor's (or at least the director's) understanding of the character. Again, even during a live stage performance an actor may fall in or out of character momentarily, especially in scenes that require presence rather than action and dialogue. Yet, analytically, prior to any actual performance, the intensity of the demand for inflection or deflection depends on the fundamental fit between person and character. So unless the actor's box-office pull requires that s/he play 'herself' or 'himself', casting ensures as close a physical fit as possible between the actor and existing conventions about the appropriate categorical qualities (young, old, tall, short) of the relevant character.[3]

In essaying a particular character, an actor is faced with a strategic choice: to what degree does s/he deflect or inflect given personal – physical and behavioural – characteristics in the performance of character? (Rozik, 2002) A character actor, in the strong sense of the term, aims to deflect as many as possible of the semantic entailments that arise from his/her physical being, habitual gestures, looks and voice, replacing them with 'fresh' sets of behaviour that plausibly arise from the character as written. Plausibility is a complex phenomenon. It is not solely a function of professional opinion. It may be a standard applied by the audience on grounds that actors or drama critics might not recognize. It will vary with time and context: the prevailing norms of everyday behaviour, the traditions of performance, and what other actors have done. Where an actor studiously inflects his/ her personal qualities into a portrayal, it is usual to refer to this as personality acting or, if a strict standard of character acting is applied, as not acting at all but behaving, meaning by the latter the ability to seem oneself despite the presence of spectators or cameras (Quinn, 1990; Knox, 1946).

Character portrayal is not a solitary activity and enjoys the support of backstage (or behind camera) crafts, to say nothing of what other actors are doing. But in terms of the production of a useable elementary resource, the individual actor has responsibility for his/her own

performance, sometimes as a matter of competition with other actors. Once cast, wardrobe and make-up artists having assisted in altering the actor's features – hair and skin colour, beards, shape of nose, and so on[4] – the actor is left to take care of the business of fitting gestures, voice, posture, to character, sustaining these in performance with other actors required to do the same.

Noting these immediate constraints, my concern herein is with the strategy, rather than the tactics, of embodiment – what does a particular style of acting imply about the relationship between the actor's being and appearance.[5] For it is in this space that the audience's sense of the actors' identity is formed.

As an initial characterization of the agencies available it is useful to consider the space of stardom as composed of the following trajectories. This is a present-centred mapping of possibilities – not all of these were available to actors before technologies of image capture became widely available. Again, the scale of circulation was much smaller before the invention of mass media. Finally, it needs to be emphasized that vectors are pragmatic accomplishments or performances of identity (or opportunities missed in the case of failure) that ascend or descend from the private to the public and vice versa.[6]

Table 3.1 Vectors of articulation of identity in the mediated public sphere.

1	Self \Rightarrow Person \Rightarrow Self + Δ
	Threshold of media attention
2	Person \Rightarrow Persona \Rightarrow Self
3	Personage \Rightarrow Character \Rightarrow Persona
4	Persona \Rightarrow Personage \Rightarrow person
5	Person \Rightarrow Character \Rightarrow Persona
6	Character \Rightarrow Persona \Rightarrow Person

KEY

1. $S \Rightarrow P \Rightarrow S+ \Delta$: Any individual managing changes in the relationship between the self and the person, outside media scrutiny, though likely as a consumer to draw upon existing public media as much as the local peer group for the construction of personhood.
2. $Pn \Rightarrow Pa \Rightarrow S$: An ordinary person (not a trained performer) given extensive media exposure who develops a persona based on 'being themselves' on camera. Dependent more on external resources,

rather individual abilities or talent, this persona is ever liable to be exposed – and may deliberately be so by self or others as a false image that hides their 'true' self. Indicative examples are a Big Brother contestant, Reality Television participant or online celebrity – what Rojek (2001) terms a celetoid.

3. Pge \Rightarrow C \Rightarrow Pn: An individual who is already an established public figure performing in theatre, cinema or television as a character, extending his/her public recognition beyond its original field of application. Indicative examples are a sports star, model, a war hero, who has a marketable name that can brand commodities and services, or add glamour to a cameo appearance. In Garrick's day, this would be an aristocrat or the King and Queen attending public theatre, who given the absence of a strong distinction between on- and off-stage appearances, was part of the spectacle (Sennett, 1978).

4. Pn \Rightarrow C- \Rightarrow Pa: An actor or other performer in character who because of public approval repeats the character type with minimal variation, leading to the development of a persona. An indicative example is a popular performer on stage, film or television; in short, a star.

5. Pa \Rightarrow Pn \Rightarrow S + Δ: A star or celebrity who is subject to media scrutiny in non-performance (or off-'stage' contexts) that exposes aspects of the person that are discrepant with his or her persona. Indicative examples are celebrities, socialites, performers proper in meltdown mode, for example, Michael Richards, Charlie Sheen, Lindsay Lohan, Wynona Rider and participants in Celebrity Reality TV shows.

6. C \Rightarrow Pa \Rightarrow Pn: A character having only a textual existence in one medium (written, visual or computer graphic) that becomes an intertextual node for a suite of textual renditions in other media. Again, a textually sequestered persona that evokes a constative person behind multiple appearances in different 'windows' and may go 'live' through 'incarnation' by real performers. Indicative examples are Homer Simpson, Aki Ross, Cosplay figures.

Although these vectors are represented as discrete three-step sequences, they may be combined in longer strings; for example, in circuits of Celebrity gossip, when a person performing a character develops a persona that transforms his/her person and reveals aspects of the self hitherto hidden from public view.

Fundamentally, the extension of a string depends on the actor's degree of economic success in building and sustaining a career or staying visible to fans and the general public. Given the possibility of image capture, with the exception of 1, the various configurations found

from 2 onwards may survive the death of the actual individual because they are retained as visual or graphic records that can be reactivated and reanimated.

Whatever the actual initiation point of a particular sequence, the vector formed pulls in entailments and affordances – meaning by the former, conditions and states that must be preserved with some degree of integrity and by the latter, emergent opportunities and possibilities that must be carefully managed and will preserve and ideally expand market value and the reach of publicity. As will be readily appreciated, the field of stardom in Garrick's time was but an embryonic version of what it would become. Certain vectors of self-promotion were not available as practical possibilities before the development of motion-based (audiovisual) transcription technologies or, in our time, the Internet. Nonetheless, Garrick managed to obtain a national level of exposure through his likeness being attached to commemorative materials such as portraits, engravings, statues, miniatures, snuff boxes, fans and pottery as well as print materials. Certainly, the eventual development of cinema increased the chance of direct observation of the actor. In Garrick's day, the only way to achieve this was to attend a live performance. But this does not necessarily mean that his likeness is more truthful or authentic if compared to a static portrait, because what is decisive is not the medium but the mode of being in which the actor appears. The invention of cinema certainly increases the circulation of the actor as animate image compared to an inanimate image. But this does not automatically make him or her somehow more truthfully present. So the issue has less to do with the actual circulation of a likeness than with the truth-value that can be assigned to it. To address this it is necessary to consider the credibility or 'truth' basis of kinds of performance. There are two aspects to this process. First, the audience perception of the 'truth status' of the actor's presence, what his/her performance purports to tell spectators about the relationship between his/her own identity and the identity of a character as written and performed. Put simply, the question here is, 'what does a particular style of performance imply about the relationship between the actor's being and appearance in character?' The elements of this relationship can be charted by the use of a veridicatory square (Hébert and Everaert-Desmedt, 2006) (see Table 3.2).[7]

Outside the frame of an actual performance, non-being and non-seeming could refer to the appearance of an image 'deficit' found during everyday contact with a star or celebrity, which is to say, in situations where s/he lacks the enhancement of appearance and the dramatic power afforded by in-frame or on-stage techniques (lighting, make-up,

Table 3.2 Actor/character relationships

Actor/ Character relationships			
1	Real	Being	Seeming
2	Illusion	Not Being	Seeming
3	Dissimulation	Being	Not Seeming
4	False or non-pertinent	Not Being	Not Seeming

costuming, and so on). Or it may refer to unguarded moments (bad hair days), which nowadays are the life-blood of paparazzi. Not being or seeming as one's publicly understood image is a zero degree that any actor (whether aspiring to be or actually a star) strives to avoid. Happily, ordinary people tend to lack the means for controlling their appearance and thereby provide a nice invidious contrast.

Clearly, there are variations of fit, and a gradient relationship between inflecting and deflecting the impact of the (given and acquired) qualities of the self on the 'being and seeming' relationship. Whatever the actual psychological dynamics of a spectator's identification with a character, the process of identification is mediated by the veracity claim postulated by the actor's mode of embodiment and the subsequent passage of an identity claim as through the modes of person, personage, persona or fictional character.[8] So, for example, the actor may appear as a character but this appearance is contextualized as emerging from or afforded by the qualities of his/her person. Alternatively, the actor may contextualize his/her person through exploiting the semantic resonances of a character as a unique individual, developing a persona, or, alternatively, may present him- or herself as a public figure or personage.[9] In the latter case, typified by Garrick, the actor deflects the affective resonances of character from his person through a virtuoso display of technique that says to spectators: 'I am an instrument for the revelation of universal qualities implicit in a specific character. Further to underscore my disengagement, I will find the universal in a range of different characters.' The success of this strategy in concealing Garrick's extra-theatrical 'private' life is in part evidenced by the paucity of private detail found in his biographies as compared to the exceptionally large critical literature devoted to analysing his performance and its aesthetic and moral implications (Wanko, 2003). One fundamental reason for this trend, outside of Garrick's careful control of his image, is that character performance, as a virtuoso exercise of craft skill, works to minimize the disjuncture between appearance and being.

The ratio of being and seeming is fundamentally a spatial relationship regulating distinct modes of being. These modes of being are best seen as channels through which the logic of identity passes or, alternatively, is studiously reposed. From what we can gather from his contemporaries, Garrick was always 'turned' out as a gentlemen, in part because of the persistence of sumptuary expectations and in part because of his social aspirations.[10]

Configured to an eighteenth-century spectator's perception of character – as a fictional event with strong moral implications – some examples of the four conditions are the following:

1. *Real:* A performer playing his/her person as publicly known (cameo) or a fictional character that is a transparent nom de guerre for a currently or previously existing person. Famous personality actors such as Frances Abington, Samuel Foote, Mrs Oldfield tended to fall under this category.
2. *Illusion:* An actor playing a series of fictional characters (human, non-human or animal) substantially different from his/her off-stage personality. Sara Siddons, David Garrick, Susannah Cibber as character actors.
3. *Dissimulation:* A female actor playing a male character (such as the 'Breeches' role made famous by Charlotte Charke or Siddons as Hamlet) and a male actor in drag. Boy actors as surrogates for women in the Pre-Restoration theatre.
4. *False or non-pertinent:* Any performance of a character that does not pass the prevailing threshold of credibility. For example, the older Colley Cibber as Lord Foppington – 'not the ruins of his youth but the ruins of the ruins'. Outside of an inept performance, this condition could apply to a particular plot, where a character is spoken about but never actually appears. Since absence is an ingredient of a present character's psychological reality, it is paradoxically a present non-presence.

These relationships of being and seeming can be seen as variations on a gradient of performance that ranges over:

1. *Personation:* The inflecting of apparent attributes of the person (the self as publicly presented) in the construction of a fictional character; this may also be seen as the mode of presentation.
2. *Impersonation:* The deflecting of the apparent attributes of the person in order to appear as a fictional character – the mode of representation (King, 1987).

What was the identity option pursued by Garrick? Through a combination of personal aspirations and contextual reasons related to status aspirations, he played characters as appendages or tokens of personage. To tease this out it is necessary to note the repertoire of identities that was actually rather than logically available to him:

1. *Personage*: The person, treated as an integral or indivisible expression of a self, extrapolated to the level of a collective symbol, a superior embodiment of collective values and a personality-invested allegory of what defines national character at its moral best. Personage is best seen as a totemic symbol in two senses: first, it models in an exemplary fashion the relationship between nature and culture, particularly between the mind and its passions; and, second, it signifies the invidious divide between those persons who are inside or outside the realm of the cultured or 'polite' society. Personage in the age of Garrick (and arguably still today) was the assured birth right of the aristocrat or person born into wealth who, appropriately dressed and following etiquette, was assured a facile appreciative scrutiny, an indulgent visibility, if compared to a middle-class counterpart:

 'If the nobleman, merely by his personal carriage, offers all that can be asked of him, the burger by his personal carriage offers nothing. The former has the right to seem, the latter is compelled to be and when he aims at seeming becomes ludicrous and tasteless'.

 (Habermas, 1989: 12–13)

2. *Person*: As pointed out in Chapter One, the conception of human identity prevalent when Garrick and his contemporaries acted viewed the person as an aspect of the self, attuned for presentation in social interaction. This presentation was not judged for its authenticity – as a veridical expression of inner feelings – but for its sincerity, the declaration of a commitment to honour a particular social code. Such a declaration might involve deception, hence a strong interest in reading external signs, but it was not inherently questionable. It might be said that in Garrick's time, the self as presented was not so much a signifier as a signal, comprehensible without further elaboration so long as there were no discrepancies on the surface. The notion of an interior essence – hidden from the self and others, which might be uncovered by a depth analysis – did not emerge as a commonplace idea until late in the nineteenth century

(Wharman, 2004). Compared to personage, person is an ordinary individual without particular social distinction.

3. *Character*: The studied coloration of the person of the actor by the virtual qualities of a character; in other words, a personality. A character is always an instantiation of type, which has a moral weight both in life, as in the sense of a person's character, and on the stage.[11]In a strict sense, Garrick does not type himself as a concrete character. His approach to performance was to exhibit the passions through the construction of the character as a visual and auditory spectacle of feelings. Garrick's performances are character performances but in the sense of aiming to exemplify the passions *through* character, rather than the passions *within* a character.[12] His approach to performance (which was not his alone) was to present a series of 'points' which segment narrative flow and isolate the character from its intensive existence in the small world of the narrative (Freeman, 2002: 28; Worthen, 1984). Nor did he specialize in a distinct line of business based on a fixed character that would generate a persona. He demonstrated his versatility through a wardrobe of transient personae, keying his presence to a higher principle.[13] If the term persona applied at all (and this is doubtful) it could only be as a momentary phenomenon that made no durable claim to embody a singular character type. Moreover, as noted above, the available means for the collective distribution of his image in character – paintings, graphic images and figurines – did not create 'live' doubles but static, superficial, depthless traces of resemblance that pointed back to an animate but absent self. These serialized images folded his appearances back on his person as the property that justified and authorized their constitution as a significant public symbol. The personal, in the sense of person, was a source that was withheld.

4. *Persona*: An image of a person raised to the same level as a personage, as a representative of a category, but because of its competitive efficacy having only one member. If a personage is marked as real outside of the theatrical world, a persona is entirely a theatrical representation that is based on the inflation of a character-furnished persona to the level of a collective symbol. Because the persona is a product of fusion between a collective symbol and a personal identity, persona is always susceptible to suspicions of pretence, falsity and mystification. Before the invention of recording media such as cinema and sound, the persona of stars such as Edmund Kean was tied to their immediate presence, because there was no facility to

produce a 'live' double under standardized and controlled conditions of performance.[14] In this case, compared to persona under full reproducibility, the persona of Kean is a paleo-celebrity, or what I shall term an eidolon – an illusive rather than a fully visualized presence. Judged from contemporary standards, an eidolon is a celebrity whose forte is performing pseudo-events or personal appearances for the media.

A more pragmatic reading of Garrick's self-construction as a personage can be made if a further dimension provided by Erving Goffman (1981) is added to the 'being versus seeming' contrast. In a discussion of the lecture in *Forms of Talk*, Goffman makes a distinction at the level of the speaker's performative scope of identity, his/her represented discursive location as speaking *for* something. Any performance can be seen as a modulation between speaker positions, whether explicit or implied. Thus, the *animator* is the one who literally delivers the performance as a spoken and gestural event and seems to be representing the implied identity; the *author* is the being who has written the text, and therefore stands for what is said; and the *principal*, an institutional representative rather than an individual, is the one who takes moral responsibility for the view of things implied by the text (167). In any particular performance, these capacities can be compounded – for example, as in autobiographical performances by stand-up comedians such as Lenny Bruce or Spaulding Grey – or they can be rigidly separated (Carlson, 1996). In Garrick's case, he staked a claim to all three positions – as an animator, an author as playwright and amender of Shakespeare, and as a key, if not *the* key representative of the institution of national theatre. He was not represented as a personality playing himself in the pretext of a character, as a theatrical person or actor who 'disappeared' into a wardrobe of distinct characters or as a persona – a performer who was seen as the emblem of a singular character type – but as an eidolon behind all three, acknowledged as a personage.

Early stars and the vestigial persona

The development of persona as a functional mask mediating the actor's interaction with the public was not a stable feature of early stardom. Indeed, in view of the crucial role of persona in maintaining stardom and celebrity today, stardom in Garrick's day may with hindsight be defined as para-stardom. Several factors can be cited for this. The first concerns technological development. No technology of live capture existed

which could ontologically separate and so sustain an extra-theatrical life for a specific character to be set against the ostensive person and actual existence of the actor.[15] This factor will be developed subsequently but in general terms, it meant that the substantiation and personal ownership of the personality resonances of character had to be manifested in the person of the actor, as s/he went about his/her off-stage life. As Garrick did, an actor might claim to be a national symbol, as a personage, above the level of any specific character. But the effectiveness of this claim rested on the ability to transcend the limitations of a particular character type. It seems undeniable, as his contemporaries recognized, that he was a performer with exceptional skill in character portrayal. The range of his performances alone demonstrated that the personality content of different characters was an expression of a controlled and distant virtuosity. Characters lived through him, as opposed to the actor living in the same character which is played over and over, albeit under different names.

But the concept of skill and its distribution does not entirely explain why other actors could not transcend the conventional constraints of their persons. Such an explanation needs to address the issue of the social worth of the actor's person as a sample of a social category. This leads in turn to a consideration of social inequality and intersectionality, the process whereby the various personal attributes of the individual – race, ethnicity, sexual orientation and gender – interact to produce an alignment of the person within existing frameworks of social inequality (Yuval-Davis, 2006). Such frameworks calibrate the individual's worth and entitlements and are consequential for the individual's life chances. In Garrick's case, he was a commoner, once in the wine trade and now pursuing a suspect occupation (and to boot a sexual suspect), yet enjoying a parvenu status as a public symbol.

As an actor Garrick, like his fellow performers, was positioned on the boundary between public and private life, between the self as privately experienced and the self as publicly presented. In Garrick's day, this boundary was also a moral threshold that discriminated between individuals according to their alignment with aristocratic notions of quality. Persons of the 'lower sort' were depicted as lacking (and worse, failing to desire) emotional control, closer to animals than to civilized persons. This lack of control was contrasted unfavourably with the reformed (polite) behaviour of the 'better sort'. In public at least, 'persons of quality' honoured the Cartesian division into mind and body, with the former acting as monitor over the excesses of the latter. Failure to control the passions was a kind of moral evacuation of the quality of the self.

The notion of politeness, however contested, sought to produce a means of aesthetic discrimination. In this manner, the practices and beliefs of popular culture were depicted as inferior to elite culture in a hierarchy of value, instituting a trend of discrimination that has continued down to present times (Payne, 1979).

As we saw, the innovations in the discourse and practices of English acting, of which Garrick was a key exponent, made the control of the external signs of the passions the hallmark of a 'natural' performance – one deemed in conformity with the fundamentals of human nature. Garrick's ability to project himself as a personage depended substantially on the prestige and security that derived from his position as an actor-manager. Such a prominent public role offered compensation for the low status of his birth (though it was more respectable than that of many of his colleagues) and his occupation as an actor or player. Garrick's standing, as any actor's, was like dirt – matter out of place (Douglas, 2002: 36). Yet he was, in the eyes of the better sort, an individual with collective prominence that was normally reserved for the aristocracy or upper gentry. We have seen how he strove to cloak this abject prominence in the vestments of respectability, aping an aristocratic lifestyle. His talent as an actor (not, take note, as a mere player) – with a substantial amount of self-promotion as a connoisseur thrown into the mix – empowered him to claim the social rank of a personage. Certainly, his ability to project himself as a personage, as against his acting peers, depended on the advantages and security that derived from his position as an actor-manager and the prevalent petty ownership pattern. I will return to this in what follows. But there was also an exogenous determination that arose within the culture in general and prevalent notions of gender. Men as a biological category were deemed to have an exclusive 'natural' right to the representational capacity of public figures or personages (Brock, 2006). The socially approved role for women was to provide domestic and conjugal support for men within the private realm of the home or family. Moreover, in the historical period from the Restoration forward to the eighteenth century, a marked misogyny permeated public life (T. A. King, 1992).

The categorical assignment of women to the domestic realm and their subordinate status to men was represented as a natural fact that expressed their sexual identity – the distinction between gender and sexual characteristics being culturally unmarked. This 'natural' fact was invested with great economic significance, not merely in terms of the function of providing children and, especially for the elite and those with descendible property, establishing lineage, but as a source of sexual

use-values (favours). In a strongly patriarchal society, women were valued for their sexual affordances to men, according to the order of their attractiveness, and – whether or not marriage was in prospect – the exclusiveness of their sexual services. Under these cultural assumptions, the person of a female was the conduit through which her concrete qualities as an erotic object and personality were recognized as a value in the sphere of commodity exchange. Fundamentally, the sexual contract mixes up two aspects of exchange: the immediate exchange of services for cash, as a prostitute, and as a wife or mistress in which male protection is provided on the basis of an exclusive relationship (Pateman, 1988). The former might be loosely defined as the retailing and, the latter, the wholesaling of sexual property in the person. But there was an additional legal determination. In the eighteenth century until late into the nineteenth, the legal doctrine of coverture prescribed the destiny of women to become, as wives, the property of a husband, to the extent that in assuming their normatively prescribed social role, husband and wife were legally only one person (Blackstone, 1979). In a single state (femme sole) women might own property or wealth, but upon marriage they themselves became the property of their husbands. Personal wealth – an exception in the general condition of females – might mitigate the degree of subordination, but even those of independent means were subject to patriarchal norms, and at hazard if lacking the protection offered by association with a man. In this sense, women were shadow persons with the prospect of a complete identity only to be found in marriage or, at least, by association with a wealthy male lover and protector. This exigency was rationalized by the view that females were more susceptible to their passions than men, who had the capacity and were expected to exercise control through reason. Nature, so to speak, stole a march deeper into the female as opposed to the male psyche.[16]

In contrast to the formal and informal strictures of coverture, itself yet another example of the pervasiveness of patronage forms in the eighteenth century, the actress cuts an ambiguous, enticing figure in the sexual marketplace. Leading female players especially complicate the gendered segregation of public and private space. By appearing as full rather than shadow or male-incorporated persons in the public realm, they exhibited their bodies as sexual use-values in the market transactions involved in theatre attendance. This exhibition process is not merely a matter of performing a part, but of inserting a sexually desirable body into the nominal husk of character. In one respect, any performance (on-stage or -screen) makes a spectacle of the actor's body,

drawing attention to his/her physical characteristics as an erotic object (Straub, 1991). Such an eroticization derives in part from the cynosure provided by performance and therefore can apply to males and females alike. Male actors, to be sure, could be admired for their physical attractiveness, as was Spranger Barry – Garrick was not noted for his – but this was a sub-rosa form of appreciation.[17]

Accepting the claim that the spectacle of actors' bodies makes them all sexual suspects, my interest is in the way this 'erotic' potential is managed specifically by leading actresses.[18] Young attractive actresses, especially, displaying what many thought was best kept private, ran the risk of being stigmatized as impudent whores (Pullen, 2005). One response, common to women of quality (or those who desired to be so), was for an actress to subsume her person under the protection of a wealthy, ideally aristocratic, man as lover or husband – a connection desirable, in itself, as a prospect for social advancement (Nussbaum, 2010). But this grounding of identity in coverture is best seen as standing in reserve to the more immediate impact of their bodies in performance. In competition with their peers, they could use their beauty and attractiveness to beguile audiences and attract green room admirers.

So alongside their talents – Susannah Cibber and Kitty Clive, for example, were accomplished singers, contributing to the first performance of Handel's *Messiah* – actresses in Garrick's day (as much as today) developed a conscious strategy of placing an emphasis on the display of physical attributes in performance. Celebrated actresses such as Fanny Abington, Peg Woffington, Ann Oldfield and Kitty Clive, when in their youth, were the forerunners of today's sex symbols, their popularity depending as much on their personal attractiveness as their skills. Indeed, beauty was a too fleeting a substitute for craft skills since 'the life of youth and beauty is too short for the bringing of an actresses to her perfection' (Cibber 1822: 465).[19] The 'beauty qualification' was a double-edged sword that might cut down rivals, but at the price of devaluing actresses' skills and the monetary recognition of their contribution (Laffler, 2004: 78ff). So a kind of identity disablement in respect of social standing was also implicated. Leading female actors could not claim the status of a personage with the comparable assurance of their male peers, and certainly not of Garrick's.[20]

Siddons, the great female star of the late eighteenth century, would seem on first glance to be a major exception to the law of diminishment of public significance on grounds of gender. But, to a degree not encountered by Garrick, her private person as a mother was set against her pursuit of the public status of a personage, producing a condition of

status ambiguity. So as Felicity Nussbaum and others have pointed out, Siddons' attempts to portray herself as a chaste mother and wife created tensions that subtracted from her efforts to claim the status of a personage – specifically, as the personification of tragedy.

Unlike Garrick – despite the early patronage of Lord Bruce, and late career recognition by George III notwithstanding – Siddons was unable to shake off the mundane associations attached to her person as a wife and a mother: subject to the sway of passions, which a man might resist, and subordinate to her husband and to manhood in general (Boaden, 1893). Paradoxically, she tended to undermine her own efforts – both on stage and through the genre of the theatrical portrait – to identify herself with the personage of the Tragic Muse. In the role of Isabella, she cast her own son as the character's son, and more generally affirmed her personal identity as a mother. On a critical public occasion she used the stage to answer charges of personal greed and meanness (Nussbaum, 2010). Such confusions of the public and private tended to short-circuit the aura of ethereality necessary for projecting oneself as a personage – a confusion Garrick was careful to avoid.

Siddons' responsibilities as the family breadwinner required her to work during pregnancies, which reiterated the potential clash between 'lofty' ideals and the mundane impulses of carnality. Supportive critics and portraitists sought to bolster her status as a personage by emphasizing her masculine qualities, a framing that conflicted with the acknowledgement that her popularity as an actress rested on her sympathetic qualities as a female. Indeed, her ability to suggest emotional conflict and possession was the basis of her popularity with audiences. If like Garrick, her claims for apotheosis were objectified in material objects – the most important of which was Reynolds theatrical portrait, *Sarah Siddons as the Tragic Muse* – she nonetheless remained an ambiguous figure, circulating between the transcendence of the universal and the deflation of the feminine particular[21] (Nussbaum, 2010; West in Asleson, 1999). Unlike Garrick, even in her benefit work, where a public image of aristocratic noblesse oblige might be nurtured, she inclined to private and domestic acts rather than public acts of professional consolidation (Spratt, 2013). Her brother John Philip Kemble, a lesser talent, was regarded as the premier actor of the day, suggesting once again that her acclaim as the personification of tragedy succumbed to conventional gender expectations about the position of women in society.[22] Observation of her performance suggested that unlike Garrick – who could crack jokes backstage whilst playing tragedy – Siddons had to maintain in her person a 'tragic' mood which (even if this was a matter of technique) re-enforced the

cultural equation between femininity and the sway of emotion over the body (Cole and Chinoy, 1970).

Nor did Siddons seek to be a sex object as did many of her peers. Her personal identity as a wife and mother, subject to her husband, closed this option off; and given her conservatism, shared with her brother, there is little to suggest that she would have preferred such a route to identity. Her marginal position acknowledged, it is tempting to see other leading actresses as performing a persona – that inferential credit of personality – made by the fusion of physique and physiognomy that accrues to the self through playing a market-proven character. It might seem, to choose one out of many possible examples, that the character of Lady Townly in Colley Cibber's *The Provoked Husband* is an extension of the off-stage persona of Oldfield, evidencing her aspiration to be regarded as a lady of quality, a claim reiterated through a range of similar characters under different names (Peck, 1997). Again, Frances Abington was able to extend her on-stage presence as a mannequin to the social role of off-stage fashion adviser to high society – much as, say, Gwyneth Paltrow does today, albeit in her case through mediated rather than face-to-face interaction (Nussbaum, 2010).

In assessing the performances of leading actresses, Nussbaum has postulated that they asserted their power over the stage through the development of an interiority effect, which other writers have confirmed. In creating an 'interiority' effect, actresses performing a specific character would load their performance with tricks of appearance and manner that inflected rather than deflected their apparent physical and psychological attributes (Nussbaum, 2010). Although I agree with Nussbaum, I am inclined to see the interiority effect as tied to the being of the actor as a person and not, as Nussbaum suggests, as a persona. As already mentioned, an autonomous persona requires the capture of a performance in an animated visual record – though, as will become apparent, extravagant off-stage behaviour can compensate for it. But there is a more immediate reason. The concept of persona in the eighteenth century was not detached from the notion of a truthful representation. Writers, especially of satire, might assume a persona but the expectation was that this would be validated by the actual qualities of the author as a person and thereby subject to a morality of truth-telling. The literal reading of a 'mask' assumed its connection to the underlying behaviour of the person who assumed it (Weinbrot, 1983).

In the 'live' context of performance, actors eager to win audience favour away from potential rivals would have every reason to exploit the positive aspects of their personalities and appearance. Reading

actresses as present *in person* rather than *in character* drew on the prevalence of lay theories of physiognomy (which, as we saw, was also cultivated by professional advice given to actors and painters), intensified by gender assumptions and the prevalent view of the actress as a 'loose' woman, which drew on fairly recent historical usage. Since the Restoration, when women were first permitted to appear on stage, they were routinely read as presenting themselves as persons with sexual qualities that could be facilely ascribed to their appearance and 'feminine' nature. The preceding theatrical convention of cross-dressing males, especially boys, in female parts meant that the first actresses were seen as 'natural' sexual objects or persons and, indeed, the language and plots of Restoration theatre moved to emphasize such attractions (Howe, 1992; Maus, 1979). This anchoring of stage presence in 'extra-diegetic' sexual attributes clearly followed everyday sexism, and the perception of what made women immediately interesting (or uninteresting) depended on age and appearance. But it was underscored by their deployment 'in person' in extra-dramatic situations of direct address, such as prologues and epilogues. Moreover, it seems that the performance of character proper tended to reproduce the 'out of character' presentation of the self through personalizing by-play even when in character.[23] Given that many early actresses – as well as actors – lacked professional training and 'drifted' into acting on the basis of their given attributes, this is hardly surprising. But the result was that the public image of the actress, howsoever glamorized by theatrical artifice and the aura generated by on-stage cynosure, presented a personality rather than a character as a fictional self and, in this sense, can be seen as character acting in reverse[24] (Perry, 2007; Nussbaum, 2010). From the Restoration onwards, the key performance strategy for leading actresses was flirtation, a playing with audiences' expectations through the promise of sexual favours from their person. Although flirtation may be given a psychoanalytical gloss – as a primordial topological division of identity brought about by the introjection of an image of what others desire of the self – as a strategy of performance it is a second-order, consciously adopted strategy of performance (or, if one will, a strategy within a certain zone of intention).[25] Like an anachronistic expression of post-feminism, flirtation was the exploitation for personal advantage of the commonplace perception that only 'loose', hence potentially attainable women, would exhibit themselves on the public stage.[26] The term *parasexuality* has been coined to describe 'sexuality that is deployed but contained, carefully channelled rather than fully discharged' (Bailey, 1998: 2).

What Nussbaum correctly identifies as an interiority effect is therefore connected to the process of self-commodification whereby the individual constructs a self-image that maintains a degree of privacy within the framework of service (Bunten, 2006). But the pervasive sexism of eighteenth-century English culture makes it doubtful that many actresses had the opportunity to construct a persona as a 'shelter' which prevented self-commodification from reaching down to fuse their most intimate sexual and biological capacities to their social roles. Aristocratic women might use their status as a boundary against sexual exploitation, but this seems likely to have been a feature of public rather than private life. For 'low-born' actresses a status shield was not an option; professionally, they had not only to conform to public expectations, but to entertain a coercive competition with their rivals. Mrs Siddons might be cited as a successful steward of a public identity sequestered from the sexual economy of the market, but her solution to embrace coverture was hardly a blow against sexism. Nor was it a matter of individual choices and strategies. Mid-eighteenth-century London society demanded self-commodification in depth through the development of a public culture of spectacular exchanges (Castles, 2008). In public sites such as masquerades, pleasure gardens, exhibitions and concert halls, the relationship between femininity and sexuality was explored by women of quality and the demi-monde such as actresses and courtesans. The interest in sexual encounters aside, the intense fascination with identity created by the incursion of capitalist market relations into customary society made permeability a pervasive topic of fascination. Given the confluence between theatrical and off-stage public culture, the characters that actresses assumed on stage were facilely read as extensions of their persons – a confusion that actresses who were ambitious for income and social advancement did well to exploit. Being a flirt off-stage and carrying this into stage performances (especially in epilogues but also in character) underscored a particularistic grammar of the person rather than the status of a collective symbol or personage. The rise of celebrity – as fame for the person – had its origins here, just as the concepts of an interior life were developed in the emerging novel form, which addressed a predominantly female readership (Armstrong, 1987).

The interiority effect, as Nussbaum implies by her claim that the eighteenth-century theatre was the age of the actress, is a function of the gendering of market value. If self-commodification involved the performance of a marketable identity, creating an inner sanctum protected from the incursion of exchange value, the latitude for escaping alienation followed a gender gradient. Given a sexist reading of human

nature, the degree of incorporation or self-colonization by commodification was more intensive and deeper for women than for men. To put it succinctly, for actresses, seeming was more pervasively read as being. Despite the renown of Mrs Siddons as a force of sensibility, it required a man of feeling as a star to invest – on some accounts, to over-particularize – the register of the personage with expressions of private feeling. In the English theatre, this would not be Garrick, who sought the respectability and prestige of a personage. That man was Edmund Kean.

Enter Kean

Kean's contemporaries thought of him as a force of nature, the epitome of the romantic hero. Socially prominent individuals, aristocrats like Lord Byron and the Earl of Essex (albeit with quite different motives) and the theatregoers who packed his performances in the first three years of his career regarded him as a wonder. His most consistent supporter, William Hazlitt, praised him, when acting at his best, as a praeternatural exponent of great passions and recognizing this accolade one of biographers depicted him as Prometheus who brought to theatre a 'fire from heaven' (Hazlitt, 1818: 34; FitzSimons, 1976). It is indisputable that Kean was a charismatic performer and eyewitness accounts of his best performances confirm this – something singular emanated from his person. But it would be a mistake to see his genius as somehow anterior to what he learnt before his successful debut at Drury Lane in the role of Shylock on 26 January 1818. The following factors need to be taken into account as abridgements and preconditions for his appearance as a 'feral' genius.

First, compared to Garrick, Kean by the time of his breakthrough performance as Shylock in Drury Lane in 1814 was seasoned performer. He had been acting in fairgrounds and on the provincial theatre circuit since the age of seven. He had been billed as a child prodigy actor, in the mould of – but less successful than – Mr Betty (Altick, 1945; Slout and Rudisill, 1974). Unlike Mr Betty, whose stardom was finished when he reached early adulthood, Kean's career continued to develop as he matured. He was a versatile player, experienced in 'low' forms of entertainment in fairground booths as well as a utility actor in provincial theatre. His skill set encompassed tragic roles, acrobatics, sword-fighting and pantomime as harlequin, often rotating through all these within a single evening (Fitzsimons, 1976).

Second, despite his image with audiences as a spontaneous and natural actor, his performances were meticulously prepared down to the finest detail – stage movements, number of paces, vocal dynamics, facial

expressions – and choreographed in advance. In addition, performances that proved successful with audiences were fixed into his personal repertoire and then repeated without variation.

Third, his style of performance was driven by the logic of tournaments or contests.[27] Other actors were perceived not as collaborators but as rivals for his position as the pre-eminent tragedian, leading one commentator to suggest that his conception of performance was closer to a boxing match than a collaborative endeavour. He used the threat of the withdrawal of his star power to influence the selection of plays and to ensure that mediocre performers were cast in supporting roles, the better to shine forth as a consummate professional. Where these tactics of exclusion could not be exercised, he summoned his considerable powers of emotional projection to bemuse and intimidate his acting partners such as Junius Brutus Booth, stealing their thunder and capturing audience approval and applause (Kahan, 2006: 10). When he feared that these stage tactics might well fail, he flat out refused to perform as he did with Charles Mayne Young, whose 'good looks, imposing stature and lordly connexion' Kean felt put him at an automatic disadvantage (Davis, Freeman, Raby, 2009: 64).

Fourth, as a prerequisite for the success of the foregoing, Kean seeking to overcome his physical limitations as a tragedian – his short stature, poor bearing and a less-than-sonorous declamatory voice – developed an exclusive performance idiolect. Essentially a 'branded' presence that other actors could neither surpass in expressiveness nor successfully imitate, his performances drew on an acquired toolkit of pantomimic, vocal and gestural 'tricks'. These saturated his portrayal of fictional characters with what his contemporaries saw as a natural expression of his person. Nonetheless, he was admired by critics such as Hazlitt, Leigh Hunt and the poet John Keats as a force of nature and an emblem of the Romantic movement (Manning, 1972/73).

In Peircean terms, Kean trained his body and voice to produce, and then replicate as needed, a fixed set of hypo-iconic sign forms. Such sign forms work by resemblance but they also effect a capture of specific qualities – owning them as properties of the self As a result – even though Kean liked to claim the status of the Great Tragedian – compared to his contemporaries such as John Philip Kemble or his sister Sarah Siddons, he did not attain the generalizable status of personage. As Fanny Kemble observed, Kean did not aim to *be* any of the successful parts he played – as Shylock, Othello or Sir Giles Overreach – but he intended the parts to be him, as a presentation of a staged honed self (Kemble, 2000/1789: 430). Moreover, this self was matched by his behaviour in person, which

was not solely confined to scandalous backstage behaviour – getting drunk and whoring between acts – but through an extravagant and dissolute lifestyle that, if not directly calculated to do so, had the potential to outrage respectable society.[28] By these means, Kean's identity did not (and as a consequence of his behaviour could not) anchor itself in a transpersonal framework of dramatic action like John Philip Kemble or Garrick. He stood in the place of and yet was not accepted as a personage.[29] Conversely, Kean did not protect his personal space from commodification so much as dissolve the interface between character and his person, in order to present himself as the sole proprietor of a singular service that other actors could not own. In this latter endeavour, he was a more intensive version of the self-commodification in depth that marked the common fate of the actress: to being a person, rather than seeming to be a character.[30] The theatre audiences – high- and low-born, male and female – were thrilled by his systematic indistinction of character and person, seeing the subordination of the former to the latter as an expression of nature. Again, his publicly revealed misbehaviour, notably when Councillor Cox brought a case against him for 'criminal conversion' with Mrs Cox, cemented the impression that his passionate acting was a matter of being rather than seeming. His personal morality, not quite as abnormal backstage as it appeared in public, effectively eclipsed his pretensions to the personage of the Great Tragic Actor and at the same time, tarnished his integrity as a person fit to be the servant of the public.[31]

Finally, it is important not to neglect the impact of contextual factors on Kean's management of his image. Unlike Garrick before him or Kemble as a rival, Kean never managed to remove himself from the uncertain and insecure status of an employee, albeit a very well-paid one – despite his two attempts to become a manager at Drury Lane, in competition with Elliston and, towards the end of his career and life, the American theatre impresario Stephen Price.[32] Kean achieved the security of being a manager only in the twilight of his career, in a small provincial theatre on Richmond Green. His impoverished underclass origins meant that despite being feted early in his career by the aristocracy, he remained uncomfortable in their company. His personal preference was for the 'low' company of the tavern and the brothel rather than the bon ton dinner party. For example, Byron – an enthusiastic fan – was annoyed to learn that Kean had excused himself from a dinner party in order to attend a boxing club (Hillebrand, 1933). At the same time, as a 'lower'-class parvenu, he was psychologically ambivalent, both admiring and despising the aristocracy. Nurturing an aspiration to be a

gentleman that conflicted with his carnivalesque impulses, he fabulated claims: that he was the illegitimate son of the Duke of Norfolk; that he had attended Eton (though he sent his son Charles to that same college, so that he might become a gentleman rather than actor).[33]

The example of Kean is a harbinger of the average specific condition of the star as a theatrical and eventually a cinematic phenomenon. Operating as theatrical worker for hire, negotiating the terms of each season's engagement, Kean never attained the status of an actor-manager in one of the patent theatres.[34] A subcontractor or freelance (like Siddons), marketing his services on terms that for the most part were personally advantageous, he never attained the security and prestige of the actor-managers of the eighteenth century such as David Garrick or John Rich, or of the nineteenth century, John Philip Kemble and, subsequently, Henry Irving. As he never attained direct personal control over the conditions of his own employment, Kean is a harbinger of the star as a celebrity, one whose fame supersedes its vocational context and becomes a name linked to quantum of publicity (Bratton, 2005). His refusal, perhaps inability, to conform to middle-class notions of respectability barred him from stabilizing his status as a personage – the Great Tragedian – that might have won him the control of Drury Lane. The Cox affair, his alcoholism and his riotous behaviour equally undermined his claim to respectability as a person and middle-class professional. More immediately, his idiosyncratic approach to performing, the fits and starts of delivery, placed him in a position of adjacency to any specific character, even within the tragic roles in which he was commonly perceived to excel. Obliquely and ambiguously positioned as a personage, person or character, he had only a vestigial persona, presenting itself immediately as parasocial behaviour on- and off-stage. In this last contingency he, like his peers, was a victim of the absence of a technology that can create a 'live' technological double – a means of connecting with his personality that *does* reach to his person. Lacking an assured and stable connection between the theatrical and para-theatrical aspects of his identity, he appeared as a figure outside of society – the star as vagabond. Like Byron, who indulged in a similar pattern of extravagant display, Kean appeared as a being that cannot be conventionally placed, contributing to a newly emergent concept of genius as a force of nature bursting the stultifying confinement of civilized society.[35] But in Kean's case, the gains and losses of being an 'outlaw' were played directly before an audience vocal in its praise and criticism and demanding his servitude. By contrast, Byron, that other 'wild child of nature', could hide behind his literary persona as Childe Harold, and enjoy the protection provided by his aristocratic

lineage, or by aristocratic patronage and acceptance as won by Kean's predecessor, Garrick.[36] As a well-paid hired hand, his limitations as an actor, such as a poor speaking voice and unheroic stature, were not protected by the acquisition of the status of an actor-manager. Actors who became theatre managers, such as Elliston (like Kean, a drunk), the asthmatic Kemble or, later, the ungainly Irving, found their limitations not directly confronted by the judgement of the market, and thus had the space to cultivate a dramaturgy and performance style adjusted to their personal limitations, shifting the crux of the spectacle away from themselves towards the totality of the performance. In comparison to Kean, these other stars were able to render their shortcomings as non-pertinent to their fame, sustaining a shallow self-commodification, a discriminating social distance between their personal qualities and the demands of the market. Kean had no such shelter – admittedly, a partly self-imposed condition – and was obliged to commodify himself in depth, staking all on the immediacy of his performance and his ability to see off rivals in a theatrical tournament. Deploying a repertoire of performance tricks, and driven by economic necessity to seek to create audience-pleasing coups de théâtre, Kean arrived pragmatically at a figure that could not be contained within the minimal qualification of a person – the outcast or abject.

In sum then, beyond all the particularities of motive, Kean is an early example of the symbolic degeneracy associated with celebrity – he enjoyed a quantum of public attention that steadily emptied of substantial achievements (as an actor) (King, B.: 1992). Yet his historic location, in a society positioned between traditional customary order and market society, embroiled him in a contradictory set of expectations. Should he have aspired to be a personage as an associate of the aristocracy, or a person as a member and emblem of the cultural achievements and moral standards of an emerging middle class? (Bratton, 2005).[37] He did neither with any consistency, retreating to the assertion of his individual genius as a person. In general, his career is like a progression through, and an exhibition of, the conditions of selfhood – an existential passage through personage (the Great Tragedian) towards persona (extravagant off-stage lifestyle to project charisma) and then a recidivist falling back to his person (drunk, low life and fornicator).

Accordingly, Kean's image fascinated as a vacillation between these foci of identity that was never resolved. Other stars would follow this path. Clearly there was a foreshadowing of a contemporary phenomenon in which individuals with achievements in specific fields adopt extravagant lifestyles designed to excite through a challenge to contemporary

morals and mores.[38] But, like leading actresses of his day, Kean ultimately did not pass beyond the reference threshold of his person. In this 'exit' from transcendence, in part his own doing, he provided an especially clear-cut example of the representational possibilities that develop around the figure of the star as a performer in any sphere of endeavour – sport, literature, science, politics – who seeks to broaden his/her celebrity beyond an established reputation in a particular field. More will be said about the nuances of marketable performances subsequently; but in general terms, the basic elements of variation in the modes of stardom and celebrity are in place by the late eighteenth and early nineteenth century.

4
Emergent Modes of Stellar Being

The genealogy of stardom now needs to be placed in the immediate context of broader structural changes in the theatre as mode of production and employment. The star or the celebrity is by definition a special individual.[1] But individuality, particularly in the cultural industries, needs to be set against a directly intensive, collaborative labour process. Stardom, however represented as unique, is a pattern within an organizationally constructed space, as the term star *system* suggests. Drawing back from the tantalizing immediacy of a star's fame, it is necessary to consider changes in the organization of the theatre and, relatedly, changes in the technological base of performance that lead to self-commodification of the star as a determinate response.[2]

The purpose of this chapter is to outline the organizational underpinnings of this space and to show how stardom is steadily transformed by external and internal developments – by structural change, the transformation of agency effected by stars themselves, the introduction of cinema and the role of audience selection. It is through these developments that the field of stardom shifts through its quadrant of identities, selectively mobilising its core identity – as person, character, personage and persona – for appearance in the media public sphere.

The new context of theatrical production following the 1843 Act, which ended the patent theatres' exclusive licence to present drama, had been expected to encourage increased competition around 'legitimate' drama within London and in the regional theatres. But the Patent theatres – effectively two, given that the Haymarket only operated in the summer – had never constituted an iron-clad duopoly. This was in part because unlicensed theatres found ways to evade the licensing regime by presenting legitimate drama in a burletta format or, especially in the East End, evolved new forms specifically aimed at 'lower-class'

theatregoers such as the pantomime, melodrama and the music hall. The Patent theatres, in order to maintain their share of the market, were compelled to introduce elements of 'illegitimate' theatre into their own repertoires and staging practices. So in London at least, the end of the Patent regime was less a new unleashing of free competition than the recognition of the status quo, in which a respectable 'national' drama vied with more demotic, class-driven forms of theatre. Even in the regions, the Deregulation Act failed to energize local markets. Local stock companies – whether committed to the project of cultural betterment, respectability and civic pride or pragmatically seeking an affluent audience prepared to pay top price – depended on the drawing power of expensive London talent and stars, as did the career aspirations of many local actors whose road to stardom was firmly linked to the West End.

One organizational manifestation of an increasing dependency on the West End was the tour, where London stars or substitute 'country players' – the slavish imitators of their idiosyncrasies – brought plays to suburban and provincial theatres. In the days of Edmund Kean, a star would tour solo and be showcased with the support of local stock players. From the second half of the nineteenth century, facilitated by the development of the railways, provincial tours would increasingly be undertaken by an entire cast headed by a star or by his/her clone, depressing local employment opportunities and wages (Macleod, 1983).

The structural driver of these developments was the increasing subordination of theatres to capitalist forms of management. Given the overarching imperative of profitability, this meant in general terms a shift from formal subsumption to real subsumption. Expressed as the polar ends of a spectrum, in the former, the pursuit of profits is tempered by craft values; in the latter, these values are directly and progressively transformed by profit maximization (Marx, 1990: 1019–1038). Despite the commonplace view of theatre as an area of aesthetic autonomy, by the second half of the nineteenth century, the theatre in Britain led the trend in replacing pre-capitalist and only formally subsumed modes of theatrical production with mature capitalist forms of investment such as the joint stock company and the syndicate. These forms of ownership had limited liability and were therefore conducive to the minimization of risk for external investors who saw the theatre as an opportunity for rapid profit maximization. This development saw the increasing marginalization of craft-centred forms of ownership and management such as the local stock company and, until late in the century, the supremacy of the actor-manager as lessee – most prominently represented by Henry Irving and Herbert Beerbohm-Tree (Davis, 2000).[3] These forms, evoking

the old system of commonwealth or actor partnerships, were by no means simple havens of craft-inspired communism. Yet they nurtured a profession-centred approach, to set against the commercial, profit-maximization approach to theatre management which increasingly became the norm of business organization (Macleod, 1983).

The shift to direct capitalist management led to the shrinking of the repertoire as production coalesced around long runs of market-proven plays to the point of saturation, a process concentrated in the West End and on regional tours. Decreasing the range of plays presented and spelling the end of the seasonal repertoire, these developments also reduced actor employment in stock companies and, given rising costs of touring, with sets and costumes accompanying casts, depressed wages for rank-and-file actors. This created a flattened hierarchy, composed of a mass of impoverished players and a compact and exclusive coterie of affluent stars.

A decisive feature of deregulation was the replacement of the old hierarchy of high and low theatrical genres with new notions of quality based on theatrical spectacle.[4] Market demand urged a similar focus on the staging of spectacles, as an accommodation to a mixed-class audience with differing degrees of literacy. Visual elements could provide a common denominator and a ready source of excitement for sustaining mixed-audience engagement. But there was also an axial shift in the logic of display. From the early nineteenth century, public demand for spectacular forms of entertainment had been rapidly if not frenetically increasing (Booth, 2005). There was rising interest in extra-theatrical forms of spectacle such as dioramas, panoramas, museums, waxworks and, as a culminating moment, the Great Exhibition of 1851 (Altick, 1978). For Charles Kean (son of Edmund) at the Princess Theatre, as well as other actor-managers, such 'shows' were biting into theatre attendance. Kean in particular went further, not merely seeking to provide theatrical spectacles as a counterattraction, but becoming directly involved in the Great Exhibition itself, fusing the stage and public amusements into a pervasive celebration of national culture (Foulkes, 2004).

In the immediate context of theatre, the increasing emphasis on spectacle reflected the increasing popularity of melodrama, which both the major and minor theatres had embraced. The exploitation of popular forms carried an implicit challenge to the responsibilities of the former patent theatres as stewards of a national theatre, as engines of refinement and taste, deserving of the cachet of Royal approval. The elite core of West End actor-managers – Charles Kean in the 1850s, followed

by Irving and Herbert Beerbohm-Tree – sought to bring their personal imprimatur as stars to the provision of a more refined spectacle. So Eton-educated Charles Kean sought a knighthood from Queen Victoria for his services as Director of the Windsor Private Theatricals (Wilson and Barrett, 2002).[5] His disappointment in this endeavour was followed by Irving's success in cultivating Royal favour, particularly of the Prince of Wales who was a fellow Freemason. Such individual aspirations for advancement were not unconnected with more pragmatic concerns and even sincerely held artistic beliefs. If the leaders of the profession were honoured – and by that fact made the claims of professionalism more compelling – they would advance the standing of actors as a whole, continuing the process of identification of the Theatre with the Fine Arts and learned professions that Garrick had initiated.

From its own specific context, the impetus towards theatrical spectacle contributed to the development of a new mode for regulating public behaviour: the exhibitionary complex, which supplemented the already reduced rituals of display associated with the scaffold and the state ceremonial.

The significance of the formation of the exhibitionary complex. . . . was that of providing new instruments for the moral and cultural regulation of the working classes. Museums and expositions, in drawing on the techniques and rhetorics of display and pedagogic relations developed in earlier nineteenth-century exhibitionary forms, provided a context in which the working- and middle-class publics could be brought together and the former – having been tutored – into forms of behaviour to suit them for the occasion.

(Bennett, 1988: p. 86)

For example, Charles Kean, Irving and Beerbohm-Tree ascribed to the view that historical accuracy of staging had the power to return theatre-goers to the beneficial context of medievalism with its promulgation of the aristocratic virtues, chivalry and the Great Chain of Being (Foulkes, 1977). In other words, accurate historical representation would recover a traditional structure of feeling (Williams, 1954: 116; Wrobel, 1970). Naturalistic stage spectacles, with a decidedly conservative bent, were not merely to be a delight for the eyes but a moral tonic that would restore respect for the great age in which the values of Englishness were formed and realized. To underscore the point, visual tutorials in regal splendour, at times connected literally to coronations, favoured Shakespeare's plays of Kingship. Such exercises in romantic realism – the use of historical

detail to propound ideal moral states – confirmed Guy Debord's maxim that the spectacle is a social relationship mediated by images and 'by means of the spectacle the ruling order discourses endlessly upon itself in an uninterrupted monologue of self-praise' (Debord, 1995: 19) For the theatrical entrepreneurs and actor-managers who furnished these nostalgic 'medieval' spectacles, there was grandeur by association and the demonstration of their standing as personages – particularly concretized by a close association with Royalty, and for Irving, a knighthood – not mere personalities. The histrionic implications of theatrical spectacles are best traced in various pronouncements of Sir Henry Irving as the public face of acting qua profession.

In general terms, Irving conceptualized the role of the actor as a non-obtrusive bearer of the spectacle – a necessary behavioural axiom, if a total visual effect was paramount. His adherence to this principle departed from traditional ideas about the primacy of the playwright's text. The resulting performance was a visual interpretation, in which the play text could be altered and truncated to provide spectacular scenes and visual effects. Accordingly, the actor following Irving's precept was recommended to view the script as a series of scenes. However, what held for actors in general did not hold for stars such as Irving himself, who were expected to express their distinctive personalities. Irving's own approach, which contributed to his reputation as a mannered actor, was in-depth exploration of by-play – bits of business that drew the audience's attention to the individual player and away from the surface of the spectacle – to draw attention to himself.[6] Nor were these idiosyncratic bits of business, as markers of personal presence, meant to aid the impersonation of characters, but rather the converse – that characters that Irving played often became a presentation of Irving as publicly known.

> My boy, there are only two ways of portraying a character on the stage. Either you try to turn yourself into that person – which is impossible – or, and this is the way to act, you can take that person and turn him into yourself. That is how I do it!
>
> (quoted in West, 1955)

Given his acknowledged flaws – slovenly articulation, poor voice production, shambling gait, graceless angular gestures – the emphasis on personalized by-play as the channel for the expression of his 'artistic' vision suggests a rationalization (Stoker, 1907, Volume 2: 10; 23). But it was also a means of creating cynosure through the steady accretion

of detail. By emphasizing idiosyncrasies, he placed his persona (and those of his co-stars, especially Ellen Terry) at the centre of an otherwise transpersonal spectacle (Schultz, 1975: 431; Macht, 1968). An aesthetic rationale for Irving's approach might be derived from the late Victorian interest in doppelgangers, installing a dramatic disjuncture between surface behaviour as signalled by the formalized exchanges of the script and the by-play which might hint at a subterranean self, a gestural Hyde to the vocalized Jekyll (Danahay, 2012). Irving's popular appeal rested on such effects. But the critical establishment remained unconvinced by the quality of Irving's acting which it saw as a vitiating descent into banal particulars that punctured the integrity of the spectacle, even allowing that they accepted the desirability of romantic realism. His 'look at me' approach to characterization and his tendency – whether deliberate or as a result of his limitations – to turn characters into clones of himself seemed to be a usurpation of the playwright's role, subverting the normal function of an actor as an animator of the playwright's text.[7] As Shaw astringently put it, Irving's by-play was not in-line in service of the text but off-line in the service of himself (Archer, 1883).

It is tempting to claim Irving is an early example of acting through persona. But apart from the fact that this was only a vestigial possibility before the cinema, Irving did not borrow qualities from a character but ensured that all characters referred back to himself as a publicly established personage – the fashionable tragedian[8] (Archer, 1883). There are two aspects of this reduction to personage, one semiotic and the other economic. First, with a limited adjustment to the dramatic context, Irving integrates his personal qualities into the construction of the signs of character – this process entails materializing qualities (iconic elements) that are his personal properties into an indexical compact with his personage, creating a hypo-iconic meta-sign. Second, because he is an actor-manager, he is able to exclude others from a similar opportunity to personate characters or, for that matter, to challenge him through a virtuoso display of impersonation. The severe criticism he faces from some quarters can be judged as too personalized, but ironically this is understandable as a response to his own style of performance. It also reflects expectations aroused by his standing as a star, exercising absolute control over productions.[9] Had he been a rank-and-file actor personating a stock character, his idiosyncratic performances would have attracted less criticism. Even his severest critics, Shaw for example, admitted that Irving's limitations fitted some characters. But these performances – coincidences between personal idiosyncrasies and character qualities – were exceptions to his standard practice of converting

or reducing different characters to reiterations of the 'Irvingness' of Irving.[10] This process had a vampiric quality, turning 'possible' characters into so much nourishment for the personator. This was one reason why it was felt that Irving was the inspiration for Count Dracula in the novel written by Irving's business manager, Bram Stoker. For the duration of his tenure at the Lyceum (1878 to 1899), as the premier West End actor-manager, Irving colonized the theatre both practically and metaphorically (Warren, 2002: 1131–1132).

The market erosion of personage

It is to Irving's credit that he eschewed a narrow pursuit of profits in favour of his aesthetic vision. This vision, given the consistency and determination with which he pursued it, had the nature of a cultural projection – a favourable image of acting as a profession meant for public consumption. With its emphasis on chivalry, refinement and hard work, such a projection was part of a broader hegemonic formation, celebrating the cultural supremacy of aristocratic values. Irving, much like Charles Kean, was unflinchingly Royalist and like Royalty itself, stood publicly aloof from the immediacies of politics (Irving, 1952: 438; 521). Reaching a mass (in the sense of cross-class) audience, Irving's staging of traditional dramas and Shakespearean adaptations afforded the middle and 'respectable' working classes an object lesson in taste and a formula for self-improvement that deferred to a conservative and aristocratic world view (Richards, 2005b). Not surprisingly, given its pre-capitalist nostalgia, Irving's 'vision' was fundamentally incompatible with profit maximization and the relentless pursuit of the bottom line. This emphasis was left to his successors – the syndicates that saw theatre as an investment opportunity – to pursue. Irving's productions were costly, involving a huge cast and staff and expensive costumes and scenery, and rarely turned a profit. Like other actor-managers, such as Beerbohm-Tree, George Alexander and Charles Wyndham, he relied on tours to stay out of the red or break even. But even here, Irving showed an unusual commitment to preserving the integrity of his vision, insisting on taking the entire company and its effects on provincial and even American tours.

At the same time, Irving's belief in the moral efficacy of stage spectacles was qualified, if not contradicted, by his zealous protection of his personage as a star. This contradiction was perhaps not apparent to (or at least not admitted by) Irving because he deemed himself to be the summation of the qualities of chivalry and Royalism represented by the total spectacle. In short, he presented himself as the living crux, as a

knight in anticipation, of theatrical splendour. Leaning outwards from the semantics of the text, his on-stage appearances were framed and grounded by 'live' personal appearances in exclusive locations such as learned societies, universities, prestigious clubs, Masonic events, private Royal performances at Windsor and staged celebrations of Coronations and Jubilees (Tetens, 2003).[11]

These examples demonstrate Irving's determination to maintain his status as a personage of good standing in polite society. His commitment to maintaining the integrity of spectacle (and drawing on the personal charisma this provided) was facilitated by his standing as an actor-manager. Even when at the end of his career, not long before his death, he finally lost control of the Lyceum, he retained the right to tour with a full company, excepting supernumeraries (Hughes and Brown, 1981). This privileged status, shared by other actor-managers, was not the common lot of the profession Irving strove to dignify. The typical form of employment for actors was as freelancers or labourers for hire, though with the pressure to secure market success as a short-term result. Actor-managers such as Irving, stewards of their own reputations, were able (and more likely) to take a longer view of profitability or define success more in aesthetic rather than commercial terms. In doing this, Irving, in particular, seemed especially responsive to the old aristocratic distaste for 'trade' and commercial relationships. As claimed by his 'fulsome' declaration of loyalty (which was never in fact presented to the new King, Edward VII), the theatre's highest vocation was serving King and country, rather than the low pursuit of profitability. This posture of lofty disinterest in venal matters generates a persistent theme that commerce compromises the highest aspirations of theatre. Such perception endures, leading, for example, to Laurence Olivier's insistence that his American commercials for Polaroid never be shown on British television.[12] Yet in the immediate context, Irving's example stood in contrast to the path followed by his near-contemporaries and peers who sought to maximize their earnings and public interest in their legitimate productions by making short appearances or 'turns' in music halls and variety – a crossover pattern that developed in Britain and America. One marker of Irving's disdain for low cultural forms and the sense of himself as personage was his refusal, although in poor financial straits, to participate in this lucrative side-line (Leigh Woods, 2006; Burrows, 2003).

In summary, in the terms I have suggested above, Irving was a leading proponent, but not the only one, of a totemic mode of stardom based on personage which in time would be displaced from dominance by the mode of stardom as a fetish.[13] He preferred to be a monument, rather

than a flexible, character-adjusted performing instrument. Nonetheless, his erratic emphasis on the visual – on the mimic (some thought pantomimic) use of his body – insinuated the possibility of a new basis for stardom based on appearance rather than performance, on being rather than seeming. For this form of stardom to emerge, new relationships of employment and new opportunities for visual display had to develop which finally were realized with the advent of cinema.[14]

The transatlantic transfer

To trace the general lines of this development it is necessary to step back briefly and consider the link between the star system in the English theatre and the development of an American theatrical market. From Colonial times forward, theatre in America was heavily dependent on British theatre for repertoire and leading players. The War of Independence saw the 1774 Continental Congress banning theatrical entertainments, always an anathema to Puritanism, until the end of the hostilities. However, this temporary measure did not prevent rank-and-file British players from finding employment in American stock companies, and in the antebellum period, the majority of professional actors were British (Brown J, 1995). By the early nineteenth century, English stars such as George Frederick Cooke and Edmund Kean were extending their tours as solo performers to major American cities, with the same effects on the stock companies – reduction of repertoire and reduced opportunities for local talent to work – observed in the British theatre. By the second half of the nineteenth century, major actor-managers such as Irving, Beerbohm-Tree and Charles Kean depended on American tours to generate profits – Irving in particular, as already noted, toured with an entire company, which further narrowed employment for local American actors (Williams, 2006; Pritner, 1965b). In the United States, syndicates, known there as 'combinations', became the dominant form of business organization, much as in Britain. Theatrical consolidation continued rapidly in the depression years of the 1870s, with the number of stock companies reducing from 50 to 7 by 1880, subsequently to be replaced by star-led touring combination companies. 'By 1870 . . . the hegemony of the American business class pervaded the theatre . . . Leg shows, dramatic theatre and increasingly minstrelsy worked within the cultural systems of respectability and rationality' (McConachie, 2006: 175).

A similar process was observed in Britain in the same period and was facilitated by transatlantic exchanges of personnel – actors but also

managers and impresarios. For example, Stephen Prince, co-manager of the Park Theatre in New York, was also from 1826 to 1830 the manager of Drury Lane, and regularly hired British talent for his American interests (Hewitt, 1971). The Hallam family, having played a significant role in the development of British theatre, moved to the United States in 1852 and founded the first stable and lasting theatrical companies in New York and Philadelphia (Highfill, 1970). Similarly, leading actors such as London-born Junius Brutus Booth resettled in the United States, and his sons John Wilkes Booth and Edwin Booth became leading stars of the American stage. Edwin Booth, having finally lived down the opprobrium attached to his brother, appeared on the London stage with Irving. The American star Edwin Forrest, a great admirer of Edmund Kean, also played in London, as did famous American actresses such as Amy Roselle.

British, European and American theatre stars became a regular feature on American circuits, where they functioned as brands imparting dignity and 'class' to what was commonly perceived by respectable society as 'low' entertainment. A late-career Sarah Bernhardt received very lucrative engagements designed to add legitimacy to vaudeville and ultimately to film. Other stars such as Maurice Barrymore, Lillie Langtry and Mrs. Campbell undertook similar lucrative engagements. These American developments were matched internally by British stars consenting to appear in variety, an upmarket version of the music hall. For stage actors, the motive for such engagements was primarily economic – they provided significant extra income and, as stripped-down versions of performances in which they had built their reputations, required minimal preparation and effort. On the circuit owners' side, there was the chance to offer top-line attractions and to augment the prestige of their business (Woods, 2006; Burrows, 2003).

Such forays into hitherto déclassé areas of performance, if motivated by commercial opportunism, could not fail to be conditioned by the nature of American society as it emerged in the decades following the War of Independence. American public culture, whatever else was the case in the private settings of the club and home, affirmed that America was an 'open' society. Historical factors such as the absence of a court society and a republican culture based on natural rights worked to ensure that American character formation was more directly reliant on market competition as a mechanism for expressing democratic choice, with social inequality being seen as a 'natural' outcome. This created the paradox noted by de Tocqueville: that if market competition led to the formation of elites, public culture emphasized conformity to the taste of the majority (Mennell, 2007).

These larger processes affected the theatre as an instrument for disseminating an American culture. President Andrew Jackson, the advocate of a new pride in American democratic virtues, saw the theatre as a key site for encouraging national 'sentiment' provided it could be made genteel by a purge of its unrefined and baser elements.[15] This conflict played out in the theatre as a clash between British aristocratic *hauteur* and the expectation, perceived as an acknowledgement of American democracy, that actors were public servants. The violent clashes occasioned by Edmund Kean's refusal to play a Boston engagement and, with even more dire consequences, the Astor Place riots were the more extreme examples of a pervasive populism (Butsch, 1995).[16]

One response to this larger framework of class contestation – itself replaying British conflicts between legitimate and illegitimate drama, conflicts that were to resurface with the development of cinema – was to devise a method of commercial appeasement that would represent travelling stars of the legitimate stage as charismatic individuals in their own right, detached from any invidious connotations of superiority. It will be recalled that Edmund Kean had attempted to promote himself through studied (and when drunk, presumably unstudied) iconoclastic public behaviour. Bernhardt was another particularly zealous self-promoter – hence the nickname 'Sarah Barnum'. But these earlier, starkly ego-centric attempts at creating a persona were limited on a number of levels. For a start, they lacked the persuasive imprimatur of third-party objectivity. A press agent, by staging events that captured press attention and an apparently spontaneous public response, could be more effective than self-promotion.

This strategy was pioneered by Henry E. Abbey, who throughout the 1880s was employed as a press agent for visiting stars such as Sarah Bernhardt, Henry Irving, Lillie Langtry and the singer Madame Patti. Second only to P. T. Barnum, in creating pseudo-events – events constructed to be reported – Abbey specialized in generating publicity for his clients that softened the aura of superiority that attached to them as personages (Collins, 1966). Using press agentry and publicity methods, Abbey turned the star's efforts at self-promotion into a business practice, anticipating the development of the publicity system in early Hollywood (Reichenbach, 1936). Press agentry emerged as a counterpractice within the human-interest story, a form of reporting that played a dominant role in the development of the mass-circulation press; a process that in the United States, compared to in Britain, was more saturated with market populism.[17] But the process of self-promotion also had inherent limitations. As the array of texts and

para-texts – personal appearances on stage and off, newsprint reports, photography and graphic illustrations – proliferated, the compact representation of the subject as a personage began to disperse, posing questions about authenticity, the relationship between public and private life, the relationship between personality and character, being and seeming. Moreover, Victorian celebrity journalism found that as its chosen celebrity was approached, s/he became more rather than less mysterious (Salmon, 1997). This persistent default to the opaque and mysterious was prompted in part by the claimed purpose of celebrity journalism, to reveal the true self of the celebrity. But it was also the result of commercial competition that was based on new revelations and insights to sustain public curiosity and build celebrity storylines (Ponce de Leon, 2001: 104). So, even in its elementary form, press agentry tended to multiply the celebrities' possible selves generating a hypostatic image of the celebrity subject, one in which different selves seemed to be vying for ownership of the person. No longer bracketed as the 'great tragedian' or popular stage star, actors seeking maximal positive coverage began to appear as manifold selves with differing aspects and capacities, which called for management. The transatlantic trade complicated this process, since it meant catering to different sets of cultural expectations. This multiplicity, even at this early stage, was designed to fuel audience speculation and the search for the authentic centre of an unfolding panorama of identities.

A proto-cinema

The development of persona proper is tied up with the transition from the theatre to cinema, from 1895 onwards. But there was a mediating step in this process. As noted above, in the United States and in Britain, stars of the legitimate stage were increasingly accepting engagements to play variety and vaudeville. The traffic in transatlantic exchanges is significant here as a kind of virus that generalized a new mode of performance – the turn, a synoptic performance of scenes from the star's 'greatest hits' signalled a return to the logic of Garrick's 'points', but under more intense conditions of abstraction from the totality of the performance.

A number of writers have noted that developments in staging and lighting on the Victorian stage contributed to an audience interest in pictorial realism that influenced the development of cinema (Vardac, 1950).[18] So, for example, the development of lighting, central to the development of the Victorian theatre of spectacle, became an important

means by which a star such as Irving could isolate his own presence on the stage. Certainly, the potential for silent film to create greater psychological depth, particularly through a tighter focus on nuanced gestural play, meant an intensification of cynosure on leading players, especially if acting became a restrained and eloquent process (Pearson, 1992; Gunning, 1991). Yet it was not simply a matter of discovering new ways of representation released by the technological potential of film. Previous media such as the magic lantern and the comic strip had already sketched out a visual grammar that offered templates for developing shot scaling and framing in film (Lacassin, 1972). Yet the close-up, the paradigmatic example, did not become a standard part of the film toolkit until around 1913, more than a decade after the first motion picture screening. Again, even if it seemed obvious that silent film acting should be a species of mime, the broad gestural style of stage performance persisted because mime was conflated with the low status of pantomime[19] (Burrows, 2003).

In other words, the realization of the technological potential of silent film faced cultural limitations connected to the social cachet of theatre. This cachet gave precedent to the long shot as the filmic equivalent of the proscenium. It also made theatre stars, seeking to exploit a lucrative niche in film, reluctant to adapt to the general limitations of a silent medium. To give one prominent example, Irving's near-contemporary Johnston Forbes-Robertson, like others, saw film as an opportunity for personal marketing. Yet wary of damaging his reputation, he was careful to speak key scenes in full before the camera, thereby underscoring that his stage performance was the 'highest' expression of his art. This practice, recognized by American audiences as mugging, was regarded as a typical flaw of British actors. Forbes-Robertson, immersing his image in an 'inferior' medium, referenced the superior reality of live theatre in order to protect his status as a personage. Ironically, in more spectacular productions, the centrality of the actor's performance tended to be minimized[20] (Buchanan, 2007).

In sum, in the early years of film, from 1895 to 1913, the prevalent array of mimetic capacities would still leave the 'live' appearance as the definitive site of encounter. But even on the legitimate stage, in part as a response to the tendency of spectacle to subtract from the actor's performance, self-presentation was becoming a studied process (as in the case of Irving), aiming to create an idiomatic acting style which worked against standardized templates for projecting personality in character. What came to be called 'personality acting' was furthered by the development of the turn in vaudeville and variety. Live

appearances still provided the fulcrum on which secondary accounts such as newspaper and magazine features, graphic images and still photographs ratified their purchase.[21] The emphasis on personality foreshadowed the development of persona, but it was only with the development of cinema that the persona, as an animated double, could ensure the endurance of a star's apparent stage personality beyond the moment of the performance, providing the spectator with a means of repeating the live experience. The tendency towards personation – for the actor to play the same type of character with idiomatic constancies of performance and when possible, make 'asides' to the audience that drew him or her out of the already thin husk of character – gave consistency to the actor's presence on stage but this was still tied to the moment. When its potential to register 'interiority' was sufficiently developed, the cinema enabled the persona to emerge as a 'double' of the actor.

Pending this reconfiguration of the 'mediated real', the persona inheres as a potential, which to distinguish from persona proper, I have termed an eidolon: a dispersed figural presence that circulates between disparate texts, but does not attain the putative status of a being.[22] A persona proper evokes the actor's live presence in public, a walking (and ultimately talking) image that shares properties, to some degree, with the person of the actor. A verbal account, evidently shares very few – a name, a description, a photograph, a portrait or graphic image, or a three-dimensional statue or bust will share a restricted number of qualities, sufficient to refer to but not present an animate or actual presence. A motion picture image is, even in its two-dimensional and silent form, the highest possible level of sharing.[23] One way to express this is to say that these earlier and thereafter correlative media denote their object, whereas a persona is an exemplification that refers to properties the object already possesses – or, strictly, to the number of pertinent properties that make it an absolute replica or double (Goodman, 1961; Eco, 1979). This is not to say that the audience member or fan necessarily confines his/her attempts to engage with the star's 'persona' to the cinema, but short of attending live appearances, the moving image is the most direct form of mediated engagement, even if in need of supplementation by less direct textual forms.[24]

A moving image has another effect. As it separates the actor's live performance from a record of that performance, it inscribes a material gap between being and seeming which are co-present, if fleeting, in a live performance, where we see the being of the actor as s/he goes about the business of seeming. Given a moving image, and at lesser degree

of detail, a photograph, the viewer is provided with a dual perception, seeing the performer *as* the image in character and seeing *through* the image to the real person (McGinn, 2005: 40–41). One consequence is that the most stereotypical, hence depersonalized, performance can be read for interiority, if the public has the motivation and background information (reliable or unreliable as may be) on the performer. If the confluence of cinematography and the mass press affords the basis for reading the star as a persona, as we shall see in the next chapter, it is the evolution of fan-magazine writing as a discourse that provides a warrant to read the star in character as a variant of an appearance in person.

Americanizing cinema

By the turn of the century, as the motion picture business emerged, the sources of migration to the United States had shifted from the old areas of the British Isles, Germany, Holland and northwestern Europe towards Russia, the Austro-Hungarian empires, the Balkan states and Southern Italy (Gordon, 1964; Hartmann, 1948). An elite coalition of groups of politicians, educators and business leaders and, by origin or by cultural adoption, a largely WASP (White Anglo-Saxon Protestant) middle class launched a moral crusade to impose their 'American' manners on the new strangers in the land (Hartmann, 1948). Historians have documented how the Americanize the Immigrant movement campaigned to have the fledgling industry externally censored and regulated – an effort that, if failing on legal grounds, nonetheless underscored the mood of disapproval emanating from respectable and WASP society (Weinberger, 2012).

As a silent visual medium, able to transcend language barriers, film was uniquely positioned to teach the newly arrived immigrant American mores and customs. Located in cities such as New York and Chicago, which were the primary destination for immigrants, the fledgling industry was a ready target for reform, reviving fears (well rehearsed in the theatre) of cultural debasement and an ethnically inflected class conflict. Even the trade paper *The Moving Picture World* (*MPW*), especially through the editorial and public lecturing efforts of W. Stephen Bush, sought to prevent censorship of an industry which was widely held to be prone to the temptations of pandering to the low-brow tastes of its audiences; audiences that had a substantial new immigrant component (Stromgren, 1988). To give one example of a letter published in the *MPW* – ostensibly written by a suburban exhibitor – suggests that

behind the lofty ideals of cultural uplift lurked a measure of racially driven disgust:

> The audience also stood for one or two high class films without any fuss, although we are sure they didn't understand what they were looking at anymore than they would a Chinese Opera. I would have been more comfortable on board a cattle train than where I sat. There were five hundred smells combined in one. One young lady fainted and had to be carried out of the theatre. I can forgive that all right, as people with sensitive noses should not go slumming. But what is hardest to swallow is that the tastes of this seething mass of human cattle are the tastes that have dominated, or at least set, the standards of American moving pictures (MPW, 1910).

Such a forthright statement of class racism was not unusual (Nashaw, 1993: 174–185). For even sympathetic accounts of the early audiences implicitly endorse the charges of UnAmericanism, agreeing that there was a pressing need for refinement if not censorship. Such urgency was rarely perceived in the case of vaudeville, which included films as part of its entertainment fare. But the main audience for vaudeville was mainly native-born, blue- and white-collar workers who enjoyed better wages and shorter working hours, a labour 'aristocracy', who were morally armed against the perils of debasement by their public embrace of 'all American values' (Merritt, 1976).[25] But the likelihood is that the generality of nickelodeons did not depart from the standards of 'decency' set by vaudeville. Moreover, the two forms of theatre were symbiotic, with short one-reel movies shown as part of vaudeville and vaudeville acts offered as part of nickelodeon shows. In addition, the movies borrowed many of their topics and themes from popular theatre.

Viewed in the round, the fledging film industry faced the same kind of accusations of low quality that were made about the illegitimate theatre, in Britain and in the United States, though class racism was perceived as aggravated by foreign origins and the fact that English, even as a class-specific argot, was not a shared language. The belief in the persuasive power of the cinematic image over word was thought to add an additional danger, leading to imitation and uncheckable emotional arousal. Yet if nickelodeons were stereotyped as nurseries of crime and depravity, this was not borne out by marked differences in content. In an abbreviated form, the movies shared similar themes and topics with the popular stage, with its spectacular effects and melodrama.

In the final analysis, what seemed to be distinctive and lamentable about storefront theatres was not their content but their patrons. In contrast to the typical vaudeville audience, the core audience for the nickelodeon was new immigrant workers, in jobs that were lowly paid and meant longer hours. The moral economy of such an audience drew on old world forms of dress and behaviour that at least in a second generation might become adjusted to American values, in public if not in private life (Gordon, 1964). In this case, the argument could be advanced that nickelodeons were performing a prosocial function, inducting immigrants into the American scene. There is evidence that in the immigrant districts of New York, nickelodeons were closer to community centres than dens of iniquity, sheltering immigrant men, women and children from the less salubrious male-dominated saloons and burlesque shows (Peiss, 1986).

Yet the movement to reform the nickelodeons indulged a readiness to attribute moral degeneracy to new immigrants that conflicted with facts. Right or wrong, the arguments for reform were made by individuals whose social standing as All Americans required an answer if regulation was to be prevented. The preservation of free enterprise and the protection of investments required a response. Within the industry, the most significant response came, ironically, from new-immigrant Jewish exhibitors, many of whom were to become Hollywood moguls. In essence, the efforts to improve the social image of the film trade rested on an imitation of the legitimate theatre. In the period from 1910 to the early 1920s, the film business underwent a process of embourgeoisement, adding an aura of 'class', in the sense of taste and refinement, to what had been denigrated as a 'low' cultural form – a criticism levelled at Vaudeville but with lesser severity. Leading entrepreneurs moved to replace the storefront nickelodeon, the mainstay of the early industry, with the better-appointed and more upmarket 'combination' theatre that offered a mixed program of movies and vaudeville. Ensconced in a purpose-built exhibition site whose architecture and decor had already associated vaudeville with the legitimate theatre, movies eventually became the sole attraction, gaining respectability by association and at much lower admission prices. Eventually through the initiatives of individuals, such as Adolph Zukor and Marcus Loew, 'dream palaces' were built in urban centres to showcase the premier release of feature films of at least two reels' length or more. Features replaced the 'skit' or turn format of early films with lengthier productions, notably and controversially D. W. Griffith's *Birth of a Nation*, that further evoked a kinship with 'serious' stage plays. The vaudeville precedent of hiring

famous stage stars, such as Bernhardt, to establish 'artistic' credibility was also followed and, after an initial reluctance, film stars proper, as opposed to stars and celebrities from other fields making a 'guest' appearance, began to be part of marketing of quality films (Nashaw, 1993). As films became longer and more complex, the presence of the star provided a more immediate point of engagement than the more deliberative contemplation required to understand the plot with only inter-titles to compensate for the loss of dialogue. The development of a more intimate scale of gestures and development of close camerawork, already mentioned, furthered the reliance on the player.[26]

These innovations of the silent film era, leading to the formation of the Hollywood Studio system, are clearly interrelated but for my purposes, of course, the star system is the key development. But rather than proceeding now in the time-honoured manner to consider the professional biography of this or that player, I want to focus on the underlying grammar of stardom and show how Hollywood, particularly through its borrowing from the theatre, came to grips with the discourse of stardom. This means that in creating its own star system, Hollywood had to negotiate a matrix of identity possibilities already preformed in the theatre. For although the real contribution of Hollywood is to fill out the capacity of persona, the means by which this happens is another innovation – the invention of the fan magazine.

5
Writing the Stars

The embourgeoisement of the early American cinema, its drive to acquire an aura of respectability, amounted to a mimicry of theatre – its conventions in respect of genres, styles of performance, the architecture and design of cinemas and, in the best locations, the provision of liveried ushers and attendants. But there was one aspect of theatre that the cinema strove to avoid – the star system. Stage stars might appear in films, but the idea that actors in films might be stars only gained acceptance slowly, and even then was a competitive device that overwhelmed considerable resistance. The Motion Picture Patents Company ([MPPC]; The Trust), formed as a cartel out of the pooling of (especially Edison) patents, viewed film as a standard commodity to be rented to exhibitors at a standard price per foot. Basically a coalition of 'old'-immigration interests, the MPPC was opposed by Independent producers and exhibitors, some of whom were from a new-immigrant background and did their main business with new-immigrant communities, or at least chafed at the Trust's heavy-handed attempts to impose its quantitative monopoly. Some of the early companies within the Trust, notably Biograph and Vitagraph, recognized the importance of quality and sought to brand their films as superior products. But fearing demands for salary increases, this branding did not extend to directors, such as D. W. Griffith, or to leading actors. Recognizing that particular actors increased box-office takings, and faced with an intense audience interest in them, some of the independent companies took the view that an increase in salary costs would be justified by the competitive advantage to be gained over the Trust and rival independent companies. In the period from 1909, a number of exhibitors or producers initiated small-scale efforts to publicize the names of popular players. This trend was pushed to new heights in March 1910; Carl Laemmle of the Independent

Motion Picture Company (IMP; eventually Universal Pictures) revealed that a former Biograph girl, now signed with IMP, was named Florence Lawrence. As part of a publicity stunt, Laemmle took out a full page advertisement in *Motion Picture World* announcing that Lawrence would make a public appearance in order to scotch rumours that she had died in a streetcar accident – rumours that Laemmle himself had started, but ascribed to unscrupulous rivals (DeCordova, 1990: 56–58). Though not quite the first movie star to be named, the dramatic manner in which her name was revealed took her popularity to new heights.[1]

The fan magazine, a new kind of magazine emerging around 1910, also encountered a demand for film favourites to be named. Requests to readers to express their opinions about particular films were outnumbered by letters requesting information about the actors that featured in them. The double movement of naming might be seen as the decisive moment of emergence, the first concrete manifestation of the persona, from the shadowy state, which I have called the eidolon. But in fact the process of identifying stars tended to repeat, albeit within a compressed time span, the entire history of the discourse.[2] The process through which this occurred, though seemingly a matter of increasing concreteness or specificity, was actually a process of increasing abstraction.

Positioning stardom

In writing about the social meaning of stardom and celebrity, two broad approaches have been dominant. The first approach is the biographical narrative: claiming to document the star's life course, it bestows a coherence that the star's professional and private life may lack. This labour of construction, familiar to anyone who composes a curriculum vitae, is often no more sinister than putting the best face on the flux of circumstance. But in the case of the star, it is also supposed to legitimate a claim to wealth and privilege and explain its subject's collective importance. The second approach, often embedded in the first, treats the meaning of a star as emblematic of a specific conjuncture in American popular culture.[3]

Of these two approaches, the biographical and the historical, it is the latter that produces the most convincing delineation of the social meaning of star images. But it is not the approach favoured by Hollywood itself, insofar as this is revealed in fan magazines, where writing about stars tends to be transcendent discourse written after the fact of stardom.[4] Looking back from what you are today, it says, reveals what you have always been. This orientation favours a transhistorical or mythic

style of writing, with personal 'psychological depth' substituting for the minutiae of time and place. All stars, living or dead, past or present, abide in a common space of celebrity, a kind of Valhalla of recorded existence.[5]

The traditional function of fan-magazine writing is to guarantee the coherence of the star as a presence before the reader. Only when given such coherence can the star and the reader keep in touch. No threatening strangeness of cultural background, personal preference or behaviour must disturb the illusion that the process of writing about the star is a 'free' encounter by which the star's true self – or what functions as a true self, the persona – will be revealed.

Compared to the visual staging of star appearances, which is a fluid and complex process, verbal reports and commentary have the qualities of simplicity and definitiveness.[6] Fan-magazine writing, because of its unabashed partisanship, provides the most transparent synoptic site for constructing an authentic representation of the star. For although the spectator is likely to have an intensive experience of the star as a 'living' presence in the context of fiction, it is through fan and celebrity journalism that the promise of the on-screen presence is confirmed (if at all) as an actual as opposed to virtual state of being.[7]

In aiming for a consubstantiation between the star and fans, fan-magazine writing is required to emphasize a fundamental continuity between the concept of the average reader, a normative rather than real entity, and the star as a creative elaboration of the average. This is why, until recent times, stars have been represented as if they were naturally given personalities or gifted amateurs rather than highly prepared professionals. The discourse of stardom declares: I am like you in my general qualities, but unique in the extent to which these qualities are realized in my person (Braudy, 1986).[8] The bond between the reader and the star is a *mimetic contract* based on the mediation of public standards and private behaviour, seeking to align the latter with the former, negotiating between conformity and an acceptable degree of personal licence. Fan-magazine writing must avoid the encouragement of an overly personalized or 'psychotic' attachment on the part of the reader and suppress those details of the star's actual life that conflict with his/her publicly acceptable persona.[9]

If the relationship between stars and fans is a simulated dialogue, is there any variability in the manner in which stars are connected to the realm of the collective as person-based representations? How does this variability affect the relationship of representation between the star and the consumer? If the positioning of stars is historically variable,

does, for example, the persona of Tyrone Power position the spectator in the same way as does the persona of George Clooney (viewed by some as his latter-day incarnation)? Intuitively, the answer seems obvious: no. But to understand this it is necessary to consider how the relationship between stars and fans has varied during different periods of Hollywood's development. So I suggest another approach: looking at the evolution of writing about the stars as a process marked by shifts in the mimetic keying of the star as represented in fan magazines. Such an approach will not produce an analysis of the biography of a particular star – what the John Wayne persona meant in the various phases of his career.[10] Rather, it would focus on how the general relationship between star and fan is defined in specific periods of Hollywood's history, seeking to identify variations in the way stars are represented to society at large and to fans in particular.[11]

In sum, the discursive production of persona within fan magazines is a process of positioning (Davies and Harre, 1990: 43–63). Depending on the specification of *standing for*, the ideal reader is positioned by the star in relation to the realm of collective experience. So another way to read fan-magazine discourse is to ask what particular mode of public being – as personage, person, character or persona – is dominant in the institutional coding of stardom with person in different historical periods.

The star–fan relationship historically has passed through three modes of positioning and, as we shall see subsequently, has entered a fourth. To approach this it is necessary to realize that the term subject itself has three modalities or positions of referring to the individual:

1. The **cultural subject**: furnished by typecasting and occupational selection, but pre-existing in the pro-filmic realm antecedent to filmic representation. The dominant framing of the star is *symbolic*, conforming to (or, if not, evaluated in the light of) prevalent expectations concerning race or ethnicity, gender, sexual orientation and class.
2. The **grammatical subject**: the subject doing or being acted upon within the represented realm. The dominant framing of the star is *hypo-iconic*.
3. The **logical subject**: the individual (or thing) as a virtual presence to whom it is feasible to attach intentions and purpose. The dominant framing of the star is *indexical*, registering reactions, physical and emotional, to events.

These subjects are produced by different ways of reading and writing about stardom: *personage* corresponding to the cultural subject, *character*

corresponding to the grammatical subject and *persona* corresponding to the logical subject. At any time, the three aspects of the subject coexist as ways of writing or talking about the star as a topic and one or other may enjoy a greater or lesser degree of salience in a body of writing. In other words, there is a patterning of articulation between modes of the subject.

This patterning can vary significantly during performance because the actor is at once a character within the dramatically represented world, a human being of some sort in the extra-dramatic world and a material body. So s/he can shift the keying of the subject in the course of the performance, for example, by stepping momentarily out of character to ask the audience to stop talking or simply fail to deliver the lines or business required. The audience likewise can shift its regard from the character to the actor's physical appearance or to his/her existence outside of the performance.[12]

When viewing the actor in character, audiences identify primarily with the cultural subject, with the grammatical and logical subject set aside in the interests of suspending disbelief. In the commercial speech of fan-magazine writing, by contrast, the emphasis is on presenting the actor as a grammatical subject, because this draws the reader into an individual and intimate as opposed to a categorical relationship, with the star as a narrative agent.[13] The business of persona cultivation requires the manipulation of the subject's three aspects in order to emphasize the grammatical subject as a cultural force of great importance and significance.[14]

A small history of synoptic binding

Any text or body of texts is governed by a recurrent pattern of meaning-making or a *register* that regulates the relationship of the text to its environment, even as it reveals that environment in a particular form. A register, in short, governs the transitivity of a text, its mode of connecting to the world to which it refers. A body of texts that share common linguistic features can be said to operate within the same register. The components of a register are:

Field: The representation of specific kinds of actors, subjects and themes, with ascribed purposes, intentions and causes.
Tenor: The kinds of interactions and forms of participation between participants in the speech (or equivalent) situation that are understood as given; the definition of the participants' rights and obligations, explicit or implicit.

Mode: The channels through which the materials of expression func-
tion – spoken, written, scripted, unscripted, live or recorded – and
the genre of the materials of expression: narrative, exposition, argu-
ment, phatic, didactic, hortatory and so on (Halliday and Hasan,
1992: 21–30, 294; Halliday and Matthiessen, 1994: 30ff). For most of
Hollywood stardom's history, the mode has remained under source
control, though this is changing with the incursion of the Internet
and the paparazzi.[15]

In what follows, my concern is the star's persona – an interactively real,
out-of-character identity that regulates the star–fan interaction – so my
focus will be on the representation of the field.[16] In this element of the
register, the rules of *standing for* the audience, of being popular, are for-
mulated.[17] This is so because the mode and tenor functions of discourse
are routinely fixed in advance by the source, and, barring accidents,
operate as the given background framing of the new or 'fresh' talk.[18]

Ongoing action is vested in the aspect of the field that constructs an
invitation to the reader to share a common frame of reference, con-
sisting of a discursive positioning of the participants that governs their
interaction. As I construe positioning it is part of the larger function of
transitivity, of the relationship between the elements of a text and the
larger context to which it refers (Halliday and Hasan, 1992). The nature
of transitivity is very complicated in the case of visual images. It is here
that verbal texts have a paramount role in signalling a synopsis of which
kind of subject governs the transitivity of the text and provides its prin-
ciple of coherence. Even the simplest element of analysis – the clause –
will show a variation in degree to which of these states of the subject
becomes the primary crux of transitivity. Likewise, a performance con-
tains similar dimensions of the subject, but these are inseparable from
aspects of the actor as a material sign.[19]

Building and sustaining a persona involves the selection of words and
images that fix the central features of the relationship between the star
and the general public. It is here that assumptions are advanced about
the participants' identities. These assumptions mark the participants as
involved in a specific kind of relationship, with its own emergent narra-
tive and more or less explicitly defined positions in that narrative. The
typical question (and the question of typicality) is, 'in what capacity as a
signifier of identity does the star refer to the context of culture in which
s/he is embedded; a context that is selectively manifested through the
persona of the star?' So long as fan-magazine discourse is fixed in terms
of its interactive infrastructure (tenor and mode), its routine latitude of

variation – routine, if it is to stay within the parameters of its established register – will depend on the way the three aspects of subject are balanced as components of the field.

In fan magazines, the positioning process is centred on the star or celebrity as a sign standing for a state of the world in some respect – typically, humanity as epitomized by American democracy, by Hollywood as a culturally significant place or by the star as a charismatic individual. As a sign form, the persona can have a collective–symbolic, organizational–iconic or individual–indexical context.

Schematically, the discourse of stardom has passed through three modes of positioning or synoptic binding:[20]

Anagraphic positioning or written by category, in which the formation of the persona of the star is dominated by the type relevance of personality as character. In this relationship the star is not unique but exemplary: a kind of human being defined by a socially recognized set of tastes and cultural dispositions. In early stardom the star positions the readers through stereotypes: regardless of the fact that the stars are actors, their persona is readily or facilely perceived in accordance with type and to that extent is a signal of the type.

Biographic positioning or written by exemplars, in which the persona of the star becomes a unique individual – still related to a social type but constituting a superlative rendition of the type's core features. In the Studio period (from the early twenties to the late forties) stars were positioned as prototypes. There was a Bette Davis type in the external world, but there was only one Bette Davis that could fulfil its essential features.

Autographic positioning or written by personalities, in which stars are *monotypes*, categories with a membership of one. Persona ceases to refer to a consistent type of person, becoming a polyvalent performance. The stars no longer have a single persona but a portfolio of personae based on presenting themselves as professional performers with a diversity of roles – as actors, models, spokespersons for causes, entrepreneurs in fashion and beauty products, authors, and socialites of Café society. In late stardom, atypicality predominates.

These modes of positioning correspond, respectively, to different economies of reference in relation to type and different types of sign relationship. With anagraphic positioning, the symbol is predominant; with

biographic, the icon; and with autographic, the index. No position, however, is "purely" symbolic, iconic or indexical.

The relationship between these positions or schemes of prominence comprises the synoptic economy of fan writing within each epoch, pointing the audience towards certain kinds of values and beliefs and aligning the stars to these values and beliefs. These modes are also expressions of the degree of social distance exercised by the star in representing the popular: what kind of authority does the star claim (usually implied rather than stated) for his/her occupancy of the public stage? What standards or norms are assumed to be in force? What dimensions of the self are claimed to be relevant to the formation of the persona? What is deemed private, and what is public?

To make these points, I will focus on *Photoplay*, the most prestigious of the fan magazines and the one most identified with industry interests and a positive approach to stardom. *Photoplay* began publication in 1911 and for several years, until James R. Quirk became owner and then editor in 1917, followed the format of the earliest 'pre-studio' magazines such as *Movie Picture Story* magazine.[21] These early magazines consisted of fictional pieces with a motion picture setting and theme, which were soon supplemented by short 'novelizations' of movie scenarios and articles that addressed the interests of fans in the technical and 'professional' aspects of motion picture making.

Under Quirk's editorship, *Photoplay* established itself as the pre-eminent outlet for national advertising and consumerism. If stars were sought by advertisers to pitch commodities, it followed that they should be named and given concrete personalities. The stars came down to earth, as Thorp (1939) put it, but only through the foregrounding of 'personality' in the star–fan relationship. Although the scandals of the early twenties and the onset of the Depression muted the emphasis on glamour and affluence, the trend was not towards de- but re-glamorization (Fuller, 2001). These developments saw the end of stardom's anagraphic phase of stardom and the development of the biographic phase.

The idea of constructing the 'inner' life of the star did not originate with Quirk, though he made this an industry norm for fan writing. Through a succession of protégé editors, starting with Kathryn Dougherty and continuing after the acquisition of *Photoplay* in 1940 by Mcfadden Publications, the Quirk approach covered the Golden Age of Hollywood, a coherence ensured in part by the fact that fan-magazine writers were a small and close-knit group of mainly female writers (Cotter, 1939).

From the 1940s onwards, seasoned industry professionals who had often acted as quasi-official press agents for the subjects of their columns – such as Adela Rogers St John, Ruth Waterbury (herself editor of *Photoplay* in the 1940s) and Gladys Hall – were increasingly supplemented by society gossip writers, the likes of Louella Parsons and Sheilah Graham, and socialites such as Cornelius Vanderbilt. In an effort to accommodate the factual decline of the studio system, writing about the stars became merged with writing about Café society, with Hollywood no longer seen as a company town but as one location on the social orbit of the playboy, fashion maven and show business celebrity. With this steady transition, fan-magazine writing began the process of evolution away from being a sequestered Hollywood activity, preoccupied with protecting the human capital investments of the Studio cartel.

Between these broad limits is the era of biographic positioning. This era – the late 1920s to the 1960s (the Golden Age of Hollywood) – is by far the longest phase and is equated in popular perception with stardom per se. When people write or say today that stardom isn't what it used to be, it is generally this period they have in mind.

The new autographic representation of stardom developed as a response to the decline of the Studio system, which saw the end of the corporate husbandry of stars. This response is evident in *Photoplay,* as a rear-guard action to adapt film stardom to new conditions of mass representation – the need to accommodate a younger reader (the female teenager replacing the suburban housewife) and, relatedly, the rise of hybrid forms of film stardom. Movie stars such as Elizabeth Taylor whose representational status veered between fashion plate mannequin and film star, and 'teen music idols' such as Elvis Presley and Fabian – crossover performers within multimedia formats – demanded a more abstract form of persona to feed an increasingly synergized market. A more intensive application of the physiognomic standard, directly conflating appearance and demeanour with the inner 'soul', sustained a new concept of performance as a set of appearances coordinated to the serial marketing of product in a variety of windows (Griffith, 1971: xvii–xxxii). Although not alone in reflecting these developments and perhaps less able to adapt than its rivals, *Photoplay* served as a transitional object in the forging of the new conditions of stardom. It also gave an early signal of the shift to generalized celebrity that was marked by the publication of *People Magazine* in 1972 – *Photoplay* itself mutated into *US* in 1976.

Parsing stardom

Anagraphic positioning

Prior to 1907, slightly more than a decade after the invention of cinema, the specific contribution of the film 'actor' to the 'show' was seldom remarked upon, outside of isolated comments on a poor performance, usually linked to an overly expansive gestural style. Actors in film were not perceived as acting, and the term 'posing' was the accepted designation of what an actor did – implying both passivity and the need for restraint. Film 'posing' was a low-status activity, deserving only of routine levels of pay. The engagement of famous stage stars underscored the view that movie acting was not acting proper which could produce its own stars.[22] Reflecting this, fan-magazine writing began by assuming that film actors are consubstantial with the type of character they played so that they behaved rather than acted. Accordingly, the response to a growing public interest in the 'real' individual behind the type took the form of constructing a new type as person within the discourse of acting – the picture personality that was closer to a technician, absorbed in the process of film performance, than to a star (DeCordova, 1990: 35–36, 86–98). In order for picture personalities to emerge, the actor had to be named and consonant with the process of professional or stage naming in general; the naming of picture personalities implied some predictable association between a set of personal traits and screen appearance. Unless such traits were fixed, they could not function as signals of marketability. At this phase, given anti-Semitism and the movement to 'Americanize' the new immigrant, professional naming was Anglocentric (and would remain so for decades to come). For the film actors themselves, a British-sounding stage name added a touch of 'class' which could defuse the charge of lacking culture. Personal names were, in short, the brand names of a type. Obvious exceptions to the Anglocentric rule such as Theda Bara, Alla Nazimova or Rudolph Valentino depended on it for their exoticism and besides were tightly connected to types: the vamp, Salome and the Sheik.

Until 1913, the greater part of knowledge made publicly available about a player was restricted to commentary on his/her personality as a professionally deployed resource in the service of character. After this date, trade magazines and nascent fan publications began to steadily increase the amount and depth of personal information included in their copy. This development has been identified as reflecting a growth in a female readership bent on adulation rather than an appreciation of the technical and organizational aspects of motion picture making and acting. The commercial efficacy of this kind of writing in selling

advertising space began to push these other once-dominant themes into the background. Within the space of three or four years the motion picture personality, in which the film actor is understood as a kind of technician specializing in a type, was challenged by the imperatives of building a persona. This meant extending the radius of identity beyond the fictive engagement with character and so inaugurated a search for the 'real' person, actually the persona, of the actor. (DeCordova, 1990: 86–98).

The evolutionary development from anonymous person through to type-governed personality and then persona was not accomplished once and for all. The sex and drug scandals of the early 1920s prompted the industry to adopt self-censorship. Will Hays, the Postmaster General in the Harding Administration, was appointed as 'Czar' or Head of the Motion Picture Producers and Distributors of America (MPPDA). With this totemic personage, symbolizing overall conformity to conservative and WASP values, in charge of censorship, the Studios also tightened control over stars' off-screen behaviour through the introduction of morality clauses into standard contracts. Semantically, this meant that the elaboration of persona slipped back under the rubric of type – in person the stars were morally sound and hard-working professionals, as, for example, W. S. Hart was to explain (Fine, 1997).

If coverage in the general press was sensational, *Photoplay* virtually ignored the key scandals – Roscoe Arbuckle's alleged manslaughter of Virginia Rappe, the unsolved murder of William Desmond Taylor and Wallace Reid's death from drug use. It might be assumed that scandals would spell the end of a facile identification of the actor with his/her on-screen type. But the opposite interpretation seems to be in order. The development of morality clauses in itself proves the strength of the industry commitment to typing: the actor must live up to the type or, in the case of playing a morally suspect type, emphasize his/her off-screen normality. Thus despite Reid's drug-related death, a tribute 'from a friend', Herbert Howe, reclaimed Reid as an exemplar of American youth and treated his struggle with addiction as the 'greatest role' he ever played. *Photoplay* editor Quirk, in an open letter to Will Hays, acknowledged the need for a moral clean-up, but only of certain individuals because 'side by side with the men of highest principles you are going to find the scum of the earth'. One candidate for the epithet 'scum' is actually a victim of injustice. In his 'Speaking of Pictures' editorial of August 1925, Quirk made a plea for the rehabilitation of Arbuckle, citing Arbuckle's acquittal in a third trial, his record of 'clean' picture making and his probity in not seeking the shelter of bankruptcy. Readers who cherish

the spirit of fair play embodied in the Constitution – there must be few who would admit they did not – and believe in the teachings of the Man of Jerusalem, were urged to write to Will Hays direct (Quirk, 1922; 1925).

Outside of these specific interventions, the possibility of developing a persona remains firmly connected to the notion of personality as an expression of type. One general indication is to be found at the level of the persistence of format; until at least the onset of the 1930s, articles devoted to the real 'personalities' of stars and would-be stars were in the minority. Features such as short stories with a motion picture setting, reviews of current releases and new releases, articles concerning practical motion picture criticism, fashion, beauty and 'marital' hints, and state-of-the-art or industry articles produced a largely impersonal context of reference. The regular gossip feature in *Photoplay*, written by Quirk under the pseudonym Cal York (California/New York), was closer to a traditional society page applied to stars than to gossip, in the sense of intimate revelations concerning a third party.

The print media equivalents of the personal appearance, such as display advertisements and rotogravure, certainly appeared in the early teens and provided evidence of an increasing focus on the star. But at this time these formats did not constitute a direct address from the private personality of the star so much as an identification of the star in a functional capacity, for example, as a celebrity endorsing a product in an advertising format that is primarily product-centred, as an example of a Society portrait, or as in photo-essay ('X seen in the beautiful home furnished after the fashion of Y').[23]

A more direct example of anagraphic positioning is provided by articles that focused on the leading stars in Hollywood, purporting to introduce readers to the 'real' individuals, but in fact depicting the star through the framing of social type. A typical example is the article 'Mary Pickford: Herself and Her Career' by Julian Johnson (1915). Written when Pickford was 22 years old and had just launched on her career as the 'World's Sweetheart', the first instalment of Pickford's 'biography' is framed by an introductory poem, 'The Garden of Eyes'. This brief encomium in one stroke connects its subject with a high cultural form, 'poetry', and affirms a deep-rootedness in the popular imagination:

Mary comes and Mary goes\On the screen in countless parts\
But the little Pickford knows\She is planted in our hearts.

The 'baser' forms of sexual attraction dissolved in a refined poetic swoon; the following text is free to describe the nature of the Pickford mystique.

Mary is 'not so much a famous individual as a symbol whose very name, in any land, is a personification of the thing itself'. Like Maxim typifies the machine gun, Stephenson the steam engine or Herbert Spencer synthetic philosophy, Miss Pickford typifies 'the great new art world of living shadows' (Johnson, 1915: 53). Other great actresses of the age, such as Sarah Bernhardt, are worthy of respect, but they lack Pickford's soul, her deep imaginative connection with millions of motion fans everywhere.

The fame of this 'shy, quiet, sweet girl whose glory is greater than any queen's; and whose kind and gentle eyes are twin sceptres over an empire wider than Napoleon's' is beyond question – as the box office shows. Her appeal is beyond rational analysis: other actors have enjoyed the same 'tremendous multiplication' of the self afforded by the motion picture, but none have become a 'universal favourite'. If her fame rests on her personality, this remains a mystery none has fathomed.

The author prefers not to add to the speculation, even though he alludes to a veritable flood of letters – 'some curious, some quite impertinent, some a bit sad, others wholly legitimate and respectful' – sent to The Answer Man, a regular readers' questions feature. That such a 'congestation of interrogative intimacies' – in itself an archly distancing formulation – is set aside defines what can be discussed with decorum. One probable limit is the perception that such 'interrogative intimacies' are unmanly – arising from a disturbingly 'feminine' interest in the star. The familiar contrast of the time between the fan as a rational admirer – concerned with objective criteria of performance, as typified by the male sports fan – and the fan as an emotional adherent typified by female followers of matinee idols is an obvious subtext that informs the writer's sense of what is proper and improper interest in the star (Fuller, 2001).

Nonetheless, for all its reticence, the self-declared purpose of the article is to tell the 'truth' about Pickford. The show of intimacy is, paradoxically, a phenomenon of absence – the actress is only seen through the eyes of others, and the text of revelation remains impersonal and in the third person. This is because the star's so-called 'personal' self, present but not directly defined, is never less than categorical and governed by the conventions of type. The person she is, is related to her ancestry, aristocratic, of pure Irish strain, but not disloyal to Anglo-Saxon hopes and traditions; her education, private, but productive of a remarkably cultured young woman; and her profession, her natural talent finding an early outlet in the theatre. The manner of revelation is steadfastly typal – Pickford is an instance, luminous to be sure, of respectable middle-class America, despite her Canadian birth and humble origin. She is

not so much a self-made as, given her 'pedigree', a self-recovered person of culture.

This keying of reference secures a double identification. First, the writer is placed on the same level with the reader, as a distant admirer; and, second, the personality of the star becomes the immediate manifestation of social structure and hence its alibi. If you love Pickford, then you must accept that her background is a productive form of inequality, much like her success as a star.

The notion of licensed withdrawal (Goffman, 1979) evident in this 'biography' is in itself a reflection of type expectations related to respectability and superior class standing – women are the 'retiring' sex. But even allowing for a certain degree of masculine public breeziness, the same sequestration of individual particulars behind type is evident even in extroverted stars. In this regard it is useful to consider Mary Pickford's husband-to-be, Douglas Fairbanks, who by 1915 was already a star of a similar magnitude.

From November 1917 to June 1918, Fairbanks addressed *Photoplay* readers in a feature, 'Douglas Fairbanks' Own Page' (DFOP) (Fairbanks, 1917). These pages were ghostwritten by a member of Fairbanks' retinue (also the likely author of a series of self-improvement books for boys sold under Fairbanks' name). Each article was headed by a personal logo – a photograph of Fairbanks, bent over a typewriter in a 'Safari'-type setting, suggesting a momentary pause from the rigorous demands of location shooting or high adventure. The purpose of 'DFOP' was, like the self-improvement books and the typical Fairbanks production, to display Fairbanks' own version of robust masculinity, providing wisdom and insight on the ways of manhood for, principally, young male readers.

The first DFOP opens with a prologue in reported speech in which Fairbanks describes the Editor as instructing him to write 'any little thing you happen to think about'. This rather open brief turns out to be quite a challenge ('no film play has ever given me the mental exercise this job did'), causing sleepless nights despite long days of hard labour on location in Wyoming. Ever the man of action, Fairbanks decides his agenda will be to provide insights on getting into 'my' profession, restricting the discussion of his own 'history' to aspects that will serve this purpose. The tone of this article, as with all, is breezy and chatty, consonant with the parameters of the Fairbanks persona ('Mr Pep') – boyish, exuberant, optimistic and irreverent, full of derring-do.[24] Unlike the Pickford text, and because it is framed as a personal address to the reader, this text is littered with adverbs of stance – *surely, seriously* and *personally* – as in 'Personally, I have never tasted liquor of any sort.' – that suggest the

direct presence of the star before the reader. Such stance qualifiers are consistent with a performative address in which the logical subject – the 'I' who is saying, and doing by saying – is prioritized over what is said or reported as done. But they are deceptive because the breezy informal style does not reveal anything personal about Fairbanks beyond what he is conventionally understood to be as a cultural subject or type: a WASP (despite his part-Jewish background) in the rugged, outdoor mould of Teddy Roosevelt.

This points to a general feature of all the articles. The tone of hyperbolic banter, although meant to impress the reader with Doug's 'down-to-earth, at home in the saddle but not at a desk' personality, only serves to install a third-person framing that maintains the social distance between the implied reader and the star. Fairbanks has no intention of taking himself seriously:

> So we'll now cut back to the boyhood of our hero (using this appellation only as a euphonious figure of speech).

But neither should the reader. Forthcoming 'personal' revelations are governed by decorum rather than authenticity. This is apparent as Doug warms to his assignment – the mechanics of getting into the business. The reader might expect to read how it is done but what he hears is that Fairbanks' success is the outcome of a long immersion in theatrical culture. True, he did not come from a theatrical family, but his father, a lawyer, had a knowledge of drama that few professionals can claim. From the time he could eat, Fairbanks was fed on Shakespeare. The 'Greats' of the Theatre (such as Edwin Booth and Stuart Robson) were regular attendees at his family home, and their advice – to learn fencing, painting and the French language – was acted upon. To what degree of success, modesty forbids him to proclaim. The reader, who is meant to bond with Fairbanks' nervousness about his assignment, suddenly finds a social and cultural gulp yawning. It is not a matter of simply summoning up the nerve to seize the moment but of undergoing a lengthy and rather elitist cultural preparation.

In the following DFOP, the reader learns that for all his exclusive social and cultural capital – resources beyond the average reader – Fairbanks' path to the stage was 'devious'. He faced obstacles and needed a strong will.[25] His parents opposed his interest in the stage and his abilities were not recognized by his teachers. His academic performance at the Colorado School of Mines and then at Harvard was not outstanding, nor was 'Mr Pep' a great athlete. His first stage break, the role of Laertes

in a presentation of Hamlet in Duluth, Minnesota, was a matter of luck when the actor cast for the part was arrested. Ten long years were to elapse before his Broadway debut.

Even when Fairbanks recognizes his own part in his success, it is owed to a social obligation imposed by his mother: a promise to avoid liquor of any kind. His fame likewise rests on the principle 'a healthy mind in a healthy body'; a Latin tag that evokes an Ivy League ethos.

The emphasis on impersonal forces or on personal behaviour moulded by social obligations is re-enforced in succeeding pages. Luck, the ultimate indication of the individual's lack of control, is re-emphasized as a major force in his success. Observations on the Christmas Spirit, the War Effort and advice on decorum and mental hygiene by far exceed references to the person. Paradoxically, these 'own pages' read more like a public sermon on respectability and Americanism. Fairbanks is a personage in accord with notions of his time – a moral character, one who stands for a group and as an individual is governed by its social code.

The reliance on third-person reference is also marked in 'Charles Chaplin's Story', an apparent first-person narrative that begins with a disavowal of the central purpose of biography: 'Actors trying to write autobiographies are like girls trying to make fudge. They use up a lot of good material. . . . and don't accomplish much. Like fudge the story of a fellow's life ought to be reserved for his immediate relations'.[26] This opening trope is underscored by the use of cartoons that place Charlie *as character* in scenes ostensibly from the early life of Chaplin as a private individual. When he is frankly presented as a private person, it as a businessman and entrepreneur, even when the topic is marriage.[27]

Evident in the representation of three of early cinema's most popular stars, this tendency to construct the persona anagraphically – to refer to the self as a token of a transindividual category – is a common feature of early fan discourse. In early stardom, the tendency is to construct the persona of the star through symbols tied to social conventions. Essence is not in personal details but in social standing.[28] Up until the late 1920s it was routine to make symbolic connections, especially of a lofty or cosmic significance. W. S. Hart's middle name is Shakespeare, stars are versified as the seasons or as literal heavenly bodies and actors are explicitly identified as symbols.[29] But there are also more proximate causes that underlie anagraphy.

In early cinema, the absence of the voice, a primary ingredient for reading personality, meant that the spectator was reliant on such narrative surrogates as mood music and intertitles, which were strongly keyed to character type, action and mood rather than fastidious psychological

content. External markers such as dress codes and bodily comportment were also deployed to ensure that behaviour was keyed to character through clear-cut dichotomies, such as bad people wearing black and so on. Given the absence of recorded speech, 'by-play' – the production of arresting gestural detail – became the means through which motion picture players competed for popular favour. By-play, as Henry Irving had already demonstrated, had the potential to undermine typing, by abstracting to the individual qua individual. It is not accidental that a distinctive appearance and manner is the mark of the early stars, for example, Charles Chaplin, Douglas Fairbanks, Lillian Gish. Looking like a character is an important but only partial form of identification, leaning towards the supplement of speech. This supplement is what fan writing intends to supply. The absence of the actor's voice, at once a deeply personal and a categorical property, accounts for the foregrounding of type in appearance, behaviour and name.[30] But these factors alone will not account for the prevalence of typing in the public representation of the stars' private life. The emphasis on anagraphic representation was also part of an effort to establish the social credentials of Hollywood itself – as a new branch of the stage and, more insistently than the latter, a presence in the national realm of fame and prestige.

The historically low standing of acting as a profession was compounded in the case of Hollywood. First, whilst the rewards were great, the actual skills involved were associated with low cultural forms, for example, vaudeville, the circus and popular melodrama – even King of Hollywood Douglas Fairbanks was primarily an acrobat on screen – or, worse, were not perceived as a product of training or craft but of 'being oneself'. One response to this situation is found in the defensive reverence accorded to stage actors, even after the realization that film acting was a practice with its own demands and skills. In *Photoplay*, stage actor Theodore Roberts is dubbed the Grand Duke of Hollywood, for bringing his prestige and acting ability to the movies and proving that the days have passed when youth and beauty were the only qualities required of the screen actor (*Photoplay*, September 1915: 38).[31] Similarly, Geraldine Farrar, introduced in the following issue, is said by no less a personage than Marconi, the Wonder of Wireless, to be bringing 'the biggest brain of any woman I have ever met' along with her energy and talent to the new industry (*Photoplay*, November 1915: 104).[32]

This perception of the low-level skill (or of the 'low' content of the skills required) was also related to a social perception shared by fans and critics alike, though with a varying degree of approval, that the individuals who succeeded in the new occupational field need not be

highly trained, well-educated or of the highest social or moral standing. This was an image that the emerging discourse of fan magazines, even before the events of the Arbuckle affair, was concerned to correct. But the process of correction was inherently unstable, since part of the purpose of stardom was to generate excitement both on- and off-screen. Even if the stars led blameless private lives (and many did), the protective emphasis on the discipline of professional existence – the need for healthy recreation and early nights in order to be ready and in good shape for the camera – conflicted with images of sexual adventurousness and hedonism projected on screen and with the glamour promoted through publicity (DeCordova, 1990: 124–138).

At the same time, the moral judgement of the 'respectable' middle class had an objective correlate in the industry's path of development. If we consider the period before the consolidation of the Los Angeles film-making community – always a matter of occupational rather than geographical identity – the earliest film-making in the area was literally closer to a travelling circus troupe than a settled industrial activity with an identifiable address. Physical marginality was equated with social marginality, even after the geographic stabilization that came with the formation of studios. As previously noted, some of the key figures in the industry were of Jewish, new-immigrant origins. The higher circles of Los Angeles, a remarkable concentration of WASP culture on all levels, were closed to these early entrepreneurs because of anti-Semitism. Individuals such as Cecil B. DeMille, a passable WASP, played the role of go-betweens, representatives with the requisite cultural capital to open the doors to the local circles of influence. Likewise, stars such as Fairbanks and Pickford were actively presented as the 'Royalty' of Beverly Hills, providing (despite Fairbanks' own Jewish origins) an aura of Anglo-Saxon legitimacy to a largely Jewish enterprise (Vance, 2008: 65ff). The cultivation of an aristocratic lifestyle – the Fairbanks' mansion, Pickfair, providing a setting in which stars and high society could commingle – became a distinguishing characteristic of early stars. Notable marriages by Gloria Swanson to the Marquis de la Falaise de la Coudray, or Joan Crawford to Douglas Fairbanks Jnr, heir to the Fairbanks aura, were evidence of the fusion of 'old' and new fame in a mutually beneficial exchange of symbolic and financial capital (Williams, 1946: 330–349; Starr, 1986).

The blurring of the line between the early stars and lesser nobility was a function of a general social equation.[33] It provided a loose but socially serviceable parallel between those who are noble by birth and those who become famous on the basis of the cultivation of their natural endowments. A privileged background did not necessarily make a

gentleman, any more than humble origins guaranteed a clod. As long as stars were represented as being famous for being themselves they constituted a democratic form of aristocracy; a powerless elite, but an elite nonetheless. Through marrying stars, aristocrats acquired an unearned popularity and the not-inconsiderable benefit of being seen as attractive in themselves, outside the trappings of birthright. Stardom, like aristocratic standing, was at base an arbitrary status associated with luck. It was one thing to be lucky, but a better thing to ratify luck as a just dessert. For early stars, such liaisons added glamour but also promoted the idea of a natural gentleman or lady – an individual who through self-cultivation and the acquisition of taste became a 'noble' example of his/her type, its platonic realization.[34]

Biographic positioning

By the late twenties and early thirties the stars were perceived as 'coming down to earth', a democratic style that remained pre-eminent until the end of the Studio period in the late forties. Since these decades represent the high point of Hollywood's engagement with a mass audience, the period in which Studio control over publicity and influence over fan-magazine content was greatest, and when fan-magazine circulation was highest, it is reasonable to see biographic positioning as stardom *proper* (Gabler, 1995; Goodman, 1961). The perception of a disenchantment of stardom did not occur because the stars in 'real' life became less glamorous, or, indeed, Studio efforts notwithstanding, because star earnings were seriously curtailed. Rather, it was a change in the way stars were represented. This change was tactically dictated by the onset of mass unemployment, which served to increase the negative associations with hedonism that were the legacy of the sex scandals of the early twenties.[35] The introduction of sound, fully effective by the end of the twenties, was an important precondition. For as the addition of the voice could elaborate characters' supposed personal qualities with a greater degree of specificity, so did the actor's supposed off-screen personal qualities require a compensatory elaboration.

In anagraphic positioning, the distinction between the star's persona and type was for the most part unremarked upon. Evidently, 'old' stars like Chaplin or Fairbanks had their 'foibles', but these were not connected to a 'depth' psychology. As the notion that stars are legible in the characters they play is called into question, the star's 'true self' emerges as a quality to be uncovered by the removal of 'tired' conventions. Such conventions, once the crux of transparent understanding, are now seen as impediments to the fan's desire for a closer and more intimate

involvement.[36] A demand emerges for a more nuanced treatment of persona to foster the inference that the screen image is a kind of hieroglyph of an underlying 'real' self. Personality, only poorly signalled by type, becomes an enigma that must be resolved. When this happens, personal details become a competitive device designed to draw the reader more intimately into the physical presence of the star.

Given the establishment of stars as public figures, the new emphasis on their 'private' lives as a relevant sphere of information meant that there could be no return to privacy. Rather, a simulation of private life must be prepared for purposes of promotion and publicity. Whilst fan writing took this task of glamorizing normality as central, the mass press was eager to seize on sensation. What was once a uniform field of representation now became bifurcated between officially sanctioned sources supplying saccharine publicity and potentially debunking coverage in the mass press (DeCordova, 1990: 124–138). This contradiction would eventually rupture the framework of biography.

At a more immediate level, competition from newcomers required that the recent past be treated as the dead hand of tradition. Recalling Oscar Wilde's epigram that being too modern is the quickest way to become old-fashioned, the first-generation stars – who had established a niche in 'high' society and personal monopolies over specific types– were regarded as passé, outmoded by the introduction of sound and rendered dull through overexposure. Even *Photoplay*, the most conservative of the fan magazines, declared a second dawn in the movies, heralded by a new wave of stars (Gelman, 1972: 112).

Fairbanks, once the epitome of the film-making establishment and President of the recently founded Academy of Motion Picture Arts and Sciences, was sarcastically pilloried as an 'out of date' blusterer. 'Sir Douglas', with 'goodly squire Conrad Nagel' seemed like ancient fools in the way of progress when they opposed the trend for actors to accept employment in national advertising.[37] The 'old' lights in the firmament found the development of a more 'modern' persona difficult if not impossible. An ageing Pickford, for example, found it difficult to succeed in roles that did not replay her 'Little Mary' persona, in itself increasingly seen as anachronism, drawing on Victorian ideals of pure womanhood. The term 'legends' was now unblushingly applied to stars of little more than a decade earlier. But this was more an announcement of a 'passing' than an act of living reverence.

Larger changes in the cultural understanding of personality and gender such as the emergence of the 'new woman' – deployed opportunistically to show that the stars are in touch with popular experience – established

a 'creative' edge, but the direction of the deployment and its underlying logic were latent in the star system. The rhetoric of 'revitalization' did not, however, mean that the process of typing was abandoned. Rather, the concept of type was now elaborated, so that it could encompass 'interior' values such as 'spirit' and 'sensibility' – a development consistent with a trend in American society at large. The 'old' stars had been preoccupied with forging an equation between film acting and WASP respectability; the new stars took that equation as given, and looked for a more detailed and implicating involvement in the particulars of their 'personality'.[38] For new aspirants (or even jaded placeholders) in a chronically overcrowded labour market, the way forward still rested on being a type – Crawford, for example, surfacing around 1923,was one of several 'dancing girls' or flappers, young actresses who built a persona out of the dance 'craze' of the twenties (Pumphrey, 1987). But increasingly the type's general features were etched in with idiosyncratic details that imparted the sense of a unique personal rendition of a collective entity. Stars now had a quality that was indefinable outside their instantiation of it, glamour or 'sex appeal', or 'IT' as typified by Clara Bow.[39]

In contrast to anagraphic positioning, therefore, biographic positioning involves the foregrounding of 'personality' in the formation of a persona. These qualities are, of course, just a different kind of assumed identity, but the way is open for the exploitation of the reader's curiosity about the 'true' person of the star, in the interest of maintaining a public profile.

As ostensibly 'personal' details infiltrated the delineation of the star's persona, the place of iconic resemblance steadily displaced conventional analogies. If anagraphic positioning represented the rule of the cultural subject, biographic positioning ushered in an increasing emphasis on the grammatical subject. The specific qualities of the individual star, inside his/her type, were now spelt out rather than the general inference from type relied upon. If the early stars were always stereotypes, what follows now is a competition to produce the most definitive iconic embodiment of a type – to become a prototype, the instance of a category that seems composed of its essential qualities.

To exemplify biographic positioning, it is best to start with articles that are transitional between the two modes. A good example is the article on Joan Crawford, 'The Story of the Dancing Girl'. Much like Fairbanks, over a decade earlier, this article begins with reservations about using the first person:

Write my Life Story? But how can a woman write her life story? A woman's life is not a matter of 'I was born here' or 'I was educated

there'! It is a matter of thoughts, longings and temptations suc-
cumbed to, or temptations repudiated. . . . And to any woman, if she
is honest with herself and her Creator, Life is a series of men – men
who have influenced her growth, her career, her ambitions.

(Biery, 1928: 86)

This declaration obviously pays homage to gender stereotypes. Since
Joan is marrying Fairbanks Jnr and thus into Hollywood's royal family,
her 'gay' dancing feet are to be stilled for the womanly pursuits of
cooking and sewing.[40] But consonant with her social trajectory as an
individual who struggled from the bottom of the social ladder to the top,
the mood of gender conformity quickly gives way to assertions of auton-
omy. The categorical 'I' of the opening sentences, speaking to the com-
mon experience of being a woman in a man's world, immediately defers
to another 'I'. This 'I' is not an empty pronoun of presence, guaranteed
by the implicit acceptance of type membership – 'a gay dancing girl of
Broadway' or 'Mrs Fairbanks – but the mark of a concrete individual
with her own experiences and story to be narrated. The 'real' Crawford
cannot be equated with a type, the 'devil-may-care flapper'. Appearances
to the contrary, past and present troubles have meant that Crawford is
far from fancy-free. She has known much unhappiness.[41] But revelation
has its limits: 'There are certain memories deep within a woman that she
cannot drag out even though she wills it.' Such limits are personal and
(loosely) psychoanalytic, rather than dictated by decorum.

This inaccessible 'inner self' not only escapes the star's comprehen-
sion, it also defeats the public who wants to know, adding mystery and
promising more attempts at revelation. The play of non-identity evident
here will become a central aspect of Crawford's persona – the woman
who remakes herself despite adversity – so that what distinguishes her is
not what she is, but the role she plays in a life story. 'I can't just sit back
and be a star . . . I've got to justify my life.'

Such a narrative of self-fashioning is familiar enough in the liturgy
of the self-made man. But in the case of an actor, who specializes in
fashioning the self into different characters, it becomes a double
affirmation of the process of self-formation. Like an early harbinger of
the protean self, the Crawford persona readily conflates two activities:
preparing for a theatrical role and refining the everyday presentation of
the self. 'I need the experience of the stage. Not only for my work but
for me.' Crawford had a past to conceal, but it is not this 'real' past as a
performer in early 'stag' movies that is being neutralized (Anger, 1986).
Rather, it is the past that called her to the social destiny of her type. By

1935 Crawford is now 'The Girl without a Past,' her persona is now a matter of self-creation (Manners, 1935; Baskette, 1935)

The strategy of replacing the conventions of type with the iconic 'mysteries' of the star's persona is also visible in the 'life story' of one of the 'Youthful' new stars, Gary Cooper. Like Crawford, Cooper began his life story with a brief confession of its ineffability. He was unable to explain why he became a motion picture actor as opposed to a cowboy. His involvement in the film-making community seemed barely to touch him, nor did his relationship with his contemporaries – his current date, Lupe Velez, had less influence over him than such decisive moulders of a man's life as his mother and his primary school teacher.

To emphasize his own authenticity, Cooper notes that the superficiality of Hollywood is easily overwhelmed by the power and grandeur of Montana. That is where his heart is and that is the place to which he plans to return when his day in the limelight is over.

The essence of Cooper does not lie in his chosen profession or his social background as it might with Fairbanks. If Crawford speaks of her intimate destiny under the tutelage of men, Cooper speaks of himself as made through a primal contact with nature. The formative impact of 'nature' is both unfathomable and of 'infinitely greater' impact than any rewards or honours that fickle and shallow Hollywood might bestow. To engage with Cooper as he 'is', the reader must accept that objective social realities are not the taproot that leads to the 'innermost' desires of the star.

> I did not crave to go to school, something within me wanted the amber and red sunsets, the clear bright days with a buzzard planing through the sky.

England, where Cooper spent some time as a schoolboy, does not function as it did for the Anglophile first generation of stars such as Fairbanks as a symbol of decorum, but rather as a negative experience:

> I didn't like the close compactness of the tiny gardens, tended for centuries and the ultra formal parks. It weighed down on me, all the evidences of this country's terrific age. I wanted the stark youth of America.
>
> (Spensley, 1929a: 134)[42]

Whereas Fairbanks expected privacy outside of his formal commitments, Cooper does not even want the formal commitments. Cowboy that he

is, he wants wide open spaces, consonant with the largeness of his soul, hence his restiveness with the task of conveying his innermost feelings and thoughts to the reader. Defined neither by his social background nor by his profession, Cooper may be a star, but what he really is, is outside of stardom. He is *in* but not defined by Hollywood.

This evocation of nature recalls the cult of masculine self-reliance and assurance that marks Fairbanks. But whereas the latter assimilated the personal to social rites de passage, Cooper offers a roster of formative experiences: an automobile accident, the influence of an early school teacher, his restlessness born of his life on the range. It is by these experiences that the reader can understand Cooper. Yet ineffability persists: 'A life story to be real must speak of emotions – but how can one speak of emotions?'[43]

These tropes do, indeed, fit with Cooper's 'lean, lanky cowboy' type – six foot four of Montana Boy – but the referral to type is vestigial. For one thing, the cowboy as a type was somewhat de trop for aspiring stars in 1929.[44] Cooper speaks of admiring real cowboys but does not speak of himself as a cowboy. The wild men of his youth are not figures of influence in their own right so much as human repositories of the power of the wilderness and the true root of his 'inner self'.

The strategy of visualization rather than explanation, apparent here, is evidence of a new field of interpersonal engagement. The type may permit the reader to identify the kind of person the star seems to be, but it is not the means to identify with the star. The close-up photograph of Cooper that authorizes the headline 'The Big Boy tells his story' says in its caption that Cooper's 'tousled hair, frank eyes and all . . . typifies what we like to think of as the best of young American manhood'. But unlike Fairbanks, the writer feels no need to tell the reader what the best is. Cooper looks right without any pressing need to define what that *right* is.

The weakening of type binding is also evident in the treatment of 'old' stars. Gloria Swanson, enshrined for later filmgoers as the passé silent-movie queen in Billy Wilder's *Sunset Boulevard* (1950), was in 1929 'an amazing woman, who has had everything and lost it and found it again' (*Photoplay*, July 1929; reprinted in Gelman, 1972: 129–130). But what she has found is not what she has lost, unless fame is regarded as a simple quality of exposure. What is lost is the market power of her old persona – all refined elegance and taste (as tutored by Elinor Glyn). This has been replaced by another that reveals all the frailties behind the hauteur. Beset by a tendency to overspend and yet possessed of refined tastes, Gloria appeals to her fans to salvage her career and return her to

solvency. Her marriage to the Marquis close to an end, she is at one with her true self, which has always chafed at the restrictions of relationships, be it Joseph Kennedy or the Marquis:

> Men cannot fill Gloria's life. They can only be a side issue, for she is too full of energy and vitality and activity to give herself completely to a husband.
>
> (*Photoplay,* July 1929; reprinted in Gelman, 1972)

Gloria is now very much a 'new woman' like Joan Crawford. This transition is not final since Swanson's persona rests on a claim to glamour – she is featured as a model for Chanel clothing in a promotional piece for her 1932 film, *Tonight or Never.* But 'classiness' is now a functional value, a job she does rather well as opposed to an expression of an inner self. As with Crawford, doing has replaced being (Griffith, 1971: 190–191).

These examples are part of a trend affecting the content of *Photoplay* at the start of the third decade of its publication. Through 1929 the contents of the magazine still show a contrast between general information articles about the business and the industry of film-making, fiction and studio chit-chat (as opposed to gossip) and articles about individual stars. Initially, general information content predominates over fan materials, but this is soon to change. A harbinger of a more direct cultivation of the psychological parameters of persona is the section called 'Personalities', which is first introduced in the March 1930 edition. This section is the first to be exclusively concerned with exploring the allure of the stars and extends a new feature started a month earlier, 'The Girl on the Cover'. The inaugural image is Crawford's and the accompanying full page reiterates her persona: none has fought more gallantly than the turbulent, talented Joan. By October 1930, the special section of personalities is gone, but that is precisely because personality has become the essential content.

6
The High Tide of Biography

In general terms, biographic positioning rested on a circular relationship. The stars, as the legal possessors of virtual identities, were grounded in the transpersonal space of Hollywood as the 'home' of motion pictures. They, in turn, provided the flesh and blood, the engines of desire and hope through which Hollywood, itself a virtual place, could be manifested as an apparent community. As such, biographic positioning was a sequestered institutional activity (Giddens, 1991).

In the biographic phase, the imagery of stardom was a protected, corporate resource, managed by the Studios with the willing, because self-interested, cooperation of fan magazines and, by today's standards, a compliant press.[1] Control over the press had been established in the early 1930s through the operation of a 'white list' of journalists with approved access to the stars. The Studios were not likely to ban a particular magazine, but they could refuse to work with 'uncooperative' journalists. In a largely freelance environment, withdrawal of the right of access was a potent sanction. On the other side of the coin, approved journalists were showered with favours that walked a fine line between bribery and goodwill relations (Goodman, 1961; Turow, 1978). Biographic discourse, in short, was the literary expression of the Studio's restriction of public information about stars to approved sources.

Photoplay, the 'Aristocrat' of fan magazines, was the official broadsheet of sequestration, issuing its bland version of Hollywood and revealing, in its avoidance of certain subterranean topics, its latent limitations.

But by the late forties, the cosy populism of *Photoplay* was cracking from within. Ingrid Bergman, who at the beginning of the decade could be comfortably portrayed as a Swedish anti-Garbo – openhearted and disarmingly natural – became, through her involvement with Roberto Rossellini, an example of betrayal of the best ideals of the business. With

the testimony before the House Un-American Activities Committee in 1947 of stars such as Gary Cooper, Robert Taylor, Robert Montgomery and band-wagoning lesser lights such as Adolphe Menjou and Ronald Reagan, uncritical patriotism became a shibboleth. Hollywood construed Communist affiliation as a breach of the standard 'morals clause' and thus equated political allegiance with moral turpitude; the writer Lester Cole had his contract terminated on these grounds. An old-fashioned democrat such as Humphrey Bogart, having fronted a deputation to Washington from The Committee for the First Amendment, was placed in the humiliating position of declaring that he was not a Communist.[2]

On another moral front, Errol Flynn, 'who had the great good fortune to portray upon the screen the heroes of our country,' was charged with statutory rape. Joan Barry's paternity suit against Charles Chaplin was, for Louella Parsons at least, symptomatic of a greater betrayal: the crime of not using his genius to cheer up the country in wartime. Especially since other stars, such as Leslie Howard (whose obituary was placed like a reproach on the same page), had made the ultimate sacrifice.[3]

Romance presented its own problems: betrayal was found in the marriage of Rita Hayworth to Prince Aly Khan. As noted, Society marriages had been a feature of Hollywood from the start. But now that movie fame had its own hallowed place, Hayworth's marriage was construed by Parsons (in her usual role as a mouthpiece for management) as disloyalty towards the industry and its 'master', the fans. Worse than that, the Prince would not be a freedom-loving and lenient American husband, so Hayworth was also unpatriotic. Hayworth, Parsons waspishly noted, was already losing her looks and glamour.[4]

In hindsight, the moral economy implicit in these strictures marks the high tide of biographic positioning: the star is construed as having entered into a mimetic contract with the average (predominantly female) reader. The price of fame is to shoulder the obligation to behave off-screen in a manner consistent with that contract. Care of the persona was seen as part of a larger obligation to serve collective values concerning how people ought to behave. The function of the fan magazine was to regulate and reproduce the moral relationship between the star and the mass audience. But with the end of the Studio system, the mimetic contract began to lose its institutional compactness and operating integrity.

Under biographic positioning, the star had become a prototype, a being whose individual qualities seemed to so define a category that the category itself could be contemplated in the immediacy of the star's persona. For fans, at least, Clark Gable was an effect that obviated the examination

of its causes, just as great physical beauty can be apprehended without a resort to genetic sampling. Besides, the social significance of Gable was given, performatively, by the fact that he was being written about.[5] All that needed elaboration was a socially acceptable version of the (female) reader's attachment, so that the (ideal) reader was equally transparent or normal. Such was the accomplishment, when it worked, of biographic positioning.

The context for Autography

Although in an embryonic state in the early fifties, the elements of a new articulation between type and persona manifested as a crisis of representation. Contrivance between those seeking publicity and self-promotion is an eternal precondition of fan-magazine writing. But increasingly in the post-Studio environment, fan magazines created the events they reported. Studio sources for copy become inactive or are too narrowly focused on promoting a specific release. General-interest magazines such as *Life* and *Look*, whose larger readerships are less obviously tied into the minutiae of star biography, become the primary targets for retrenched publicity activities. As longer-term objectives related to personae cultivation cease to drive studio efforts, it is left to fan magazines, like *Photoplay*, to supply the semblance of personal continuity essential to biographic positioning. Having spent over two decades routinizing the practices of biographic positioning, *Photoplay* attempted to tinker with its established formula in a manner that maintained the old while preserving the new. But as teenage girls began to replace suburban housewives as the core readership, a new kind of star–fan relationship emerged that, like the discursive equivalent of a black hole, enervated the old formula.

Facing a dwindling circulation, *Photoplay* attempted to expand the definition of what constitutes a motion picture star: pop stars in the fifties and television star in the sixties began to be treated as honorary film stars. In one sense there was nothing new in this practice, which had been rigorously codified in the thirties following the introduction of sound, but crossovers like Bing Crosby, for example, had a sustained engagement with narrative identity as characters. In the fifties it became routine to identify teen idols like Fabian as film stars on the basis of guest appearances as themselves.

An early foreshadowing of autographic positioning can be found in the article 'Fabulous Frank Sinatra: crooner of intimate love songs' by Parsons.[6] Sinatra was in Hollywood for a series of engagements – a

live performance at the Hollywood Bowl, a spot in Hollywood Canteen before an audience of servicemen and the filming of a guest appearance as himself in RKO's production *Higher and Higher*. The ultimate purpose of the article was to exploit the drawing power of a fresh, young 'pop' commodity.

Not yet established as a motion picture star in the mould of his older and more established rival, Bing Crosby, Sinatra's fame (some might say, notoriety) rested on his appeal – to a previously quiescent segment of the mass audience. If Crosby's appeal lay with an adult audience, Sinatra was the first teen idol, with an especially vociferous and ardent following of teenage girls – as Parsons points out, his appearance at the Hollywood Bowl attracted 20,000 screaming bobby-soxers.[7]

Although introduced to *Photoplay* readers as a new star, Sinatra's candidature was discrepant on a number of levels. First, he lacked a persona in the established sense of a personal image derived from a narratively embedded character. Sinatra was the epicentre of a string of vocal performances, each presenting an emotional state or situation complete in itself. He presented micro-narratives, but by definition existed outside these momentary presentations, as he shifted from number to number. Second, his appeal cannot be readily defined in terms of a successful incarnation of mass values, because it rests on a segment of the mass audience not yet recognized culturally and legally as adults. At best he might stand as a symbol of a subculture. Third, this subculture is perceived as deeply problematic, and Sinatra, through his ability to invest 'bedroom' lyrics with the sensuous 'grain' of his voice, was likewise dangerous and suspected of being a Svengali, ruling over the vulnerable psyches of teenagers.

Parsons' task in this piece of puffery was rather complicated: She had to recognize the power of Sinatra, in order to justify writing about him. But she had to defuse the threat implicit in his performances by showing that he was, underneath it all, a regular guy.

Improbably, to say the least, Parsons recognized his power by presenting herself as a fan. At the Hollywood Bowl she, staid Louella, was 'in a spin'. In a coast-to-coast telephone call before Sinatra's visit, Parsons was smitten by the 'old black magical voice saying gently, but with all the stops out: "Hello, Louella, this is Frank." That did it. It wasn't what he said. It was the intimate Sinatra-way he said it.' The appeal of Sinatra was personal and unique. Accordingly, you either loved him or hated him – Parsons loved him and was prepared with the other girls to have a 'fine old heart-to-heart talk about Frankie in Hollywood.'

As the diminutive suggests, Louella claims to be closer to Sinatra than the average fan and the tag line to the article identifies her as 'singular Sinatra's famous friend' – a confidante to whom he defers, and trusts.[8] In this manner Parsons uses her own staid authority to recognize and contain the mystery of Sinatra. If she, Louella, is his friend, can he be that 'bad' – can his appeal be merely sexual? The road to a more matronly identification is opened, even as the passion he elicits is sealed inside the mysteries of romantic attachment.

All this is par for the course, except that writing about 'Frankie in Hollywood' lacks a meaningful physical location or a history of sustained professional involvement. When Parsons comes to construct the Hollywood heart-to-heart it consists primarily of descriptions of Frankie's personal experiences. Getting to know Sinatra, Parsons tells us, 'We talked about everything' but itemizes only his favourite food and melody, how he sleeps, how he feels about acting and his favourite human being, who turns out to be (since Sinatra is in the dutiful husband mode) his wife Nancy.

That Sinatra is *in* Hollywood but not *of* Hollywood is a theme that is broached several times. The article mentions twice that four years earlier Hollywood had rejected Sinatra – that his appearance at the Hollywood Bowl raised local 'blueblood' objections. Not having a great number of friends in Hollywood, he preferred the company of his New York entourage. Parsons assures the readers that Sinatra is not bitter, but she protests too much!

The article gives prominence to a snapshot showing Sinatra, his wife and daughter on the steps of a modest rowhouse – a setting that is far from the established practice of showing glamorous and conspicuously affluent star interiors (Dixon, 2003). This indexical link does not signal the intent to root Sinatra is his (presumably) Hoboken past, but rather stage an exploration of personality. We learn that despite the implied disadvantaged beginnings (Jersey, Catholic, Italian), Sinatra has always had enormous self-confidence, perhaps too much, since until the long struggle to succeed humbled him, his wife Nancy refused to marry him. The man with the 'world of femmes at his feet' was a pain in the neck and risked his chance for love. But Parsons knows him better; he is not naive (read uncouth and uneducated), nor is he cocky and overconfident as others have suggested. These are trimmings of a more desirable quality – perseverance, a quality that is the quintessence of his newfound stardom.

Where is the real Sinatra? He is not in Hollywood; there is no domestic situation, à la Bette Davis, in which his charisma can be contained.

He is not in the sexual chemistry of his performance, for that is too threatening. With no developed Hollywood presence to drawn on, he must be in his past. But if his early years in Hoboken and his marriage contain the real Frank, this detracts from the purpose of the purpose of the article, which is to luxuriate in his having 'gone Hollywood'.

In many respects the materials here strive to fit the mould of biographic positioning – rendering the present as a mere extension of the star's biography. But it is the infiltration of other materials that is interesting. The interview is unusually marked as an encounter. Most *Photoplay* interviews were written after the fact and, given Parsons' habitual mode of working from her bedroom, it is not even certain that she actually met Sinatra. Nor, if she did, was it the close intimate encounter implied. What is striking is the effort (creakily exposing her own artifice) to make it seem as if an encounter had occurred. Sinatra remains a star who has, so to speak, absconded. He is not comfortably a type; nor is he a fully developed persona, but an eidolon, a presence in circulation.

In the long run, *Photoplay*'s efforts to maintain biographic positioning do not succeed. Yet until it ceased publication in 1978, it struggled to maintain the biographic lineaments of the Golden Age of Stardom. In so doing, it paved the way through its own innovations for a new condition of stardom, which it could not accommodate. It is with the publication of *People* magazine, started in 1974, that an expanded definition of stardom that met the need of a general-interest readership was forged.

Viewed in retrospect, *Photoplay*'s decline is part of the development of *abstract familiarity* or 'pure' celebrity. To a 'post-modern' reading of stardom there is nothing new here, beyond complication. The integrity of the persona was and is always (and never definitively) a textual accomplishment. But the fundamental acentricity of stardom is not something that *Photoplay*, or its peer publications in the McFadden chain, can fully embrace. It remains committed commercially, if not cognitively, to representing persona as an extra-discursive reality, naturally centred inside the person of the star: a private set of psychological and physical properties, physiognomic capital which is elicited but not created by the process of casting. Constructiveness and its potential giveaway, *auto-referentiality*, are qualities to be disguised.

The new flexibility of persona might appear to audiences as an example of increasing the emphasis on self-reflexivity that Anthony Giddens (1991) has seen as characteristic of the self in modernity. But this probable total effect must be seen close up as a process of containment, an effort to balance plasticity with the imperative of being the possessor of the image. If the decline of biographic positioning is a process of

desequestration, autographic positioning is an attempt to resequester the persona as a personal service product, precisely because with the collapse of the studio system, the stars are left to fend for themselves.

In the post-Studio period, stardom is no longer synoptically keyed to notions of a kind of person or a kind of performer. In reality, success rests on engaging in multiple forms and levels of performance and being only tentatively present in each one. Publicity is increasingly a self-referential mix, containing fictional performances and performances in quasi-factual settings such as chat shows, commercials and elite events linked to the media industries or more general forms of public relations. The stars are just as likely to make a film or a music video; appear on television; be seen at a political or charitable fundraiser or an haute couture fashion show, and be reported in each activity.

The emphasis on the person-defining value of physical presence is both an opportunity to transcend the limits of traditional media involvements and a constant source of challenges from other stars, and from forces concerned to exploit the market value of an image. Competition means that the care of persona becomes an even more intensively specialized activity, no longer able to rely on a linear equation between personal identity and dramatic performance, since performance in character becomes just one aspect (and a sporadic aspect at that) of a hypertext of public performances. Motion picture stars are just as likely to play themselves – that is, their persona – or to play the social type of *the film star* as to be before the public in character, reversing the relationship whereby these aspects were once simple adjuncts to on-screen performance. Such multiplying vectors of performance mean the breakdown of the old arrangement whereby narrative identity – always compromised by the element of pretence and obedience to a specific plot – is sutured by the subsidiary practices of fan writing breaks. Rather than solidifying identity such practices may lead to its dispersal, creating an image of star identity as a process, a working-through of identifications.

The challenge to innovate is self-propelling, since image must be constantly refurbished with new details in order to avoid overexposure. Exposure, of course, no longer encompasses only positive publicity but, increasingly, negative forms of publicity that exploit public interest in the star. Opportunistic publicity practices and the exploitation of the commercial value of the star's persona jeopardize the star's publicity right – the right to profit from the use of an image (Gaines, 1991). Even where the flow of publicity is controlled and sequestered under the star's control, there is a constant need to find new angles to the star's image. This can lead to the leaking of eccentricities to the tabloid press, as when

Michael Jackson provided the *National Enquirer* with pictures of himself inside a hypobaric chamber. But as Michael Jackson was to learn, there is need to draw a line between eccentricities that fill out an image nicely and defalcations that destroy it.

The other side of the field: the gauge of the audience

The primary function of star discourse is to sustain the star and the spectator-fan as participants in a mediated quasi-interaction governed by the logic of persona. By entering into such an interaction the ordinary spectator is placed in a biographical framework in which, to echo Leo Lowenthal (1961), the big events of the time are rendered as personal experience. If a persona is a professional identity for the star, for the audience it is a template for thinking about the relationship between self and society.[9]

If this relationship is uppermost then it is prudent to leave the space between person, persona and character undisturbed in order to fix on larger patterns in the symbolic construction of social order. If the star is regarded as an actor then his function as an agent of narrative, as a character, is all that should concern us, so that matters of social or cultural significance are focused on the level of the story and the plot. One of the effects of persona building is to displace these broader questions with a micro-politics of personality that is not about connecting the personal and the political so much as finding the real person beneath his/her narrative identity as a character. It can be politically useful to query the connection between star and character in order to derail an ideologically charged representation. But such a tactic can have progressive or reactionary uses. It is pleasing to me to know that John Wayne did not live up to his own image, but that is simply a reflection of my preferences – I would dislike recognizing that the same rule applied to, say, Denzel Washington. Relatedly, it is not difficult to see that tabloid coverage aimed at exposing the 'messy private lives' of socially symbolic figures, such as Roseanne, is a form of control through de-narrativization.

I am not, therefore, denying the usefulness of treating a star as a character. But if one's concern is with the institutional standing of stardom, the question of *how* the stars stand for popular experience – rather than the endless permutations of *why* – is at the forefront. It is not difficult to point to a starless cinema in which narrative purpose is freed of the dreary entailments of preserving persona. Examples such as the work of John Sayles or Ken Loach demonstrate the conscious recognition of an

infrastructure of collective narrative work that will always be the submerged premise of even the most vanity-driven star vehicle.[10]

The processes I have attempted to track as a changing mode of address to the reader have largely been a matter of inference from textual examples. It is still possible that there is no echo or trace of these changes in the way in which the readers of fan magazines read and interpreted the representational function of the stars. Obviously enough, the fact that *Photoplay* and, subsequently, *People* magazine succeeded commercially is a presumption that variations in the register of stardom, if not informing, at least followed changes in readership perceptions of what constituted a valid public identity. It might be argued that fan magazine readers tell us little about attitudes in general – certainly such readers (mostly young females) are likely to be more homogeneous than the population at large. But fan magazines are sites of crystallization where a general image of stardom is formed for those less engaged and interested. Even if changes in the register of stardom seemed associated with changes in the core or target readership, this finding would still be relevant to the question of whether a different kind of star–fan relationship is formed with different kinds of readers. It would be useful to draw on a run of independent data that confirmed that the social symbolic meaning of stardom changed independently of magazine readership.

To get at least a partial confirmation requires evidence of what motion picture fans actually inferred about the reality keying of stardom. Did different generations of readers regard the type status of stardom differently? A comprehensive body of this kind of data is not available currently, though further archival research into readers' letters and readership surveys may take us further towards it. But it is possible to reinterpret existing data in relation to a new question: does it support the claim for the presence of different economies of typal reference underlying moviegoers' responses. This doesn't answer the question of causality – did changes in fan magazine content follow or inform readers' responses? But it would provide evidence of a correlation.

The earliest *comprehensive* research into audience attitudes to Hollywood stars is the material collected under the aegis of the Payne Fund, located at the University of Chicago (1929–1932). This research project published a series of reports that explored the relationship between motion picture attendance and anti-social behaviour, particularly juvenile delinquency and crime. Irrespective of the various avenues of research and in some cases the actual findings, the guiding hypothetical framework of the Payne Fund studies was a powerful media or direct impact hypothesis. The novelty of the 'movies', the

apparent visceral attraction of the medium and its massive infiltration into the leisure time of working-class and then middle-class audiences seemed to argue for a powerful formative influence, especially on the young. Although published in 1933, the data actually drew on materials collected in the late 1920s and in some cases, reaching back to the late teens.[11] Herbert Blumer's research, part of which was published as 'Movies and Conduct', is particularly relevant. Taking a qualitative approach which emphasized subjects' interpretation of movie stars' personalities, Blumer asked his subjects to write motion picture biographies. In these biographies, the writers reflect on the influence of motion pictures on their personal formation and aspects of their life such as childhood fantasy and play, romantic involvements, daydreams and lifestyles, roaming freely over past and present experiences. Not all of the biographies were published – or for that matter survive – but thanks to the work of Garth Jowett and his associates on the Payne Fund archives, unpublished work by Paul Cressey on working-class boys as well as materials on sex and the movies collected by Blumer are now available in partial form (Jowett, Jarvie and Fuller, 1996). The movie biographies, of which somewhat in excess of 1800 were collected, were drawn from a population in which university, college and junior college were preponderant – only 125 office workers and factory workers, for example, were sampled.[12] Blumer's reliance on a sample that was predominantly composed of white, middle-class and educated young adults was in part a matter of convenience, but it also rested on a 'least risk' hypothesis: if the 'cultured class' (as he put it) were susceptible, then how much more influential the movies must be amongst the less culturally equipped and the less mature. This line of reasoning clearly shows the influence of the 'powerful media' model that was a common assumption of the day.

Baldly stated, the 'at least risk hypothesis' sounds to contemporary ears like a particularly lame example of the ecological fallacy. It smacks of class prejudice to assume that working-class adults are more susceptible because they lack the sophistication of middle-class respondents. In Blumer's defence (a defence he does not explicitly advance) it needs to be recalled that the 'birth' of the movies occurred in an intensely unstable and novel environment in which old beliefs and assumptions about America had been challenged by mass immigration. It is probably true to say, at the risk of infantilizing the audience, that audiences in this period were situationally disposed to be receptive to motion picture influence, especially as this concerned modelling behaviour and learning cultural patterns. Not only was the medium new but a large

section of the audience was new, consisting of new immigrants receptive to 'New World' influences and under pressure to 'Americanize'.[13]

The publication in detail of Paul Cressey's study (Jowett, Jarvie and Fuller, 1996) of working-class boys in East Harlem, New York, not published originally because of the sensational nature of the materials – reflections on prostitution, gang rape and adolescent sexual practices – means that it is possible to round out the limitations of Blumer's published report.[14]

For obvious reasons it is not possible to give a detailed examination of the range and variety of the responses exhibited in these materials. But Cressey's conclusion that the movies were a powerful source of informal learning about 'questions of etiquette, social amenities, style of dress, carriage and posture of body, techniques for gaining favour with the opposite sex' is confirmed in Blumer's published and unpublished materials. If there is a 'class' difference in the perception of the stars it would seem to rest less on the content of the lessons learned than in the literalness of the relationship between on-screen and off-screen behaviour. Cressey's working-class boys seem more likely to believe in the literal equation between the character of the star and his/her real-life qualities. Thus James Cagney and Edward G. Robinson are believed to be real streetwise types who have used their street fighting skills to break into the movies (Jowett, Jarvie, Fuller, 1996: 181).

In Blumer's published results, his middle class-respondents, by contrast, seemed less likely to confuse character type and the actual person of the actor. But this difference is not as firm as it seems if one examines the materials Blumer did not publish. This data on movies and sex should demonstrate – if the earlier results have general validity – that confusing character and person is a working-class trait. But this is not the case. Around half of male college students admitted to being sexually stimulated by female stars, and their comments on the erotic qualities of individual stars centre on the social type they represent rather than the person. A star is sexually attractive because she is 'a hot type' or a blonde, not because she is Jean Harlow. Where a specific star is mentioned – for example, Greta Garbo – there was no elaboration of her personal qualities beyond the blunt fact that she was an effective masturbation aid (Blumer 1933: 285–286, 291, 293).

Such an approving response was not universal; many subjects reported revulsion at on-screen explicitness. But even negative responses partake of the confusion between pretence and actual behaviour. No subjects are reported as radically distinguishing between the actor and the role, recognizing implicitly that the stars are, for better or worse, modelling real-time possibilities and situations. Even those who saw a connection between

screen content and self-arousal, tended to speak of the star as an external prop for masturbation rather than as a figure to 'possess' in all his/her particularity. Confirming Cressey's view that the movies provide a context for ongoing behaviour, college males and high school boys in particular, admitted taking girls to 'hot' movies in order to pave the way to sexual relations (a tactic which rarely seems to have paid off) (Blumer, 1933: 292).

Such a pragmatic orientation positions the spectator outside the image of the star in a mode of objectification rather than engagement. Such a typal regard is strikingly at odds with contemporary accounts such as *Star Lust* in which the stars are not merely voyeuristically scrutinized, but are rendered literally as participants in fans' scenarios of desire (Vermorel and Vermorel, 2011). What is true of sexual attraction is true of the less morally fraught (at the time) use of stars as models for behaviour that communicates status and class membership. Both working-class and middle-class respondents read the early stars as exemplars of social types, with little emphasis given to the private person of the star. A cognitive economy operates that suppresses individuality in favour of selecting generic personal qualities that speak to type rather than the individual. Stars are equated to character because character is the appropriate mode for stereotypes. Such an orientation is consistent with the anagraphic mode of fan-magazine writing.

The next substantial body of data dates from the late 1940s, a time frame that is roughly consonant with the high tide of biographical positioning. As reported by Leo Handel (1950) in 'Hollywood Looks at its Audience', audience involvement in this period is driven by patterns of identification based on personal preference, foreshadowing the concept of lifestyle as a way of social bonding. The audience seems both more involved in Hollywood product and more personally involved with individual stars – a trend that is consonant with a more particularized delineation of star identity. In Handel's data, particularization has two dimensions: (a) a general star popularity rating, which is consonant with other forms of rating such as exhibitor reports, counts of fan mail received and so on, which is designed to identify the top ten male and female stars; and (b) an individual star rating which is designed to determine which particular star is most popular within a given category. The data suggest a correlation between gender and preference. For example, it was found that respondents were more likely to prefer (and presumably identify with) stars of their own 'sex' – though males were more likely to prefer 'own-sex' stars than females – 76% of males reporting this as against 54% of females.

This counterintuitive result was investigated further. In a subsample of 65 subjects, five reasons for own-sex identification were given. These

were conscious self-identification (35 mentions), emotional affinity (27), better acting ability (22), projection or idealization/idolization (10) and imitation or admiration of fashion and style (4).[15] Male respondents were more likely to identify with the star as a matter of conscious self-identification, placing themselves in the position of the star as a protagonist. Female respondents were more likely to cite emotional affinity, which can be defined as a sense of general sympathetic involvement with the star without losing the sense of being an onlooker.

In Andrew Tudor's (1974) reworking of Handel, conscious self-identification and emotional affinity are seen as phenomena specific to the motion picture viewing experience, the former involving a high level and the latter, a low level of star–fan identification. Projection and imitation are seen as respectively high and low levels of extra-cinematic forms of star–fan identification. In the case of *projection* the worship of a particular star becomes the central purpose of the fan's existence; in the case of *imitation* the star serves as a model for styles of dress, grooming and social behaviour.[16]

A clue to what is going on is in the response that is excluded from Tudor's scheme: own-sex better acting ability, which is, in fact, the third most frequent response. Tudor may have subsumed this response under emotional affinity, but this is only feasible if the aspect of 'own sex' is more important than 'acting ability'. I believe this is valid because this appears to be what Handel's respondents are doing. They see their relationship to stars as a matter of personal preference for a socially prominent collection of peers. Given the prevailing norms, for these respondents the stars are an idealized expression of gender roles, which are more inclusive than norms derived from race and class which mark the anagraphic era.[17] The molar emphasis on collective symbols found in the Payne Fund data dissolves into factors of 'personality' and reflects lifestyle choices rather than moral or ethical principles. The majority of responses fall into a more intensively constructed space of the personal. Fan responses treat the stars as persons like themselves or as they, the fans, would wish to be. The psychologization of the star–fan relationship is a general feature of the data.

Jackie Stacey's (1994) study of British female fans of the 1940s and 1950s provides corroboration. She argues that Tudor's typology is too static. It fails, on the one hand, to catch the actual variability found in fans' attitudes and, on the other, by drawing a distinction between screen-based and everyday patterns of identification, understates how these are intertwined in fans' perceptions. For Stacey, imitation and projection are preconditions for fan identification that underlie

what happens during the act of viewing. She argues that the star–fan relationship is a symbolic interaction, in which two primary orientations are discernible towards the star as an object of identification. In projection, the fan sees the star as an ego ideal that has attained what the fan cannot. The process of projection is a matter of identification *with*. Imitation is a process of introjection wherein elements of the star's image are selected and incorporated into the fan's self-image. Introjection is a process of identification *by* means of the star in order to fashion the self. Rather than being possessed by the star, the fan uses the star to achieve a desired lifestyle.[18]

For my purposes here the grain of Stacey's argument – though I think it is substantially correct – is less important than the fact that her respondents see the star–fan relationship as primarily personal. For Stacey's respondents, much like Handel's, identification or projection is concerned with lifestyle rather than concerns about moral order. This is apparent in her finding that the dominant vector of identification shifts from *by* to *with* when consumerism becomes a social reality in Britain.[19] Stars are unattainable ego ideals in the era of post-War shortages and rationing, models for self-fashioning in the shift towards a consumer society. In either case, stars are drawn into a frame in which the concept of a peer or lifestyle model predominates.

The same orientation is also found in another study by Elkins, which examines the movie star preferences of a sample of 63 women – half defined as middle-class, the other half as upper class[20] (Elkins, 1955: 195). Although all of his subjects were housewives with a common interest in the movies, as indicated by star awareness, pre-adult fan letter writing and fantasies of going to Hollywood, Elkins found significant differences between middle- and upper-class women in terms of personality trait approval. Middle-class women were more likely to approve of individuals, male or female, who were home- and family-centred, devoid of snobbery and non-competitive. Upper-class respondents were more likely to approve of individuals, male or female, whose demeanour and behaviour emphasized formality, etiquette and social distance; who were ambitious, intellectual and competitive.[21] Thus far class factors are present. But when the respondents are addressed as women, class differences disappear. Evaluating male stars, all respondents agreed on what was desirable (dependability, modesty, confidence) and undesirable (wolfishness, weakness, indecision and irresponsibility).

Having derived these trait preference 'profiles', Elkins asked his subjects to rate six male and six female stars in terms of their undesirability/

desirability. Once again, the preferences of the respondents showed a remarkable level of agreement, despite differences in class membership. James Stewart scored first on both the middle- and upper-class rankings because of his perceived sincerity, boyishness and goodness. Only Betty Grable (too common) and Katherine Hepburn (too eccentric) revealed substantially different evaluations.[22]

Overall, 'upper-class' women were more likely to distinguish between the actor and the role and to reject typecasting. But they, no less than their 'lower-class' sisters, were prone to describing their favourite stars as *real persons* possessed of qualities – strength, confidence, beauty or handsomeness and family values – that surpass the differences of culture and habitus imposed by social structure. Such findings are consistent with *other-directedness*: the disposition to treat one's contemporaries as a source of direction, but only insofar as they function as accessible – that is, not typally constrained – *individual* role models.[23] The star's persona is no longer the sign of a collective mode of conformity that is prescribed, but a style of the self that can be imitated.

This brings me to the current situation. Joshua Gamson's *Claims to Fame* (1994) is the most important single source for documenting contemporary American attitudes to stardom. Gamson interviewed a total of 73 individuals, organized into 16 small groups – 7 of which were female-only, 3 male-only and 6 mixed. Of the 28 males and 45 females, over 50% were white, middle class (as self-reported) with the biggest occupational categories being students (25 persons) and the second biggest (23) office and sales workers. The interviews, conducted in informal settings such as family homes and libraries, were open-ended in form and designed to probe questions such as how were celebrities made, how did they succeed and was their fame deserved[24] (Gamson, 1994: 197–215).

On analysing his discussion group data, Gamson found three basic response sets:

Traditionalists, who believed that stars were naturally talented and deserving individuals and accepted at face value all they read or heard. A subvariant of this type was second-order traditionalists who, mindful of the fact that publicity is routinely manipulated, nonetheless still believed that the 'real' person of the star could be uncovered by reading behind the lines of public knowledge and peeling away layers of inauthenticity.

Post-modernists or anti-believers, who viewed the search for the real star as futile and naive. These individuals derived satisfaction from learning the mechanics and tricks of the image-manipulation trade and saw

star 'biography' as essentially a kind of fiction that could be enjoyed without an inhibiting reference to its ultimate truth-value.

Finally, *game players*, who used the output of the celebrity system as a resource to set in play a discussion and debate about issues that they deemed relevant; for example, treating stories of celebrity marital infidelity as an opportunity to interrogate the limits of conventional or straight sexuality, or simply to gossip about those who enjoyed high visibility.

The formation of these *sets* was a function of two broad factors, which ranged from high to low: first, the level of awareness of the celebrity production process; second, the level of belief in the realism of texts. Gamson's discussion indicates that the traditionalist and 'post-modernist' position are comparatively rare – fans are rarely completely gullible or radically cynical about the materials they consume. The mere investment of time, perhaps, requires (if not indicates) a residual belief in the possibility of a genuine revelation or insight (Gamson, 1994: 149, 172–177). But this revelation may be said to emerge from a more complex process of scrutiny.

Despite his insistence on the differences between the strategies he identifies, there is a common feature – which I shall term *circumspect fascination*. Self-identified fans no longer have a naive expectation that media interviews or performances will reveal the 'true' personality of the star. Such texts are embroiled in a network of references and allusions and can only reveal aspects of the star's complex and multi-layered self.[25] As such, they are not transparent and cannot be resolved into a common underlying personal reality. The task of the fan is to integrate such 'aspects' by finding a meta-level of coherence founded on personal interpretation. In this the fan mirrors the nature of celebrity journalism with its use of free indirect reporting.

If star texts have become performative – they enact or must be made to enact what they claim to represent – does this mean that the identity of the fan is not given or fixed either? For Gamson's 'post-modern' fans this would seem to be the case – in consuming the texts of stardom, these fans test out and 'play' with their own identities. But Gamson stresses that it is rare to find fans who look upon celebrity as a groundless play of signifiers. Rather, they see themselves as players who must negotiate all kinds of texts to access the being of the star. They are, in short, believers and non-believers at the same time, a condition emphasized by the fact that traditionalists, post-modernists and game players were not kinds of fans but kinds of readings, in which all his respondents engaged at times.

The most frequently encountered responses reveal a second-order traditionalist or game-player orientation. These orientations entail an interest in gossip and a strategy of reading that rests on 'artifice detection'. Far from rejecting the notion of celebrity as a naturally or immediately given state of being – justified, for example, by talent – these strategies still cling to the notion of truth as an emergent property in the process of star–fan interaction. Gossip, whilst not inherently objective, still relies on the principle that the truth could be known, just as detecting artifice implies the idea of a 'true' depiction. Conceptually, these game strategies do not seem far removed from second-order traditionalists, who believe that the authentic self of the star can be diligently uncovered or suddenly revealed (Gamson, 1994: 156–57, 178, 180 and 185).

So, allowing that the nuances may be ethnographically important, the common feature of Gamson's respondents is the recognition that a spontaneous engagement with the star is no longer possible, since it requires a comprehensive knowledge of the means and substance of representation. More succinctly, it requires the willingness to weave together a number of narrative threads 'found' in the media in order to construct the star's biography.

The sense of an interposed thicket of meaning standing between the star and the fan and, on the other side, the fan and the star is also evident in an ongoing survey I have been conducting into attitudes to stars amongst male and female undergraduates, primarily in the age range 18–25. The key feature of the questionnaire is to explore attitudes to the stars as figures of identification, whether *with* or *by*. The distinctive feature of the findings is a denial of representativeness per se. In response to the bigger question – 'Regarding stars and celebrities in general, do you think of them as role models that guide ordinary people in their behaviour?' – the following configuration emerged.

The pattern of response is statistically significant at 5% level. But the trend to disavowal is more pronounced than this suggests. A closer reading

Table 6.1 Survey response – stars and celebrities as role models

	Yes	No	Maybe	NR
Male ($n = 53$)	12	37	2	2
Female ($n = 40$)	10	24	5	1

of 'yes' responses reveals a tendency towards imputed affirmation – in 14 cases (6 females; 8 males) stars and celebrities were identified as *role models* for other, *more naive or vulnerable individuals* but not for the respondent.[26] The remaining responses, barring two which were simple affirmations, are similarly qualified: as role models, *yes*, but only because anyone in the media is taken as one; as deceptive, unrealistic or 'poor' role models; as role models because people are too passive or too weak to 'do their own thing'. In short, many of the Yes responses turn out to be, at best, *Maybes*.

The indecisiveness of affirmative responses contrasts sharply with the majority who denied that stars could be role models. Many of the respondents saw the question as misplaced – actors could not be role models, only people such as parents or athletes that one met in real life could perform that function. Given that the entire sample had a medium to high exposure to the media – film, television, music, videos, magazines and newspapers – the data suggest that the level of media use does not impact, positively or negatively, on the likelihood of identification. Certainly, given that these respondents were not underexposed to media content, in terms of self-reported use and having grown up in a media-saturated environment, the low level of approval or credibility for stars and celebrities remains striking.

The overall tendency of these data, like Gamson's, points to an increasing sense of disengagement or distance from the stars in the contemporary period. For those individuals, the anagraphic binding of stars as *role models* or the autographic binding of stars as *peers* is questionable. Such identifiers, once common, seem to have only a small place in the moral economy of contemporary fandom. Today's stars and celebrities are more like fellow travellers or, in a less favourable construal, rivals.

It has been argued that evidence of a heightened awareness of the 'fictionality' of the persona testifies to the power of the audience, its resistance or indifference to media efforts at manipulation. But the variability of response seems to suggest a more complex relationship. The conversation of stardom is a monologue that fans may observe, but not directly participate in, unless the star extends an invitation.[27]

Fans realize that they would have to be dupes to believe what they are told and prepare themselves in advance for disappointment. Hence the tension between cynicism and a willingness to believe should their hopes for a 'communion of souls' be unexpectedly fulfilled.[28] Even those who admit that the stars are fake must also admit that some varieties of fakery are more successful than others. The frauds and the soul mates must be sorted. Circumspect fascination is the rule.

7
The Rise of Autography

Under the Studio system, the unit of persona cultivation was the roster of actors, each actor bound by a long-term contract. The long-term contract represented a mutual obligation: the Studio took responsibility for the care of the stars' personae, and the stars accepted personal responsibility for their physical and moral 'well-being'. The number of stars and leading players on contract underwent a sharp decline in the aftermath of the Paramount decree which required the Majors to sell off their theatre chains. By 1947 there were 487 players with term contracts with the major studios; by 1953 this had fallen to 179, and despite fluctuations never went above 250. In 1965 Sandra Dee became the last star to be under an exclusive contract to a major Studio.[1]

Although box-office success was a prerequisite of stardom, in the Studio system the policy of 'slate' rather than single-project production, with its supporting practices of blind and block booking, meant that a star's career was not exclusively invested in any particular production. To protect a long-term investment, Studio management would tolerate the odd flop and indeed, within limits, a poor performance was useful to rein in overweening salary demands. This paternalism was to cease in the post-Studio period, as long-term investment in talent development declined.

Contrivance between publicity seekers and the media is a venerable tradition, if not an eternal prerequisite, for fan-magazine writing. But increasingly in the post-Studio environment, as studio publicity departments become inactive or too narrowly focused on promoting a specific release, fan magazines tend to create the events they report (Boorstin, 1963). Crossover star Frank Sinatra is an early example of an effort to maintain a sense of Hollywood as a place when its relevance is substantially diminished.

By the early 1970s the advent of the blockbuster, with its tendency to emphasize action and spectacle, led to a hollowing out of character as a source of professional identity. If established stars like Paul Newman and Steve McQueen could coast through *The Towering Inferno* on star power and brand-name recognition, new actors, even stars in dramatically complex narratives – such as James Caan in *The Godfather* – ran the risk of being submerged by a single role, or at least being confined to a narrowly defined type.

The once-routine alternative of creating a persona that transcended particular roles became equally problematic. The long interval between production and exhibition and the tendency of the star to emerge for 'real life' observation only during a promotional blitz meant that where stardom had once stood for a whole way of life, it now took on the quality of a series of appearances, narrowly tied to the exigencies of publicity. Increasingly, if stars still have the opportunity to speak for themselves, this freedom is legally confined to publicizing their latest role. As these appearances accumulate, they reveal to even the most naive of viewers that what was once represented as a definitive expression of the star's 'true' self (functioning as a persona) was actually a situational self, governed by a particular character. This progress, like a royal tour, from one apparently essential identity to another, has to be explained in order to be forgotten. Persona, if it is to function as an interactively real self to set against the pretended self of character, must be protected from the revelation that it is only a pose. For marketing purposes each 'fresh' incarnation must be deadly earnest, for the star and, perhaps, for the fans.[2]

Developments such as celebrity gossip journalism threaten to deplete an established persona. Charges of immorality are bad enough, but at a more sustained level, gossip threatens to reveal that the actor is pretending when s/he is supposedly being him/herself. Worst of all, 'private' revelations of personal preferences in partner or fashion, or physical and intellectual defects, may lead to the perception that 'charisma' is just a media artefact. Whether through lapses in the prepared self on a promotional tour, in a publicity interview or on screen, the revelation that all is a 'groundless' performance threatens to undermine the projection of a unique self from which artistic expression springs.[3]

The new way of writing about stars – the autographic mode – is, to be sure, a mere twinkle in the eye of commercial necessity at the dawn of package production. Looking back from the present, there is a danger of confusing a result with the process as it was consciously perceived by participants at the time. Two broad factors stand out.

First, the turn to package production brought with it a new prestigious composite professional identity: film-maker. Producers, directors and writers – once thought of as mere functionaries – now assumed the mantle of auteurs or demiurges through a process of 'hyphenation': writer-director-producer (Baker and Faulkner, 1991). The star, treated under the Studio system as a mannequin or a 'sex symbol' (paid not to think, as King of Hollywood Clark Gable put it), underwent a compensatory elevation. If not making a claim to hyphenated wizardry – producing, directing and starring, like John Wayne with *The Alamo* – the contribution of the star at the level of performance began to be invested with claims of vision and deep particularity. Actors began to claim the status of creative visionaries, as individuals with something to say, rather than the disparaged mouthpieces of others.

Second, the elevation of the actor was legitimated by the impact of what (loosely) became known as 'The Method'. In the hands of its greatest exponent, Marlon Brando, the fine details of a performance were removed, with good effect, from the director's control, or for that matter from the direct influence of other actors. It was not just that Brando was capable of arresting by-play – Wayne was also capable of that. Nor did this new 'authority' rest on great powers of impersonation, though Brando assuredly excelled in these. It was rather that character itself became even more intensively tied into the presence of the actor, as 'sense' memories and personal experiences, from the past or deliberately cultivated as part of participant research, were deployed to create idiosyncrasies in depth. Viewing a performance by Brando, it was difficult to say whether the fictional was personalized or the personal fictionalized; nor did it seem to matter in terms of results (Naremore, 1988).

But there were more quotidian and opportunistic uses for The Method. If character portrayal was really a matter of deep psychological investment, then it was possible to ratify being 'oneself' on screen. The disadvantage of being a character moulded to type was that it left the star open to accusations of being a 'ready-made', or of being unable (or unwilling) to be different on screen. If ready-mades will do, why employ stars at all?

The Method ratified claims to uniqueness because it personalized the texture of performance. If performance is actually a product of personal vision, then it is indeed unique.[4] The full appreciation of a performance could no longer rest with character as an agent of narrative, but was drawn into the realm of biographical appreciation. Such an appreciation did not extend to the actual personal life of the star – Montgomery Clift would still be 'a troubled bachelor' for some time to come – but to the point of authenticating the star's persona.

The representation of the star as an auteur suffusing screen characters with a deep authenticity was also a reflection of changing employment opportunities, as Hollywood moved into television series production. The early television stars were more likely to be identified with characters because of the regularity of their appearance and the mode of consumption. The domestic setting, small screen and the mundane levels of audience effort, occasion and expense made television stardom a less glamorous status. Television revived images of B-movie film stardom, which many stars had worked hard to avoid or, as with Wayne, to leave behind. The successful legal action undertaken by James Garner, the most popular of the TV stars, to terminate his contract with Warner Bros Television, served as a cautionary tale against subsuming one's professional career into the demands of predictable characterization.

The distance between rival forms of stardom presented themselves as an opposition between character and persona. Method acting legitimated persona as arising from a personal mystique. But mystique had a necessary precondition: privacy.

Enter *Confidential*

Despite the fact that its period of effectiveness and influence was relatively brief, from 1952 to 1957, *Confidential* magazine can be regarded as embryonic of the practices of today's much-ramified celebrity gossip industry. Starting with the aim of bringing insider political gossip to the general public, from a decidedly right-wing agenda, publisher Robert Harrison soon discovered that gossip about movie stars and show business celebrities dramatically improved circulation. *Confidential*, with a monthly circulation of 4.2 million, became the leading Hollywood gossip sheet, with a shoal of imitators such as *Hush-Hush* and *On the QT* pushing the monthly circulation for this type of periodical to 15 million.

In one respect, *Confidential* was a creature of its age, which, as one commentator put it, comprised the quiet decades of political gossip. Unlike the early heroes of the emergent profession – the muckrakers of the 1920s – American journalism in the 1950s had lost its critical edge. The sensationalism of the early years, when "muck raking" was deemed a defensible practice, was steadily marginalised by notions of respectability, objectivity and impartiality. Until the turmoil of Watergate, political gossip was regarded as largely an insider matter, a background noise that might affect political elites but was rarely revealed to the general

public (Collins G, 1998: 191). There was a market niche that was awaiting exploitation. *Confidential* stepped in.

The sharp focus on personal gossip and the thematic preoccupations of *Confidential* – adultery, homosexuality and interracial dating – made it seem the antithesis of fan magazines like *Photoplay*. But in fact, *Confidential* was closer to Hollywood's own practices in a number of respects:

(a) The use of a network of paid informants: disaffected lovers, friends and even family members and professionally placed onlookers such as doormen, chauffeurs and private detectives. If it was actually true that Hedda Hopper or Louella Parsons never paid cash for tip-offs, they used similar networks.

(b) Leverage of differential exposure – a gossip item on a particular star could be withdrawn before publication in exchange for another gossip item. *Confidential* agreed to suppress an item about Rock Hudson's homosexuality in exchange for a story on Rory Calhoun's prison record. Hopper and Parsons' practice of extracting favours for keeping gossip from a star's employers is only a shade different from this practice (Goodman, 1961).

(c) A shared belief that an individual's sexual preferences and activities were a central aspect of his/her identity. In the case of politicians, this belief had usually involved the notion of corruption by association – blackmail by a foreign power. In the case of stars, persona credibility was the critical issue.

(d) A deep awe for the targets of gossip, implied by the belief that lapses of credibility are important news.

(e) Structural inconsequentiality – Dirt on a politician might demobilize a political platform; dirt on a star usually only stops a career.[5] Certain movie stars, such as Jane Fonda and Paul Robeson, could be regarded as being punished for overstepping the line into structural consequentiality.

Given these parallelisms, there seems to remain an important point of difference: the studio publicist wishes to preserve or build a reputation, the gossip journalist to tear it down. At the time of *Confidential* this conflict was real and led to its final downfall. But with the contemporary development of tabloid journalism as a news genre, even this conflict is far from clear-cut. Routine practice celebrity gossip is very much a "negotiated celebration" because gossip writers and publicists have a mutual interest in preserving the affective bond between gossipees and the general public (Gamson, 1994).[6] Yet in recent times this negotiation seems to be breaking down or, more exactly, changing its terms.

Contemporary gossip magazines give scant attention to the professional careers of stars and celebrities in favour of an exploration of their romantic engagements and sex lives. (McDonnell, 2014)[7]

But until this later development, the 'wild' side of stars and celebrity behaviour only became public in special circumstances when the gossipee has committed (or at least been charged with) some offence, a misdemeanour or felony that finds its way onto the public record, thereby becoming subject to intra-media competition. Not only is such an item hard news, it is also libel-proof – conditions which ensure a media blitz and the haemorrhaging of 'sources' in a cascade of bids and pay-offs.[8] The global reach of tabloid gossip also offers its own isolation from public reaction, because what would be sanctioned in one group is a welcome endorsement of cherished values in another. Absent a connection with an organized pressure group (and even then, given free-speech rights), readers lack the power to enforce sanctions against individuals who, courtesy of mass media, can be present in their living space, or for that matter in the culture at large, and yet behave in ways that the viewer finds offensive. The viewer or reader, when not finding consolation in other celebrities, has his/her deep moral convictions (if any) reduced to a matter of personal preference.[9]

In hindsight, the significance of *Confidential* was that it took Hollywood at its own word – not debunking stardom, as it may have appeared, but testing the grounding of biographic positioning. It should not have mattered whether a particular star was actually consonant with the characters s/he routinely portrayed; it should not have mattered that the consonance was figurative rather than literal. But it did matter, because Hollywood publicity had said it did.

The seeding of autography

In *Photoplay*, the onset of autography is signalled by the attenuation of its traditional object. From the fifties onwards, pop stars and television stars were treated as honorary movie stars, with the latter losing their once-celebrated singularity. Crossover stars from pop music had been recognized from the introduction of sound, but new crossovers such as Fabian were given the accolade 'movie star' on the basis of celebrity guest appearances in teen movies. Whatever the acting merits of such earlier crossovers as Bing Crosby or Sinatra, these individuals at least endeavoured to shoulder the burden of characterization. In blurring the definition of movie star, *Photoplay* undermined its unique selling point as a movie magazine, becoming a vehicle for a generalized media celebrity.

This transition, if unmarked at the level of substance, reveals itself at the level of form. Noteworthy here is a tendency to represent stardom more emphatically as a visual phenomenon, in which the figural supersedes the discursive. *Photoplay* was, of course, always a visual magazine, even discounting the ubiquity of display advertising. But by the 1950s, the balance between the discursive and the figural had shifted sharply in favour of the photograph and the graphic sign. In its heyday, an issue of *Photoplay* would run to at least 150 pages; issues from the 1950s onwards were around 50–60 pages, the reduction occurring at the expense of the written over the visual. The foregrounding of the figural is even more pronounced than this: typographical and lexical features of the written text were in themselves increasingly embedded in a display mode. Captions and those cousins of the factoid – the bullet point and the list – became the preferred devices, displacing the linear text with its punctual ordering of images by kaleidoscopic modes of presentation, familiar today in the tabloid press.

The proximate reasons for these innovations relate to marketing. As television eroded the readership for general-interest magazines among suburban housewives, the key readership for *Photoplay* became teenage girls whose interests centred on music and television. The new format of non-linear presentation and jazzy graphics was meant to appeal to this important new demographic. Relatedly, general-interest magazines like *Life* and *Look* had established the marketability of a candid photography format with the general public. Hollywood publicity photography followed this lead, adopting an informal but more sexually emphatic approach to stills production, most pronounced, of course, in the case of female starlets. The popularity of the pin-up – a kind of photographic sexual currency meant to encourage troop morale – also valorized the look over the statement, especially in the person of Betty Grable. Howard Hughes, through a winning combination of immense wealth and a deep appreciation of publicity, must be credited with creating, in Jane Russell, the first individual to be nationally known as a film star without appearing in a single film, the eventual release of *The Outlaw* merely codifying Russell's status as the prototype of corporeally persuasive starlet. This mode of stardom would be taken to a new level of studied application by Marilyn Monroe and her derivatives, Jayne Mansfield and Mamie Van Doren.

To exemplify these points, it is useful to contrast materials, randomly selected, that draw on biographic positioning even as they push beyond its parameters.[10] *Photoplay*, January 1950, is to all appearances a traditional issue. On the cover is a reproduction of a 'natural colour' portrait

by Don Ornitz of Elizabeth Taylor, the then star of *Conspirator*. The contents seem formulaic. All the feature articles are devoted to motion picture stars: Cary Grant, Montgomery Clift, June Haver, June Allyson, John Wayne. But there is a heightened emphasis on the human interest of the persona and on subjective experience, which is not counterbalanced by an emphasis on the professional context. For example, Cary Grant and Betsy Drake have marriage on their minds; June Haver writes of the end of a love story, a revelation continued in the June issue of the same year, which reveals how she overcame heartache; shy, retiring Montgomery Clift has no time for company, though company would obviously have time for him. The article on John Wayne, written by *Photoplay* veteran Herbert Howe, recalls the old fusion of the professional and private but only to immediately dissolve the former into the latter. Wayne 'will go down in mythology as the blue-eyed Hercules, altitude six four, weight 220, who single-handed lifted Hollywood out of hysterical depression and set her highballing' (Howe, 1950: 54).

A similar transition occurs in the article by gossip columnist Sheilah Graham, 'I'd Like to See Them Married' (Graham, 1950: 36). What is unusual about this example of the matchmaking feature, essentially a fan magazine cliché, is its whimsy. According to Graham, ideal matches are Kirk Douglas and Deanna Durbin, Montgomery Clift and Joan Fontaine, Liz Taylor and Lew Ayres, Stewart Granger and Joan Crawford. Even as deadpan jokes, the proposed matches were contrived and implausible; for example, Douglas was still married to his first wife in 1950 and Durbin, divorced from her second husband, was about to remarry and retire from the business. Clift, the same issue has already told the reader, wants, Garbo-like, to be left alone.

If the article is make-believe, where is it grounded? Not in persona. Kirk Douglas, who on his own account made a living out of playing sons of bitches, is hardly a complement to Durbin, Winnipeg's sweetheart and a saccharine star of musicals. Conversely, if this pair is a good romantic fit, then their respective personae are not reliable keys to their inner life. These disparities suggest a new situation in which the persona is losing its function as an authentic expression of the self and becoming a construct or a pose for the purpose of writing.

This development certainly reflects the retrenchment of Studio publicity. In Graham's case, letting fantasy reign is an easy way to complete a relatively unimportant chore – about this time, she wrote an article a month for *Photoplay* and was much more involved in radio work. The fact that this article was published speaks to a declining earnestness in the care of persona, a weakening of *Photoplay*'s traditional insistence on

providing an authentic entrée to the stars' private lives. Graham's style is more significant than what she writes about. Other pieces written for *Photoplay* – see, for example, 'I am in love with ten men' – reveal Graham as an exponent of the *tidbit*, the morsel of information that displays rather than explains its subject. Where *Photoplay* stalwarts like Adela Rogers St. John or Louella Parsons strive to essentialize stardom to the point of lecturing stars on noblesse oblige, Graham's forte is to register how the star affected her (Gelman, 1972: 346–347).

This new framing of persona is the discursive equivalent of the pin-up and has the same paradoxical effect. It seemingly brings the star closer, since the writing strives to mimic a 'live' encounter, and yet it confines itself to the rule that the encounter itself says all that needs to be said. The reader, if interested at all, is either content to look or regards the report of the writer's reactions as a surrogate for a more sustained contact. Being a fan becomes premised on a process of inter-passivity, delegating the power to 'know' the star to a third party. As the style of writing becomes more vivid, the star becomes more distant, filtered through a free indirect account of the writer's reactions to a literal presence.[11]

The new coding of star–fan interaction, a novelty in 1950, became the axial principle governing the representation of stars a decade later.[12] In *Photoplay*'s 'fiftieth' anniversary issue, December 1960, two featured articles play on the theme of eternal Hollywood. Under the banner headline 'Over the years things haven't changed much', contemporary female stars are displayed in dresses modelled after fashion plates of female stars like Mae Murray in 1925 and thirties stars like Greta Garbo, Katherine Hepburn and Bette Davis. Star power is equated with good taste which, transcending history, unites Old Hollywood and the New. The essence of taste is the look, and the look is the essence of stardom.

Physiognomic identification – you are as good as you look – is also evident in a photo-essay on Elvis Presley, then the pre-eminent example of a teen idol as a faux-movie star. Elvis, with his brooding, dark, sultry looks, is presented as the physiognomic inheritor of the star power of John Barrymore, Rudolph Valentino and Ramon Navarro, Robert Taylor being thrown in as a more proximate exemplar. This theme of similarity and shared physiognomic capital, descending like a patrimony on the latest stars, also surfaces in 'If I were Lana Turner' by Dee, another teen idol (*Photoplay*, 1960a). In another example, offered to unmarried girls in a Leap year when the initiative is theirs, 'bachelor' stars are displayed according to the warning signs they represent on the road to romance: 'Slow down, curves ahead' (Sinatra), 'Caution' (Dion of the Belmonts), 'Soft shoulder' (Grant). Married women of course are free to dream.

Avid fans can also learn that Frank Sinatra is Girl Trouble, whereas both Andy Williams and the Kingston Trio are Too Good for their own Good (*Photoplay b*, 1960)

Two things can be noted about this kind of article. First, there is the theme of revelation through appearance – stardom is a quality that is plainly seen in the physical presence of stars. Iconicity works pragmatically; such figural parallels telescope history, establishing a lineage and facilely bestowing the mantle of proven popularity on new stars.[13] Second, although eternal recurrence is a fan magazine cliché, what is striking is the degree of self-sufficiency with which these parallelisms are articulated. There is no recourse to a discussion of inner qualities to construct them. Not only are biographical details, outside of names, virtually absent, it is difficult to see how these details can be accorded any substantial importance if the visual parallelisms are to be maintained. The notion that Elvis is the same as Ramon Navarro or Robert Taylor is flimsy, if not absurd. If it is reasonable to assume that readers know all about Elvis, it seems unlikely that they can be expected to know or even care about Barrymore.

Another device that deepens the 'present in appearance' effect is the teaser: a headline that implies that the following story contains sensational revelations, usually of a sexual nature, about its subject. But the promise of scandal is immediately replaced by the impression of the scandalous as the content turns out to be innocuous, resting more on a breach of semantics than of morals. Ezra Goodman (1961), surveying the fan magazines of the early sixties, finds that they are infested with teaser articles. For One Glorious Afternoon I was Rock Hudson's Mate – Jane Wilkie goes sailing with Captain Rock; My Baby's Four Fathers – Gale Storm's three brothers can barely contain paternal affection for her daughter; The Man Kim Can't Get (her father) are typical examples.

The teaser is a figure of false transgression; there is no offence because nothing has actually happened – though the reader is supposed momentarily to believe or wish for the headline to be 'all too true'. The truth notwithstanding, the significance of the teaser lies in its contribution to the new way of constructing stardom as performative, rather than communicative. Like eye-catching graphics, the teaser grabs a space, which turns out to be empty.

In the new logic of publicity, what matters is position and the star's profile of visibility within the media. Stardom becomes a spatial quality defined against the position of other contenders. The capture of a portion of available space – and the place of that space in the hierarchy of

content, on the cover and so on – becomes an end in itself. Practically, the concept of persona shrinks to the minimal guarantees of presence – a name and a physical, usually photographic, image – so that star presence equates to the status of a marker or an autograph.

Elizabeth Taylor, in particular, epitomizes the new figural star or celebrity, whose image on the cover of an edition will boost sales regardless of the factuality of content and its direct relevance to the activity of film-making.[14] An example of this trend, to be further endorsed by the Taylor–Burton love fest, is the extensive coverage of the love triangle between Elizabeth Taylor, Debbie Reynolds and Eddie Fisher. Banner headlines in Photoplay in the first three month of 1960 such as 'What Debbie did when Liz and Eddie walked in' and 'Why Liz had to leave the party' turn out too have no basis in any actual encounter but are rather speculations on how either woman must have been feeling if the events had actually happened.[15]

The trend of visual abstraction in the foregoing examples is certainly in response to the uncertainties of persona-making in the aftermath of *Confidential*. *Photoplay* is faced with a dilemma: how can the market advantages of the shocking and scandalous be reconciled with stardom as a desirable state, worthy of emulation? The alteration in the star–fan relationship through which presence is detached from intimate acquaintance is the basic solution. A rationale of immediacy, organizing the verbal to serve the visual, connects the pin-up, the tidbit and the teaser. They are all vehicles for a kind of contact in which the star is present, as an eidolon, a shadowy other behind a visually rendered exterior. In previous times, stars were rendered as concrete personalities that stood in an allegorical relationship with a way of life. In the new scheme, stars are represented as emblems or signals – visual displays that claim to directly convey meaning. If what is interesting about stars is given through appearance then there is no need to explore their work as actors. Anyone who fits the photographic specification of good looks can be a star.[16] The reader, too, is spared any context beyond an immediate 'encounter'. Photographically and verbally, she is furnished with images to be grounded in a private narrative of desire (Vermorel and Vermorel, 2011).

For motion picture stars, the opportunity to be visible in public and yet withdrawn as a person is not without its disadvantages. If anyone who looks good can be a star, then looking good becomes a physiognomic requirement, not visited so stringently on stars of the past. Yet if looking good is all, then how can actors maintain their advantage over anyone with the right physical equipment? The answer that emerges

is that movie stars must assume the mantle of creative visionaries – seeming no more like ordinary folk who made it big, but big talents who were never ordinary.

People Magazine

Photoplay cannot fully embrace the logic of autography; this is left to a new rival, *People* magazine.[17] From its first national weekly issue in 1974 (a pilot copy, with Elizabeth Taylor on the cover, was test-marketed in 1973), *People* focused on 'the active personalities of our time . . . on people, especially the above average, the important, the charismatic, the singular.'[18] Within three years of its successful launch, *People* editor and guiding light Richard Stolley expanded the realm of celebrity to include any individuals, not just media personalities, who had obtained national eminence. Equating cultural significance with media attention, and offering its coverage as the benchmark of the 'active personality', *People*'s pool of 'stars' was not restricted to 'show business', but covered 'active personalities' from the worlds of politics, sport and the Rich and the Royal. Unlike *Photoplay*, its eclectic embrace of any celebrity was an advantage rather than a straining after currency.

People's elitist orientation and upbeat, supportive style made it (and makes it today) the preferred outlet for celebrity promotion to a mid- to down-market readership, especially in contrast to even the least outrageous supermarket tabloid, the *National Enquirer*. The latter, as the premier tabloid, had abandoned its original emphasis on sex and gore, and by the early seventies was operating with a format that is evident today. The dominant thematic emphasis, like *People*'s, is on celebrity gossip journalism, which, contrary to a common perception, is primarily positive in substance, if not in tone. The ethical compass of the *National Enquirer* is markedly confined to the realm of personal morality and breaches of socially approved folkways, rather than core values. Lapses of caring and decency, infidelity, greediness, hubris and vainglory in personal and professional life make up by far the greater majority of leading stories. Where the circumstances to be reported involve issues of alleged law-breaking, as in coverage of the O. J. Simpson murder trial, the *National Enquirer* (much like the rest of the tabloid press) has no inhibitions as regards the sensationalism of its coverage or the accuracy or reliability of its sources. But most of its coverage is far from these moments of 'carnivalesque' licence – a licence in any case intimately dependent on police involvement (Bird, 1992: 44ff).[19]

If the focus on peccadilloes is a common feature, in contrast to its rival inheritors of the *Confidential* tradition, *People*'s treatment of celebrities is more deferential and reflects a 'soft' rather than 'hard' news orientation. If forced by circumstances to address serious breaches of moral conduct, its primary orientation – like *Photoplay*'s before it – is to preserve and rehabilitate an image, as opposed to letting the logic of debunking run its attention-grabbing course. The implicit lesson is 'famous people can do bad things, and still be nice' – indeed, for the most part they *are* nice.[20]

Persona preservation (or rehabilitation) is not simply a matter of house style, however. *People*'s investment in preserving persona is driven by concrete considerations of marketing. The term 'active personality' is in fact more restrictive than it seems, since it is the face (or faces) on the cover that is perceived as the locomotive of circulation.

Summarizing his experience as the founding editor, Stolley, quoted in Kessler (1994), concluded that the successful cover, which maximized copy sales regardless of content, followed certain elementary rules. The first set, which might be called rules of being, indicate personal qualities and the second, rules of activity – occupational qualities.

> Being
> Young is better than old;
> Pretty is better than ugly;
> Rich is better than poor.
>
> Activity
> TV is better than music;
> Music is better than movies;
> Movies are better than sports;
> And anything is better than politics . . .

If Stolley's rules are regarded as empirical propositions, then the evidence is that overall stars from Television, Music and Film dominated the pride of place on the cover of *People* Magazine from the first issue onwards. Since 1975, the second full year of national publication, stars so defined have occupied more than 50% of the available cover space and in many years, as much as 75%. In recent times, from 1990 onwards, there has been an increase in the number of 'personalities' featured on the cover connected with spectacular crime stories, for example, the Texas Cheerleader and Amy Fisher trials, or sensational celebrity divorces involving, for example, Woody Allen or Burt Reynolds, but this has been at the expense of coverage of celebrities from the world of Sports, Politics and the Rich and Famous.[21]

If individual cover stories are considered, Diana Spencer, even prior to her death, was an outright winner, with 55 covers; Liz Taylor, with 26 covers, was a distant second (Kessler, 1994).[22] But this is clearly an exceptional case, not unconnected with television and movie stardom, which continues to epitomize the highest level of media fame. For example, well over half of *People* Magazine's '50 most beautiful people in the world' were actors whose celebrity rested on motion picture production involvement. Significantly, motion pictures are the field in which stellar earnings are the highest.[23] Indeed, it seems as if the generalization of motion picture stardom, marked by audiovisual crossovers, is undergoing a further extension into the field of modelling, as film stars like Cameron Diaz or Sandra Bullock replace professional models on the covers of haute couture magazines such as *Vogue*.

Although these developments might appear to contradict Stolley's law that motion pictures are one of the least desirable fields for successful cover celebrities, the more likely relationship is that movie stardom is recognized as the ultimate goal of 'celebrity' and, consequently, is the field in which the basic criteria of celebrity being – young, good-looking and actually or potentially very wealthy – are in plentiful supply.

Rules of thumb are not, of course, to be taken too literally, though in this case they are derived from a close study of what actually sells and reader-preference surveys. Much like rules governing news processing, the cover rules are interactive: an individual of exceptional beauty, regardless of field, is more likely to be considered for cover celebration than one who is considered less attractive (Harcup and O'Neill, 2001).

The less attractive might make inside copy but not the cover; individuals lacking the necessary looks, unless associated with extraordinary events, are likely to be excluded. The face on the cover does not just sell an issue; it also establishes a hierarchy of fame and celebrity: sorting celebrities into major and minor leagues, signalling who is on the rise and who is on the wane, who will never reach the highest levels of acclaim and who already has. The realm of celebrity has its own winners and losers, the exemplary and the average, offering a glittering condensation of the overall relationship between celebrities and ordinary people.

What *People* magazine codified is a quality that is generic to the entire range of celebrity publications, whether these are primarily laudatory or debunking: the essence of a celebrity is to be found in his/her appearance. A name is linked to a look, and a look fills out a name. In this sense the stars become the authors of their own images. The anxious appraisal of the gap between the 'look' on screen and everyday appearance, the

worship of makeovers, the litany of the costs of fame – relationship breakdown, substance abuse, sex addiction and so on – testify to stars' determination to make the most of their looks and talent; to become, in effect, the authors of their own identities, or gloriously fail in the attempt (Gabler, 1998: 144–151).

What does not change, of necessity, is the function of the name as a personal marker, as evidence of the abidance of the star behind the diverse activities that constitute his/her talent. But what appears in one aspect to be a new literalization of the persona is at the same time the precondition for its more intensive deployment. For if stars become instantly knowable through their appearance, then the career of a star can become a career of appearances without reference to actual motion picture-related involvements. Indeed, since anyone can make use of the star's image with or without permission, celebrity status carries with it the immanent risk of being taken into an uncontrolled and less flattering context. The image once publicly externalized acquires a history of use, which, as in the case of the Pamela Anderson–Tommy Lee private video or, to cite an earlier example, Monroe's nude pin-up, can rub against the professional interests of the star. Spin management and identity triage become as important as image creation, if not more so.

The notion that stellar being is a string of performances means that the notion of a relevant performance is replaced by the assumption that all performances – professional, private, accidental or planned – are relevant. The star's image becomes a personal exchange value, with a potential myriad of uses. Such a value must be protected against the consequences of misuse, so it follows that persona maintenance becomes auto-referential, driven by the self-interest of the star. Overexposure becomes endemic, not just in terms of the risk of sameness, but also in terms of too much detail subtracting from a positive image. The defensiveness that accompanies this development further removes the star from an engagement with collective processes of representation. As the essentially self-interested business of pursuing a career imposes itself on the process of public recognition and fame, a new paradox emerges: the greater the scope of publicity, the more narrowly the collective meaning of stardom must be defined. Given the intensity of competition and the scale of reward in a winner-take-all environment, the stars are driven to behave like shoppers in search of a personal bargain in the department store of collective significance (Frank and Cook, 1995). The public are searching for a personal bargain too. So the problem is, how to balance self-interest with the box-office demand that the stars commune with their audiences?

Sharon writes herself [24]

In the post-Studio context, fan-magazine writing increasingly became a depiction of celebrity: a presence *connected* but not *defined by* the vocation of movie star. Stars began to take on the mantle of celebrities or at least function as both stars and celebrities. Where stars once endorsed specific products – cosmetics, personal jewellery and fashion – as 'ideal' consumers, the stars of the post-Studio era began to develop into brands that incarnated total lifestyles, as coaches that embodied a suite of experiences (Rojek, 2012: 139). But there was a moment of transition, or a cultural lag in which fan magazines sought to contain new forms of stardom and celebrity within the frameworks and the cultural capital established by the Studio era. Now instead of representing pop stars like Sinatra or Fabian as movie stars, the category of star became defined as a 'career' built around a flexible portfolio of identity-based products and services in any plausible area of personal services marketing. Where once the movie star was understood to be a creature of a specific milieu, s/he now becomes an image entrepreneur marketing his or her named likeness to anyone prepared to pay for its use. When this occurs the movie star's persona, in search of new earning opportunities, expands to become an omnibus brand that encompasses traditional 'character' playing as well as product or event endorsements. Conversely other stars from other realms of performance and celebrities proper begin to enter into movie stardom.

One driver in these developments relates to changes in the social distribution of fame that follow with the rise of new formats such as Reality Television, celebrity journalism and ultimately social media. More will be said on these developments subsequently, though in general they tend towards the replacement of representation by presentation (Marshall, 2010). The focus here is on how Hollywood stardom attempts to adjust to these new possibilities and realities. How can the accumulated symbolic capital and prestige of being a move star and not a media celebrity be preserved in the new conditions? One answer, which in fact is finally ineffective, is that a new mode of positioning is developed which can be termed autography – the star writes (or at least has written) his or her biography – how to preserve a persona without maintaining a consistent relationship with a particular kind of character. To give a brief example of this new kind of writing about stars – essentially how stars (or their agents and employers) write about their persona from a place outside of or existentially adjacent to it – I will focus on Sharon Stone who provided an early example of a response within Hollywood

to post-feminism, a new assertiveness which challenges patriarchy by means of a hypersexual conformity, in turn demanding hard male bodies to match the newly 'liberated' woman (McRobbie, 2007).[25]

It comes as no surprise that Stone's persona is intimately connected with the contradictions of gender. On the one hand, she cultivated the look and appearance of a 'Blonde Barbie Doll' – an alluring and fascinating sex object that typifies to the general public, if not to the Hollywood community, a heterosexist ideal. At the same time, she also emphasized at the start of her career that she was blonde but not dumb, claiming an IQ of 153.[26] Moreover, she emphasized that she was far from a passive object of male desire:

'If you have a vagina and a point of view, that's a deadly combination' De Vries (1992)

In this prepared statement, we find the entire enigma of the Stone persona: deadly for whom and in what way – by grievous bodily harm or sexual ecstasy.[27] But such obvious bon mots prepared for promotional tours also point towards a more systematic tension. Compounding the contradictions of her apparent type, she also manages to condense in her persona the task of seeking to be a traditional motion picture star when Hollywood no longer exists. She seems to model herself after Jean Harlow or Monroe in a context where the linear equation of place and being is undermined by overexposure and a global scale of employment.

The persona constructed by her public statements has been connected with her character in the erotic thriller *Basic Instinct* (1992), the role that made her a star, though an earlier role with Arnold Schwarzenegger in *Total Recall* (1990) established her credentials as a kickboxing femme fatale. As Catherine Tramell, a successful crime novelist who prefigures the murders of her lovers in the plots of her bestsellers, Stone's performance with Michael Douglas stretched the limits of explicitness in mainstream cinema. An early scene, a frame grab of which is still available online, where an apparently underwear-free Tramell 'flashed' a group of interrogating police officers generated intense interest. The opening orgasmic sequence in which a naked blonde – eventually revealed to be Tramell – straddles and then murders her trussed-up male sex partner with a teasing phallic ice pick, have assumed a legendary status. Rather than being seen as an insight into the world of her character, such scenes have been interpreted as an insight into Stone herself.

That *Basic Instinct* had three leading female characters that were at least bisexual, if not lesbian, served to deepen the association between

Stone's persona and alternative (media conventions imply deviant) sexual practices. Protests by lesbian and gay groups during filming over the pathologizing aspects of the plot served, inadvertently, to cement this association and generate advanced publicity and controversy.

The plot of *Basic Instinct* does not actually condemn Tramell's behaviour nor, in full recognition of the double standard, the behaviour of Michael Douglas' character, Detective Nick Curran. Tramell is certainly the deadly sexual trickster, delighting in manipulating others and showing an evident relish in 'perverse' sexual practices. But reined in by the sexual prowess of Detective Nick Curran, she manages to elude justice. Nor does the plot make much of extenuating circumstances for her conduct, such as a backstory of childhood abuse and trauma.

Given the box-office success of *Basic Instinct*, Stone's newly consecrated stardom was associated with the persona of a sexually aggressive femme fatale or 'bitch goddess' who gets her way. As a starlet, in a breakout role with an established star, Stone had little choice but to accept the equation between Tramell's personality and her own as the basis for future projects. So although she subsequently voiced concerns about typecasting, her next role in the erotic thriller *Sliver* (1993) – again written by Joe Eszterhas – followed her established persona. However, she used her star power to correct the erroneous view of female sexuality projected in her first box-office hit:

> *Basic Instinct* was about fantasy. I mean who makes love like that? All back-bends and an orgasm every second! And who has such confidence to rip off all their clothes? . . . This time, my character is more real, and women will recognise all her insecurities. She has spent most of her life with one man and she is frightened about making a new relationship. She is shy and scared about making love with someone else. I have tried to do it in a way women go about their private lives – me included.
>
> (Munn, 1997: 100)

Yet for all the proclaimed effort at corrective casting, the character of Carly Norris in *Sliver* – 'fragile, damaged, vulnerable, insecure about sex' – still replays elements of Tramell. In one scene, set in a posh restaurant, Carly reveals her breasts and removes her panties to pass them to her lover (played by William Baldwin). *Sliver*'s plot with scenes of nudity, covert surveillance of sexual activities, voyeurism, and frank sexual dialogue recall similar scenes in *Basic Instinct*. Carly Norris may not have, like Catherine Tramell, 'deep psychological and sexual defects, which affect her mental

stability,' but she is the visual crux of voyeurism and pathological desire, as a victim rather than a predator. *Sliver* as a camouflaged clone of the Tramell persona was unsuccessful at the US box office.[28] She capitalized on her bankability in a series of films: *Intersection* (1994), *Last Dance* (1996), *The Quick and the Dead*, (1996), *Diabolique* (1996), *The Mighty* (1998). None of these forays into new kinds of characters – inter alia playing a wronged spouse, a prisoner on death row, an avenging cowgirl, the mother of a gifted child – proved as big a box-office success as *Basic Instinct*. So they amounted, in Hollywood terms, to dishonoured cheques in the bank of reputation and she failed to cash out her desire to be seen as an actor rather than a wound-up sexual mannequin. Given that these cross-casting efforts have had decidedly mixed reviews for acting and poor box-office returns, Stone seems to be a prisoner of her own persona. It is worth noting that this is not her view. She observed of her Oscar-nominated role of Ginger in Scorsese's *Casino* (1995) – that it had wiped out the Tramell legacy. Nonetheless, the character of a coke-snorting hooker could be plausibly seen as the Tramell persona in victim mode. The long saga of the making of the sequel, *Basic Instinct 2* (2006), seems to have marked a final capitulation of her thespian ambitions. *Basic Instinct 2* seems to have been designed to fulfil the fantasies of males who prefer mature women, or if not erotically engaged are at least curious to see if the body of an aging actress can live up to the demands of sexual display. Stone herself did not see fit to dispel such expectations and she was reported to be keen to perform in even more explicit sex scenes.[29] The movie was a box-office disaster and one reason for this was its failure to deliver a superlative simulation of sex, when the 'real' thing was available in abundance and with greater functional explicitness on the Internet. Regarding Stone herself, the imaginative appetites of fans and other online lurkers far exceeded what she offered within the confines of being a movie star or, indeed, what the motion picture rating system would permit. In this respect, the ever-expanding discourse of Internet pornography becomes in her case, a demand that she *be who she really is*: that is, Catherine Tramell. Nor would the media let her identification with *Basic Instinct* lapse. In 2001 when she adopted a child and in 2008 when she lost custody the headlines carried the pun 'maternal instinct'.[30] Ironically, given the wilder speculations, being forced back into the Tramell persona might not be a bad thing. It meets a market demand, maintains a personal monopoly over a role and offers the excuse of feigning.

Her own unsuccessful efforts at rewriting her persona are meant to serve notice on the general public and Stone fans, in particular, of an interactive rule. All concerned must recognize the gulf between Stone, the actor as a personage, and the characters she portrays. She has repeatedly insisted on

an unbridgeable gulf between what she feels and how she is required to act, on screen and in promotional settings. The Tramell persona, far from being a vehicle for self-expression, is a 'stupid objectification' an observation that positions her in solidarity with all women in late-capitalist America. Even though she is privileged and rich, sexism has affected her opportunities as an actor because lacking the standing of major actors such as Meryl Streep and Glenn Close has forced her to comply with Hollywood's perception of women who look like she does and presumably come from a background as a model. As the evocation of Streep and Close (though she seems to have forgotten the latter in *Fatal Attraction*) playing Tramell did not necessarily require nudity and sexual objectification, but to save her career she was willing to do them (Munn, 1997: 84, 57). Moreover, the persona of Tramell was professionally enabling:

> When I first got famous, the image of the movie (*Basic Instinct*) really protected me. Everyone thought I had so much bravado and was so wild. So I could continue to be that. It was a blast.
>
> (Berlin, 1996: 43)

The triumphalism of subordination now turns into a metaphor of empowerment straight out of the writ of post-feminism:

> It is so rare that a female character is more than an appendage to some guy. But I never thought of Catherine as bisexual or even sexual. Sex is just the currency she uses to get what she wants . . . and when she sees that something excites him, it makes her all the more excited.
>
> (Munn, 1997: 69)

Moreover, underscoring the collapse of on-screen and off-screen life, she has said that the fact that men she meets believe she is Tramell is a tribute to her artistry. At the same time this artistry is not entirely a fabrication.

> "People who are sophisticated enough to know that I'm not Catherine are sophisticated enough to know that I could be, if I wanted to."
>
> (Schruers, 1993: 65)

Statements like these suggest that for Stone the line between being and seeming is very permeable. In part, this may be an effect of the Hollywood tradition of method acting, which emphasizes the enlivenment of character portrayal through the use of personal experience.[31]

This approach may convince audiences that they are 'getting' to the real Sharon, but for the star herself, there is the risk of depleting the back files of disclosed intimacies. Better to remain ambiguous to feed the hermeneutics of suspicion, sustaining the semantic ricochet between real and false that is the meat of publicity. So the curious reader can learn that 'basic Sharon' is really more like a cuddly toy than a tigress. Yet the star's reported sexual affairs suggest that the image of a sexual predator is not entirely undeserved. Even quotes in authorized materials failed to dispel this implication, discussing, for example, her very messy 'fling' with producer Bill MacDonald during the making of *Sliver*, or informing the reader that Stone's willingness to 'show all' 'in a Playboy centrefold surprised even an assignment-hardened photographer. Her reported musings that sexual realism in *Basic Instinct* did not go far enough since anal sex was not depicted seem to hint at a greater sexual sophistication than was possessed by Tramell or the screenwriter Joe Eszterhas. Likewise, her protests about being exploited by Paul Verhoeven in the 'flash' scene suggest a lack of inhibition since the matter under contention is not impropriety but respect for her standing as a professional actor:

> As a mature artist, I agree that shot was the best for the movie. I really disagree with the way he got it. Because it made me look incredibly stupid when I was very, very willing to do what it took to be that character.
>
> (King, 2003: 57)

But if Stone is prepared to 'go to the limit' in pretence and masquerade, readers may wonder: how different is she from Tramell? Allowing that Tramell is a fictional construct, might not the erotic energy and imaginativeness arise from Stone herself? Even her promotional efforts for *The Mighty* counterfactually endorse the premise that convincing characters spring from personal experiences. Her decision not to have children is accepted as a potential disqualification for playing a mother, as though parts can only be played from experience.

One might suspect that such avowals of deep personal engagement are a matter of promotional expediency, and certainly this is an element of what is going on. But there are longer-term ramifications, since the confusion between the 'bitch goddess' and Stone's actual person is a valuable commercial device for generating excitement. Over time, the multiplication of claims of existential bonding should work to underscore the distance from any particular character, serving to place Stone outside of any particular character as a manipulator of appearances.[32]

If each role is a part of the real Sharon, then each performance can be evaluated in terms of what it does by way of actualizing her underlying self. If this reasoning is applied, then surely her most successful and powerful performance is the one closest to who she is, given that successful portrayal rests on empathy. It is a short step to conclude that the narrative existence of Catherine Tramell is simply activation with deep existential roots in Stone's struggle to succeed. So if her authorized publicity reassures interested male fans that Stone is really – despite her physiognomic capital and professional determination – an ordinary, small-town girl who falls for guys who are 'regular' and 'square' like her father, the halo effects of *Basic Instinct* are there to contradict this reassuring image. For Paul Verhoeven, Stone is Catherine Tramell minus the killings; for Robert Evans, the producer of *Sliver*, she has 'Balls like Mike Tyson' (Cagle, 1993).

In this line of interpretation, the very intensity of her denial is revealing: if she was not like Tramell, why would it be necessary to talk so much about re-rewriting her persona? If we step across the threshold of authorized biography, the relationship between the fictive and the real becomes even more confused and blurred. Frank Sanello (1997), for example, opens his unauthorized biography *Naked Instinct* with an 'eyewitness' account of a lesbian encounter between Stone and an unnamed woman in the powder room of the Beverley Hills Hilton that reads like a scene from *Basic Instinct*.[33] William Baldwin, who starred with Stone in *Sliver*, has referred to her as a 'paean to Lipstick Lesbianism'. Stone herself adds further fuel to speculation:

> I have to straighten out my karma. . . . I've become a sex symbol, which is an absurd thing for me. Particularly since I symbolize the kind of sex I don't believe in.
>
> (Schruers, 1993: 59)

The ambiguity of statements such as these interfaced with proclamations of heterosexual desire serve to re-enforce the perception that Stone is bisexual. But if this is true then Tramell is, in some sense, an 'apt' extension of the 'real Sharon Stone'.

The foregoing observations pose a contradiction: Stone's persona can only be accorded a real (as opposed to virtual) existence by asserting that a private self exists below the threshold of publicity; but the private self is clearly identified by her as an external reality imposed by stardom. It is useful to be a blonde in dealing with men, even if she is not a natural blonde. It is not difficult to discern, and this may be quite consciously

intended, the notion of femininity as a strategic masquerade (McRobbie, 2007). A theme that reaches back to the female stars of the eighteenth century and with the same dilemma: how to commodify the self without loss of integrity. The agency of Stone – acted out on-screen and in auditions – embodies the script of masculine desire, the better to gain control of her career.

Stone is like a star of the studio system in the sense that her performance on screen tends to be represented as being an exercise in self-expression. If this holds true, then her assumption of a different character will not disturb the cinemagoer's expectation of a uniform 'personal' encounter. But she is unlike a studio star in that she only provides an ambiguous answer to the question of being rather than seeming. She has not unequivocally affirmed or denied that she is Tramell, and others that have had the opportunity to observe her at close range neither affirm nor deny the existential bond. So in the practice of autography, the issue is not just a matter of establishing a distance from a specific character – which is, after all, how an actor has a career – but of establishing a distance from the process of persona construction itself. In part, Stone does this by building a reputation as a personage involved in social causes, receiving, for example, the Nobel Peace Laureates Summit Award in 2013 for her work for the Aids Foundation, but her gaffes in various public events, vide her unfortunate remarks at Cannes in 2008 about the Sichuan earthquake, tend to suggest that she lacks the requisite skills to comfortably inhabit the personage implied by these elite occasions.[34]

Ultimately, what credibility she has rests on being a star. And even in a protected site such as an authorized biography, it is no longer possible to present stardom as a condition of settled identity, a condition that affects not only Stone but her peers. The possibility of the disintegration of persona is endemic. This is not merely a matter of the effect of counter-images and discrepant persona specifications arising from rumour and urban legends that link stars with 'bizarre' events and practices – such as the false rumours about a deep tissue contact between Richard Gere and a gerbil. Discrepant information is part of the 'normal' condition of persona in the post-Studio era, even in authorized publicity work. Attention-grabbing opinions uttered in different contexts can be brought together in discrediting collages. So as identity is chronically decentred by being written and talked about in so many disparate settings, certain strategies emerge that tend to intensify, rather than alleviate, the propositional ground to be covered; producing a synthetic personality that invests the burden of 'truth' in moments of minimal narrative articulation such as sound bites, the photo-opportunity,

the Talk Show interview and the promotional Q and A event – for which responses can be scripted and prepared in advance (Tolson, 1991).

Alternatively, the star may engage in a strategy of 'licensed withdrawal' – of being visible in public and yet marked as having an inner self that is withdrawn from the encounter (Goffman, 1979). This is most often accomplished by a free indirect style of writing in which the writer puts his or her reactions to the star in place of the star's reactions – an effect often brought about by the fact that the star and the interviewer do not meet (Delin, 2000). Another protective device is the 'bon mots' compilation in which celebrity one-liners are collected by authors outside of the star's entourage and published online or in books with or without permission.[35] Such morsels of stellar wisdom provide for the maintenance of a public profile with a minimal level of 'self' exposure.[36]

The real problem for all these strategies is that persona construction can no longer be guaranteed as a *negotiated celebration* between journalists and stars. The Internet has made images and text about stars a common resource available to anyone who wants to comment online.[37] Corporate sites like *Mr. Showbiz* and individual sites, such as those found on the Sharon Stone web ring, tend to recycle authorized bio-data or recount the writer's favourite scenes or photographs. But such sites can do little to contain fans' curiosity, since they exist in the same hyperspace as newsgroups and web sites that invite readers to engage in more imaginative interrogations of the star's public identity in blogs and on hate sites.

This is not without its complications. As she observes: 'In this business there is Plan A, in which you become successful by living and acting with a lot of integrity. Then there's Plan B, where you sell your soul to the Devil. I still find it hard to distinguish one from the other.' (Biography – IMDb)

The literal encasement of the persona and person in a character – of the actual Stone in the fictional Tramell – exemplifies the tendency of autographic representation but also its points towards its supersession. Writing Sharon in this way (and Sharon's ostensible writing of herself) destabilises the process of self-presentation through the circulation of possible identities in which the only constant is her name as a label for her body – hence her deep investment in appearance. Consequently she vacillates between a personage and a person – the successful actor and controversial ambassador for charities, and a sex symbol deploying her looks to sell movies.[38] (Adams, 2008)

Like *Photoplay*, Stone is mounting a rear-guard action, but on two fronts: on one front against the corrosive effects of time on her principal

business asset – her looks. On the other front she faces the need to maintain a media profile that will fade or be displaced by a rival unless she does something sensational with her body. These manoeuvres are exercises of free will but are constrained by the need to confirm the identity script set by the character, Tramell (Pringle, 2007). Caught between a sense of reserve in respect for her craft or because there are other younger, perhaps more capable or physically less worn rivals, she no longer seems able to resolve her public identity into a wearable persona.

Her trajectory provides an example of an attempt to stay within the boundaries of autography that is doomed to fail. Her recent role in Lovelace (2013) seems to acknowledge that her bid to remain a star is coming to an end because, as one account has it, she is virtually invisible, which is to say the Tramell persona has retreated behind a character (Horn, 2013).

The trials of Stone, self-inflicted or not, are a precursor of a new form of positioning which in order to evade the attempts of the media to attribute to the self an essence or core, writes the self as elusive and protean.[39] This form of writing the self, explored in the next chapter, marks the limits of autography.[40] A consequence – mostly unintended or, at least, outside the power of any star or celebrity to control – is the emergence of a condition of fame without a direct or even coherent collective function; Boorstin's nightmare of empty celebrity realised.

8
The End of Seeming

A feature of the contemporary scene of stardom is the mutation of autography into a more intensively reductive form of writing the self. If autography pushes the limits of the relationship of 'standing for' to self-presentation, the new mode of writing and performance pushes the presentation of a self below the horizon of selfhood so that being private in public becomes a priority – the self of the star is there, so to speak, but hidden, inspiring a search in others for "authenticity". In the way it is used here, steganography refers to the hiding of the "authentic" self behind an intertextual assemblage of performed identities.[1] This new practice exceeds and ruptures the framework of person, personage, character, persona, in which seeming – the performer's forte – is reduced to being or a bare nominal presence. Compared to autography, which declares, 'Here I am', steganography renders its subject as a trace, ambiguous and underspecified yet sufficient to maintain a media name profile. The fullest extent of this process of hiding in plain sight I identify with *intimate fame* or celebrity (Redmond, 2006). In such a condition of fame, the star or celebrity is reduced to a nominal presence, fleshed out by selective images and publicity per se, good or bad, becomes of paramount importance.

In order to suggest how steganography works to present, rather than represent, a self, I offer two examples – the first weak and unpersuasive and the second, a fully realised example.

(1) Macaulay eats a pizza

On December 2013, a video 4.28 minutes in length, was posted on YouTube. It features Macaulay Culkin eating a slice of pizza. The former child star is shown seated at a refectory table facing a static video

camera. The video is comprised of a single shot of long duration covering a bare minimum of activity. Culkin removes the pizza from its bag, tears off the crust and sets it to one side, wipes his lips several times with a serviette; then, having finished eating, returns the leftover crust to the bag, which is then vigorously scrunched and set aside on the table. During the whole sequence, he looks off into space, eyes wandering left and right, scanning the environment in a bored or anxious manner. His eyes address the camera fleetingly – the most direct and sustained gaze occurring near the end of the video. Throughout he is silent, speaking only twice: first, to say that the oregano he was trying to sprinkle on the pizza slice was not coming out of its jar and, second, at the end, when he names himself and says the viewer has watched Culkin eating pizza. During the last seconds of the video, a voiceover intones 'Pizza, New York,' which is repeated in a title on screen. The posting has so far attracted nearly a million and half views.

As most viewers may know (and, if not, can easily find out), Culkin's video is a simulation of an earlier clip, 'Andy Warhol Eats a Hamburger', from the documentary *66 Scenes from America*, made in 1982 by Danish filmmaker Jorgen Leth. Culkin's video mimics Warhol's in all the essential details – length, shot composition, performance style, mainly silent delivery, even down to a closing title in which 'Pizza, New York' replaces 'Burger, New York'.

This closely engineered replication prompted online speculations, kicked off by an article in *TIME* magazine in which Eric Dodds asked 46 questions about it, only to be castigated for not being aware that it was a spoof of Warhol's original. Or was it homage?[2] Or was it Culkin engaged in an infinitely subtle form of performance art? Other questions struck a personal note: Was he stoned? How aged he looked, so distressed. Why is the bag so big; why did he not eat the crust, and so on.[3]

One seemingly minor difference between the clips is that in Warhol's, the brand of the hamburger, Burger King, is prominently displayed on the bag and the bottle of ketchup is Heinz.[4] In the Culkin clip, the bag has no logo and the oregano jar no visible label. But if the overt product placement in the Warhol clip were set aside, would this make any difference to the fact that Warhol and Culkin are the products being promoted? No, except they are being promoted on different scales of importance – Warhol as a personage or strong corporate brand, and Culkin, who is positioning himself, as a personage too, claiming a comparable status to Warhol. But copying the original video, even if it claims the personal authority of a dead-pan spoof, does not support a claim to originality or authenticity. It might, if Culkin was impersonating Warhol or replicating him but he

simply uses the original as a script for his own performance – staring at the camera or the surrounding screen space as though referencing the absent spaces of Warhol's own performance. Looking right but not looking right *as* Warhol – which it might be said is literally impossible but then why do it? Because Culkin has a status revival agenda.

Neither as a spoof nor in an acknowledged act of homage, Culkin is (rather slyly) claiming the credentials of a performance artist within the New York 'High Art Lite' scene.[5] As shown by the example of Jeff Koons, this scene has turned the postmodern conventions of quotation and pastiche, depthlessness and the melding of high art references with popular culture materials into marketing formulae (Jameson, 1991). Culkin's reference personage, Warhol was clearly a trailblazer but it was the Young British Artist scene in the 1990s that consolidated the persona of the artist as a popular culture poacher and celebrity (Stallabrass, 1999). But there is a second dimension of promotion, which in itself subtracts from Culkin claiming this persona: the video is a built on a pun that announces the spoof band Pizza Underground of which Culkin is a recent member. Here too, a claim to a High Art Lite pedigree is evident. Pizza Underground's repertoire consists of medley performances of covers of Velvet Underground songs with newly added pizza-themed lyrics.[6] As a member of the collective, Culkin is not building a new persona as an expression of a unique personality. Rather, this engagement is part of his attempts to position himself as a 'postmodern' artist and, through his sponsorship of artists and performers, a creative entrepreneur. As he observed of the first show of Art collaborative *Three Men and a Baby* (3MB), the purpose of their art was to express their own tastes through a process of random association:

> We would take two or three words – 'disco' . . . 'luau' . . . 'Hellraiser' – and we'd all just kind of giggle about that. 'Alright, let's do 'it.' We have no idea really what it's going to look like, or what our grand vision is, but we would have a good old laugh and just go for it. And I think the results speak for themselves in a certain kind of way.[7]

As the tag 'life after fame' suggests, the driver behind these 'stunts', is Culkin's attempt to rebrand himself, freeing a new identity from a child star afterlife of drug addiction and relationship failures (Boshoff and Witheridge, 2012). Yet despite the invidious contrast his 'cute' persona as a child film star places on his mature behaviour, he is not free to abandon it – in part because the public, fans and celebrity gossip journalists will not let him forget it and in part because he still wants to trade on his name as brand.

The claim to be a personage contained by the designation of 'performance artist' is more than just a rite of passage to artistic maturity appealing to the cognoscenti. It is a means of insinuating into his persona a new level of mystery created by a series of erratic appearances and pseudo-events, which are designed to suggest a creative vision, hence his restaging of the Warhol clip as a copy, but a *knowing copy*. By channelling Warhol, Culkin is claiming, under cover of an exercise in playful pop cultural reference, to re-consecrate his existing persona – a strategy not devoid of irony, given Warhol's own propensity to appropriate ready-made pop references for self-advertisement.

If this strategy works – and, on the whole, commentators conclude it does not – he would effect a self-transformation from the being of a crumbling persona of Kevin McCallister from the *Home Alone* series. Shielded from market pressures by his personal fortune, Culkin is trading on his name to express somewhat surreptitiously his allegiance to Pop Art that only the culturally savvy will appreciate - a Lilliputian version, it might be said, of what Garrick did with Shakespeare. But the difference lies less in the fact that Culkin's accomplishments are slight compared to Warhol, let alone Garrick. Rather it lies in the hidden retrospective quotation of Warhol's original video, a precedent obscured by Culkin's performance for the unknowing – though a minutes' web search is all that is required to get educated – or for the cognoscenti as a witty pun. In either case, the value of his performance can only be that he is doing it under a somewhat defunct persona.

The virtue of the example of Culkin is that it shows in a stark form the fundamental impulse of modern celebrity. His problem is that he is known as an actor whose fame is based upon seeming, but that is a form of fame he can no longer claim. He cannot be just a person performing, like a reality television contestant or a private person caught up in the media news – or, more exactly, when this applies to him it is only to discredit him as a freak or a junkie, to put his reputational credit at risk of depletion and devaluation. Nor does he have the licence of someone like a rock star, for example, Lady Gaga or Miley Cyrus, to be outrageous both on- and off-stage because his 'art' is not primarily accepted as the product of an artistic vision. His involvement with Pizza Underground might suggest this but it has more of the feel of a hobby, not helped by its reliance on 'postmodernist' quotations and a generally flat level of performance and affect.[8] Nor is he a personage like Paris Hilton, who was a socialite before she became a celebrity. Culkin's turbulent and poverty-stricken background places him as a nouveau riche parvenu whose story the media want to render as a rise and fall (Rein, Kotler and Stoller, 1987).

Culkin's efforts to establish himself as a personage remain inherently problematic, so that he epitomizes the uncertain identity dynamics in the context of steganography. If he could establish his personage as a performance artist, then he might evade the condition of being just a person, a name, confined to the dregs of past fame and nominated as a has-been persona. His fate, like Lindsay Lohan's – to mention just one other child actor who has problems transitioning to adult stardom – is to watch his public identity shrink to a condition of 'absolute' celebrity, the state of being in which a name, rather than an accomplishment, is the driver of media attention. The unintended transparency of his efforts seems to smack of self-aggrandising narcissism and a need for approval it creates (Young and Pinsky, 2006). As the activities of his celebrity peers and rivals for media attention suggest, he is certainly not alone in this endeavour.

(2) Lady Gaga

Culkin's defensive steganography can be set against the example of Lady Gaga, whose engagement with otherness is more provocative and offensive – in the military and, for some, in a moral sense. Lady Gaga (Stefani Germanotta) is a massively successful pop star on par with Adele and Beyoncé – with 26 million albums sold, 50 million singles, 1 billion views of her music videos and other materials on You Tube – whose fame rests on the pervasive use of social media, viral marketing and direct forms of fan engagement. Utilizing social media networks and platforms and live concert tours to promote her latest album release – *Monster Ball* (2009), for example, having 200 dates in 27 countries – Lady Gaga places a great emphasis on ritual communion, of becoming one with her fans in a shared context of celebration (Frith, 1998). The 'traditional' view of a rock star's performance is that it is (or should be) a direct process of self-expression – the star is expected to actually feel the emotions expressed through the song and thereby demonstrate authenticity.[9] By contrast, an actor may choose to stand back from being a character without incurring the accusation of inauthenticity. Recalling Goffman's (1981) tripartite division between animator, author and principle, the ideal rock star comes closest to fusing all three: incarnating the feelings and attitudes conveyed in the lyrics and musical form and making the principle behind them experienceable through signature performances. S/he is to be a singular persona marked by emblematic performances that become personal standards whether s/he is actually the songwriter or not.[10] Lady Gaga is active across all of Goffman's performer categories,

a fact that contributes to her market penetration and the multiplication of revenue streams.

Like her predecessors David Bowie or more recently Madonna, Lady Gaga places a great emphasis on the assumption of avatars, assumed versions of a self that do not crystallize into a durable persona because of protean shifts from one ostensible self to another. Such switches mean that her person remains hidden in public and no durable persona emerges to cover it because her identity is always shifting and circulating. In fact she makes contradictory claims – that there is no person behind her many masks and that her real person is always the same inside. This existing in and outside her avatars is the basis of her mystery, her presence as enigma (Davisson, 2013, Chapter one passim). This does not prevent, and is arguably contrived to incite, fans and observers to speculate on which is most authentic, but all speculation remains conjecture. Like Proteus she cannot be tied down, even if the agents of definition could get that close to her. Accordingly, since she seems to be staging herself, the concept of identity remains teasingly ambiguous and deferred – in itself not a bad outcome for extending demand. I will return to this matter; for now it can be said that Lady Gaga is an example, and I believe an exceptional example, of performers who base their appeal on *authentic inauthenticity* – the sincere use of artifice (Grossberg, 1993). This strategy creates its own expectations and needs careful management, if fan loyalty is to be maintained. As one Lady Gaga fan put it:

> I would hate for that to be an image . . . It seems so genuine . . . I hope to God it's true.
>
> (Callahan, 2010: 4)

As a star cultivating her brand in a mass market, Gaga needs to sustain an illusion of intimacy, of engaging with individual consumers – at least niche aggregates of consumers – whilst pursuing the marketing objective of appealing to anyone whatsoever.[11] The established formula for reconciling the particular and the universal has been developed in the context of broadcasting, and involves basing output on mass appeal or anonymous communication which evokes the 'universal' condition of humanity, the facts of life that affect everybody, albeit not equally – mortality, hunger, pleasure, search for love and so on (Lohisse, 1973).[12] At the same time, for competitive reasons, individual stars need to relate their personal experiences to relevant aspects of anonymous communication. The standardized method for doing this – long perfected in the 'one to many' broadcast format – involves the performance of para-social intimacy (PSI).

In its original formulation, PSI refers to the immediate moment of address, the conjuring up by the performer of a repertoire of looks, gestures and speech addressed to the camera that simulate a face-to-face encounter (Horton and Wohl, 1956). But the star or celebrity looks to maintain a continuous para-social relationship with fans or audiences across time, hoping to replicate the intensity of the moment through repeat offerings to old, as well as new, fans and followers (Schramm and Wirth, 2010). This is one reason for the development of publicity tours, talk show appearances and the sedulous leaking of positive, rather than negative, gossip.

An established way to develop a para-social relationship is to grant fans access, through cooperation with the friendly media, to the backstage of the star's or celebrity's 'private' world, the 'real' that subsists behind performance or is actually created as the residue of what performance leaves behind (Muntean and Petersen, 2009).[13] Unusually for a star, Gaga goes to great lengths to keep her public life separate from her private life as Stefani Germanotta (Benton, 2010). One factor to note is that her outré and outlandish stage behaviour means that there is little about her private life that would be more shocking – she admits to doing drugs, stripping, being bisexual and so on, in a strategy of hiding the intimate self in the light of public exposure. The question of these revelations' truth value – are they actual confessions or staged para-confessions? (King, 2008) – adds another protective layer of speculation and mystery that replicates in 'real' time the enigmas posed by her performance avatars. But basing self-disclosure on a claim of authenticity, her fans and the general public are privy to her experiences of performing and her attitudes to being a pop diva. This disclosure strategy is not without its own forms of misdirection – for example, how much of what we see is her own effort or a team's is not on the agenda – but it represents an advance in frankness over the 'luvvie' talk of actors on promotional tours. When her self-disclosure works – which, for now at least, it certainly does for many – it has the effect of placing her in a third-person relationship to her own performances and her stardom, mirroring the social placement of her fans. So, for example, her album *Fame Monster* reflexively defines the star as a victim and fame as a predatory process. (To be sure, she would know, wouldn't she?)

This distancing from the world of show business is furthered by her promulgation of what one critic has termed a creation myth (Callahan, 2010: 19). In order to bond with her fans, she emphasizes that as a teenager she was abused by her high school peers at the exclusive Convent of the Sacred Heart for her looks, her dress and 'kooky' ideas. Her former schoolmates actually recall that she was very popular. But it is not the

objective facts that count because even affluent (perhaps especially affluent) teenagers experience 'alienation' and this is pervasive enough to act as an emotional passepartout to the inner lives of her fans. Likewise, her attempts to break into the music business, despite the support of her father's business contacts, are construed as a rite de passage built on rejection, or (not entirely fanciful given her Catholic background), a Calvary road to redemption. Evoking the show business legend of 'many years of paying dues' – though her own ascent was much faster – she can claim to have drunk deeply from the well of survival. Hence the lesson she sends from her heart to her fans everywhere: never give up on your dreams and follow your instincts. Despite the asperities of her past, she has never wavered in the knowledge from an early age that she was a star. These purported experiences of rejection, which her schoolmates regard as a tall tale, have earned compound interest in the bank of sympathy. They allow her to elide the realities of her own background as a New York-born, upper-middle-class, cosmopolitan Italian American. But this may not work for her Little Monsters who lack the minders and security guards to protect them in less tolerant environments. But then the gate is strait; the path is not for everyone.

> If you have revolutionary potential, no matter who you are, you have a moral obligation to try to make this world a better place (Interview Television Four, UK 2013).

In order to understand how this incipient contrast between the elect and the abject works, it is necessary to consider her trademark use of the bridging metaphor of 'monstrosity' as a semantic bypass rendering the personal as universal. The monster is a creature that exists outside of the 'normal' or quotidian world, promising miracles but also, through its otherness and deformity, the threat of destruction (Ingebretsen, 1998; Corona, 2011). A figure of abjection, the monster inspires fear and contempt, and if defined as marginal remains central to the collective imagination.

In a textbook example of Louis Althusser's (1971) concept of ideology as a process of interpellation, Lady Gaga is represented through what she says and how she appears as the big subject S (Mother Monster) who invites her fans (little subjects s) to be her 'Little Monsters' (Althusser, 1971).[14] A classic example of an existential interpellation, Monster Discourse offers her fans a form of agency that validates their own sense of alienation, of felt oppression, provided they accept the centrality of her place in their lives (Therborn, 1980).

If traditionally the monster is a figure of profound existential rupture, Lady Gaga's version is a disturbing rather than convulsive figure, opposed to conventionality and yet reliant on it to flaunt its provocations. In this case, Lady Gaga, despite what the self-nomination claims, seems closer to another figure, the trickster – an archetypal figure of provocation who plays with the deep cosmological structure of myths in order to refresh and renew them[15] (Hyde, 2008). But Gaga's cosmological playground is not the deep structure of myth, but popular culture as entertainment (Gellel, 2013). For such is the realm she mines for the arresting images and referential tags that populate her music videos and live performances and refresh her marketability or exchange value. The critical edge of her artistry rests on provocation, recombining through a process of pastiche and parody what has already been sold with new forms that challenge, particularly, the framings of heteronormativity. So for some observers, her insistence that she is just being herself is problematized by her performances and music videos, which are tightly contrived exercises in serial mimicry. It is not difficult to detect quotations from 'techno-pop' predecessors such as Klaus Nomi and Missing Persons' Dale Bozzio, as well as Rock Establishment stars such as Bowie, Marilyn Manson, Alice Cooper and Gwen Stefani, Grace Jones and, above all, Madonna – the original meta-textual girl who flaunted a wardrobe of identities (Tetzlaff, 1993). Again, there is an implicit homage to (at least a semi-conscious echo of) that theatre of sexual non-conformity, the demotic talk show, whose fulminations against mainstream polite society are more homeopathic than poisonous (Gamson, 1994).

For all the aura of provocation and iconoclasm, Gaga has not taken rebellion so far as to reject the central institutions of capitalism that have made her rich and famous. Her company, Haus of Gaga, has been praised for its inspirational leadership in viral marketing, admired for its relentless pursuit of a 360-degree business plan that aims to maximize revenue for itself and its partners from every available point of sale (Peters, 2011, Anderson et al., 2012). To succeed, this strategy relies on avoiding too close an identification with a particular niche – the gay community is the prime example, because it has been a critical source of ideas and support. In short, her monstrosity is a more a version of the carnivalesque that is licensed rather than transformative, serving to advance a liberation marketing strategy (Frank, 1997).

Another mechanism for avoiding the trap of particularism has been to draw on the back catalogue of popular imagery, drawing on popular musical precedents and movie iconography already widely distributed in the public realm, with a personalized reactivation. Gaga is clearly a deeply engaged student of cultural theory and 'cool hunter', who knows

how to appropriate the look of other acts (not always acknowledged) for a striking mash-up aesthetic. This avant-gardism of the copyist, already ratified by High Art Lite, has led her critics to suggest she is a shallow plagiarist.[16] But she has her answer:

> Warhol said art should be meaningful in the most shallow way . . . He was able to make commercial art that was taken seriously as fine art . . . [and] that's what I'm doing too.[17]

Nor is this opportunism, but a deep commitment to the vocation of the performance artist:

> I strive to be a female Warhol. I want to make films and music, do photography and paint one day, maybe make fashion. Make big museum art installations. I would be a bit more mixed-media than him probably—combining mixed media and imagery and doing more of a kind of a weird pop-art piece.
>
> (Barton, 2009)

Indeed, as her fame has grown it seems she has outdone Warhol, by bringing fine art to pop. As stated in a blog concerning the release of her third album, *ARTPOP*:

> Exploring Gaga's existence as a cultural interface, the user will share in the 'adrenaline of fame.' Altering the human experience with social media, we bring ART culture into POP in a reverse Warholian expedition. For her this is a celebration of obsession.[18]

Liberation marketing has clearly worked for Mother Monster as a performance artist and entrepreneur, but how does it work for Little Monsters? For them it offers a chance to express a commitment to an imagined community of outcasts, even if under terms that are market oriented. The Wikihow posting *How to Become a Little Monster* states:

> Lady Gaga loves nothing more than her fans. She's down to earth, caring and eccentric. Little monsters hold a very special place in her heart. Here (sic) how you can become a loving one!

To get the love it is necessary to embrace a Gaga-centred consumerism, shunning her rivals, grooming the self by reading all one can about Lady Gaga (in magazines and on such web sites as littlemonsters.com

and Gagapedia), buying her CDs, tickets to her concerts, and bundles of clothes, music, toys and books.[19]

Yet despite the cash nexus, Gaga declares that she is just a tool for liberation, urging her little monsters to succeed on their own terms.

> I want for people in the universe, my fans and otherwise, to essentially use me as an escape, she says. I am the jester to the kingdom. I am the route out. I am the excuse to explore your identity. To be exactly who you are and to feel unafraid. To not judge yourself, to not hate yourself.
>
> (Van Meter, 2011)

As her Little Monsters Facebook page commands:

> Don't idolize me. Idolize Yourself ~ Lady GaGa

To which Little Monsters prayerfully respond:

> Lady GaGa our MOTHER MONSTER changed the lives of many people and from those people, came into existence a new race within the boundaries of humanity loving their MOTHER and spreading the GaGa preachings. This new race came to be known as LITTLE MONSTERS.
>
> The race of LITTLE MONSTERS began to multiply. It was not finite; it was infinite. They were eternally known as little monsters. And we do idolize ourselves as well as our MOTHER MONSTER.
>
> BEING CREATIVE ALL THE TIME NO MATTER WHAT PEOPLE SAY.

Such expressions of spirituality may work as a form of Dale Carnegie's positive thinking on steroids, but can they moderate the massive disparities of wealth and influence between our Lady and her initiates?[20] With the resurgence of a fad for dressing up and masquerading on the New York party and club scene, what 'look' could be as outré as Lady Gaga's, the reigning monarch of cool hunters, and how would the masqueraders avoid the demeaning attribution of being mere followers? (Coleman, 2010). Yet being a little monster is not without its compensations, the uppermost of which is the love Gaga returns to her loyal subjects:

> We have this umbilical cord that I don't want to cut, ever . . . I don't feel that they suck me dry. It would be so mean, wouldn't it, to say,

'For the next month, I'm going to cut myself off from my fans so I can be a person.' What does that mean? They are part of my person, they are so much of my person. They're at least 50 percent, if not more.[21]

Secondly, her artistry is a spur to self-expression and empowerment because if she is their leader, it is only her acolytes, as co-creators, that complete her mission of inspiration:

When you listen to a song like *Love Game*, is it communicating my soul to you?' Gaga asked. 'No . . . I make soulless electronic pop. But when you're on ecstasy in a nightclub grinding up against someone and my music comes on, you'll feel soul.[22]

Again, explaining the lateness of the music video *Do What U Want* and the poor performance of her *ARTPOP* album:

It is late because, just like with the Applause video unfortunately, I was given a week to plan and execute it. It is very devastating for someone like me, I devote every moment of my life to creating fantasies for you.

Lady Gaga herself is an arch exponent of paradox mongering, like a dynamo driving the polarities of difference:

What's the difference between Joanne Stefani Germanotta and Lady Gaga? The largest misconception is that Lady Gaga is a persona or a character. I'm not – even my mother calls me Gaga. I am 150,000 percent Lady Gaga every day.

(Scaggs, 2009)

Taken literally, this statement places her outside of the standard contrasts of identity as a performance. She is neither a persona, nor a character nor a mere person because she is hyperreal, to the tune of 1500 times more real. Nor is she a personage unequivocally representing a specific community.[23]

Despite their clichéd quality, these articles of faith – would a pop star say publicly that she despised her fans? – remain ambiguous. Practically, as her career has developed, her ability to shape-shift now encompasses the mainstream, as, for example, her appearance on Oprah. This creates a tension between her pursuit of the mainstream and her avowals that her 'little monsters' are outsiders who she, the arch outsider, has dedicated

her art to serve. In order to forestall the accusation of commercial oppor-
tunism, her moments of 'normality' can be explained as passing or par-
ody. But her demeanour – without mask, her actual face revealed, relaxed
and groomed in a twinset – offers sparse evidence of such a strategy.
That she performs 'normal/straight' is not unexpected in the context of
a 360-degree marketing plan, which aims to sell to both the marginal
and the mainstream. But it puts the sincerity of her commitment to
the margin, to 'queer' feminism and the rejection of biodeterminism in
doubt (Williams, 2014). Part of the drive to 'own' Gaga is a response to
the notion of performativity, which cannot escape the implication that
there is a core identity from which one acts. When a pop star has a stable
persona, then the question of authenticity has a purchase. But the flux of
Gaga's performances suggests there is no stable core, which consequently
dissipates the idea of a persona into a stream of avatars – versions of the
self. The absence of a stable persona creates a hermeneutic problem for
those (fans and for that matter theorists) who want to see her as a sincere
partisan for their particular worldview or cause. But an undeniable con-
sequence of the 'queering' of identity that has proved to be Gaga's brand
is that she is licensed to engage in serial mimicry without the need to be
faithful to a particular niche of her fandom.[24]

So surfaces a contradiction in the attack on essentialism: it ends up
fetishizing its own preferred reading, to the point where it demands
that Gaga must be an incarnation of, for example, gay sensibility, rather
than an agent who makes a gay reading possible.[25] Nor is the academy
immune to her mesmerizing parade of neither-norisms. So we learn that,
from the perspective of lesbian historiography (but this could be the fate
of any reading), her music video *Telephone* with Beyoncé 'surfaces issues
around identity, naming, subjectivity, sexuality, representation, friend-
ship, ethics and politics to name just a few.'[26]

But wait, there's more! Is she a figure of hypermodernity extending
the modernist impulse for mastery over nature deeper into the psycho-
logical and corporeal depths of the self? Her radical contortions of her
body and face suggest she might be. Is she a postmodernist, engaged in
semiotic guerrilla warfare deploying parody, pastiche and quotation, in
order to expose the incipient artificiality of 'taken for granted' forms of
identity? Or is she a romantic manqué who refuses to countenance the
waning of affect and blankness through the verve, passion and indi-
vidual vision she brings to her identity mash-ups? Does she fake the fake
to make it hyperreal? So many readings; so many Gagas. The relentless
para-tactics of identity, laying different avatars side by side as discrete
subjects, sets interpretation into hyperdrive.

The public must make their choice or simply not care. But if they care (and many do) understanding can only come through a commitment, emotional and fiscal, to multiple engagements with her ever-expanding portfolio of performances. For the 360-degree star, only a 360-degree fan will do.

In sum, her approach might well be defined as a homeopathic carnival: a licensed release that restores and revitalizes commodity exchange while giving an adrenaline rush to conservative morality. In terms of a discursive subject position, what Gaga presents (as does Culkin in a more milquetoast variant) is retreat from the overt level of the cultural subject towards the logical subject who makes things happen – retreats, in short, from *seeming* to just *being* there (Muntean and Petersen, 2009). Although many feel Lady Gaga is a powerful example of self-assertion, there is something of 'hiding in the light' in her self-presentation, a kind of defensive mimicry. In the long war of position between the self and market, she stands for the articulation of stardom – she is undeniably a talented performer – before it accedes to the empty nominal space of celebrity, the sea of media exposure that swims around her. Culkin, by contrast, may be said to be floundering in that same sea. In *Claims to Fame* Joshua Gamson has provided a more empirically focused example of being celebrated not for doing but being, in his account of Angelyne, who describes herself as a bringer of 'joy' and always famous as 'a celebrity in waiting'. This is an uncanny pre-echo or Ur-scripting of some of Lady Gaga's reflections on her own fame (Gamson, 1994: 1ff).

But there is also a decisive, more intensified emphasis on engaging the audience – not as followers but as co-celebrants of the rites and rights of self expression. As Lady Gaga's Facebook page proclaims, Little Monsters should not strive to *be* her, but to imitate her mode of being. But this mode of being is not a baseline referent presence that marks off earlier star-identity positions. Nor is it a persona formed out of the fusion of a state of being and a mode of seeming. Rather, it is a vestigial figure in circulation, the eidolon, the shadowy presence that once awaited the advent of the visual and audio recording to become concretized in a persona – the durable forging of being and seeming.

Today a new kind of meta-eidolon is being formed through the intensive media saturation of everyday experience, its associated cognitive overload and pluralization of identity options.[27] This new eidolon I shall term an *ectype*, the impression of an individual thinly etched in traces of presence. One does not know Gaga, purposively cannot know her, but one desires to find her in her traces. This passion to know, this epistemophilia fed by her promulgation of her mystique, she advises fans

Table 8.1 The map of fame

Context	Early stardom	Stardom	Post-stardom	Celebrity
Dominant sign form	Symbol	Icon	Index	Name
Dominant type modality	Stereotype personage	Prototype character	Monotype persona	Ectype eidolon
Synoptic identity	Anagraphic	Biographic	Autographic	Steganographic

to turn upon themselves as the precondition for freedom as her loyal subject. This advice is consonant with a new figuration of identity that is principally narcissistic, tutored to see itself as under the gaze of others a Foucauldian process of governmentality. Writing of this new figuration, Kenneth Gergen (1991) suggests that it is better to speak of the inner experience of the self as pastiche, rather than modernist or postmodernist self. Lady Gaga is perhaps the most egregious advocate and example of the pastiche personality, for whom 'life becomes a candy store for one's developing appetites' (Gergen, 1991: 150).

Table 8.1 above lays out the current map of stardom and celebrity. It suggests, as a static map and progression, that the modes can be roughly periodized according to the predominant emphasis on kinds of cultural subjects available and dominant in different historical periods. But in fact that they coexist in the present as different identity options. In other words, they constitute the semiosphere of fame: a homoeostatic field of meaning that is loosely structured, open to change within limits, but driven to maintain its boundaries and modalities (Lotman, 2005).

These modes can be seen as the logical possibilities of being famous, though they have become fully realized as sociological possibilities in recent times with the advent of celebrity as I define it. As a process of historical development (rather than as a copresent set of identity options) there has been a shift from totemic fame to fetishistic fame.

Stardom, celebrity and commodity life

It is my argument that the process of how the performer is brought into a relationship with commodity exchange that constitutes the infrastructure of the star/audience relationship. The modes of writing the stars are historically inflected attempts to convert a potentially divisive relationship of economic and social inequality into an apparent relationship of service to and mimicry of popular experience. Yet the mask and mantle

of populism, as it shifts through the modes of representation, has been undergoing a depletion of its typal range. In its broadest terms, this depletion entails a shift from representation to presentation and in its last phase beyond presentation, with its connotation of openness, of showing a 'true' face. One potent factor in this shift is certainly the increase in the social distance between today's stars as very wealthy people and the average life chances of the general public. But since I have discussed this matter elsewhere, and consistent with the general emphasis I have placed in this book on semiotics and discourse, I want to conclude with an emphasis on the cultural impact of the logic of commodification on the actor as a symbol. So if we are all actors or performers now, the arguments I have presented in this book have focused on the semiotic processes that have taken the once marginal figure of the actor to the centre of contemporary imagination about how to be popular and successful by performing a 'cool' image of the self (Kershaw, 2001).

As Goffman (1990) observed, all forms of social interaction involve self-presentation, but acting is a second order of presentation, a presentation of self-presentation or, in character, the presentation of a representation.[28] The actor's work before a directly present audience has the potential, depending on how the audience behaves, to cause a depletion of feigning, forcing him or her to slip out of character into a 'mere' name with celebrity – like Edmund Kean in the aftermath of the Cox affair. But as noted in the introduction, the primary determinant of stardom and celebrity is mass-scale market recognition. For what is such a market but a medium for aggregating different consumer choices into a single undifferentiated mass of approval? In other words, such a market recognises individual consumer choice as an expression of the alienated will of the collective. Accordingly one may recognise the fame of, say, Lady Gaga because the big Other of the media and the box office have done so. Even if one feels a genuine admiration for a star or celebrity, it is the star or celebrity or those who represent them that are left to explain the true source of their popularity. Or, in the case of the gossip industry, why that fame is undeserved. Nor is the reliance of the consumer on agents of collective definition merely a matter of post-hoc definition; the forces of definition are already in progress before the product goes to market (Wernick, 1991).

If the fame of stars and celebrities is a product of the law of large numbers, the proposed solution to the alienation through quantification of audience preferences in stardom was once, as noted above, linked to the idea of universal constants, the glue of anonymous communication. In anonymous communication, stars were samples of a social type, though the genealogy of stardom, as I have identified it, shows

that the gearing of the relationship between type and token has varied. In anagraphic positioning, stars are represented as types; in biographic positioning, as prototypes that are definitive renditions of a social type; in autographic positioning, the stars begin to define themselves as self-sufficient tokens, singular individuals who track towards presentation rather than representation work. Finally, in steganographic positioning, the concept of self-presentation itself shrinks, becomes hidden behind a labile succession of identities that hide the star and constitute, if not a denial, then a systematic deferral of the status of a token. This procession might be viewed, à la Baudrillard, as the hermetic isolation of the sign from the referent and the triumph of the simulacrum. But given the example of Lady Gaga, it seems more like an alluring procrastination about referents, a kind of flirting with identity, and certainly her 'Little Monsters' show no inclination to see her as an empty play of signifiers.[29]

There is a more fundamental relationship that gives the star, in whatever type capacity, existential persuasiveness. Performing is a type of labour that directly connects the physical capacities of the body and the intellectual capacities of the mind together in the sale of labour power. This form mirrors the basic conditions of labour per se, bodily presence only to take it to the level of an aesthetic object.

To appreciate this it is necessary to return to the nature of acting and performance as a kind of labour. Under capitalist relations of production, the worker, in whatever line of work, exchanges his/her labour power for a wage. In this exchange, the actual body, or person, of the worker functions as a source of psychological and physiological energies, as a social body.[30] All forms of labour involve the worker as a sensuous being, but the degree to which the worker's qualities become a factor of production varies. So in unskilled work (or work so defined), the properties of the self that are exchanged, or alienated for cash, are primarily physical. The worker's personality is functionally disregarded or suppressed as an element to be managed, whether by the workers themselves or by management.

In the category of labour considered here, performance labour, recognition of the worker's personal qualities is the fundamental condition for exchange to occur at all. Here the work process reaches deep into the person of the worker, turning physical and psychological qualities – appearance, personality and intellectual capacities – into exchangeable values or commodities. In this manner, with the development of the service industries, the self becomes the crux of an accumulation strategy

on the side of capital and a tactical bargaining resource on the side of the worker (Harvey, 1998).

If the worker's personal qualities, mental and physical, are the use-values offered or sought for exchange in performance labour, how these qualities are articulated into the labour process of performance determines his/her place in the hierarchy of reward and esteem. When the qualities and appeal of the individual performer are in high demand then the notion of exceptional talents and a distinctive, if not beautiful, appearance creates a star or a celebrity. So although it is sometimes the case with labour in general that personal qualities such as attractiveness may influence the level of reward, in performance labour these qualities are part of the commodification process rather than an additional relational benefit that goes along with the decision to employ. Service work in general entails the commodification of personal qualities governed by a process of physiognomic equation. There are obvious variations in the degree and intensity of the mobilization of personal qualities for exchange. In routine service industry occupations involving face-to-face interaction, such as hospitality and catering, control is exercised over the worker by the provision of a standard uniform (or at least a common standard of dress) and a standardized patter. These features, requiring self-fashioning, may be experienced as an incursion into the self, yet at the same time they can provide a 'mask' under which the more private aspects of the self may be sequestered. Such 'fractal' jobs, requiring workers to look and behave alike, are also found within film and television with the extra, walk-on or bit player (King, 2010b).

Compared to a worker in the fast-food industry, the actor/performer is often viewed as enjoying greater opportunities for self-expression. Any performer, it might be said, gets treated less as a body than as a sign of a body, and accordingly the pressure of self-commodification is diluted by pretence. But the effort of feigning draws more intensively on the psychological and physical resources of the worker than is the case with routine service workers. Fast-food employees are sheltered more from emotional exploitation – though not from boredom, overwork and so on – than even average actors, who are expected to give the highest levels of commitment even when confined to routine parts. As the old cliché goes, attributed to Stanislavski: 'Remember – there are no small parts, only small actors.'[31] But this points to a situational truth. How the qualities of s/he who labours are brought to bear on task performance has a direct and consequential impact on the individual's prospects for future employment and place in the hierarchy of reward and esteem.

From the perspective of continuity with service work in general, the star or celebrity constitutes a privileged variant, commanding an economic rent for his/her services. Paradoxically, the qualities of the star or celebrity only reach their fullest expression after the resources of production are committed. But this makes little difference to the perception that stars are rewarded for some unique combination of talent, exceptional attractiveness and aura.[32] Streaming through these organizational realities is a fundamental semiotic process – the qualities of the star, or any actor or performer, are mere iconic qualities and only become concrete indices or realized exchange values after they have been captured as images. But post-capture, the means of image production becomes dependent on the material of the self as exchanged, as though the latter were its origin as a fact of nature, rather than a product of artifice.[33] In a manner that recalls the pre-capitalist views of physiocrats, the star or celebrity seems like a natural resource because his/her intrinsic qualities command an economic rent (Marx, 1952). So from a capitalist point of view – the viewpoint of profit maximization – it does not matter, however much it matters to the fan or the general public, whether Johnny Depp can act and Paris Hilton cannot. Both are a source of natural value that is non-fungible, at least, until the box office says their usefulness for exchange has been exhausted like an overworked goldmine.

So far, the 'mystery' of the star and the celebrity can be regarded as a limited case of self-commodification in general. Indeed, one of the key developments in recent times is that many workers are expected to give the same kind of commitment, deliver the same kind of emotional labour, as an actor might give to a particular role. As the functional properties of goods and services are intensively presented as life style choices and opportunities for experiences, it has been argued that the theatre provides a model for 'success' for all organizations. In this process, the figure of the actor has emerged as a contextualizing metaphor for labour in general, a way of representing self-commodification as a process of creative expression.

The power of the star or celebrity metaphor lies precisely in its demonstration of the ability of the worker to turn the tables on the employer, or more exactly the market (as the employer in general), by securing an individual contract in an overstocked labour market where work is scarce, underemployment is endemic and entry qualifications are either non-existent or irrelevant. No one gets to be a star because of their training, even if some stars are highly trained or only get to be highly trained after they are stars. In this sense the celebrity, as a famous person

without discernible skills, is the fundamental category of stardom rather than its corruption.

What empirical trends have brought this 'procession' about? Since others have explored the organizational changes that define contemporary Hollywood, I will focus on processes more proximate to the formation of star image, especially in the latest phase of steganography.[34] The first feature is the progressive spectacularization of the actor's body and appearance. It has long been the case that the actor's body has functioned as a cinematic spectacle but what is in train now is more pervasive and intensive.[35]

With the rise of the Internet and social media, technologically based systems have transformed the relationship between the public and private self, massively extending the scope of surveillance and facilitating the high-speed global circulation of words and images. Images and texts once sequestered in particular locations are more or less sealed off from unauthorized use by practical impediments to access. The 'new' media have vastly extended the public sphere and accelerated the processes of circulation from production to consumption – whether the latter is legal or illegal. As shown by the example of Lady Gaga, for one, web sites such as YouTube have proved very effective in stimulating demand for forthcoming tours and albums and encouraged through viral marketing the release of preview materials for free download. Through blogs and media-dedicated web sites such as IMDb, the speed-up in the circulation of performance commodities has been matched by the proliferation of commentary that dissects and generates buzz about their content. DVDs and Blu-ray discs or satellite and cable subscription programmes afford viewer access into the backstage of production, multiplying the database of images and commentary on them. The latest developments in mobile technology such as Instagram deepen the molecular circulation of star and celebrity images and para-texts into everyday life and generate new forms of fan association and micro-celebrity, encouraging ordinary individuals to value self-commodification.

Against these primarily, though not exclusively positive circuits, must be set the fame debunking practices of celebrity journalism and the paparazzi system. In particular, celebrity surveillance sites such as TMZ accumulate a mass of discrediting detail about celebrities, turning their apparent beauty qualifications and generally admirable social qualities and prestige into sordid tales of hypocrisy, poor relationship manangement and emotional incompetence (Petersen, 2011). These developments, seemingly in contestation, are actually refinements of the logic of self-commodification. Every celebrity fall operates like a quality-control

mechanism for fame products, providing the opportunity for improve-
ment – such as a comeback – or a swift replacement. Moreover, they
exist to nourish new niches for the circulation of fame, selling images
of stars and celebrities – caught on video, photography, in tweets or in
sound bites – to gossip magazines and television entertainment shows
such as Entertainment Tonight. These shows in turn broadcast them to
national and international audiences as stories, and images are picked
up on newspaper web sites and print editions as breaking news. Such
materials are eventually collated on sites such as Wikipedia, making it
relatively easy for feature writers to produce copy.

Less direct trends are also impacting the celebrity system as part of
industry efforts at burnishing its social profile. Entertainment jour-
nalism programming has led to an intensification of the emphasis on
the look, already a fierce weapon in the competition between celebri-
ties. Industry events, such as the annual Oscar ceremony, now feature
physiognomic contests especially amongst female stars and starlets who
pose on the red carpet, permitting the viewer to see which star looks
gorgeous and which is likely to fill the viewer with sumptuary nausea.
These stand-offs, aided by commentary by fellow celebrities, serve to
tutor the public in good taste and replicate the 'worst dressed' pages of
gossip magazines and other fashion tutorials. They also have the addi-
tional advantage of showcasing the output of haute couture designers
and set off the cascade of style. Such moments of celebrity monstration,
along with celebrity participation in talk shows and other media events,
demand that the off-screen 'spectacle' of the self ratifies what can be
accomplished on screen. So that the face, far from just being made-
up, approximates to a mask through surgical and cosmetic procedures
that tend to immobilize the features.[36] On screen, facial rejuvenation
through digital technology and the alteration of appearance through
seamless mash-ups further accent the status of the face as mask that
must be imitated in real time off-screen. Similar masking procedures can
be applied to the body, which must present a youthful sculpted surface
on screen – this may be readily accomplished, courtesy of body doubles
or digital 'cosmetics' and Photoshop manipulations – but, nonethe-
less, requires its off-screen confirmation (King, 2011). Developments in
digital cinematic practice are also having an impact. Post-continuity
editing techniques are displacing narrative with a set of effects, or
effect collages, that inhibit the formation of a rounded character and
the traditional route to consolidating (or renegotiating) persona, sug-
gesting rather that the actor's coherence rests in his/her presence as
behavioural material deployed for action, especially pronounced in the

action movies that dominate mainstream cinema. In this circumstance, doing and being are restricting the opportunity or the need for seeming (Shaviro, 2010).[37] Behavioural acting is also encouraged by the policy of placing actors in 'boot camps' to experience the 'real' thing as preparatory to acting on screen. The echo here of celebrity reality TV procedures is probably not accidental.

These tendencies towards prioritizing being over seeming obliterate the boundary between private and public behaviour that once circumscribed how stars were represented to the public in the early and Studio phases of Hollywood. Nor does it help that certain stars and celebrities actively market intimacies, looking to exploit their 'celebrity right' as a means of increasing personal income and further revenue-generating projects.[38] The sex tape, for example, has become a standard promotional tool for Reality Television celebrities such as Farah Abraham and Kim Kardashian. Such examples of voluntary self-commodification can be seen as a privatization of the public good of collective representation – as suggested by the notion of a 'sell-out'. Indeed, the perception of selling out, whether justified or not, produces its commercially infused hermeneutics of suspicion – did Lohan deliberately or accidentally leave a list of her sexual partners for someone (her personal assistant) to pass to the media? Speculation becomes interminable, which hopefully will reinvigorate a flagging media profile (Merriman, 2014).

The long development of the modes of representing the self to an audience is at base a process of self-commodification. It was with the development of a commercial theatre that the physical body of the player was positioned as a body in public that acceded in varying degrees to the process of commodity exchange. The process of subsumption of the self has followed a different route for men than for women. But as actors or performers they all face the same choice to adapt themselves to the market in order to secure fame and fortune or return to obscurity. In our time the process of subsuming the self to self-commodification has begun to push beyond the framings of the social body so that the physical attributes or carnality of the star become the basis of what has been termed *intimate fame* (Redmond, 2006). In intimate fame the rule of the flesh, of carnality, becomes the basis of eminence so that all kinds of individuals, whatever their skills and accomplishment, can become famous – the condition of celebrity. But the commodification process does not stop there because the physical body of the star or celebrity, no longer shielded by a concept of a social body, also becomes an information commodity as gossip and news. So the logic of marketing the self has worked, often with the willing cooperation of the star or celebrity

to reduce the social body to a physical presence or rather a media trace. One outcome of this process is the morselization of identity. It is no longer the case that the self is hypostatic, but that each identity within an operating portfolio of identities is being broken down into marketable pieces of 'me.' To recall Deleuze and Guattari's metaphor of the body without organs, within today's celebrity system, the social body is coming to seem like a collage of organs without a body, a significant mass without any discernible essence (Boundas, 1993: 254–256). Indeed, considering the intense panoptic probing of inner life, the spectacle of fame suggests a body flayed, having its interior exposed to public scrutiny. Equally, the lines of flight, of ceaseless indeterminism, connected to the body without organs, seem to have been reimagined as flights into the heart of commodification imagined as a process of liberation.[39]

Fame as tokenism

In its general features, the ideology of stardom and celebrity are different variants of a paratactic operation, binding together an instance or token and type. How the star stands for everyday experience is ultimately a matter of the gearing of type and token relationships in the process of representation, of standing for the popular. In each phase of the 'writing' of the star or celebrity, s/he was once (and in some cases can be still be) being presented as a token of such changes, an exemplar that puts them in an existentially plausible format. But more often today in the search to break through the clutter, this type-token relationship is being breached.[40]

The process of stardom or celebrity starts when an actor or performer is successfully represented as a collectively significant token of the popular. In such a translation, what was initially a metaphor is materialized as a part of collective reality, becoming a metonym.[41] The task of persona maintenance is to make this standing-for relationship appear as an indexical connection. If this occurs, then in popular parlance, the star or celebrity becomes an icon or strictly as I have noted a hypo-icon. Tokenism, at this fundamental level, is the acceptance that the star is an authentic sample of the whole. To be a token in this latter sense, it is necessary to prevent two kinds of degeneration of a successful persona:

(a) The loss of the capacity to stand-for by the revelation of 'inconsistent' personal detail. This is obvious in the case of 'scandalous' revelations. But loss of the capacity to stand-for can occur through too much detailing of the actor's private personality, undercutting

the referential concordance between and actor as a person and his/her ostensive type. This I have referred to as *symbolic degeneracy*.

(b) The perception that the conceptual fit between the actor and the type is artificially constructed or performed. This occurs when the star's persona begins to be subject to backstage coverage that emphasizes the actorly labour of performance, professional values and techniques, distancing the person of the star from the furnishing of character and persona. This can be defined as *hypo-iconic degeneracy*.

Viewed in the broadest sweep, the second form of degeneracy has supplanted the first. This is most apparent in autobiographic positioning, where the image of the star or celebrity as a professional practitioner replaces the view of the actor as a social type. But steganographic positioning takes this de-differentiation further by withdrawing the self behind the process of making and, moreover, adding layers of personae to the public presence of the star or celebrity. This process can be forced on the star or celebrity, in the 'leave Britney alone' mode, or it can be carried out as a pre-emptive seizure of the status of a creator or visionary operating within romantic realism. As the example of Lady Gaga shows, this latter move is also associated with images of victimage, culminating in the *ARTPOP* declaration.[42]

But there is a more conventional understanding of tokenism: a process in which popular experiences of inequality are mollified by the recruitment of individuals from subordinate groups to positions of high reward and power.

> In popular culture . . . a token can be defined as a persona who is constructed from the character and life of a member of a subordinated group, and then celebrated, authorized to speak as proof that the society at large does not discriminate against members of that group.
>
> (Cloud, 1996: 124)

By this definition, tokenism is an ideological process within liberal democracies such as the United States that 'glorifies the exception in order to obscure the rules of the game of success in capitalist society' (Cloud, 1996: 122). As a form of individual recognition that substitutes for collective change, tokenism works to reward those who manage to overcome the oppression resulting from actual or symbolic minority group membership – as if oppression itself is productive of virtue and deservedness. In the case of Oprah Winfrey, for example, it is her

personal will to overcome discrimination and disadvantage rather than her witness to injustice that has proved the key to her success.[43] The exercise of will in adversity is, of course, a ritualized ingredient of the success story, adjusted to fit this or that individual's story through the use of clichés and stereotypes. The role of will in this kind of account is not entirely false; indeed, tenacity can be seen as required by circumstances. Falsity derives from the exclusive ascription of such virtues to the private person of the star or celebrity rather than to the help of others and, no less significantly, the encouragement offered by the process of recognition itself. This primitive reduction of success to individual qualities is a defining feature of a departure from the traditional notion of tokenism. For the intensity of the 'inner' fixing or projection of the qualities into the interior of the individual is at the core of the fetishism of the persona.

The stars of yesteryear were in effect totems, representing to audiences the relation between the individual and nature, especially human nature. Today's stars and celebrities assume the role of the fetish that is formed by its departure from an appropriate framework of collective identity. Indeed, what is entailed is a relationship of standing against the quotidian, by an implicit, if not explicit, invidious contrast. For if still claiming to have won on the basis of natural talents, these begin to include such non-fungible qualities as good looks, good taste and will power. Stars and celebrities alike, but celebrities in a pure state, now struggle relentlessly to bring this natural capital to a state of individual perfection, becoming the platonic revelation of what is inert, incomplete or unfinished in ordinary people, and if the truth be known as the gossip magazines and websites reveal, in themselves. Public figures now bring this logic to its ultimate consummation as someone revered and magical in themselves. In this movement they depart from fellowship with the limited opportunities of the larger community. Even if referring to the commonalities of culture as tokens, they veer towards the satisfaction of having overcome (or being always in the process of overcoming) the limitations of an average existence in late capitalism. At best, fans are no longer invited to identify with them as concrete individuals but as managers of a personal life course in which the dynamics of performance are all. Stars and celebrities now wear – if not unabashedly claim, as in Oscar or Grammy acceptance speeches – the mantle of winners.

Absolute winners are protagonists in the exclusive dramas of their own life stories, superlative survivors who have only a tenuous connection with those who fail or fall short of stellar accomplishments. Epitomizing an escape from the burden of representing average experience, not the

least because the average is no longer a viable destination, they are the ones who have seriously 'got their act together' (Giddens, 1991: 54, 148; see also Thompson, 1974). Tokenism has then a progressive and retrogressive moment. Progressive because individual stars can bestow prestige and pride on a particular identity – the being of a particular gender, race, nationality, sexual or moral orientation – imparting an affirmative glow. Retrogressive, because the process of representation which once advanced as a social type has been turned into a competition that fetishizes a specific token of a type. Jennifer Lopez is not merely a beautiful Hispanic woman, there are plenty of those; she is the epitome of Hispanic beauty. So, too, for his own kind, is George Clooney, as is Lady Gaga for those outside, actually or psychologically, the mainstream.[44]

Contrast this condition of success with the fate of the ordinary and obscure multitude. Paradoxically, the multitude finds that the more their range of identity options are enriched and expanded by the action of the mass media, the more they become dependent on scripts of identity whose provenance is beyond most individuals' capacity to sustain. This is not merely a matter of access to the appropriate technologies and grooming practices. The very multiplicity of self-images created by media saturation, and the ceaseless exploration of ways to be, is likely to produce confusion, multi-phrenia and dependency, and possibly resentment.[45] Stars, celebrities and stars *as* celebrities, by the gorgeous scale of their success, the rich plenitude or exceptionalism of their personality, move away from the burden of standing for us. In such circumstances, the view that the aura of stars and celebrities stems from their embodiment of an immanent contradiction between the ordinary and the extraordinary enters a phase of intensive external contradiction (Dyer, 1987). Rather than performing a totemic function, mediated fame now works to stage a competition between individuals who have exchange value and those who do not – a potentially manageable contradiction for those striving to be stars or celebrities but an absolute contradiction for those who live outside the gated communities of success. Circumscribed and protected by copyright and publicity rights that aim to prevent unauthorized use of their image and products, fame has become a market system in its own right, placing a price on the likeness (Radin, 1982; Gaines, 1991). Moreover, the commodification of the self is now a depth process, in which fragments of the star's persona, his or her likenesses are mined for commercialisation. In a manner that recalls the medieval commerce in holy relics, parts of the stars go on sale (Geary, 1988). Hollywood memorabilia companies such as Premiere Props sell items from movies sanctified by the contagion of the stars. Debbie Reynolds, a studio system

star herself, has amassed a huge collection of such relics, raising more than USD25 million through auction in 2011 (Macaulay, 2014). It would be true to say that these phenomena are as much about investment as they are about star worship. But on the other hand, the items sold would not have an investment value unless they had been valorized by the 'touch' of the stars. Again, to choose an example closer to the performance of value, it is reported that Hilton sells her 'presence' in a variety of markets – cosmetics, fashion, music and acting – earning about USD8 million a year, supplementing her considerable personal fortune from the Hilton Empire. Not content with a life of gilded indolence, Paris is a celebrity entrepreneur in the business of marketing her decidedly carnal attractions. In recent times, for the pleasure of her presence, she commanded somewhere between USD150,000 and USD200,000 for 20-minute appearances at upscale parties – and even more than this in Japan.[46] Such 'sheer' appearances are mixed with quasi-actorly engagements, for example, with Nicole Richie in the celebrity reality show *The Simple Life* (2003) or as the character Paige Edwards in the movie *House of Wax* (2005).[47] In cases such as these, the distancing effects of impersonation do not hedge or deplete her presence and her exchange value in yet another window of fee earning.

These developments indicate a move towards rendering the corporeal person – especially as a personage at the height of their fame – as a commodity. Unlike ordinary persons who simply give up, if they can, their use-value for exchange, the celebrity and star come to embody the process of exchange itself as a mobile and free subject on which various market processes depend for profitability.[48] Today's stars and celebrities symbolize the potentiality for the human body to act as a money form through the materiality of their universalized image.

If this is correct, then certain features follow. The terms star and celebrity are now (for those actors who do not insist on the professional distinction) practically common terms for a common substance. This substance is not the collective labour power of film-making, a necessarily collaborative activity, a kind of artistic communism, but the star/celebrity's inner essence, manifested as an outcome, a person centred spectacle. The old function of the stars as totems defining the relationship between the ordinary individual and society and nature now slip from centre stage. In its place sits the fetish of the celebrity/star as universal equivalent for the collective powers of cinematic labour, the bodily substance in which the sensual effects and affects of the cinema are manifested and concretely valorized as profits. Another way to say this is that the social body of the star/celebrity no longer withdraws or

sequesters a zone of the self from commodification. Individual stars may indeed insist on being private when in public, as anti-paparazzi legislation indicates, but not all will have the choice (because of career or personal meltdown) and some will actively embrace self-commodification.

Lady Gaga, for example, does not resist the market so much as internalize it as a process of identity mining for affect. So if we consider her public being it is not so much that she wishes to oppose herself to the market but rather to develop analytically broken-down aspects of herself for commodification. This process of morselization is carried out whilst her 'real' self remains hidden or, more exactly, abides as spectral presence (an eidolon) waiting to be reincarnated in the next persona to take to market. In essence, she operates as a merchant of her own inner space, the market incarnated, and advises her fans to do the same. This market pragmatism means she can only function uncertainly as totem – witness the slipperiness of attempts to claim her as a community voice – and more as fetish that summates a mystical space, a force of magic, a gig of being for wondrous contemplation and, for her fans, another moment of purchase.

Commodity fetishism arises when the products of collective labour power are rendered as the objective qualities of the things produced – in the case of the cultural industries, these things are personalities (Marx, 1990: v1, 164–165). The star/celebrity system once regulated by ideas of typicality now has a new system of signification that presents demiurges, wonderful beings fully deliverable within capitalism. For Herbert Marcuse, the star system was the very opposite of the place of cultural transcendence:

> The vamp, the national hero, the beatnik, the neurotic housewife, the gangster, the star, the charismatic tycoon . . . are no longer images of another way of life but rather freaks or types of the same way of life, serving as an affirmation rather than negation of the established world.
>
> (Marcuse, 1972: 57)

His thesis of this process as repressive desublimation was undoubtedly too categorical, not the least because elements of transcendence can be rescued from the most banal-seeming materials (Dyer, 1987). It would be an exaggeration (even as it was in the sixties) to claim that the impulse to negate the established world has completely vanished from the popular imaginary today. Gaga negates the monotony of the normal, only to recuperate it to the deep and exclusive mysteries of her being. Rather, what

seems to be in train is that the register of transcendence has changed in line with the neoliberal celebration of winner-take-all contests and the celebration of the entrepreneur as a hero. Our stars and celebrities – if ever the more shocking in their actions on screen or physically charismatic for their cut bodies and remarkable looks – seem like models of the absolute power of transcendence offered by the market and self-commodification. For sure, they tap, or rather resource, a popular desire for an escape from the fate of the majority who live on the wrong side of the labour market and the wrong side of a Pharonic scale of inequality. The stars (if not all of them) and celebrities now construe and depict success in the tournament to be a commodity fetish. In this they stage a show of repressive resublimation, celebrating the power of capital to effect a personal salvation, bestow a state of commodity grace.[49]

Notes

Introduction

1 The term 'celebrity' dates from the 1600s where it referred to the due obser-
vance of rites or, when applied to individuals, to the condition of being much
talked about. It is only after 1849 that the term took on the connotation of a
person who possesses the quality of notoriety or of being well known (OED).
2 Thus Cheryl Wanko (2003: 224) notes the first use of star is in *The life of Anne
Oldfield* by Edmund Curl, 1731. See also Varey (1993).
3 It would be lazy thinking, indeed, to assume that the term capital was some-
how a recognition of the capitalistic nature of stardom.
4 On France see Brownstein (1993) and Mary Louise Roberts (2010). It is worth
noting that for the Paris Opera Ballet the term 'étoile' has a much longer
pedigree and is tied to the highest level of craft accomplishment that only
very few can attain, there being only 18 dancers named stars in the com-
pany's 346 years (Westphal, 2007).
5 Such a reduction is not a once and for all accomplishment but a recurrent
process of contradiction and contestation, providing the fodder for celebrity
journalism.
6 Foucault's use of these conceptions remains confusing – does the latter
term, genealogy, replace the earlier term, archaeology, or does it bring out a
dimension neglected earlier (Dreyfus and Rabinow, 1986). My use of Marxist
categories seems evidently at odds with Foucault's conception of power as
micro-politics. But see his remarks on Don Quixote (Foucault, 2002: 52).
7 No individual study can hope to provide an exhaustive analysis of all the
influences that form a particular cultural practice. That said, it is possible
to provide, on the basis of existing research, an account that is tolerably
comprehensive.
8 Compare Richard Schechner (1982) on theatre as twice restored behaviour.
9 Kean in the aftermath of the Cox affair and Sissons facing the accusation of
meanness. See Bratton (2005).
10 The parallel with politics is obvious, though politicians do not ask the public
for an affirmation of support as often as working stars and celebrities.
11 Kantorowicz (1997) is rightly cited in this connection but it is also worth
noting Durkheim's view that sacred beings were a means of symbolizing the
power of society over the self.
12 See Macintyre (2007) and Skeggs and Wood (2012).
13 The philosophical grounding of the self as a kind of theatre in which identity
is staged experiencing is found in Hume (1969). It is not difficult to see how
the Lacanian triad of the Real, the Symbolic and the Imaginary could be
applied here but I am less concerned with elaborating the constitution of the
self than in exploring the topology of performance. On the paradox that the
postulate of a self creates a flux of identities see Seigel (2005).

14 Moral values are not likely to be the only values under consideration and, as we shall see subsequently, it is economic notions of value, such as box office performance, that tend to serve as the marker of moral value in a capitalist cinema.

15 Though Miley Cyrus spitting water on the mosh pit shows that even this sense modality could play its part.

1 Unsettling Identities: From Custom to Price

1 'Report of fashions in proud Italy,
 Whose manners still our tardy apish nation
 Limps after in base imitation.' W. Shakespeare, Richard 11, 1, 21–23.

2 It is this connection that Elizabeth's projection as a Virgin Queen, that is, as a sovereign without a master, needs to be understood (Bailey, 2001).

3 An additional consideration is that the system did not intensively connect personal morality with role identity. A Duke might well be a heinous offender against moral codes but so long as these activities did not bring dishonour to his public ducal status this was not relevant. See Chaney (1995).

4 As Stallybrass makes clear, a brisk second-hand market developed out of the recycling of aristocratic clothing, in which public theatres located outside the jurisdiction of the Crown and the Master of the Revels were key sites for the imitation and acquisition of courtly fashion. At the same time, clothing was a kind of currency in its own right.

5 Of course still draconian – and to become more draconian – penalties remained in place for impersonation for purposes of deception and fraud.

6 The romantic notion that appearance and sensibility might be at odds with authenticity so that the flouting of the constraints of society was the hall-mark of truth against hypocrisy did not gain full social recognition until the nineteenth century (Wharman, 2004).

7 The London Encyclopaedia (Weinreb and Hibbert, 2008).

8 As Voltaire pointed out, the chain of being had many broken links and worse linkages that were entirely arbitrary. But for the proponents of customary order, arbitrariness was the mark of divine purpose (Voltaire, 1764/1972: 59–61).

9 Golby and Purdue (1984: 55–57) note that the aristocracy and gentry, whether in the City or the countryside, were withdrawing from direct social engagement with the lower orders.

10 A power bloc composed of the landed aristocracy and gentry and, increasingly, a merchant plutocracy, which numbered around 400 families (Mingay, 1963).

11 In this sense, these developments anticipated and set in train the mature formation of classes under industrial capitalism (Thompson, 1978).

12 The ranks in the hierarchy are few and strongly demarcated – superrich, rich, well off and poor – with the lowest rank containing the great majority. Today we might refer to this as a Brazilian scale of inequality.

13 The middling sort was the larger part of the London theatre audience played to by Garrick (Pedicord, 1954).

14 Though traditional notions of noblesse oblige could be diluted by new ideas such as the idea, advanced by Mandeville's parable of the bees, that

self-indulgent consumption, especially the grander the scale, benefited everyone (Dew, 2005).

15 The formation of the middle class remains is much debated but one feature is clear; it is a collective entity whose destiny is to mediate between the ruling class above and the working class below by means of creating its own forms of distinction (Bourdieu, 1983). But although the cultural and social ambitions of the 'middling sort' need not entail the infringement on aristocratic sovereignty, the form they took of social mobility through individual attainment of social mobility necessarily contributed to the ongoing dilution of the aristocratic monopoly of honour. Viewed in this way, the 'middle class' in England can be seen as a pre-eminently historical category, the result of accumulated 'middles' or spaces – between aristocracy and working class, land and labour, highbrow and lowbrow, provincial marginality and metropolitan power – the balance of which has altered over time (Gunn, 2005).

16 This was not necessarily a bad thing, but it could be. To take a well-known later example, Mozart – unlike Beethoven, who was able to live off earnings from publication of his works – never attained financial independence from aristocratic patronage. His efforts to free himself forced him into poverty and obscurity (Elias, 1993, 13).

17 Http://www.william-shakespeare.net; accessed 27 May 2012.

18 It might be observed that they rarely do, but what is important here is that because of the manifest effects of social mobility and the rise of the cash nexus, the discrepancies can no longer be comfortably overlooked.

19 The reasons for the continuing dominance of the English aristocracy are the subject of a vast literature and considerable debate (Cannon, 1984). Here I am focused more on the cultural pre-eminence of aristocratic norms of conduct rather than the economic realities of power which have long devolved to a capitalist upper class.

20 Which is not to say that all consumption was driven by the desire to emulate elite culture or to engage in a status competition (Nenadic, 1994: 145). For overviews of the debates, see Barry (1991) and Klein (1995).

21 Although the periodical press was the most powerful medium of publicity, traditional courtesy manuals continued to play their part, as what we might call 'lifestyle coaches' today (Langford, 2002).

22 'There are no more useful Members in a Commonwealth than Merchants. They knit Mankind together in a mutual Intercourse of good Offices, distribute the Gifts of Nature, find Work for the Poor, add Wealth to the Rich, and Magnificence to the Great. Our English Merchant converts the Tin of his own Country into Gold, and exchanges his Wool for Rubies. The Mahometans are clothed in our British Manufacture, and the Inhabitants of the frozen Zone warmed with the Fleeces of our Sheep.' – *Spectator* 69.

23 Mr Spectator, in other words, was a moralizing version of the *flâneur*. The model of the public sphere in *The Spectator* seems to anticipate the public-service model found in broadcasting, especially in the BBC's notion of uplift.

24 Mr Spectator, of course, could not see what his readers were doing – though he claimed he secretly watched the behaviour of individuals like them. Moreover, he suggested how they should behave to ensure the best and safest demeanour under public surveillance.

25 However, since, as Barrell (2004) and others suggest, the coffee house and other public settings were policed by spies and informers, *The Spectator* can be seen as part of the process of governmentality.

26 These dimensions of people-reading are related to specific forms of the visual arts – to physiognomic manuals, to history or conversation paintings and the theatre.

27 I am aware that the there is considerable debate about C. B. Macpherson's work. My notion of the self, which I prefer to term *person*, is meant to include both material possessions and certain rights – for example, the right to free expression. Moreover, the exercise of taste and discrimination is evidently not just a matter of attitude or taste but of having the economic means to exercise individual choice. It seems to me that Charles Taylor's parallel characterization of the punctual self underestimates the extent to which such a solipsistic image of the self relies on financial independence or at least the support of others. If a punctual self needs such support it is only fancifully punctual (Taylor, 1992).

28 The courtesan Kitty Fisher reported to have eaten a banknote to demonstrate it was worthless compared to jewels or gold provides a vivid example of a substantive theory of value.

2 The Formation of Stardom

1 As an actor-manager John Philip Kemble had a parallel position to Garrick, but did not depart from the prevailing 'rhetorical' approach to acting, as did Garrick.

2 Garrick seems to have solved the problem of market-driven broad appeal by introducing spectacle and elements of popular genres such as pantomime into the repertoire.

3 It seems likely that this was a personally motivated decision. Prior to the conflict with Fleetwood, Macklin had served as under-manager and, it is claimed, had been paid 200 to assist Fleetwood in lowering salaries.

4 One could imagine a more precarious career for Garrick. But the solidity provided by his ownership stake and his role of actor-manager was irreversible; his talent was clearly important but the legal status of owner was even more so since it insulated him from the insecurities faced by other no less talented actors and actresses.

5 At first sight the development of fixed companies, replacing itinerant players, suggests that long distance trade ceased to be a feature of theatre. But even where theatres localized, the orientation of production to culturally diverse audiences (as in London) weakened the tie to a specific locality. Moreover, the intrinsic qualities of drama as a heightened, secular ritual meant that theatre was an institution culturally and psychically detached from its immediate locality.

6 The opportunity arose because of an external factor – the fourth Duke of Bedford declined to renew the ground lease to the building shareholders, making it available for Lacy and then Garrick to take it (Sheppard, 1970).

7 Another variant is the private theatres of the aristocracy, which the development of public theatres reduced to a marginal practice, though the emphasis on the masque and spectacles of patriotism were revived in the development of the public stage (Bratton, 2005).

8 But had the strikers' petition succeeded, it seems very likely that the new company would have taken petty capitalist form if only to secure investment for market exploitation. It was unlikely that Garrick and Macklin, as the leaders of the strike, would not have had a management position –selecting plays and parts to showcase their talents and maintain their popularity. This was, after all, to be a commonwealth for leading players as entrepreneurs of the kind Garrick became when he took the position at Drury Lane.

9 The development of cinema of course complicates this scheme as will be discussed subsequently.

10 The actual record is less clear-cut – other actors such as Macklin with whom Garrick studied were already developing a more 'natural' acting style (Playfair, 1950).

11 Talentless or pure celebrity is a development that awaits our day. It is worth noting that talent here is, however imprecise, a quality of merit and achievement. Celebrity by virtue of birth or inherited position is an ascribed or aristocratic quality.

12 There are other problems – over-expressive in relation to what needs to be defined – in relation to the performance of fellow performers or to a certain kind of character or to what a particular actor regards as an adequate performance of character in relation to a definite style. Cibber's private self might be deemed shielded by his ever-popular portrayal of the Fop and his attempt at tragedy is unable to shake the ghost of this persona. Does character refer to the moral quality of Cibber as a private person, as an actor or as fictive being? But even if it is accepted that Cibber consciously sought in his plays and writings to create identity uncertainty, as against involuntarily exposing his limitations as a writer and an actor, there is a more positive route that affirms the personage of the actor as a consummate creative professional.

13 As Johnson's prologue for Garrick's first appearance after he became a patent holder made plain – 'we who live to please must please to live'.

14 In this project Garrick benefitted from the work of consecration initiated by the Ladies Shakespeare Club – a middle-class association with an aristocratic leadership in the person of Susanna, Countess of Shaftesbury (Avery, 1956). For a general discussion of the influence of the Bluestockings, see Eger (2002: 65, 1/2; 127).

15 Garrick was rumoured to be under consideration for a baronetcy. In a letter to Lady Burlington, he declared that it would be undeserved thereby proving by his graciousness and modesty that he was noble in spirit if not in fact. Given his propensity to seed the press with rumours, it is not entirely fanciful to suppose that he was the source of the rumour, which he might endearingly deny (Stone and Kahrl, 1979: 443).

16 In any case if there were, would this purely be his performance or the performance of other resources – camerawork, editing, lighting, other actors and so forth?

17 Cole and Chinoy (1970); Forbes (1984).

18 As Bos observes, there is actually considerable variation in the description of the temperaments in humoral psychology (Bos, 1998: 37).

19 Charles Darwin, in his book, *The Expression of Emotions in Man and Animals* (1872/1999), acknowledged Lavater as the foremost exponent of physiognomy as a natural theology. This approach, which challenged Darwin's

theory of natural selection, was still prevalent in Darwin's day in the work of Professor Charles Bell, the eminent physiologist. Physiognomy was also a popular theory. As Darwin observed in his *Autobiography* his opportunity to sail on *The Beagle* was nearly scotched because Captain Fitz-Roy, a dedicated physiognomist, thought that the shape of his nose indicated a weak character (Darwin, 1872/1999: 10).

20 In the 1850 edition, Lavater cites the necessity of merchants, engaging with a stranger in a commercial transaction to read the features of the other for trustworthiness. He is speaking implicitly of the market of strangers in which exchange values are dominant. It was eventually argued under the influence of Descartes, that the skull being closest to the mind – seat of the passions – moulded the dominant emotional complexion. 'If we consider the circuitous outline from the point a, above the eye bones, to c, behind the head, we may define with tolerable certainty, the preponderating characteristic of the mind' (Lavater, 1850: 15, 512).

21 Its implicit adherence to the moral economy of the Great Chain of Being and the traditions of customary society – finer sentiments being associated with heroes of noble birth and the genre of tragedy and baser motives with villains and comedy – did no harm. Physiognomy gave a nod to deference and, at least in principle, an inoculation against social censure. Nor did it hurt that an actor portraying tragic roles would acquire an aura of nobility.

22 One of the revered classical sources for an oratorical style, Quintilian said that the greatest impact on the feelings of an audience could only be achieved when the orator, and by extension the actor, contrived to imaginatively evoke images within themselves of the passions they wished to evoke in onlookers (Institutes 26).

23 Ewen and Ewen (2006) refer to physiognomy as the science of first impressions.

24 Descartes based this model on the observation of an automaton – a species of mechanical actor.

25 John Philip Kemble, unlike Garrick and Kean, held a view of character consistency that eschewed making a point of every passion, building steadily towards a single dramatic climax or turning point (Taylor, 1972: 62).

26 Capital' actors did their best not to frequent even final rehearsals because they were 'too proud' and because their attendance though helping other actors would not greatly alter their own final performance. Garrick was one of the few proponents of a final group rehearsal, but even he was resisted by 'capital' actors such as Susannah Cibber.

27 Of course he naturally 'owned' his own face but the way he used it was the most intensive source of singularity.

3 Garrick as a Personage

1 Even unobserved behaviour can be seen as conditioned by acquired mannerisms which anticipate being watched by others, albeit in a feckless manner if compared to what an actor might achieve in the same circumstances. In the case of cinema, the response to passivity can be constructed by direction and editing.

2 Or on camera, but the complication here is that cinematic performances are rarely continuous. Once again, the practice of 'points' may be said to execute frame-grabs on action. Before Garrick's innovations many actors simply dropped out of character when not delivering their lines.

3 For example, both Garrick and Kean had to deal with the lay perception of heroes as physically 'big' men and their own short stature. Though in Garrick's day, the signs of ageing, most severe for women, were hidden by the distance from spectators, which in turn permitted the artful use of make-up. The fact that leading actors owned their parts until they chose to relinquish them obviously intensified age-inappropriate casting.

4 Obviously film editing and especially digital compositing moderates this constraint but poses other problems as we shall see subsequently.

5 I would emphasize that I am not engaging with what constitutes a 'great' actor. This is a complex and contingent matter that can only be answered historically – a great performance for whom? Under what conditions? In which character? and so on. I accept that an aesthetically powerful performance must be credible but, at the same time, a performance can be credible because of the personal beauty of the actor.

6 In Eco's (1979) terms, they are sign functions or modes of sign production rather than signs.

7 Following Hébert I am treating the square as a grid for locating different kinds of enunciation or discursive production, not as a description of a mode of being or ontology – which is not to say, of course, that audiences and fans do not routinely read seeming as a reliable route to being. Indeed, the whole purpose of acting, in a naturalistic or realist mode, is to persuade them to do so.

8 Mediation is not determination – the spectator may entirely reject the implied identity claim but that reaction evidently depends on the identity proposed by the actor's performance. Anything can happen by way of response but not everything is relevant to the act of identifying with a specific character when watching and listening.

9 Of course an actor may do all of these at different stages of his/her career or observe that some characters are closer to his her or her real or plausibly ideal self.

10 For example, the importance of looking like a person of quality or of fashion is a recurrent theme in novels of the time such as *Tom Jones,* written by Garrick's friend Henry Fielding. This is especially a consideration for individuals extending services on credit such as landlords. Garrick is reported to have declined a mask at masquerades, always wishing to be seen in public as himself – or rather as a personage, jealously protected by the trademark of his face.

11 Strictly, a character may exist without a type, or the type is only known through a character.

12 Such a fine distinction would not be apparent in a specific performance, but it stemmed from the overarching context of his acting, accumulated in audiences' memories of his different parts.

13 He owned specific parts, like many other actors, which he repeated throughout his career.

14 It remains true of course for live performance, which can be seen as the 'authentic' touchstone of celebrity. See Luckhurst and Moody (2005).

15 Here I disagree with Perry, on whom I otherwise rely, that static forms such as written, printed and graphic representations were adequate as surrogates for the visibility provided in the theatre (Perry, 2007, 193).

16 From a male perspective, coverture was designed to ensure that males should have exclusive sexual access to females in private, through marriage or the 'sub-rosa' institution of the mistress. It could also redound against illicit relationships when, for example, Edmund Kean's relationship with Mrs Cox caused him to be sued by her husband for criminal conversion of marital 'property'.

17 Male actors were doubtless homoerotic sex objects but sub-rosa, since gay relationships were a capital offence in the eighteenth century and lesbian relationships were simply invisible. Moreover, barring rather exceptional circumstances, men (compared to women) were expected to exercise greater control over the passions whether heterosexual or homosexual – though not always successfully (Brewer, 2004).

18 Though as Straub (1991, 11 and 37) points out, even the respectable Garrick was suspected of homosexuality.

19 Cibber (1822: 465). Prior to assuming an acting career, Abington was a flower seller and prostitute, so the art of constructing personal appeal based on sexuality was not entirely a new departure. But this was a more literal instance of strategy imposed on actresses in general. Hannah Pritchard, no natural beauty, seems to have triumphed through the craft of character portrayal rather than by the immediate enticements of her physical qualities.

20 While true at this time that actors as a category could not, it is notable that leading male actors, such as Betterton and Garrick, were able to soften this categorical judgement.

21 It needs to be recognized that the tension between the universal and the particular is indigenous to acting, but this becomes a problem when the actor is expected to be universal as was the case in the context of English theatre in the period in question and in the aesthetic of the Royal Academy under the direction of Reynolds.

22 She poignantly observed: 'Perhaps in the next world women may be more valued than they are in this.' (Buchanan, 2007).

23 It seems likely that male actors did the same, but the gender assumptions granting them a public register of appearance arrested the decline into offering erotic spectacles of their person.

24 The policy of showing the self, literally and figuratively in person, was equally a means of meeting audience expectations and generating attachment to the private person, a process reminiscent of self-presentation as recommended by Lord Chesterfield and later anatomized by Erving Goffman.

25 The psychoanalytical dynamics of this process has been described as a production of extimacy – the adoption within the innermost recesses of the self an image of the external desire of, particularly male, others (Perry, 2007).

26 This suggestive play was contained off-stage by association with a male, preferably a person of quality or an aristocrat as husband or protector.

27 I am not claiming that Kean's performance style rested on an explicitly formulated commercial strategy – most accounts note that he formulated his

performance idiolect by modelling the style of the actor George Frederick Cooke, the prototype of the 'romantic' performer. But Kean did appreciate that such a style could be used as a means to see off rivals. On Cooke see Caputo (2011).

28　For example, he kept a pet lion, wore stage costumes as street clothes, indulged himself and his wife in extravagant and ostentatious expenditure on luxury items, rode like the devil on midnight rides, caroused drunkenly at his favourite pub The Coal Hole, and so on. In short, he behaved as a 'larger than life' individual in a manner consonant with his reputation as a great actor. It is worth noting that compared to his peers, for example, Elliston, drunkenness and fornication was part of the theatrical lifestyle at Drury Lane. In terms of creating a persona, Lord Byron, himself something of a rake, encouraged Kean to play the part of the Romantic hero (Kahan, 2006).

29　Where Garrick sought aristocratic and intellectual associations such as The Club, Kean created the Wolf Club as a drinking club for his fans and supporters.

30　There was no 'school of Kean' just as there was no 'school of Garrick', and for a similar reason: both actors infused their performances with particularizing touches that other actors could not successfully imitate. The more conventionalized the approach to performance – as, for example, James Quin in Garrick's day and John Philip Kemble in Kean's – the easier it was to develop a school of acting (Downer, 1943). Kean's descent into particularism was steeper than Garrick's because the latter was obedient to conventional notions of decorum in support of his status as a gentleman.

31　It is worth noting that Byron, with whom Kean was professionally and personally associated, found similar censure for his affairs. But, unlike Kean, Byron had independent means and, moreover, did not depend on a direct appearance before an audience for a living.

32　As Hillebrand (1933: 185–186) points out, Kean did not want membership of a management committee but total control.

33　Such evidences of aspiration must be set against his more collectivist impulses such as generous gifts to others – sometimes when drunk – and his patronage of the theatrical fund for distressed actors.

34　His position ownership of a minor theatre in Richmond Surrey is more a consolation to a ruined and shortly-to-end life course and career.

35　Jaffe (1980). Kahan (2006) makes a good case for the undecidability of Kean's identity and the resulting many versions of Kean.

36　If Kean was not disposed to view Garrick as a role model, a superannuated Mrs Garrick was there to remind him. Commenting in a letter to Kean on his performance of Garrick's old role as Abel Drugger, she told him it was inferior to her Davy's to which Kean replied: 'I know it.'

37　Although there are portraits of Kean and other visual materials, the scale of the proliferation of his likeness is much smaller than Garrick's or Sarah Siddons'. Moreover, Kean's likenesses are more literal and shorn of the trappings of transcendence. He is depicted in character – for example, as Sir Giles Overreach in the theatrical portrait by George Clint – or serving a market function as 'The Theatrical Atlas' (holding up Drury Lane) by Cruikshank, but not as a personification of the dramatic arts in the manner of Garrick or Siddons.

38 The hypertrophied celebrity life will be examined subsequently but there is a discernible link, plausibly connected to narcissism, that unites quite diverse performers such as Elvis Presley, Mike Tyson, Michael Jackson as limit testers (Rojek, 2012).

4 Emergent Modes of Stellar Being

1 Though I have suggested that identity can have differing modalities of reference, contesting definitions of the real.
2 Self-commodification is a gradient process. In Kean's case it might be said to be a kind of self-taylorization. Preparing his body, before the dressing room mirror, to execute prescribed actions according to scenes.
3 This is a necessary simplification because the patterns of ownership of theatres are complex and show hybrid variants. So Drury Lane was granted limited liability well before this became a standard feature of company law in 1855 and was also a partnership. See Davis (2000).
4 The emphasis on spectacle was not new. Both Garrick – in his use of Loutherberg as a scenic designer and in his own pantomimic style of acting – and John Rich at Covent Garden had given as much priority, arguably more, to scenic effects than to the spoken word and the visually static, classical style of acting (Wood, 2001).
5 Ironically seeking to gain respectability in a profession his father hoped he would not follow, contending no doubt with the latter's déclassé notoriety amongst the 'better' sort.
6 One eyewitness attested to the power of Irving's performance – eerie, visually stunning (Quatermaine, 1960).
7 Of course his advice would not have been an option for a rank-and-file actor who would be bound to the rules of mimesis rather than personality acting.
8 In my terms he was an eidolon inside each character – a shadowy presence.
9 Even sympathetic critics such as Alan Hughes recognize Irving's insistence on absolute control over the Lyceum's large casts – this control was relaxed in the case of leading players (Hughes and Allen, 1981: 15–16). But on the other hand, Irving's excessive by-play afforded fellow stars such as Ellen Terry little room to shine.
10 It is inaccurate to say that Irving did not represent the 'real' character of, say, Hamlet, since characters only exist as textual entities awaiting embodiment. The problem is that Irving in representing a character engages in self-presentation.
11 The tension between personal marketability and the universal was not peculiar to Irving but affected leading actors in general such as Forbes-Robertson and Beerbohm-Tree.
12 (http://giam.typepad.com/the_branding_of_polaroid_/sir-laurence-olivier) For general evidence of this practice by contemporary Hollywood stars, see Japander.com.
13 Irving's preference for a formal, deliberately posed painting or photograph of himself over 'candid' or impressionistic portraits is evident in his refusal to complete his sitting for the consequently unfinished portrait by Jules Bastien-Lepage; see Storm (2004). Ironically, perhaps, this portrait is on the cover of his grandson's autobiography.

14 It is speculation but it is difficult to imagine that Irving's physical limitations would have benefitted from capture on film. An early sound recording of Irving exists which, although he is not vexed by the need to project, reveals a relatively stilted and unexceptional voice (Richards, 2005b: 318–319).

15 'To antebellum Americans, theater seemed to matter; it was a reference point, a litmus test for the moral health of republican society, and a never-ending source of metaphors' (Smith, 2012: 265).

16 The immediate cause of the Astor Place riots (1849) was a feud between British star William Charles Macready and American star Edwin Forrest. Macready was perceived as an aristocratic snob who disparaged Forrest's muscular Jacksonian virtues. But the larger context was a class struggle between cultural elites from the middle and upper classes and the urban working class. The Astor Place Opera House, patronized by the Anglophilic respectable classes, was felt to be undemocratic and elitist. The fact that Macready was publicly urged by the literary establishment not to accede to popular demands to abandon his tour merely reinforced this perception (Berthold, 1999).

17 It is noteworthy that the British mass-circulation press was more restrained and respectful in its treatment of celebrities. Henry Irving, for example, was a popular favourite – it was only in specialized theatre criticism that his status of the Great tragedian was severely criticized.

18 The emphasis on moving visual spectacles was not exclusively theatrical, as Vardac (1950) tends to suggest, but part of a broad area of moving image production practices such as panoramas and magic lantern shows.

19 As Burrows (2003) points out, an extroverted and melodramatic style in film need not necessarily exclude the projection of interiority.

20 The underdeveloped state of film technology at this time is of course a factor, particularly the absence of a clear understanding of the impact of film on the sweeping gestural display developed for the theatre. Operative too is the prevailing view of film as recording events rather than constructing narratives (Gunning, 1994; Pearson, 1992).

21 But at this time, the theatrical photograph as well as ordinary photography emphasized formal poses that communicate status rather than personality (Barthes, 1981).

22 The cinematic image, to be sure, is an unstable text but in early cinema it functioned within a regime of the gaze that treated it as a spectacle or attraction (Gunning, 1986). The Victorian Theatre was a theatre of attractions (Booth, 1981). Before cinematography, photography functions as the objective correlate of what is verbally described, after the moving image it becomes just a trace referring to a mobile visual record (Gombrich, 1972).

23 It is worth emphasizing that the more intimate image of the actor – formal clothes versus informal, fully or partially clothed – is a variable that can affect the spectator's sense of engagement. Today's public-intimate images can be seen as a professionalized form of striptease that, when not stolen paparazzi shots, are markers of the star's patulous efforts to draw fans into corporeal intimacy.

24 Obviously, the availability of movie clips is historically limited in early cinema, so it would be necessary to consider different regimens of image consumption. Today the availability of moving images is widespread.

25 There is controversy about the actual class composition of the nickelodeon audiences. It was a guiding assumption that the first audiences were working class. This was questioned in the early 1970's by research that found for Manhattan, a significant centre of film production in the first decade of the twentieth century, many nickelodeons were located on the margins between immigrant ghettoes and more affluent middle class districts. This raised the possibility that there was a middle class patronage. Later research suggested however that the earlier assumption of a working class audience was largely correct (Singer, 1995). The issue of the actual class composition of the early audiences needs to be distinguished from the norms expected to govern actual behavior, which clearly expressed WASP fears over the "new" Immigrantion.

26 There is an extensive literature on this development. For a review see King (1984).

5 Writing the Stars

1 Florence Lawrence and Florence Turner of Vitagraph were both publicized by name by their studios to the general public in March 1910, making them the first true 'movie stars'. Eileen Bowser, *The Transformation of Cinema, 1907– 1915*, University of California Press, 1994: 112–113.

2 Which is not to say that the discourse compelled the new medium of cinema to copy its conditions of emergence but, rather, as I have endeavoured to demonstrate, that the cinema was drawn by its key participants to adjust to theatrical precedents and remediate its conventions and forms.

3 An approach that is better set to resist the airy generalities of myth in the sense of Roland Barthes – the reduction of what was socially formed to the force of nature in the person of the star. Richard Dyer's work in general – for example, connecting Marilyn Monroe to the regulation of heterosexuality in the 1950s, or Judy Garland as a camp idol to gay sensibility before the gay liberation movement – is both exemplary and rightly influential.

4 The post-factual status of star biography may be the result of legal restrictions on what can be said whilst the star lives. It can also be the result of natural events, for example, an early death. But more routinely, post-factuality derives from the short-term nature of stardom itself. On one, admittedly half-humorous account, the duration of stardom, defined as the peak of popularity as represented by box-office success, is four years (Menand, 1997). Stardom may be regarded as a 'peak experience' when the star is massively popular, followed by a subsequent career that 'trades' on the value of the name. On different patterns of success, see Rein and Stoller (1987).

5 The feature of time–space compression is affecting stardom as well. In this regard Eamon McCann's *The Body in the Library*, which examines the discourse constructed around Marilyn Monroe as a process of appropriation, serves as a timely warning. In part this kind of development confirms the well-established view that popular memory is a constructive and selective process that fits the record of the past to present concerns. What is interesting is the fact that this function is being performed on material records which imply an increasing reliance on the text as proof. For a general discussion see D. Middleton and

D. Edwards (eds) *Collective Remembering*, Sage, 1990, especially Chapter 3; Radley (1990: 46–59).

6 One of the lessons to be drawn from textual analysis is that the realm of images can never provide a synopsis. On the contrary, only by the rendering of visual qualities into words can these qualities sustain the burden of collective or communal understandings.

7 In the fictional realm (diegesis), the star is an animator of someone else's intention to communicate; in the fan magazine, the star speaks, or is reported as speaking, as the author of his/her own words.

8 Superlative normality explains why certain stars are an exception to the general rule of physical beauty, such as Wallace Beery, whose homely appearance is the 'best' of its type. At the same time, sheer box-office success overrides such limitations and, besides, mobilizes cosmetic and cinematic improvements on nature.

9 In the latter regard, it is not merely the eye-catching issue of morals about which film fan magazines from their inception in the early teens were defensively vague where the newspapers were not (see E. Goodman, 1961). One organizational factor needs mentioning: most fan magazines had their editorial office in New York, with a three-month lead time on articles. This factor alone militated against highly detailed reporting on current events and, moreover, required a transcendent 'view' rather than the news style of reporting.

10 As a minor B Western star in the 1930s, a major star in the 1940s and 1950s, and an icon of the Right in the 1960s and 1970s (Wills, 1998).

11 Leo Lowenthal (1961) is a clear precedent.

12 The matter of whether the performance is live or captured does not affect this potential to switch 'subjects', though the breaking of frame may become the director's or editor's prerogative. The audience's agency does not change; its perceptions of the actor are always grounded in the exterior of the action, because the overall modality of star identity, its claimed substantial reality, is physiognomic – looks and appearance are treated as reliable indicators of the interior 'self' from which everyday inferences can be drawn (Noth, 1995: 364).

13 Narrative is not a function of a star's persona unless s/he is doing a biopic and is explicitly claimed to have actually lived the sequence of events narrated.

14 If the emphasis were on the logical subject this would mean that the actor preferred to talk about the mechanics of acting and the use of self as a machine for producing actorly effects. Decordova (1990) provides evidence that this subject was dominant in fan magazines before the development of the star system

15 It needs to be emphasized that the modes of identity are co-present features of the discourse of fan-magazine writing. But, as I see it, in terms of their relative salience it is connected to the specific periods of Early stardom, Mature stardom and Post-stardom. Seen from the angle of the present, the evolution of stardom is a process of autonomization. In such a process, what were hitherto parts of some entity or structure are separated off and now appear as entities in their own right.

16 The field element of the register of fan-magazine writing is primary only insofar as the other elements of the register are under source control.

17 Popular may turn out to be merely *popularized*.

18 A studio-based event is obviously more open to disruption by surrogates for the audience at home – rude comments from a person in an otherwise compliant studio audience, for example – but such matters can be edited out or managed by the intervention of the host.

19 The actor is, at once, a character within the dramatically represented world, a human being of some sort in the extra-dramatic world and a material body.

20 I would emphasize that what is in process here is not replacement but displacement. Displaced modes continue to exist alongside a newly emergent mode, setting up conflicting currents of meaning and intensifying the ramification of detail already ongoing. The extent of ramification is an issue for discursive coherence. The first two phases of positioning are the most coherent since what is revealed and circulated about the stars is controlled by the source. The development of the social media and the intensification of celebrity news as a marketable commodity as represented by the paparazzi and sites like TMZ has complicated the drive to position stars but has not removed its necessity.

21 For a general history see Slide (2010). I have made use of the collections, Levin (1991), Gelman (1972), and Griffith (1971). In addition I have sampled copies from *Photoplay* in the relevant decades to ensure that these selections are not unusual.

22 Although some early leading silent film actors had stage experience – such as Mary Pickford, Douglas Fairbanks Florence Lawrence, Marion Leonard or King Baggott – their casting in film was driven by the immediately legible connection between appearance and type. Although the fusion between actor and character was far from unknown on the stage (for example, James O'Neill as The Count of Monte Cristo or James Hackett as The Prisoner of Zenda), the notion of a superlative rendition of pre-existent character was much weaker in the 'movies' when famous stage stars were not involved.

23 On product format, see Leiss et al. (1986).

24 See Studlar (1991), an excellent elaboration. Fairbanks was not the only star exponent of 'sound minds need sound bodies'; see Bushman (1915: 59).

25 Ironically, Mary Pickford wrote, 'In his private life Douglas always faced a situation in the only way he knew, by running away from it' (IMDb.com).

26 Carr, 1915: 27–31. To drive the point home, Chaplin remarks how little he remembers of his early experiences – which may be true, but in the context of a supposed biography this only serves to underscore the unimportance of personal details.

27 Compare Chaplin's New Contract, (Peltret, 1919), with Here Comes the Kid, (*Anonymous* 1921). To some extent this presentation (and this must be said of many of the early stars) must owe to the fact that Chaplin was known as an image – a cut-out figure placed in the lobbies of cinemas – well before he was known by name.

28 'It was a tribute to Chaplin that he made a virtue of failure and made the tramp figure an Everyman with which his audiences could identify' (Boyer, 1990: 85).

29 On 'symbols' see *Photoplay*, July 1919: 49; Hart, 1921 reprinted in Gelman, 89. As a calendar, Feb 1926: 28–29. Greta Garbo is a late example of anagraphic

representation in which the 'distance' imposed by the statuesque medium of silent film is matched by a vestigial persona, becoming, by contrast, in the age of talkies, the star who is unattainable.

30 The degree to which the actor's voice infuses character with the personal presence is most apparent when the voice does not fit the type. The case of John Gilbert, whose voice, while not unpleasant, lacked the imagined gravity of a virile romantic lead is the best-known example.

31 'A few years ago motion picture producers regarded youth and beauty as the prime essentials to successful screenplays. Youth and Beauty are glorious things but they have their limitations. Without real ability as an added accomplishment they can go only so far.' Roberts was either optimistic or self-promoting.

32 Seven years later beauty, personality, charm, temperament, style and the ability to wear clothes are deemed paramount (Lytel, 1922: 39–45).

33 *Photoplay*, 'Movie Royalty in Hollywood', June 1915: 123. Defines stars as the new royalty.

34 The notion of the gentleman is, of course, associated with Anglophilia; it is also a persistent historical theme connected to the rise of the culture industries (see Brewer, 1997). Cary Grant is an interesting example because of his British background and his rather unusual adherence to these principles; see McCann (1997).

35 The association between stardom and conspicuous consumption is played down in the teens and early 30s. See, for example, Vantol (1932) and Kitchen (1915).

36 Early fan magazine readers were not unaware of the role of artifice and fabrication, as contemporary notions of a newly emergent post-modern sensibility would have us believe. Rather, they had a different calculus of regard; signs of automatism and mannerism were seen as vitiating the freshness of the movie experience. 'The Fan's Prayer', *Photoplay* 1917: 96.

37 *Photoplay*, May 1929 Editorial, 'Close-ups and Long shots'. Quirk, of course, had a vested interest in advancing national advertising. See Fuller 2001: 164–165.

38 Robert E. Sherwood, *Photoplay* November 1925: 70 and 123, on the public's aversion to monotype roles. The interest in personality follows a general trend (Susman, 1984).

39 As far as *Photoplay* was concerned this quality still required male authorization – it fell to Joseph Schildkraut and Lewis Stone to pronounce definitively on what 'IT' was (Larkin, 1929).

40 'Gossip of all the Studios', Jan 1929: 46. See also 'Filmland's Royal Family' (Second Edition), November 1929: 29.

41 Readers can be forgiven for thinking otherwise – she is alluring enough to have no less than two wives citing her as a correspondent in divorce proceedings. Such charges were apparently groundless.

42 The second article, in May 1929, is reprinted in Gelman, 1972: 121–122.

43 From the Life Story of Nils Asther (Spensley, 1929b).

44 For example, Tom Mix is introduced as one of the most accomplished rough-horse riders that ever came out of the west (Anonymous, 1916: 33). By March 1929, Mix is parodying his former self by asserting his true love is a horse (Mix, 1929).

6 The High Tide of Biography

1 Today, of course, even the power of press contends with the power of the blog and social media.

2 'I'm No Communist', March 1948, Gelman, 1972, p 356.

3 See Gelman 1972: 'What I think about the Errol Flynn Case', February 1943, p 326; 'The Case against Chaplin', September 1943, p 330; and 'We Won't Forget', p 331.

4 See articles in Gelman (1972) on Bergman: 'Nordic Natural', October 1941, p 336; 'The Bergman Bombshell,' July 1949, p 359; 'I saw Rita Hayworth marry Aly Khan', August, 1949, p 363.

5 The personal reality being explored was not a state of being either, but a relationship to the reader – since my personal feelings are like yours, then I am like you and my opinions or experiences are a surrogate for your presence. The term 'Clark Gable' was a serviceable shorthand not only for these effects, but for their transparent manifestation.

6 Reprinted in Gelman (p 282–285) as *Photoplay* Nov 1943. But since the article mentions the Paramount riot which occurred in 1944 this dating may be inaccurate.

7 See also Rockwell (1984: 82–84).The unruliness of the 'Sinatraites' caused a riot at Manhattan's Paramount Theater on Columbus Day 1944.

8 There is little reason to suppose Parsons was Sinatra's friend. Certainly after 1947 when Sinatra's career went into decline, his association with the Mafia and, more telling perhaps, left sympathies, earned him the hostility of Parsons along with other right-wing columnists such as Westbrook Pegler, Robert Ruark and Lee Mortimer and gossip rivals such as Hedda Hopper and Dorothy Killlgallen. Pink Frank was certainly not Parsons' cup of tea (Rockwell, 1984: 102.)

9 The data examined in chapter 3 is relevant to the arguments here. What follows can be regarded as supplementing that material.

10 Though even Sayles recognizes that stars are a significant narrative source if used correctly; see Sayles (1987).

11 Systematic data on audience preferences for film genres dates from 1918 in Austin.

12 Jowett et al. (1996: 237) notes that although scholars have used Movies and Conduct to comment on the influence on working-class children, the published biographies actually illustrate the relationship between middle-class youth and the motion pictures in the period 1915 to 1929.

13 I explored this aspect in my Ph.D. thesis.

14 But not finally since most of the autobiographies collected by Blumer were not used in published accounts. Jowett estimates that the published statements derive from fewer than 20 subjects. Given that the vast majority of the biographies are probably missing there is no final way to check that these selections are representative of the entire sample. But on Blumer's authority they can be regarded as exemplary.

15 Some respondents mentioned more than one reason. It is worth noting that only 65% of respondents in a follow-up survey actually reported own gender preferences. Did the remaining 35% not identify with stars at all? If they did this is not explored.

16 (Tudor, 1974: 88ff) As plausible as these distinctions are, Handel's respondents are not making them. Handel's own view is that these dimensions of fan behaviour are interrelated and hard to separate, not the least because some respondents cited more than one reason.

17 Which is not to say that class and racial judgements are not tacitly active. Tudor (1974: 148).

18 This finding leads Stacey (1994) to make a broad distinction between identificatory fantasies and identificatory practices.

19 On the connection between stars and consumerism see Eckert (1978). In the light of Stacey's distinction between identification *with* and identification *by*, *Photoplay* from its earliest issues contains both modes e.g. advertisements in which stars endorse a particular product, especially beauty aids, so the two processes have always been dimensions of fan discourse.

20 The answers Elkins received are clearly an artefact of his definition of social class, which is perhaps better defined as status consciousness. But this Weberian definition – class as defined by occupation of husband, level education, place of residence, and so on – is a feature of American sociology overall. More important, this is the definition that his subjects regarded as normal (as presumably did Elkins).

21 Negative traits were symmetrical with these preferences, with middle-class women disliking conceit, snobbery, eccentricity and non-conformity and upper-class women disapproving of cheapness of appearance, lack of intelligence and common attitudes (Elkins, 1955: 42ff).

22 Lest this be thought to be a simple matter of gender, the women did attribute positive qualities to the other female stars selected.

23 Reisman et al. (2001).

24 This audience data was triangulated with interviews with production personnel and Gamson's own participant observation of the Los Angeles celebrity watching circuit.

25 The tendency towards abstraction evident in the progress inflation of terms – superstar, megastar – is a symptom of autography.

26 This is otherwise known as a third-person effect.

27 'Our findings suggest that people are not seeking out celebrities to emulate; rather, they seek out further information about celebrities' lives for vicarious pleasure'. Leets et al. (1995: 114).

28 Leets et al. (1995: 117) cite a respondent who is actually seeking sexual contact, but even she is aware that this may not be possible.

7 The Rise of Autography

1 Though the morality clause was less about the *actual* morality of the stars than about the right of the studios to dismiss those who failed to keep their foibles under cover.

2 It is easy to forget that character franchises like *Rocky* were very uncertain ventures at their inception and remained so at every point in the emerging series – much the same can be said of the Batman and Superman franchises.

3 The spectre of the stalker was at this point a distant prospect. For an insight into how Mark Chapman's assassination of John Lennon in 1980 altered

the attitude of stars to encounters with even harmless fans (Ronson, 2000). Stalking, nonetheless, is a marginal phenomenon for stars despite the high media profile given to some cases. See also Schlesinger.

4　The time-honoured method for coping with the fragmentary nature of film performance was to research the character in depth. Method acting as developed by Lee Strasberg was a technique for drawing on the actor's own private sense memories in portrayal, downplaying a character's historical or social context as a source of interpretation. See Baron, Carson and Tomasulo (2004).

5　This was an important consideration in the media turning a 'blind' eye on Roosevelt and the Kennedy Administrations, both of which involved sex scandals and the question of the fitness of the President (Collins, 1998).

6　As Goodman (1961) documents, the studios sometimes 'outed' one star to protect another.

7　In part this reflects specialization. Many websites now operate that explore the production context e.g. Imdb, The-numbers.

8　Even here, as demonstrated by the case of O. J. Simpson and, on a lesser scale, Hugh Grant, persona credit can still operate.

9　This modularization of morality may go some way to explain the resentment and aggression that lies behind the fascination with celebrities. Celebrity is the objective correlate of audience powerlessness.

10　For a wide ranging discussion of star identity re-keying see shifts see Petersen (2011).

11　On free indirect speech, see Delin (2000). Graham's style probably reflects the fact that she is primarily a gossip columnist, a genre in which the tidbit reigns supreme, Even more exalted high society arbiters like Elsa Maxwell get in on the act (Maxwell, 1950).

12　As Petersen (2011) observes the biggest stars still dominated coverage but they were no longer presented in a domestic framing, taking on the attributes of "sex" symbols in a manner that followed the representation of the new teen idols (151).

13　*Life* (1989) for example, Tom Hanks, today's star meets James Stewart, yesterday's star, and so on through a number of rituals of baton passing.

14　The use of Taylor in this way was an axiom of *Photoplay* operations in the 1970s as well. Nancy Walker, West Coast Editor of *Photoplay*, Jay Heifitz of Rogers and Cowan saw his objective as getting his client's face on the cover of *Time* in ten years. Interviews with author, July 1976.

15　For a comprehensive account of the press coverage of the Fisher/Reynolds break-up and Elizabeth Taylor's role in it see Mann (2009: 276ff).

16　The tendency in *Photoplay* to equate stars to mannequins or models has consequences for modelling per se (Gross, 1995: 223). In this period fashion models began to develop 'personalities' as a supplement to their 'look'. Though the deployment of the movie star as a Pin-up begins in the 1940's, by the 1960's this has become a standard format see for example Photoplay in January 1960 celebrating a leap year in which female readers can "pop" the question. A road map there is supplied in A Leap year: Eight types of Bachelors offers warnings of potential dangers e.g. Rock Hudson "Slow down curves ahead *Photoplay*, January 1960 this theme of beefcake and cheese cake continues in subsequent issues.

17 *Photoplay* soldiered on until 1978, by which time it merged with *TV Mirror* and became little more than a collection of pin-ups of film, television and music stars.

18 *Newsweek*, 1977, quoted in Gamson (1994: 42).

19 Levin and Kimmel (1977) also find a progressive narrowing of the moral compass from the public to the private in newspaper gossip columns from the 1950s to the 1970s.

20 Bill Burt, editor of the *Examiner*, quoted in Bird (1992: 91).

21 See the data on covers from 1974 to 1993 contained in Kessler (1994).

22 At the time Kessler's book was published, the single best-selling issue of *People* was on the death of John Lennon.

23 *People*, April 1998. See also 'The 20 million club', *US Magazine*, July 1998.

24 An earlier version of this section, updated and rewritten here appeared in King (2003).

25 By focusing on Stone's statements on the relationship between her person and her persona I do not mean to suggest that Stone is an individual agency. She is represented and managed by staff and minders and her persona is a "corporate" product. Yet she also clearly has a significant say, perhaps the last, in how her persona is presented. For a general discussion of star agency see York (2013) and on Stone as a "force of nature" see Bracchi (2005).

26 'Sharon Stone's Mensa Madness', http://www.imdb.com/news/wenn/2002-04-04#celeb2.

27 For a good account of Stone's overall persona see Francke (2005).

28 Like many of her peers, Stone also became a hyphenate – directing, producing and starring in films that involved her production company Chaos.

29 http://gawker.com/160219/sharon-stone-to-shock-audiences-with-her-aging-naked-body

30 See Hollywood Online, 1998.

31 Stone later said of her role as Cindy in *Last Dance*: 'I like to get the chance as an actress to get under the skin of other kinds of personalities, to find out the way another person thinks without being bound by my own life experience and background. I've never killed anyone, but I had to know how Cindy felt about it' (Munn, 1997: 175).

32 I had certain rules. I'd have to be a better actor when I came out of each role and every other one had to be a potential hit (King, 2003: 57).

33 (Sanello, 1997) In relation to his accounts of Stone's sexual predatoriness ('If Love is a battlefield, Stone is General Sherman,' p. 159); Sanello was sued by Stone. He was found not guilty of defamation and slander in October 1999. Amazon web site contains the following reader's review: A reader from Hollywood, 28 November 1997 TERRIBLE! Does as much justice to Sharon Stone as 'Sliver' did for her career. Only good for beginning readers, fans of tabloid trash, or Stone fans who love dissing Demi Moore or Madonna.

34 http://edition.cnn.com/2008/SHOWBIZ/Movies/05/31/sharon.stone/index.html?_s=PM: SHOWBIZ

35 A telling example of the latter is the collection *Toxic Fame* (Berlin, 1996) in which the experience of being famous is presented as being a pathological state in which the stars fret under the burden of being an object of media and fan adulation. Poor dears.

36 Examples of this genre most often accomplish the desirable objective of withdrawing the star into the realm of elite opinion – see, for example, Winokaur (1992).
37 The term is Joshua Gamson's (1994) and applies to the interdependency between fan magazines and their industry sources.
38 Her controversial statements as a public figure or personage have not helped. See for example, Adams (2008), Alleyne (2008), Grossberg (2009).
39 This may be positive or negative but in either case it constitutes a demand – the person will be judged by the reproduced image.
40 For a complementary argument see McHugh (2014).

8 The End of Seeming

1 Johnson, N. F., and Jajodia, S. (1998) Steganography is the art of hiding information in ways that prevent the detection of hidden messages. The term, derived from Greek, literally means "covered writing." In cryptology, steganography is the placing of a hidden message within a manifest content.
2 http://www.gossipcop.com/macaulay-culkin-eating-pizza-video-eats-slice/ and Dodds, 2013.
3 http://htmlgiant.com/music/lets-overanalyze-to-death-macaulay-culkin-eating-a-slice-of-pizza/
4 It might be argued that like Pierre Menard, author of Don Quixote in the story by Borges, Culkin's performance, even if a copy, is original because of the change of context in which it is reproduced (Borges, 1981). Unfortunately Culkin spoils Borges' surrealist joke by revealing the video to be a publicity stunt for Pizza Underground.
5 Culkin or 'Mac' has even established his own art collective in his New York Loft 3MB (*Three Men and a Baby*), which is a somewhat thin and limited reinvention of the Factory.
6 Macaulay Culkin's Life After Fame http://www.thedailybeast.com/articles/2012/06/19/macaulay-culkins-life-after-fame/ and http://www.vulture.com/2013/12/pizza-underground-macaulay-culkin-velvet-origin-story.html
7 24 March 2014, Posted: 09/05/2012 7:34 p.m. Daniel J. Kushner: *Three Men and a Baby*: When Macaulay Culkin . . . http://www.huffingtonpost.com/daniel-j-kushner/forms-an-art-c
8 Ian Port, Last Night I Went To See Macaulay Culkin's Pizza Underground Band and It Was Cold and Soggy, 3/5/13 accessed http://blogs.sfweekly.com/shookdown/2014/03/i_went_to_se
9 See Frith, 1998. It is a measure of Lady Gaga's impact that it seems necessary to put in quotes what is still part of the contemporary scene.
10 Celebrities in the sense of minimally deflected real personalities are closer to rock stars than movie stars – before even considering the possibility that they lack significant performance skills.
11 The development of the skills and technology of para-social address in broadcast media has long afforded the opportunity to feign intimate and individualized address and to do so to a spatially, temporally and culturally segregated mass of spectators (Horton and Wohl, 1956; Schramm and Wirth,

2010). The development of social media such as Facebook and Twitter has vastly increased the scope for pursuing of such interactions.

12 Such constants only serve all (are anonymous) at a high level of abstraction since how particular individuals, for example, find love and what kind of love starts to unravel the image of commonality. Hollywood's aesthetic and individualistic gloss on such standards still commands the greatest acceptability – or at least is most readily available expression of them – with global audiences and therefore serves as a universalising collective referent (Olsen, 1999).

13 Social media are an indispensible precondition for inclusiveness. She tweets her fans, including those in the immediate audience, during her live performances as well as when going about her everyday business. Her dedicated fans firmly believe that her tweets are personal rather than corporately managed messages (Click, Lee and Holladay, 2013).

14 Once again the precedent of Madonna as a prototype is striking. Madonna in the peak of her career was perceived as a low other, a monster and female grotesque that debased feminism (Schulz, White and Brown, 1993).

15 In fact, she refers to herself as a jester.

16 Her defenders have claimed that her borrowings are parody rather than plagiarism. Moreover, unlike other pop parodists, such as Weird Al Jankovic – who has, indeed, parodied Gaga – her parodies are not just amusements but serious statements with the explicit purpose of challenging stereotypes of gender, sexuality and heteronormativity (Turner, 2012).

17 Sean Michaels, theguardian.com, Thursday, 2 July 2009, 10.32.

18 http://nypost.com/2013/07/14/lady-gagas-new-album-will-be-a-reverse-warholian-expedition-says-lady-gaga/

19 See http://www.wikihow.com/Become-a-Little-Monster

20 The religious overtones are blatant. For a discussion of Gaga as spiritual, see Gellel, 2013.

21 This seems to frame motherhood as an antagonistic struggle for carnal possession. It also hints at monstrosity – only a malign baby would 'suck' a mother dry or possess her body and who but a mother could love such a monster in return? Does Gaga harbour anxieties about her true fans, let alone reasonable apprehensions about stalkers?

22 Sean Michaels, theguardian.com, Thursday, 2 July 2009, 10.32 BST.

23 For example, as Noah Michelson observed in 2011: 'Though she may perpetually be in a frenzied state of flux – decked out in a dress fashioned from Kermit the Frog heads in one instant and bleeding to death on televisions around the world in the next – one thing has remained constant since she charged onto the scene in the fall of 2008: Lady Gaga is unfailingly dedicated to the LGBT community.' But as the interview unfolds Gaga equates queer liberation with liberation per se and in relation her Jo Calderone 'transman' character admits that her claim to be bisexual is not based on actual experience, http://www.huffingtonpost.com/2011/09/23/lady-gaga-jo-caldrone. All this was before Oprah and Kermit, for whom she was Miss Gaga – a parapraxis for Miss Piggy!

24 That is so long as she succeeds in maximizing her revenue stream. The ARTPOP release, already identified as a 'debacle' has been followed by

effusive declarations of niche loyalty though not without the inflation of Gaga's standing from Lady to Queen.

25 To be clear, using Gaga as a consciousness-raising symbol for gay community politics is distinct from taking her to be an essential incarnation of gay sensibility or any sensibility whatsoever.

26 J. M. O'Rourke, Telehistoricism (or Lady Gaga on the Telephone) In the Middle Friday, 25 June 2010. If these dimensions are few, one wonders what the many would be.

27 See Kenneth Gergen, 1991; Abercrombie and Longhurst, 1998.

28 Compare Schechner's (1982) concept of twice restored behaviour.

29 Steganography supplements but does not displace the other modes in the set. It is striking that pop stars are the leading exponents of this mode in part because of the development of the music video as a mini-performance analogous to the theatrical turn. Even conventional pop stars such as Kathy Perry flirt with multiple personae.

30 Strictly speaking, the body is always a social body, a pre-given outcome of socialization. So the term here is shorthand for the physical body as socially recognized and constructed. It is worth observing that this not how the star or celebrity is represented or perceived. He or she despite the obvious contribution of technology of reproduction is a force of nature.

31 The emotional labour debate has developed out of the path-breaking work of Hochschild (1983).

32 Though it creates the phenomenon of gossip about talent and desert since other routinized and below the line workers, paid less, become more aware of the salience of their own contribution. For all that, it is the box office that is decides.

33 It seems likely that digital post-production is increasing the gap between what the star or celebrity can accomplish unaided though as is well known there is a long prehistory of manipulating the look.

34 See, for example, McDonald, 2013 and Kerr, 1990.

35 There is a line of body monstration running from the earliest motion picture stars, for example, Douglas Fairbanks Snr through to Tom Cruise, to say nothing of their female counterparts who have been systematically depicted as sex objects (Vance, 2008).

36 Hari, 2008.

37 In a comparison between Madonna and Grace Jones, Shaviro notes that if Madonna critiques subjectivity it is from the premise that it is a surface effect with 'nothing' behind it. Jones, by contrast, manipulates her image to attack the material practices of subordination that have been imposed on black women. Lady Gaga once more follows Madonna's lead (Shaviro, 2010: 24).

38 Coombe, 1991.

39 The Millennium Generation have clearly bought into the message of liberation marketing, valuing fame and riches over the community good.

40 A token, in the sense used here, is a singular sign that stands for a category of persons or type. On type token ratios, see Eco, 1979.

41 For the transfer of metaphor into metonymy, see Baker, 1983. This means more than the claim that if people treat something as real it is real in its consequences. That certainly is a factor. It also means that concrete institutions

develop to sustain the relationship of 'partnership' between the stars and audience as I have argued.

42 Though Katy Perry, a chameleon herself, goes the humorous route, see her video *Birthday Party*.

43 Thus she says of the suicide of Kurt Cobain that he did not want to be famous, *The New Yorker*.

44 Though it needs to be noted that there is an element of white triumphalism in the new crop of pop stars; Madonna, Gaga, Perry and Miley Cyrus are all white girls (Shaviro, 2010).

45 The term comes from Gergen (1991).

46 See King (2010a).

47 Not to forget her more sustained contributions to cinematic art as Cristabell Abbott in *The Hottie and the Nottie* (2008).

48 The celebrity is a well-protected form of exchange, protected by celebrity right law from far more invasive forms of commodification. In some contexts of exchange, the body of the worker can be reduced to the function of pro-creation, sexual pleasure or even more reductively as biological material that can be decomposed into its constituents – blood, organs, tissues samples and the like – and sold with, or without, the owner's consent (Kimbrell, 1993).

49 Some stars and celebrities seem to give something back through charitable actions. The question arises whether such activities are a genuine expression of concern, another example of profile building or good public relations all if which would not arise if the donations were anonymous and this remains a vexed question (Rojek, 2013). Lady Gaga's Born This Way foundation has been reported as granting a miniscule amount of the revenue it received to charity support. http://www.dailymail.co.uk/news/article-2579040/Lady-Gagas-Born-This-Way-foundation-earned-2-3-million-paid-just-5-000-2012.htm

Bibliography

Abercrombie, N. & Longhurst, B. 1998. *Audiences*. London: Sage.

Adams, G. 2008. Sharon Stone: Blonde Bombshell. http://www.independent. co.uk/news/people/profiles/sharon-stone

Agnew, J.-C. 1986. *Worlds Apart: The Market and the Theatre in Anglo-American Thought 1550–1750*. Cambridge, MA: Cambridge University Press.

Albert, K. 1929. What's Next for Gloria, July, Photoplay, Chicago, Photoplay Magazine Publishing Co, 64–65, 124.

Anonymous. 1916. Ladies and Gentleman Introducing Tom Mix: He Rode the Glory Road to Fame on a Bucking Cayuse, September, Photoplay, Chicago, Photoplay Magazine Publishing Co., 33–34.

Anonymous. 1917. The Fan's Prayer, July, Photoplay, Chicago, Photoplay Magazine Publishing Co., 96.

Anonymous. 1921a. Here Comes the Kid, April, Photoplay, Chicago, Photoplay Magazine Publishing Co., 25.

Anonymous. 1921b. His Middle Name is Shakespeare, April, Photoplay, Chicago, Photoplay Magazine Publishing Co., 47.

Anonymous. 1960. A Leap Year's Guide to Eight Types of Bachelors, March, Photoplay, Chicago, Photoplay Magazine Publishing Co., 46–48, 87.

Althusser, L. 1971. Ideology and Ideological State Apparatuses (Notes Towards an Investigation). *In:* Brewster, Ben (trans.) *Lenin and Philosophy and Other Essays*, 121–176. London: New Left Books.

Altick, R. D. 1945. The Marvelous Child of the English Stage. *College English*, 7, 78–85.

Altick, R. D. 1978. *The Shows of London*. Cambridge, MA: Harvard University Press.

Anderson, J., Reckhenrich, J. & Kupp, M. 2012. Strategy Gaga: Little Monsters Big Rewards. Business Strategy Review, http://bsr.london.edu/lbs-article/724/index.html

Anger, K. 1986. *Hollywood Babylon: The Legendary Underground Classic of Hollywood's Darkest and Best Kept Secrets*. New York: Arrow Books.

Angus, W. 1939. An Appraisal of David Garrick: Based Mainly Upon Contemporary Sources. *Quarterly Journal of Speech*, 39, 30–42.

Arditi, J. 1998. *A Genealogy of Manners*. Chicago: University of Chicago Press.

Armstrong, N. 1987. *Desire and Domestic Fiction: A Political History of the Novel*. New York: Oxford University Press.

Asleson, R. (ed.). 1991. *A Passion for Performance: Sarah Siddons and Her Portraits*. Los Angeles: The Paul J. Getty Museum.

Avery, E. L. 1956. The Shakespeare Ladies Club. *Shakespeare Quarterly*, 7, 153–158.

Axelsson, K. 2009. Joseph Addison and General Education: Moral Didactics in Early Eighteenth-Century Britain. *Estetika: The Central European Journal of Aesthetics*, 46, 144–166.

Baer, M. 1992. *Theatre and Disorder in Georgian London*. Oxford: Clarendon.

Bailey, A. 2001. "Monstrous Manner": Style and the Early Modern Theater. *Criticism*, 43, 249–284.

Bailey, P. 1998. Parasexuality and Glamour: The Victorian Barmaid as Cultural Prototype. *Gender & History*, 2, 148–172.

Baker, M. 1978. *The Rise of the Victorian Actor*. London: Croom Helm/Rowman and Littlefield.

Baker, S. 1983. The Hell of Connotation. *Word and Image*, 1, 164–175.

Baker, W. E. & Faulkner, R. R. 1991. Role as Resource in the Hollywood Film Industry. *American Journal of Sociology*, 97, 279–309.

Balibar, E. & Wallerstein, I. M. 1991. *Race, Nation, Class: Ambiguous Identities*. London, Verso.

Barker-benfield, G. J. 1992. *The Culture of Sensibility: Sex and Society in Eighteenth Century Britain*. Chicago: University of Chicago Press.

Baron, C., Carson, D. & Tomasulo, F. P. (eds.). 2004. *More than Method*. Detroit: Wayne State University Press.

Barrell, J. 1986. Sir Joshua Reynolds and the Political Theory of Painting. *Oxford Art Journal*, 9, 36–41.

Barrell, J. 2004. Coffee House Politicians. *Journal of British Studies*, 43, 206–232.

Barry, J. 1991. Consumers' Passions: The Middle Class in Eighteenth-Century England. *Historical Journal*, 34, 207–216.

Barthes, R. 1981. *Camera Lucida: Reflections on Photography*. London: Macmillan.

Barton, L. 2009. I've Felt Famous My Whole Life. *The Guardian*, Wednesday, January 21.

Baskette, K. 1935. The New Ambitions of Joan Crawford, February, Photoplay, Chicago, Photoplay Magazine Publishing Co., 52–54.

Baumeister, R. F. & Vohs, K. D. 2004. Sexual Economics: Sex as Female Resource for Social Exchange in Heterosexual Interactions. *Personality and Social Psychology*, 8, 339–363.

Beck, U. 1992. *Risk Society: Towards a New Modernity*. London: Sage.

Benedetti, J. 2001. *David Garrick and the Birth of Modern Theatre*. London: Methuen.

Bennet, T. 1988. The Exhibitionary Complex. *New Formations*, 4, 73–102.

Bennett, L. 2013. "If We Stick Together We Can Do Anything": Lady Gaga Fandom, Philanthropy and Activism through Social Media. *Celebrity Studies*, 5, 1–15.

Benton, R. 2010. Lady Gaga's Penis. *Psychoanalytic Perspectives*, 7, 297–317.

Bergel, E. 1962. Social Stratification, London, McGraw Hill.

Berland, K. J. H. 1993. Reading Character in the Face: Lavater, Socrates, and Physiognomy. *Word & Image: A Journal of Verbal/Visual Enquiry*, 9, 252–269.

Berlin, J. 1996. *Toxic Fame – Celebrities Speak on Stardom*. Detroit, MI: Visible Ink Press.

Bertelsen, L. 1978. David Garrick and English Painting. *Eighteenth-Century Studies*, 11 (3) (Spring), 308–324.

Berthold, D. 1999. Class Acts: The Astor Place Riots and Melville's "The Two Temples." *American Literature*, 71, 429–461.

Biery, R. 1928. The Story of the Dancing Girl, Photoplay, Chicago, Photoplay Magazine Publishing Co., 34 (6), 42–43, 133.

Bindman, D. 2002. *Ape to Apollo: Aesthetics and the Idea of Race in the Eighteenth Century*. Ithaca: Cornell University Press.

Bird, S. E. 1992. *For Enquiring Minds: A Cultural Study of Supermarket Tabloids*. Knoxville: University of Tennessee Press.

Blackstone, W. 1979. *Commentaries on the Law of England*. Chicago: University of Chicago Press.

Blumer, H. 1933. *Movies and Conduct*. New York: MacMillan.

Boaden. J. 1893. *Memoirs of Mrs. Siddons: Interspersed with Anecdotes of Authors and Actors*. London: Gibbings and Company.

Boorstin, D. 1963. *The Image*. Harmondsworth, UK: Pelican Books.

Booth, M. R. 1981. *Victorian Spectacular Theatre, 1850–1910*. Boston: Routledge & Kegan Paul.

Booth, M. R. 2005. The Acting of Henry Irving. *Theatre Notebook: A Journal of the History and Technique of the British Theatre*, 59, 122–142.

Borges, J. L. 1981. Pierre Menard, Author of Quixote. *In:* Monegal, E. R. & Reide, A. (eds.) *Borges: A Reader*, 96–103. New York: E. P. Dutton.

Bos, J. 1998. Individuality and Inwardness in the Literary Character Sketches of the Seventeenth Century. *Journal of the Warburg and Courtauld Institutes*, 61, 142–157.

Boundas, C. V. (ed.). 1993. *The Deleuze Reader*. New York: Columbia University Press.

Bourdieu, P. 1983. The Field of Cultural Production, or: The Economic World Reversed. *Poetics*, 12, 311–356.

Bowser, E. 1994. *The Transformation of Cinema, 1907–1915*. Berkeley: University of California Press.

Boyer, A. 1708. *The English Theophrastus; or the Manners of the Age. Being the Modern Characters of the Court, the Town, and the City*. London: Printed for Bernard Lintott.

Boyer, J. 1990. Superfluous People: Tramps in Early Motion Pictures. *In:* Loukides, P. & Fuller, L. (eds.) *Beyond the Stars: Stock Characters in American Popular Film*. Greenboro: Bowling Green Press.

Bracchi, P. 2005. Baby Instinct; She's 47, a Man-Eating Diva Who's a Nightmare to Deal With. *Daily Mail*, 34, London Solo Syndication.

Brace, L. 2010. Improving the Inside: Gender, Property and the 18th-Century Self. *British Journal of Politics and International Relations*, 12, 111–125.

Bradbrook, M. C. 1962. *The Rise of the Common Player: A Study of Actor and Society in Shakespeare's England (1962)*. Boston: Harvard University Press.

Bratton, J. 2005. The celebrity of edmund kean: an institutional story. *In:* Moody, J. & Luckhurst, M. (eds.) *Theatre and Celebrity in Britain, 1660–2000*. New York: Palgrave Macmillan.

Braudy, L. 1986. *The Frenzy of Renown: Fame and Its History*. Oxford: Oxford University Press.

Brewer, J. 1997. *The Pleasures of the Imagination: English Culture in the Eighteenth Century*. New York: Farrar, Straus and Giroux.

Brewer, J. 2004. *A Sentimental Murder: Love and Madness in the Eighteenth Century*. New York: Farrar, Straus and Giroux.

Brock, C. 2006. *The Feminization of Fame 1750–1830*. Basingstoke, UK: Palgrave MacMillan.

Brown, J. 1995. *The Theatre in America during the Revolution*. Cambridge: Cambridge University Press.

Brown, R. H. 1987. *Society as Text: Essays on Rhetoric, Reason and Reality*. Chicago: University of Chicago Press.

Brownstein, R. M. 1993. *Tragic Muse: Rachel of the Comedie-Francaise*. New York: Alfred A. Knopf.

Bruster, D. 1992. *Drama and Markets in the Age of Shakespeare*. Cambridge: Cambridge University Press.

Buchanan, J. 2009. *Shakespeare on Silent Film: An Excellent Dumb Discourse*. Cambridge: Cambridge University Press.

Buchanan, L. 2007. Sarah Siddons and Her Place in Rhetorical History. *Rhetorica: Journal of the History of Rhetoric*, 25, 413–434.

Bunten, A. C. 2006. Self Commodification in the Native Owned Cultural Tourism Industry. PhD diss., University of California, Los Angeles.

Bunten, A. C. 2009. Sharing Culture or Selling Out? Developing the Commodified Persona in the Heritage Industry. *American Ethnologist*, 35, 380–395.

Burrows, J. 2003. *Legitimate Theatre: Theatre Stars in Silent British Films 1908–1918*. Exeter: University of Exeter Press.

Bushman, F. X. 1915. How I Keep My Strength, June, Photoplay, Chicago, Photoplay Magazine Publishing Co., 59–62.

Butsch, R. 1995. American Theater Riots and Class Relations. *Theatre Annual*, 48, 41–59.

Butsch, R. 2000. *The Making of American Audiences: From Stage to Television, 1750–1990*. Cambridge: Cambridge University Press.

Cagle, J. 1993. Chopped Sliver. *Entertainment Weekly*, May 21, 16–21.

Callahan, M. 2010. *Pokerface: The Rise and Rise of Lady Gaga*. New York: Hyperion.

Cannon, J. 1984. *Aristocratic Century: The Peerage of Eighteenth-Century England*. New York: Cambridge University Press.

Caputo, N. 2011. Melodrama Gets to the Heart of Shakespeare: The "Ogreish" King Richard III of George Frederick Cooke. *Textus*, XXIV, 169–188.

Carlson, M. 1994. Invisible Presences – Performance Intertextuality. *Theatre Research International*, 19, 111–117.

Carlson, M. 1996. Performing the Self. *Modern Drama*, 39, 599–607.

Carr, H. C. 1915. Charlie Chaplin's Own story, July, Photoplay, Chicago, Photoplay Magazine Publishing Co., 27–32.

Carter, P. 2002. Polite "Persons" Character, Biography and the Gentleman. *TRHS*, 12, 333–354.

Cassidy, T. & Brunström, C. 2002. "Playing is a Science": Eighteenth-Century Actors' Manuals and the Proto-Sociology of Emotion. *Journal for Eighteenth-Century Studies*, 25, 19–31.

Castle, T. 1986. *Masquerade and Civilization: The Carnivalesque in Eighteenth Century English Culture and Fiction*. London: Methuen.

Castles, J. 2008. *Big Stars*. Perth, Australia: Network Books.

Chaney, D. 1995. The Spectacle of Honour: The Changing Dramatization of Status. *Theory Culture Society*, 12, 147–167.

Chapman, J. B. 1933. Figuring the Stars' Salaries, 68–69, 184–185, reprinted in LEVIN, M. (ed.) 1991, *Hollywood and the Great Fan Magazines*. New York: Wings Books.

Chaves, J. 2008. Strangers and Publics. *Media History*, 14, 293–308.

Chevalier, L. 1981. *Laboring Classes and Dangerous Classes in Paris during the First Half of the Nineteenth Century*. Jellinek, F. (trans.). Princeton, NJ, Princeton University Press.

Cibber, C. 1822. *An Apology for the Life of Colley Cibber.* London: W. Simpkin and Marshall.

Click, M. A., Lee, H. & Holladay, H. W. 2013. Making Monsters: Lady Gaga, Fan Identification, and Social Media. *Popular Music and Society*, 36, 360–379.

Cloud, D. L. 1996. Hegemony or Concordance? The Rhetoric of Tokenism in Oprah Winfrey's Rags-to-Riches Biography. *Critical Studies in Mass Communication*, 13 (2), 115–137.

Cole, T. & Chinoy, H. K. 1970. *Actors on Acting.* New York: Crown.

Coleman, D. 2010. Going Gaga. *New York Times* [Online]. http://www.nytimes.com/2010/02/25/fashion/25CODES.html?_r=0

Collins, G. 1998. *Scorpion Tongues: Gossip through the Ages.* New York: William Morrow.

Collins, J. 1966. Henry Abbey: Image Maker of the Flash Age. *Educational Theatre Journal*, 18, 230–237.

Coombe, R. 1991. Author/izing the Celebrity: Publicity Rights, Postmodern Politics, and Unauthorized Genders. *Cardozo Arts & Entertainment Law Journal*, 10, 365–395.

Copley, S. 1995. Commerce, Conversation and Politeness in the Early Eighteenth-Century Periodical. *British Journal of Eighteenth Century Studies*, 18, 63–77.

Corfield, P. 1991. Class by Name and Number in Eighteenth-Century Britain. *In:* Corfield, P. (ed.) *Language, History, and Class.* Oxford: Basil Blackwell.

Corona, V. P. 2013. Memory, Monsters, and Lady Gaga. *Journal of Popular Culture*, 46, 725–744.

Cotter, C. F. 1939. The Forty Hacks of the Fan Mags. *The Coast*, February, 20.

Cottegnies, L. 2002. Codifying the Passions in the Classical Age: A Few Reflections on Charles Le Brun's Scheme and its Influence in France and in England, *Etudes Epistémè*, 1, 141–158.

Cowan, B. 2004. Mr. Spectator and the Coffeehouse Public Sphere. *Eighteenth-Century Studies*, 37, 345–366.

Crean, P. J. 1938. The Stage Licensing Act of 1737. *Modern Philology*, XXXV, 239–255.

Currid-Halkett, E. 2010. *Starstruck: The Business of Celebrity.* New York: Faber and Faber.

Danahay, M. 2012. Richard Mansfield "Jekyll and Hyde" and the History of Special Effects. *Nineteenth Century Theatre and Film*, 39, 54–72.

Darwin, C. 1999. *The Expression of the Emotions in Man and Animals.* New York: HarperCollins.

David, S. 2007. Self for Sale: Notes on the Work of Hollywood Talent Managers. *Anthropology of Work Review*, XXVIII, 6–16.

Davies, B. & Harre, R. 1990. Positioning: The Discursive Production of Selves. *Journal for the Theory of Social Behaviour*, 20, 43–63.

Davis, J. 2004. Presence, Personality, Physicality: Actors and Their Repertoires 1776–1895. *In:* Donohue, J. (ed.) *The Cambridge History of British Theatre 1660–1895*, Vol. 2. Cambridge: Cambridge University Press.

Davis, J., Freeman, L. & Raby, P. (eds.). 2009. *Lives of Shakespearean Actors, Part 11 Edmund Kean, Sarah Siddons and Harriet Smithson by Their Contemporaries.* London: Pickering and Chatto.

Davis, T. C. 2000. *The Economics of the British Stage: 1800–1914.* Cambridge, UK: Cambridge University Press.

Davison, K. 2006. Historical Aspects of Mood Disorders. *Psychiatry*, 5, 115–118.

Davisson, A. L. 2013. *Lady Gaga and the Remaking of Celebrity Culture*. Jefferson, NC: MacFarland.

Dawson, M. S. 2005. *Gentility and the Comic Theatre in Late Stuart London*. Cambridge: Cambridge University Press.

Debord, G. 1995. *The Society of the Spectacle*. New York: Zone Books.

Decordova, R. 1990. *Picture Personalities*. Chicago: University of Illinois Press.

Dee, S. 1960. If I were Lana Turner, December, Photoplay, Chicago, Photoplay Magazine Publishing Co. Reprinted on http://www.bobbydarin.net/lana.html

Delin, J. 2000. *The Language of Everyday Life*. London: Sage.

De Vries, H. 1992. The Brazen Instincts of Sharon Stone. http://articles.latimes.com/1992-03-15/entertainment/ca-6812_1_basic-instinct

Dew, B. 2005. Spurs to Industry in Bernard Mandeville's *Fable of the Bees, Journal for Eighteenth-Century Studies*, 28 (2), 151–165.

Dircks, P. T. 1997. David Garrick, George III, and the Politics of Revision. *Philological Quarterly*, 76, 289–312.

Dixon, S. 2003. Ambiguous Ecologies: Stardom's Domestic Mise-en-Scene. *Cinema Journal*, 42, 81–100.

Dobson, M. 1992. *The Making of the National Poet: Shakespeare, Adaptation and Authorship, 1660–1769*. Oxford: Clarendon.

Dodds, E. 2013. Questions We Asked Ourselves While Watching Macaulay Culkin Eat a Slice of Pizza. http://entertainment.time.com/2013/12/20/macaulay-culkin-eats-pizza-and-we-have-questions/

Douglas, M. 2002. *Purity and Danger: An Analysis of the Concepts of Pollution and Taboo*. London: Routledge.

Downer, A. S. 1943. Nature to Advantage Dressed: Eighteenth-Century Acting. *PMLA*, 58, 1002–1037.

Downer, A. S.1946. Players and the Painted Stage: Nineteenth Century Acting. *PMLA*, 61, 522–576.

Dreyfus, H. L. & RABINOW, P. 1986. *Michel Foucault: Beyond Structuralism and Hermeneutics*. Brighton, Sussex: Harvester.

Dyer, R. 1987. *Heavenly Bodies; Film Stars and Society*. London: Macmillan.

Eagleton, T. 1984. *The Function of Criticism, from "The Spectator" to Post-Structuralism*. London: Verso.

Earle, P. 1989. *The Making of the English Middle Class: Business, Society and Family Life in London 1660–1730*. Berkeley: University of California Press.

Eckert, C. 1978. The Carole Lombard in Macy's Window. *Quarterly Review of Film Studies*, 3, 1–21.

Eco, U. 1979. *A Theory of Semiotics*. Bloomington: Indiana University Press.

Eger, E. 2002. Out Rushed a Female to Protect the Bard: The Bluestocking Defense of Shakespeare. *Huntington Library Quarterly*, 65, 127–151.

Elias, N. 1978. *The History of Manners: The Civilizing Process*. New York: Pantheon.

Elias, N. 1993. *Mozart: Portrait of a Genius*. Berkeley: University of California Press.

Elkins, F. 1955. Popular Hero Symbols and Audience Gratifications. *Journal of Educational Sociology*, 29, 97–107.

Engel, L. 2011. *Fashioning Celebrity: Eighteenth-Century British Actresses and Strategies for Image Making*. Columbus: Ohio State University Press.

Evans, A. & Wilson, G. D. 1999. *Fame: The Psychology of Stardom*. London: Vision Paperbacks.

Ewen, S. & Ewen, E. 2006. *Typecasting: On the Arts of Human Inequality.* New York: Steven Stories Press.

Fairbanks, D. 1917. Douglas Fairbanks Own Page, Photoplay, Chicago, Photoplay Magazine Publishing Co., 12 (6), 87.

Fawcett, J. H. 2011. The Over-expressive Celebrity and the Deformed King: Recasting the Spectacle as Subject in Colley Cibber's Richard III. *PMLA*, 126, 950–965.

Feasey, R. 2004. Stardom and Sharon Stone: Power as Masquerade. *Quarterly Review of Film and Video*, 21, 199–207.

Festa, L. M. 2005. Personal Effects: Wigs and Possessive Individualism in the Long Eighteenth Century. *Eighteenth-Century Life*, 29, 47–90.

Fielding, H. 1751. *An Enquiry into the Causes of the Late Increase of Robbers, & C, with Some Proposals for Remedying this Growing Evil.* London: A. Millar.

Fiering, N. S. 1976. Irresistible Compassion: An Aspect of Eighteenth-Century Sympathy and Humanitarianism. *Journal of the History of Ideas*, 37, 195–218.

Fine, G. 1997. Scandal, Social Conditions, and the Creation of Public Attention: Fatty Arbuckle and the Problem of Hollywood. *Social Problems*, 44, 297–321.

Fitzgerald, P. H. 1971. *The Life of David Garrick: From Original Family Papers, and Numerous Published and Unpublished Sources.* Ann Arbor, MI: Plutarch Press, Reprint of the 1868 Edition.

Fitzmaurice, S. M. 1998. The Commerce of Language in the Pursuit of Politeness in Eighteenth Century England. *English Studies*, 79 (4), 309–328.

Fitzsimons, R. 1976. *Edmund Kean: Fire from Heaven.* New York: The Dial Press.

Forbes, D. 1984. An Awful Look Upward. *Theatre Notebook*, 38, 10–16.

Foucault, M. 1979. *Discipline and Punish: The Birth of the Prison.* New York: Vintage.

Foucault, M. 2002. *The Order of Things.* London: Routledge Classics.

Foulkes, R. 1977. Herbert Beerbohm Tree's King Henry VIII: Expenditure, Spectacle and Experiment. *Theatre Research International*, 3, 23–32.

Foulkes, R. 2004. Charles Kean and the Great Exhibition. *Theatre Notebook*, 58 (3), 125–140.

Francke, L. 1996. Someone to Look At. *Sight and Sound*, 6, 26–27, 32.

Frank, R. H. & COOK, P. J. 1995. *The Winner Take All Society.* Glencoe: Free Press.

Frank, T. 1997. Liberation Marketing and the Culture Trust. *Conglomerates and the Media*, typepad.com

Freeman, L. 2002. *Character's Theater: Genre and Identity on the Eighteenth-Century English Stage.* Philadelphia: University of Pennsylvania Press.

French, H. R. 2000. The Search for the "Middle sort of People" in England, 1600–1800. *Historical Journal*, 43, 277–293.

Freudenberger, H. 1963. Fashion, Sumptuary Laws, and Business. *Business History Review*, 37, 37–48.

Friedman, R. 2014. Debbie Reynolds Puts Chaplin's Bowler Dorothy's Red Shoes Up for Auction. *Showbiz 411* [Online].

Frith, S. 1998. *Performing Rites: On the Value of Popular Music.* Cambridge, MA, Harvard University Press.

Fuller, K. H. 2001. *At the Picture Show: Small-Town Audiences and the Creation of Movie Fan Culture.* Charlottesville: University of Virginia Press.

Furtwangler, A. 1977. The Making of Mr. Spectator. *Modern Language Quarterly*, 38, 1–39.

Gabler, N. 1995. *Winchell: Gossip, Power, and the Culture of Celebrity*. New York: Vintage.

Gabler, N. 1998. *Life the Movie*. New York: Knopf.

Gaines, J. 1991. *Contested Culture: The Image, the Voice and the Law*. North Carolina: University of North Carolina Press.

Gamson, J. 1994. *Claims to Fame: Celebrity in Contemporary America*. London and California: University of California Press.

Ganzel, D. 1961. Patent Wrongs and Patent Theatres: Drama and the Law in the Early Nineteenth Century. *PMLA*, 76, 384–396.

Geary, P. 1988. Sacred Commodities: The Circulation of Medieval Relics. *In:* Appadurai, A. (ed.) *The Social Life of Things: Commodities in Cultural Perspective*. Cambridge: Cambridge University Press.

Gellel, A.-M. 2013. Traces of Spirituality in the Lady Gaga Phenomenon. *International Journal of Children's Spirituality*, 18, 214–226.

Gelman, B. (ed.). 1972. *Photoplay Treasury*. New York: Crown Publishers.

George, D. 1964. *London Life in the Eighteenth Century*. New York: Harper Torchbooks.

Gergen, K. 1991. *The Saturated Self: Dilemmas of Identity in Contemporary Life*. New York: Basic Books.

Gest, M. 1915. Farrar – that's all, December, Photoplay, Chicago, Photoplay Magazine Publishing Co., 104–110.

Giddens, A. 1991. *Modernity and Self-identity*. Stanford: Stanford University Press.

Gildon, C. 1710. *The Life of Mr. Thomas Betterton, the Late Eminent Tragedian*. London: Robert Gosling.

Glover, B. 2002. Nobility, Visibility, and Publicity in Colley Cibber's "Apology." *Studies in English Literature 1500–1900*, 42, 523–539.

Goffman, E. 1979. *Gender Advertisements*. London: Macmillan.

Goffman, E. 1981. *Forms of Talk*. Philadelphia: University of Pennsylvania Press.

Goffman, E. 1990. *The Presentation of the Self in Everyday Life*. Harmondsworth, Middlesex: Penguin.

Golby, J. M. & Purdue, W. A. 1984. *The Civilisation of the Crowd: Popular Culture in England, 1750–1900*. London: Batsford.

Goldsmith, M. M. 1976. Public Virtue and Private Vices: Bernard Mandeville and English Political Ideologies in the Early Eighteenth Century. *Eighteenth-Century Studies*, 9, 477–510.

Gombrich, E. H. 1972. The Mask and the Face: The Perception of Physiognomic Likeness in Life and in Art. *In:* Gombrich, E. H., Hochberg, Julian & Black, Max *Art, Perception and Reality*, 1–46.

Goodman, E. 1961. *The Fifty-Year Decline and Fall of Hollywood*. New York: Simon and Schuster.

Goodman, N. 1976. *Languages of Art*. Indianapolis: Hackett Publishing Company.

Goodman, N. 1981. Routes of Reference. *Critical Inquiry*, 8, 121–132.

Goodyear, D. 2009. Celebromatic: Dept. of Hoopla. *The New Yorker*, 85 (39), 25.

Gordon, M. M. 1964. *Assimilation in American Life*. New York: Oxford University Press.

Gordon, R. W. 1995. Paradoxical Property. *In:* BREWER, J. & STAVES, S. (eds.) *Early Modern Conceptions of Property*. London: Routledge.

Gordon, S. P. 1995. Voyeuristic Dreams: Mr. Spectator and the Power of Spectacle. *Eighteenth Century*, 36, 3–23.

Goring, P. 2005. *The Rhetoric of Sensibility in 18th Century Culture*. Cambridge, UK: Cambridge University Press.

Gosson, S. 1579. Schoole of Abuse. Reprinted 1841, London, Shakespeare Company.

Goudreau, J. 2012. Lady Gaga Goes from Shock Artist to Soccer Mom? *Forbes*, March 19, 2012, 34.

Graham, S. 1950. I'd Like to See Them Marry, January, Photoplay, Chicago, Photoplay Magazine Publishing Co., 36.

Grattan, T. C. 1862. *Beaten Paths and Those Who Trod Them*. London: Chapman and Hall.

Gray, R. J. 2013. *The Performance Identities of Lady Gaga: Critical Essays*. Jefferson, NC: McFarland.

Greenblatt, S. 1980. *Renaissance Self Fashioning: From More to Shakespeare*. Chicago: University of Chicago Press.

Greenstein, F. I. 1964. New Light on Changing American Values: A Forgotten Body of Survey Data. *Social Forces*, 42, 441–450.

Gregerson, L. 1990. Narcissus Interrupted: Specularity and the Subject of the Tudor State. *Criticism*, 35, 1–40.

Grieveson, L. 2004. *Policing Cinema: Movies and Censorship in Early-Twentieth-Century America*. Los Angeles, Univ of California Press.

Griffith, R. (ed.). 1971. *The Talkies: Articles and Illustrations from Photoplay Magazine, 1928–1940*. New York: Dover.

Grossberg, J. 2009. Did You Hear the One About Sharon Stone's Air Rage? http://au.eonline.com/news/132820/did-you-hear-the-one-about-sharon-stone-s-air-rage

Grossberg, L. 1993. The Media Economy of Rock Culture: Cinema, Post-Modernity and Authenticity. *In*: Frith, S., Goodwin, A. & Grossberg, L. (eds.) *Sound and Vision: The Music Video Reader*, 159–179. London: Taylor and Francis.

Gunn, S. 2005. Translating Bourdieu: Cultural Capital and the English Middle Class in Historical Perspective. *British Journal of Sociology*, 56, 49–64.

Gunning, T. 1986. The Cinema of Attraction. *Wide Angle* (3, 4), 63–70.

Gunning, T. 1994. *DW Griffith and the Origins of American Narrative Film: The Early Years at Biograph*. Chicago: University of Illinois Press.

Gurr, A. 1980. *The Shakespearean Stage, 1574–1642*, 2nd Edition. Cambridge: Cambridge University Press.

Gurstein, R. 2000. Taste and "The Conversible World" in the Eighteenth Century. *Journal of the History of Ideas*, 61, 203–221.

Habermas, J. 1989. *The Structural Transformation of the Public Sphere: An Inquiry into a Category of Bourgeois Society*. Cambridge, MA: MIT Press.

Halasz, A. 1995. "So Beloved That Men Use His Pictures for Their Signs": Richard Tarlton and the Uses of Sixteenth-Century Celebrity. *Shakespeare Studies*, 23, 19–38.

Halliday, M. A. K. & Hasan, R. 1992. *Cohesion in English*. London: Longman. 11th Impression.

Halliday, M. A. K. & Matthiessen, C. 1994. *Introduction to Functional Grammar*, 3rd Edition. London: Hodder Education.

Handel, L. 1950. *Hollywood Looks at Its Audience: A Report of Film Audience Research*. Urbana, IL: University of Illinois Press.

Harcup, T. & O'neill, D. 2001. What Is News? Galtung and Ruge Revisited. *Journalism Studies*, 2, 261–280.

Hari, J. 2008. Botox is Destroying Hollywood Stars' Ability to Act. *http://www.independent.co.uk/voices/commentators/johann-hari/johann-hari-botox-is-destroying-hollywood-stars-ability-to-act-779102.html*

Hartmann, E. G. 1948. *The Movement to Americanise the Immigrant*. New York: Columbia University Press.

Harvey, D. 1998. The Body as an Accumulation Strategy. *Environment and Planning D: Society and Space*, 16, 401–442.

Hay, D. & Rogers, N. 1997. *Eighteenth-Century English Society*. Oxford: Oxford University Press.

Hay, D., Linebugh, P., Rule, J. G., Thompson, E. P. & Winslow, C. 1975. *Albion's Fatal Tree: Crime and Society in Eighteenth-Century England*. London: Allen Lane.

Hazlitt, W. 1818. *A View of the English Stage or a Series of Dramatic Criticisms*. London: Robert Stodart.

Hébert, L. & Everaert-Desmedt, N. 2006. *Tools for Text and Image Analysis: An Introduction to Applied Semiotics*, accessed at http://www.signosemio.com/.

Hechter, M. & Brustein, W. 1980. Regional Modes of Production and Patterns of State Formation in Western Europe. *American Journal of Sociology*, 85 (5), 1061–1094.

Hecht, J. 1956. *The Domestic Servant Class in Eighteenth Century England*. London: Routledge Kegan Paul.

Hedgcock, F. A. 1912. *A Cosmopolitan Actor: David Garrick and His French Friends*. London: S. Paul.

Herwitz, D. 2008. *The Star as Icon: Celebrity in the Age of Mass Media*. New York: Columbia University Press.

Hewitt, B. 1971. King Stephen of the Park and Drury Lane. *In:* Donohue, J. W. (ed.) *The Theatrical Manager in England and America*. Princeton: Princeton University Press.

Hiatt, B. 2009. Monster of Pop: Lady Gaga's Wild Tour. *Rolling Stone, November 12*.

Hiatt, B. 2011. Unicorns, Sex Dreams and the Freak Revolution: Deep Inside the Unreal World of Lady Gaga. *Rolling Stone*, 9th June 2011.

Highfill, P. 1970. The British Background of the American Hallams. *Theatre Survey*, 11 (1), 1–35.

Hill, A. & Popple, W. 1966. *The Prompter: a theatrical paper* (1734–1736). B. Blom.

Hill, C. 1984. *The World Turned Upside Down: Radical Ideas During the English Revolution*. Harmondsworth, Middlesex, England: Penguin Books.

Hillebrand, H. N. 1933. *Edmund Kean*. New York: Columbia University Press.

Hinnant, C. H. 2008. Gifts and Wages: The Structures of Exchange in Eighteenth-Century Fiction and Drama. *Eighteenth-Century Studies*, 42, 1–18.

Hirschman, A. O. 1982. Rival Interpretations of Market Society: Civilizing, Destructive, or Feeble? *Journal of Economic Literature*, 20, 1463–1484.

Hochschild, A. R. 1983. *The Managed Heart: Commercialization of Human Feeling*. Berkeley: University of California Press.

Holland, P. 1996. "David Garrick: '3dly, as an Author.'" *Studies in Eighteenth Century Culture*, 25, 39–62.

Hooper, W. 1915. The Tudor Sumptuary Laws. *English Historical Review*, 30, 433–449.

Horn, J. 2003. "Lovelace": Sharon Stone Really Disappears into a Role. http://articles.latimes.com/print/2013/aug/07/entertainment/la-et-mn-lovelace-sharon-stone-20130807

Horton, D. & Wohl, R. 1956. Mass Communication and Para-Social Interaction: Observations on Intimacy at a Distance. *Psychiatry*, 19, 215–229.

Howe, E. 1992. *The First English Actresses: Women and Drama 1660–1700*. Cambridge: Cambridge University Press.

Howe, H. 1950. Duke in Coonskin, January, Photoplay, Chicago, Photoplay Magazine Publishing Co., 54.

Huba, J. 2013. *Monster Loyalty: How Lady Gaga Turns Followers into Fanatics*. London: Penguin Books.

Hughes, A. & Brown, J. R. 1981. *Henry Irving, Shakespearean*. Cambridge: Cambridge University Press.

Hughes, L. 1971. *The Drama's Patrons: A Study of the Eighteenth-Century London Audience*. Austin: University of Texas Press.

Hume, D. 1969. *A Treatise of Human Nature*. Harmondsworth, UK: Penguin Classics.

Hume, R. D. 2006. The Economics of Culture in London, 1660–1740. *Huntington Library Quarterly*, 69, 487–533.

Hunt, A. 1999. *Governing Morals: A Social History of Moral Regulation*. Cambridge: Cambridge University Press.

Hurl-Eamon, J. 2005. The Westminster Impostors: Impersonating Law Enforcement in Early Eighteenth-Century London. *Eighteenth-Century Studies*, 36, 461–483.

Hyde, L. 2008. *Trickster Makes This World: How Disruptive Imagination Creates Culture*. Edinburgh: Canongate Books.

Ingebretsen, E. 1998. Monster-Making: A Politics of Persuasion. *Journal of American Culture*, 21, 25.34.

Ingram, W. 1992. *The Business of Playing: The Beginnings of the Adult Professional Theatre in Elizabethan London*. Ithaca, NY: Cornell University Press.

Irving, L. 1952. *Henry Irving: The Actor and His World*. London: Macmillan.

Jaffe, K. S. 1980. The Concept of Genius: Its Changing Role in Eighteenth-Century French Aesthetics. *Journal of the History of Ideas*, 41, 579–599.

Jameson, F. 1991. *Postmodernism, or, The Cultural Logic of Late Capitalism*. Durham, NC: Duke University Press.

Johnson, J. 1919. Symbols, June, Photoplay, Chicago, Chicago, Photoplay Magazine Publishing Co., 35.

Johnson, J. 1915. Mary Pickford: Herself and Her Career, Part 1, November, Photoplay, Chicago, Photoplay Magazine Publishing Co., 53–62.

Johnson, N. F. & Jajodia, S. 1998. Exploring Steganography: Seeing the Unseen. *Computer*, 31 (2), 26–34.

Jowett, G. S., Jarvie, I. C. & Fuller, K. H. (eds.). 1996. *Children and the Movies: Media Influence and the Payne Fund Controversy*. New York: Cambridge University Press.

Juzwiak, R. 2011. Lady Gaga's Charity Donated Just $5,000 of Its $2.1 Million. http://gawker.com

Kahan, J. 2006. *The Cult of Kean*. Aldershot, UK: Ashgate.

Kantorowicz, E. H. 1997. *The King's Two Bodies: A Study in Mediaeval Political Theology*. Princeton: Princeton University Press.

Kemble, F. 2001/1879. *Records of a Girlhood*. New York: Henry Holt. http://www. gutenberg.org

Kerr, C. 1990. Incorporating the Star: The Intersection of Business and Aesthetic Strategies in Early American Film. *Business History Review*, 64, 384–410.

Kershaw, B. 2001. Dramas of Performative Society. *New Theatre Quarterly*, 17, 203–211.

Kessler, J. 1994. *Inside People: The Stories behind the Stories*. New York: Villard Books.

Ketcham, M. 1981. The Arts of Gesture the Spectator and Its Relationship to Physiognomy, Painting, and the Theater. *Modern Language Quarterly*, 42, 137–152.

Ketcham, M. 1983. Setting and Self Presentation in the Restoration and Early Eighteenth Century. *Studies in English Literature 1500–1900*, 23, 399–417.

Ketcham, M. 1985. *Transparent Designs: Reading, Performance, and Form in the Spectator Papers*. Athens: University of Georgia Press.

Kimbrell, A. 1993. *The Human Body Shop: The Engineering and Marketing of Life*. London: Harper Collins.

King, B. 1984. The Hollywood Star System: The Impact of an Occupational Ideology on Popular Hero-Worship. PhD Thesis, University of London, London School of Economics.

King, B. 1987. The Star and the Commodity: Notes Towards a Performance Theory of Stardom. *Cultural Studies*, 1, 145–161.

King, B. 1992. TV Stars as Degenerate Symbols: Observations on Television and the Transformation of Celebrity. *Semiotica*, 92, 8–44.

King, B. 2003. Embodying an Elastic Self: The Parametrics of Contemporary Stardom. *In:* Barker, M. & Austin, T. (eds.) *Contemporary Hollywood Stardom*. London, Arnold.

King, B. 2008. Stardom, Celebrity and the Para-Confession. *Social Semiotics*, 18, 115–132.

King, B. 2010a. Stardom, Celebrity and the Money Form. *Velvet Light Trap*, 65, 7–19.

King, B. 2010b. On the New Dignity of Labour. *Ephemera: Theory & Politics in Organization*, 10, 285–302.

King, B. 2011. Articulating Digital Stardom. *Celebrity Studies*, 2, 247–262.

King, T. A. 1992. As If (She) Were Made on Purpose to Put the Whole World into Good Humour: Reconstructing the First English Actresses. *TDR*, 36 (3), 78–102.

Kingsley, G. 1915. Movie Royalty in California, June, Photoplay, Chicago, Photoplay Magazine Publishing Co., 123–127.

Kinsley, W. 1967. Meaning and Format: Mr. Spectator and His Folio Half-Sheets. *ELH*, 34, 482–494.

Kitchen, K. 1915. What They Really Get, October, Photoplay, Chicago, Photoplay Magazine Publishing Co., 138–141.

Klapp, O. 1962. *Heroes, Villains and Fools*. Englewood Cliffs: Prentice Hall.

Klein, L. 1984. The Third Earl of Shaftesbury and the Progress of Politeness, *Eighteenth-Century Studies*, 18 (2) (Winter 1984–1985), 186–214.

Klein, L. 1995. Politeness for Plebes: Consumption and Social Identity in Early Eighteenth-Century England. *In:* Bermingham, A. & Brewer, J. (eds.) *The Consumption of Culture: 1600–1800: Image, Object*. London: Routledge.

Klein, L. 1996. Property and Politeness in the Early 18th Century Whig Moralists. *In:* Brewer, J. & Staves, S. (eds.) *Early Modern Conceptions of Property.* London: Routledge.

Klein, L. 2002. Politeness and the Interpretation of the British Eighteenth Century. *Historical Journal,* 45, 869–898.

Klein, L. 2012. Addisonian Afterlives: Joseph Addison in Eighteenth-Century Culture. *Journal for Eighteenth-Century Studies,* 35, 101–118.

Klepac, R. L. 1998. The Macklin-Garrick Riots. *Theatre Notebook,* 52, 8–17.

Knapp, M. E. 1949. Garrick's Last Command Performance. *In:* Lewis, W. S. (ed.) *The Age of Johnson, Essays Presented to Qhauncy Brewster Tinker.* New Haven: Harvard University Press.

Knight, C. A. 1993. The "Spectator's Moral Economy." *Modern Philology,* 91, 161–179.

Knight, J. 1969. *David Garrick.* New York: B. Blom.

Knox, A. 1946. Acting and Behaving. *Hollywood Quarterly,* 1 (3), 260–269.

Kress, G. R. & Leeuwen, T. V. 2006. *Reading Images: The Grammar of Visual Design.* London: Routledge.

Lacassin, F. 1972. The Comic Strip and Film Language. *Film Quarterly,* 26, 11–23.

Laffler, J. 2004. Theatre and the Female Presence. *In:* Donahue, J. (ed.) *The Cambridge History of English Theatre.* Cambridge, UK: Cambridge University Press.

Lang, G. E. & Lang, K. 1988. Recognition and Renown: The Survival of Artistic Reputation. *American Journal of Sociology,* 94, 79–109.

Langford, P. 1989. *A Polite and Commercial People: England 1727–1783.* Oxford: Oxford University Press.

Langford, P. 2002. The Uses of Eighteenth-Century Politeness. *Transactions of the Royal Historical Society, Sixth Series,* 12, 311–331.

Larkin, M. 1929. What Is IT, June, Chicago, Photoplay Magazine Publishing Co., 34–35, 98.

Lavater, J. C. 1850. *Essays on Physiognomy: Designed to Promote the Knowledge and Love of Mankind.* London: William Tegg and Company.

Leets, L., Debecker, G. & Giles, H. 1995. Fans: Exploring Expressed Motivations for Contacting Celebrities. *Journal of Language and Social Psychology,* 14, 102–123.

Leiss, W., Kline, S. & Jhally, S. 1986. *Social Communication in Advertising: Persons Products and Images of Well-Being,* Toronto and New York: Routledge.

Levin, J. & Kimmel, A. J. 1977. Gossip Columns: Media Small Talk. *Journal of Communication,* 27, 165–175.

Levin, M. (ed.). 1991. *Hollywood and the Great Fan Magazines.* New York: Wings Books.

Life Magazine. 1989. Hollywood 1939–1989, Today's Stars Meet the Screen's Legends. *Spring,* 1–124.

Lohisse, J. 1973. *Anonymous Communication: Mass-Media in the Modern World.* London: Allen and Unwin.

Lotman, Yuri M. 1990. *Universe of the Mind: A Semiotic Theory of Culture,* Shukman, A. (trans.). London & New York: I. B. Tauris.

Lowenthal, L. 1961. *The Triumph of the Mass Idols: Literature, Popular Culture and Society.* Englewood Cliffs: Prentice Hall.

Luckhurst, M. & Moody, J. (eds.). 2005. *Theatre and Celebrity in Britain 1600–2000*. London: Palgrave Macmillan.

Luvass, B. 2006. Re-producing Pop: The Aesthetics of Ambivalence in Contemporary Dance Music. *International Journal of Cultural Studies*, 9, 167–183.

Lynch, D. S. 1998. *The Economy of Character*. Chicago: University of Chicago Press.

Lytel, B. 1922. Can I Appear on the Screen, Opportunities in the Motion Picture Industry, Los Angeles, CA: Photoplay Research Society, 39–45.

Macaulay, S. 2014. Hollywood's Hottest Props: *Canvas*. Auckland: Weekend Herald, pp. 8–12. Edited by Michele Crawshaw.

McDonald, P. 2013. *Hollywood Stardom*. Chichester, UK: Wiley-Blackwell.

Macht, S. R. 1968. Henry Irving's Acting Theory and Stage Practice. *Quarterly Journal of Speech*, 54, 392–397.

MacIntyre, A. 2007. *After Virtue: A Study in Moral Theory*. London: Duckworth.

Macleod, J. 1983. *The Actor's Right to Act*. London: Lawrence and Wishart.

Macmillan, D. 1948. David Garrick, Manager: Notes on the Theatre as a Cultural Institution in England in the Eighteenth Century. *Studies in Philology*, 45, 630–646.

McPherson, H. 2010. *Garrickomania: Art, Celebrity and the Imaging of Garrick* [Online]. April 6, 2010. Folger Shakespeare Library Online: Folger Library. Accessed March 26, 2013.

Mann, W. 2009. *How to Be a Movie Star: Elizabeth Taylor in Hollywood*. London, Faber and Faber.

Manners, D. 1935. The Girl Without a Past, October, Photoplay, Chicago, Photoplay Magazine Publishing Co., 32–38, 86.

Manning, P. J. 1972/3. Edmund Kean and Byron's Plays. *Keats-Shelley Journal*, 21 (22), 188–206.

Marcuse, H. 1972. *One Dimensional Man*. London: Abacus.

Marsden, J. 2008. Shakespeare and Sympathy. *In:* Yachin, P. & Sabor, P. (eds.) *Shakespeare and the Eighteenth Century*. Aldershot: Ashgate.

Marshall, D. 1986. *The Figure of Theater: Shaftesbury, Defoe, Adam Smith, and George Eliot*. New York: Columbia University Press.

Marshall, P. D. 1997. *Celebrity and Power: Fame in Contemporary Culture*. Minneapolis: University of Minnesota Press.

Marshall, P. D. 2010. The Promotion and Presentation of the Self: Celebrity as Marker of Presentational Media. *Celebrity Studies*, 1, 35–48.

Marx, K. 1952. *A History of Economic Theories from the Physiocrats to Adam Smith*, Vol. 1. Langland Press. https://openlibrary.org/publishers/Langland_Press.

Marx, K. 1990. *Capital: A Critique of Political Economy*. London, Penguin.

Marx, K. & Engels, F. 1970. *The German Ideology*, C. J. Arthur (ed.). New York: International.

Maus, K. E. 1979. "Playhouse Flesh and Blood": Sexual Ideology and the Restoration Actress. *ELH*, 46 (4), 595–617.

Mauss, M. 1973. Techniques of the Body. *Economy and Society*, 2, 70–88.

McCann, G. 1988. *The Body in the Library*, Cambridge: Polity.

McCann, G. 1997. *Cary Grant: A Class Apart*. London: Fourth Estate.

McConachie, B. 2006. American Theatre in Context from Beginnings to 1870. *In:* Wilmeth, D. B. & Bigsby, C. (eds.) *The Cambridge History of the American Theatre*. Cambridge: Cambridge University Press.

McHugh K. 2014. Of Agency and Embodiment: Angelina Jolie's Autographic Transformations. *Celebrity Studies*, 5, 1–2, 5–19.

McGinn, C. 2005. *The Power of Movies: How Screen and Mind Interact*. New York: Pantheon.

McIntyre, I. 1999. *Garrick*. London: Penguin Books.

McPherson, H. 2000. Picturing Tragedy: Mrs. Siddons as the Tragic Muse Revisited. *Eighteenth-Century Studies*, 33, 401–430.

McPherson, H. 2002. Theatrical Riots and Cultural Politics in Eighteenth Century London. *Eighteenth Century: Theory and Interpretation*, 43, 236–252.

McRobbie, A. 2007. Top Girls? *Cultural Studies*, 21, 718–737.

Menand, L. 1997. The Iron Law of Stardom: Why We Need the Academy Awards This Year and Every Year. *New Yorker-New Yorker Magazine Incorporated*, 36–39.

Mennell, S. 2007. *The American Civilizing Process*. Cambridge: Polity.

Merriman, R. 2014. It's Not Her Handwriting: Lindsay Lohan Celebrity Sex List Blasted as Fake. *http://www.entertainmentwise.com/news/143496/Its-Not-Her-Handwriting-Lindsay-Lohan-Celebrity-Sex-List-Blasted-As-Fake*

Merritt, R. 1976. Nickelodeon Theaters-Building an Audience for the Movies. *Wide Angle*, 1, 4–10.

Meter, J. V. 2011. Lady Gaga: Our Lady of Pop. *Vogue* [Online].

Michelson, N. 2011. Lady Gaga Discusses Activism, Outing and Reading Her Male Alter Ego, Jo Calderone, as a Transgender Man. *http://www.huffingtonpost.com/2011/09/23/lady-gaga-jo-calderone-transgender_n_978063.html*

Middleton, J. 2003. Merchants: An Essay in Historical Ethnography. *Journal of the Royal Anthropological Institute*, 9, 509–526.

Milhous, J. & Hume, R. D. 1985. The London Theatre Cartel of the 1720s: British Library Additional Charters 9306 and 9308. *Theatre Survey*, 26 (1), 21–37.

Milhous, J. & Hume, R. D. 1988. David Garrick and Box-Office Receipts at Drury Lane in 1742–43. *Philological Quarterly*, 67, 323–344.

Miller, T. 1993. *The Well-Tempered Self: Citizenship, Culture, and the Postmodern Subject*. Baltimore: Johns Hopkins University Press.

Mingay, G. E. 1963. *English Landed Society in the Eighteenth Century London*. London: Routledge and Kegan Paul.

Mix, T. 1929. The Loves of Tom Mix, March, Photoplay, Chicago, Photoplay Magazine Publishing Co., 30–31.

Montrose, L. 1991. The Work of Gender in the Discourse of Discovery. *Representations*, Special Issue (Winter), 1–41.

Moody, J. 2007. *Illegitimate: Theatre in London 1770–1844*. Cambridge, UK: Cambridge University Press.

Morin, E. 1960. *The Stars: An Account of the Star System in the Motion Pictures*. New York: Evergreen Profile Book.

Morton, D. 2010. Convergence Between Comic Strips and Film Sketching Under the Influence? Winsor McCay and the Question of Aesthetic. *Animation: An Interdisciplinary Journal*, 5, 295–312.

Muldrew, C. 1998. *The Economy of Obligation: The Culture of Credit and Social Relations in Early Modern England*. London: Palgrave Macmillan.

Mullan, J. 1988. *Sentiment and Sociability: The Language of Feeling in 18th Century*. Oxford: Clarendon.

Munn, M. 1997. *The Sharon Stone Story*. London: Robson Books.

Murphy, A. 1969. *The Life of David Garrick*. New York: B. Blom. Reprint of the 1801 Edition.

Muntean, N. & Petersen, A. H. 2009. Celebrity Twitter: Strategies of Intrusion and Disclosure in the Age of Technoculture. *M/C Journal*, 12 (5) (December 2009). http://journal.media-culture.org.au/index.php/mcjournal/article 194

Naremore, J. 1988. *Acting in the Cinema*. Berkeley: University of California Press.

Nashaw, D. 1993. *Going Out: The Rise and Fall of Public Amusements*. New York: Basic Books.

Nayar, P. K. 2009. *Seeing Stars: Spectacle, Society, and Celebrity Culture*. New Delhi: Sage.

Neisser, U. 1988. Five Kinds of Self-Knowledge. *Philosophical Psychology*, 1, 35–59.

Nelson, A. L. & Cross, G. B. (eds.). 1974. *Drury Lane Journal. Selections from James Winston's Diaries 1819–1827*, London: Society of Theatre Research.

Nenadic, S. 1994. Middle-rank Consumers and Domestic Culture in Edinburgh and Glasgow 1720–1840. *Past and Present*, 145, 122–156.

Nichol, A. 1980. *The Garrick Stage*. Athens: University of Georgia Press.

Noth, W. 1995. *Handbook of Semiotics*. Bloomington, IN: Indiana University Press.

Nussbaum, F. 2010. *Rival Queens: Actresses, Performance, and the Eighteenth-Century British Theater*. Philadelphia: University of Pennsylvania Press.

Olson, S. R. 1999. *Hollywood Planet: Global Media and the Competitive Advantage of Narrative Transparency*. London: Routledge.

Orgel, S. 1988. The Authentic Shakespeare. *Representations*, 21, 1–25.

Owen, K. 1915. The Grand Duke of Hollywood, September, Photoplay, Chicago, Photoplay Magazine Publishing Co., 38–40.

Parsons, F. M. W. 1906. *Garrick and His Circle*. New York: Benjamin Blom.

Pateman, C. 1988. *The Sexual Contract*. Stanford: Stanford University Press.

Payne, H. C. 1976. Elite versus Popular Mentality in the Eighteenth Century. *Historical Reflections/Réflexions Historiques*, 2 (2), 183–208.

Pearson, R. E. 1992. *Eloquent Gestures: The Transformation of Performance Style in the Griffith Biograph Films*. Berkeley: University of California Press.

Peck, J. 1997. Anne Oldfield's Lady Townly: Consumption, Credit, and the Whig Hegemony of the 1720s. *Theatre Journal*, 49, 397–416.

Pedicord, H. 1954. *The Theatrical Public in the Time of Garrick*. New York: Kings Crown Press.

Peiss, K. 1986. *Cheap Amusements: Working Women and Leisure in Turn-of-the-Century New York*. Philadelphia: Temple University Press.

Peltret, E. 1919. Chaplin's New Contract, February, Photoplay, Chicago, Photoplay Magazine Publishing Co., 72–73.

Perkin, H. J. 1969. *The Origins of Modern English Society 1780–1880*. London: Routledge & Kegan Paul.

Perry, G. 2007. *Spectacular Flirtations: Viewing the Actress in British Art and Theatre, 1768–1820*. New Haven: Yale University Press.

Perry, G., Roach, J. & West, S. 2011. *The First Actresses: From Nell Gwyn to Sarah Siddons*. London: National Portrait Gallery.

Peters, G. 2011. Lady Gaga Business Guru: More than Meets the Eye. *Business Strategy Review*, 22, 69–71.

Peters, M. 2012. On the Edge of Theory: Lady Gaga, Performance and Cultural Theory. *Contemporary Readings in Law and Social Justice*, 41, 25–37.

Petersen, A. H. 2011. Producing and Distributing Star Images, Celebrity Gossip, and Entertainment News 1910–2010. PhD diss., University of Texas at Austin.

Peterson, R. & Anand, N. 2004. The Production of Culture Perspective. *Annual Review of Sociology*, 30, 311–334.

Pine, B. J. & Gilmore, J. H. 1999. *The Experience Economy: Work Is Theatre and Every Business a Stage*. Boston, MA: Harvard Business Press.

Playfair, G. 1950. *Kean*. London: Columbus Books.

Plumb, J. H. 1950. *England in the Eighteenth Century*. Harmondsworth, UK: Penguin Books.

Pocock, J. G. A. 1975. Early Modern Capitalism – The Augustan Perception. *In:* Kamenka, E. & Neale, R. S. (eds.) *Feudalism, Capitalism, and Beyond*. London: Edward Arnold.

Pocock, J. G. A. 1985. The Mobility of Property and the Rise of Eighteenth-Century Sociology. *Virtue, Commerce and History: Essays on Political Thought and History, Chiefly in the Eighteenth Century*. Cambridge: Cambridge University Press.

Pollock, A. 2007. Neutering Addison and Steele: Aesthetic Failure and the Spectatorial Public Sphere. *ELH*, 74, 707–734.

Ponce De Leon, Charles. 2001. *Self-Exposure: Human-Interest Journalism and the Emergence of Celebrity in America, 1890–1940*. Chapel Hill: University of North Carolina Press.

Porter, S. L. 1986. English-American Interaction in American Musical Theater at the Turn of the Nineteenth Century. *American Music*, 4, 6–19.

Price, C. 1973. *Theatre in the Age of Garrick*. New Jersey: Rowman and Littlefield.

Price, F. 1983. Imagining Faces: The Later Eighteenth-Century Sentimental Heroine and the Legible, Universal Language of Physiognomy. *Journal for Eighteenth-Century Studies*, 6, 1–16.

Pringle, G. 2007. The Heart of Stone, *The Independent*: Extra (UK), January 15, 14–15.

Pritner, C. 1965a. James Quin's Acting. *Communication Studies*, 16, 113–119.

Pritner, C. L. 1965b. William Warren's Financial Arrangements with Traveling Stars – 1805–1829. *Theatre Survey*, 6, 83–90.

Pullen, C. 1968. Lord Chesterfield and Eighteenth Century Appearance and Reality. *Studies in English Literature*, 8, 501–515.

Pullen, K. 2005. *Actresses and Whores*. Cambridge, UK: Cambridge University Press.

Pumphrey, M. 1987. The Flapper, the Housewife and the Making of Modernity. *Cultural Studies*, 1 (2), 179–194.

Quartermaine, L. 1960. Talking about Actors and Acting. *The Shaw Review*, 3, 6–13.

Quinn, M. L. 1990. Celebrity and the Semiotics of Acting. *New Theatre Quarterly*, 6, 154–161.

Quirk, J. R. 1922. Moral House Cleaning in Hollywood and Open Letter to Will Hays, April, Photoplay, Chicago, Photoplay Magazine Publishing Co., 52.

Quirk, J. R. 1929. Close-ups and Long Shots, May, Photoplay, Chicago, Photoplay Magazine Publishing Co., 29–30.

Radar. 2012. Kim Kardashian's Mom, Kris Jenner, Brokered Sex Tape Sale. *Radaronline.com/exclusives/2012/08/kim-kardashian-sex-tape-sale-mom-kris-jenner/*

Radin, M. J. 1982. Property and Personhood. *Stanford Law Review*, 34, 957–1015.

Radley, A. 1990. Artefacts, Memory and a Sense of the Past. *In:* Middleton, D. & Edwards, D. (eds.) *Collective Remembering*. London: Sage.

Randall, A. 2006. *Riotous Assemblies: Popular Protest in Hanoverian England*. Oxford: Oxford University Press.

Redmond, S. 2006. Intimate Fame Everywhere. *In:* Holmes, S. & Redmond, S. (eds.) *Framing Celebrity: New Directions in Celebrity Culture*. London: Routledge.

Reichenbach, H. 1931. *Phantom Fame: The Anatomy of Ballyhoo*. New York: Simon & Schuster.

Rein, I., Kotler, P. & Stoller, M. 1987. *High Visibility*. New York: Dodd, Mead.

Richards, J. 2005a. *Sir Henry Irving: A Victorian Actor and His World*. London: Hambledon.

Richards, J. 2005b. Henry Irving: The Actor-Manager as Auteur. *Nineteenth Century Theatre and Film*, 32, 20–35.

Richards, S. 1993. *The Rise of the English Actress*. New York: St Martin's Press.

Richardson, J. 1977. *Sarah Bernhardt and Her World*. London: Weidenfeld and Nicolson.

Riesman, D., Glazer, N. & Denney, R. 2001. *The Lonely Crowd: A Study of the Changing American Character*. New Haven: Yale University Press.

Rind, M. 2002. The Concept of Disinterestedness in Eighteenth-Century British Aesthetics. *Journal of the History of Philosophy*, 40, 67–87.

Roach, J. R. 1976. Cavaliere Nicolini: London's First Opera Star. *Educational Theatre Journal*, 28 (2) (May), 189–205.

Roach, J. R. 1982. Garrick, the Ghost and the Machine. *Theatre Journal*, 34, 431–440.

Roach, J. R. 1985. *The Player's Passion: Studies in the Science of Acting*. Newark, DE: University of Delaware Press.

Roberts, M. L. 2010. Rethinking Female Celebrity: The Eccentric Star of Nineteenth-Century France. *In:* Berenson, E. & Gilou, E. (eds.) *Constructing Charisma*. New York: Berghahn Books.

Rockwell, J. 1984. *Sinatra: An American Classic*, New York: Random House.

Rogers, N. 1979. Money, Land and Lineage: The Big Bourgeoisie of Hanoverian London. *Social History*, 4, 437–454.

Rogers, P. 1984. David Garrick: The Actor as Culture Hero. *Themes in Drama*, 6, 63–83.

Rogerson, B. 1953. The Art of Painting the Passions, *Journal of the History of Ideas*, 14 (1), 68–94.

Rojek, C. 2001. *Celebrity*, London: Reaktion Books.

Rojek, C. 2012. *Fame Attack: The Inflation of Celebrity and Its Consequences*, London: Bloomsbury Academic.

Rojek, C. 2013. Celanthropy, Music Therapy and "Big Citizen Samaritans." *Celebrity Studies*, 4, 129–143.

Ronson, J. 2000. "Fan Zone," *Guardian Weekend*, March 11, 2000: 7–2.

Rosenbaum, J. E. 1979. Tournament Mobility: Career Patterns in a Corporation. *Administrative Science Quarterly*, 24, 220–242.

Ross, S. 1984. Painting the Passions: Charles LeBrun's Conference Sur L'Expression. *Journal of the History of Ideas*, 45, 25–47.

Rozik, E. 2002. Acting: The Quintessence of Theatricality. *SubStance*, 31, 110–124.

Salmon, R. 1997. Signs of Intimacy: The Literary Celebrity in the "Age of Interviewing." *Victorian Literature and Culture*, 25 (1), 159–177.

Sanders, T. 2005. It's Just Acting: Sex Workers' Strategies for Capitalizing on Sexuality. *Gender, Work and Organization*, 12, 319–342.

Sangster, M. 1926. Calendar of Stars, February, Photoplay, Chicago, Photoplay Magazine Publishing Co., 28–29.

Sanello, F. 1997. *Naked Instinct*, London: Carol Publishing Group.

Sayles, J. 1987. *Thinking in Pictures: The Making of the Movie Matewan*. New York: Houghton Mifflin.

Scaggs, A. 2009. *Lady Gaga Worships Queen and Refuses to Wear Pants*, http://www.rollingstone.com. February 19.

Schatzki, T. R. & Natter, W. 1996. Sociocultural Bodies, Bodies Sociopolitical. *In:* Schatzki, T. R. & Natter, W. (eds.) *The Social and Political Body*. New York: Guilford Press.

Schechner, R. 1982. Collective Reflexivity: Restoration of Behavior. *In:* Ruby, J. (ed.) *A Crack in the Mirror: Reflexive Perspectives in Anthropology*. Philadelphia: University of Pennsylvania Press.

Schlesinger, L. B. 2006. Celebrity Stalking, Homicide, and Suicide: A Psychological Autopsy. *International Journal of Offender Therapy and Comparative Criminology*, 50, 39–46.

Schramm, H. & Wirth, W. 2010. Testing a Universal Tool for Measuring Parasocial Interactions across Different Situations and Media: Findings from Three Studies. *Journal of Media Psychology*, 22, 26–36.

Schruers, F. 1993. Stone Free. *Premiere*, 6 (9) (May), 58–66.

Schudson, M. 1984. Embarrassment and Erving Goffman's Idea of Human Nature. *Theory and Society*, 13 (5), 633–648.

Schultz, S. C. 1975. Toward an Irvingesque Theory of Shakespearean Acting. *Quarterly Journal of Speech*, 61 (4), 428–438.

Schulze, L., White, A. B. & Brown, J. D. 1993. A Sacred Monster in Her Prime: Audience Construction of Madonna as Low-Other. *In:* Schwichtenberg, C. (ed.) *The Madonna Connection*. Boulder, CA: West View.

Sechelski, D. S. 1996. Garrick's Body and the Labor of Art in Eighteenth-Century Theater. *Eighteenth-Century Studies*, 29, 369–389.

Seigel, J. 2005. *The Idea of the Self: Thought and Experience in Western Europe Since the Seventeenth Century*. Cambridge: Cambridge University Press.

Sennett, R. 1978. *The Fall of Public Man*. New York: Vintage.

Shaviro, S. 2010. *Post Cinematic Affect*. Winchester, UK: Zero Books.

Sheppard, F. H. W. 1970. The Theatre Royal, Drury Lane, and the Royal Opera House, Covent Garden. *Survey of London: Volume 35*. http://www.british-history.ac.uk/report.aspx? compid=100227 English Heritage.

Sherman, S. 1995. Servants and Semiotics: Reversible Signs, Capital Instability, and Defoe's Logic of the Market. *ELH*, 62, 551–573.

Sherman, S. 2011. Garrick among Media: The "Now Performer" Navigates the News. *PMLA*, 126 (4) (October), 966–982.

Shoemaker, R. B. 1987. The London "Mob" in the Early Eighteenth Century. *Journal of British Studies*, 26, 273–304.

Shortland, M. 1985. Skin Deep. Barthes, Lavater and the Legible Body. *Economy and Society*, 14 (3), 273–312.

Siddons, S. 1942. *The Reminiscences of Sarah Kemble Siddons, 1773–1785*, Edited, with a Foreword by William Van Lennep. Cambridge: Widener Library.

Simmel, G. 2011. *The Philosophy of Money*. London: Routledge Classics.

Singer, B. 1995. Manhattan Nickelodeons: New Data on Audiences and Exhibitors. *Cinema Journal*, 34 (3), 5–35.

Skeggs, B. & Wood, H. 2012. *Reacting to Reality Television*. London: Routledge.

Slide, A. 2010. *Inside the Hollywood Fan Magazine: A History of Star Makers, Fabricators, and Gossip Mongers*. Jackson, MS: University Press of Mississippi.

Slout, william L. & Rudisill, S. 1974. The Enigma of the Master Betty Mania, *Journal of Popular Culture*, 8 (1), 80–90.

Smart, A. 1965. Dramatic Gesture and Expression in the Age of Hogarth and Reynolds. *Apollo*, LXXXII, 90–97.

Smith, A. P. 2012. The Politics of Theatrical Reform in Victorian America. *American Nineteenth Century History*, 13, 321–346.

Sohn-Rethel, A. 1978. *Intellectual and Manual Labour: A Critique of Epistemology*. London: Macmillan.

Spensley, D. 1929a. The Big Boy Tells His Story, April, Photoplay, Chicago, Photoplay Magazine Publishing Co., 6, 70–71, 84.

Spensley, D. 1929b. From the Life Story of Nils Asther, February, Photoplay, Chicago, Photoplay Magazine Publishing Co., 30.

Sponsler, C. 1992. Narrating the Social Order: Medieval Clothing Laws. *CLIO*, 21 (3), 265–283.

Spratt, D. 2013. "Genius Thus Munificently Employed!!!": Philanthropy and Celebrity in the Theaters of Garrick and Siddons. *Eighteenth-Century Life*, 37 (3), 55–84.

Stacey, J. 1994. *Star Gazing: Hollywood Cinema and Female Spectatorship*. London: Routledge.

Stallabrass, J. 1999. *High Art Lite: British Art in the 1990s*. London: Verso.

Stallybrass, P. 1996. Worn Worlds: Clothes and Identity on the Renaissance Stage. *In:* DE Grazia, M., Quiligan, M. & Stallybrass, P. (eds.) *Subject and Object in Renaissance Culture (Cambridge Studies in Renaissance Literature and Culture)*. Cambridge: Cambridge University Press.

Stanhope, P. D. 1998. *Lord Chesterfield's Letters*. Oxford: Oxford World Classics.

Starr, K. 1986. *Inventing the Dream: California through the Progressive Era*. Oxford: Oxford University Press.

States, B. O. 1987. *Great Reckonings in Little Rooms: On the Phenomenology of the Theater*. Berkeley, CA: University of California Press.

Staum, M. 1995. Physiognomy and Phrenology at the Paris Athenee. *Journal of the History of Ideas*, 56, 443–462.

Stelmack, R. M. & Stalikas, A. 1991. Galen and the Humour Theory of Temperament. *Personality and Individual Differences*, 12, 255–263.

Stemmler, J. K. 1993. The Physiognomical Portraits of Johann Caspar Lavater. *Art Bulletin*, 75, 151–168.

Stern, T. 2000. *Rehearsal from Shakespeare to Sheridan*. Oxford, UK: Oxford University Press.

Stochholm, J. M. 1964. *Garrick's Folly: The Shakespeare Jubilee of 1769 at Stratford and Drury Lane*. New York: Barnes & Noble.

Stoker, B. 1907. *Personal Reminiscences of Henry Irving*. London: W. Heinemann.

Stone, G. W. & Kahrl, G. M. 1979. *David Garrick: A Critical Biography*. Carbondale: Southern Illinois University Press.

Stone, L. 1966. Social Mobility in England, 1500–1700. *Past and Present*, 33, 16–55.

Storm, W. 2004. Impression Henry Irving: The Performance in the Portrait by Jules Bastien-Lepage. *Victorian Studies*, 46, 399–423.

Straub, K. 1991. *Sexual Suspects: Eighteenth Century Plays and Sexual Ideology*. Princeton, NJ: Princeton University Press.

Strauss, N. 2010. The Broken Heart & Violent Fantasies of Lady Gaga. *Rolling Stone*, 1108 (1109), 66–72.

Studlar, G. 1991. The Perils of Pleasure? Fan Magazine Discourse as Women's Commodified Culture in the 1920s. *Wide Angle*, 13, 6–33.

Sullivan, C. 2002. *The Rhetoric of Credit: Merchants in Early Modern Writing*. London: Associated University Presses.

Sullivan, E. D. & PRY, K. B. 1991. The Eighteenth Century London Theater and the Capture Theory of Regulation. *Journal of Cultural Economics*, 15, 41–52.

Susman, W. 1984. *Culture as History: The Transformation of American Society in the Twentieth Century*. New York: Pantheon Books.

Taylor, C. 1992. *The Sources of the Self: The Making of Modern Identity*. Boston: Harvard University Press.

Taylor, C. 2002. Modern Social Imaginaries. *Public Culture*, 14, 91–124.

Taylor, G. 1972. *"The Just Delineation of the Passions": Theories of Acting in the Age of Garrick*. London: Methuen.

Taylor, G. V. 1967. Non-Capitalist Wealth and the French Revolution. *American Historical Review*, 72, 469–496.

Tetens, K. 2003. A Grand Informal Durbar: Henry Irving and the Coronation of Edward VII. *Journal of Victorian Culture*, 8 (2) (Autumn), 257–291.

Tetzlaff, D. 1993. Meta-Textual Girl. *In:* Schwichtenberg, C. (ed.) *The Madonna Connection: Representational Politics, Subcultural Identities, and Cultural Theory*. Boulder: Westview Press.

Therborn, G. 1980. *The Ideology of Power and the Power of Ideology*. London: Verso.

Thomas, K. 2009. *The Ends of Life: Roads to Fulfilment in Early Modern England*. Oxford: Oxford University Press.

Thompson, E. P. 1971. The Moral Economy of the English Crowd in the Eighteenth Century. *Past and Present*, 50, 76–136.

Thompson, E. P. 1974. Patrician Society, Plebian Culture. *Journal of Social History*, 7, 382–405.

Thompson, E. P. 1978. Eighteenth Century English Society: Class Struggle without Class, *Social History*, 3, 133–165.

Thompson, J. 1996. *Models of Value: Eighteenth Political Economy and the Novel*. Durham: Duke University Press.

Thorp, M. F. 1939. *America at the Movies*, New Haven, CT: Yale University Press.

Tillyard, S. 2005. Celebrity in Eighteenth-Century London. *History Today*, 55, 20–27.

Tolson, A. 1991. Televised Chat and the Synthetic Personality. *In:* Scannell, P. (ed.) *Broadcast Talk*. London: Sage.

Trilling, L. 1972. *Sincerity and Authenticity (The Charles Eliot Norton Lectures)*. Cambridge, MA: Harvard University Press.

Tudor, A. 1974. *Image and Influence: Studies in the Sociology of Film*. London: Allen and Unwin.

Turner, M. R. 2012. Lady Gaga, "Weird Al" Yankovic and Parodied Performance. *In*: GREY, R. (ed.) *The Performance Identities of Lady Gaga: Critical Essays*. Jefferson, NC: McFarland.

Turow, J. 1978. Casting for TV Parts: The Anatomy of Social Typing, *Journal of Communication*, 28, 19–24.

Valihora, K. 2001. The Judgement of Judgement: Adam Smith's Theory of Moral Sentiments. *British Journal of Aesthetics*, 41 (2) (April), 138–161.

Vance, J. 2008. *Douglas Fairbanks*. Los Angeles: University of California Press.

Vantol, J. 1932. *How Stars Spend Their Fortunes*, reprinted in Levin, M. (ed.) 1991, *Hollywood and the Great Fan Magazines*. New York: Wings Books, 12–13.

Vardac, A. N. 1950. From David Garrick to D. W. Griffith: The Photographic Ideal. *Educational Theatre Journal*, 2, 39–47.

Varey, S. 1993. A Star is Born. *Notes and Queries* (September), 335–336.

Varriale, S. 2012. Is That Girl a Monster? Some Notes on Authenticity and Artistic Value in Lady Gaga. *Celebrity Studies*, 3, 256–258.

Vermorel, F. & Vermorel, J. 2011. *Starlust: The Secret Fantasies of Fans*. London: Faber and Faber.

Voltaire. 1972. *Miracles and Idolatry*. Harmondsworth, England Penguin Books.

Wallech, S. 1986. Class versus Rank: The Transformation of Eighteenth-Century English Social Terms and Theories of Production. *Journal of History of Ideas*, 47, 409–431.

Walls, S. C. 2011. Lady Gaga's Music and Fame Hypocrisy. *www.newsweek.com/lady-gagas-music-and-fame-hypocrisy-*

Wanko, C. 2003. *Roles of Authority: Thespian Biography and Celebrity in Eighteenth Century Britain*. Lubbock: Texas Tech University Press.

Warner, J., Ivis, F. & Demers, A. 2000. A Predatory Social Structure: Informers in Westminster, 1737–1741. *Journal of Interdisciplinary History*, 30, 617–634.

Warren, L. S. 2002. Buffalo Bill Meets Dracula: William F. Cody, Bram Stoker, and the Frontiers of Racial Decay. *American Historical Review*, 107, 1124–1157.

Wasserman, E. R. 1947. The Sympathetic Imagination in Eighteenth-Century Theories of Acting. *Journal of English and Germanic Philology*, 46 (3), 264–272.

Weinberger, S. 2012. From Censors to Critics: Representing "the People." *Film & History: An Interdisciplinary Journal of Film and Television Studies*, 42, 5–22.

Weinbrot, H. D. 1983. Masked Men and Satire and Pope: Toward a Historical Basis for the Eighteenth-Century Persona. *Eighteenth-Century Studies*, 16 (3) (Spring), 265–289.

Weiner, A. B. 1992. *Inalienable Possessions: The Paradox of Keeping-While Giving*. Berkeley: University of California Press.

Weiner, J. 2009. How Smart is Lady Gaga. *www.slate.com/articles/arts/music.../2009/.../how_smart_is_lady_gaga.htm...*

Weinreb, B. & Hibbert, C. (eds.). 2008. *The London Encyclopedia*, 3rd Revised Edition. London: Macmillan.

Wernick, A. 1991. *Promotional Culture, Advertising, Ideology and Symbolic Expression*. London, Sage.

West, E. J. 1942. From a Player's to a Playwright's Theatre: The London Stage, 1870–1890. *Quarterly Journal of Speech*, 28, 430–436.

West, E. J. 1955. Irving in Shakespeare: Interpretation or Creation? *Shakespeare Quarterly*, 6, 415–422.

West, S. 1991. *The Image of the Actor: Verbal and Visual Representation in the Age of Garrick and Kemble.* Boston: St Martin's Press.

Westphal, M. 2007. *An Étoile Is Born at Paris Opera Ballet's Casual-Dress Nutcracker* [Online]. http://www.playbillarts.com.

Wharman, D. 2004. *The Making of the Modern Self: Identity and Culture in Eighteenth-Century England.* New Haven: Yale University Press.

Wheeler, S. 2012. Revealed: Lady Gaga's Charity Foundation Took in $2.6 Million – But Paid Out Just One $5,000 Grant and Spent Hundreds of Thousands on Expenses. *http://www.dailymail.co.uk/news/article-2579040/Lady-Gagas-Born-This-Way-foundation-earned-2-3-million-paid-just-5-000-2012.html*

Wilkes, T. 1759. *A General View of the Stage.* London: J. Coote.

Williams, J. 2014. "Same DNA, but Born this Way": Lady Gaga and the Possibilities of Postessentialist Feminisms. *Journal of Popular Music Studies,* 26, 28–46.

Williams, M. 1946. *Southern California County: An Island in the Sun.* New York: Duell, Sloan and Pearce.

Williams, R. 1954. *Drama in Performance.* London: Frederick Muller.

Williams, S. 2006. European Actors and the Star System in America 1752–1870. *In:* Wilmeth, D. B. & Bigsby, C. (eds.) *The Cambridge History of American Theatre.* Cambridge: Cambridge University Press.

Wills, G. 1998. *John Wayne's America.* New York: Simon and Schuster.

Wilmeth, D. B. 1973. Cooke among the Yankee Doodles. *Theatre Survey,* 14, 1–32.

Wilson, M. G. & Barrett, D. 2002. The End of Charles Kean's Directorship of the Windsor Theatricals. *Theatre Notebook,* 56, 117–124.

Winokaur, J. 1992. *True Confessions.* London: Plume.

Woo, C. 2008. *Romantic Actors and Bardolatry: Performing Shakespeare from Garrick to Kean.* New York: Peter Lang.

Wood, G. D. A. 2001. *The Shock of the Real: Romanticism and Visual Culture 1760–1860.* Basingstoke, UK: Palgrave Macmillan.

Woods, L. 1984. *Garrick Claims the Stage.* London: Greenwood Press.

Woods, L. 2006. *Transatlantic Stage Stars in Vaudeville and Variety: Celebrity Turns.* Basingstoke, UK: Palgrave Macmillan.

Worrall, D. 2000. Artisan Melodrama and the Plebeian Public Sphere: The Political Culture of Drury Lane and Its Environs, 1797–1830. *Studies in Romanticism,* 39, 213–227.

Worrall, D. 2006. *Theatric Revolution: Drama, Censorship and Romantic Period Subcultures 1773–1832.* Oxford: Oxford University Press.

Worthen, W. B. 1984. *The Idea of the Actor: Drama and the Ethics of Performance.* Princeton, NJ: Princeton University Press.

Wright, K. D. 1964. Henry Fielding and the Theatres Act of 1737. *Quarterly Journal of Speech,* 50 (3), 252–258.

Wrobel, A. 1970. "Romantic Realism": Nathaniel Beverley Tucker. *American Literature,* 42, 325–335.

York, L. 2013. Star Turn: The Challenge of Theorizing Celebrity Agency, *Journal of Popular Culture,* 46 (6), 1330–1347.

Young, S. M. & Pinsky, D. 2006. Narcissism and Celebrity. *Journal of Research in Personality,* 40, 463–471.

Yuval-Davis, N. 2006. Intersectionality and Feminist Politics, *European Journal of Women's Studies,* 13, 193–209.

Index

Printed and bound by CPI Group (UK) Ltd, Croydon, CR0 4YY